MW01010694

THE ART OF AWAKENING

The Art of Awakening

A User's Guide to Tibetan Buddhist Art and Practice

Konchog Lhadrepa
and Charlotte Davis

Snow Lion
Boulder
2017

Snow Lion
An imprint of Shambhala Publications, Inc.
4720 Walnut Street
Boulder, Colorado 80301
www.shambhala.com

© 2017 by Konchog Lhadrepa and Charlotte Davis
All drawings © 2017 by Konchog Lhadrepa

This work is based on *The Path to Liberation* by Konchog Lhadrepa,
published in Tibetan by Shechen Publications in 2005.

All rights reserved. No part of this book may be reproduced in any form
or by any means, electronic or mechanical, including photocopying,
recording, or by any information storage and retrieval system, without
permission in writing from the publisher.

9 8 7 6 5 4 3 2 1

First English Edition
Printed in the United States of America

∞ This edition is printed on acid-free paper that meets the
American National Standards Institute z39.48 Standard.
♻ This book is printed on 30% postconsumer recycled paper.
For more information please visit www.shambhala.com.

Distributed in the United States by Penguin Random House LLC
and in Canada by Random House of Canada Ltd

Designed by Gopa & Ted2, Inc.

LIBRARY OF CONGRESS CATALOGING-IN-PUBLICATION DATA

Names: Konchog Lhadrepa, author. | Davis, Charlotte, 1969– translator. |
Tshe-riṅ Bzo-rigs Slob-grwa.
Title: The art of awakening: a users guide to Tibetan Buddhist art and
practice / Konchog Lhadrepa and Charlotte Davis.
Description: First English edition. | Boulder: Snow Lion, [2017] | Based on
The Path to Liberation by Konchog Lhadrepa, published in Tibetan by
Shechen Publications in 2005. | Includes bibliographical references and index.
Identifiers: LCCN 2016009174 | ISBN 9781611803877 (pbk.: alk. paper)
Subjects: LCSH: Painting, Tibetan—Handbooks, manuals, etc.
Classification: LCC ND1046.T5 K67 2017 | DDC 294.3/437—dc23
LC record available at https://lccn.loc.gov/2016009174

Contents

Part Two: The Main Teachings

Part Three: Concluding Teachings

LIST OF ILLUSTRATIONS

FOREWORD

THE *PATH TO LIBERATION,* written by the master painter Konchog Lhadrepa, on which this work is based, is an incredible resource. He wrote it based on his years of study, contemplation, and painting Tibetan sacred art, particularly in the Karma Gadri tradition of painting. Here you will find histories, instructions, and a thorough overview of Tibetan sacred art, in particular the art of Tibetan tangka painting.

Konchog-la was a very close disciple of and personal attendant to Kyapje Dilgo Khyentse Rinpoche. Rinpoche himself chose Konchog-la to train in all aspects of Tibetan sacred art under the personal tutelage of His Holiness the sixteenth Karmapa's artist, Gen Lhadre Tragyal. Having excelled in his studies, Konchog-la returned to Kyapje Dilgo Khyentse Rinpoche's monastery, Shechen Tennyi Dargyeling, and gave himself wholeheartedly to painting tangkas, murals, tsakli cards, and so on. Whatever Rinpoche asked of him was perfectly accomplished, often under Kyapje Khyentse Rinpoche's personal supervision. These paintings, tangkas, and murals can still be seen at our monastery.

Under the direction of Kyapje Shechen Rabjam Rinpoche, Konchog-la established a school to train a new generation in Tibetan sacred art. In 1996, Tsering Art School officially opened, and the education of a new generation of artists began in earnest. Over the years, many students have trained under Konchog-la, and our Tsering Art School continues to produce many skilled artists. Although these artisans are primarily from the Himalayan regions, our student body also boasts a few from the West.

Charlotte Davis was one such student. In 1998, she came to Nepal with the express wish to train in Tibetan sacred arts. She lived and worked at Tsering Art School for six years. Having graduated in 2003, she continues to paint and assist Konchog-la and the school.

During her studies, as Konchog Lhadrepa gave an extensive commentary

on his book *The Path to Liberation,* Charlotte took extensive notes. These notes form the basis of *The Art of Awakening,* which is also supplemented with translations and annotations. It is a veritable mine of practical information, not only on the sacred art of Tibet but on every aspect of the practice of Vajrayana Buddhism.

I would like to thank Charlotte Davis for her great efforts in the field of Tibetan sacred art and especially for sharing her knowledge with the wider English-speaking world.

In conclusion, I'd like to request that you approach Tibetan sacred art not as just another style of painting to look at, but rather as a means to enhance your own contemplative practice—to deepen the practices of mindfulness and meditation.

<div style="text-align: right">

Dilgo Khyentse Yangsi Rinpoche,
Ugyen Tenzin Jigme Lhundrup

</div>

PREFACE

THIS MANUAL for Vajrayana Buddhist artists—in particular, tangka painters—is based on Konchog Lhadrepa's book in Tibetan called *The Path to Liberation*, which he wrote to assist his students at Shechen Monastery's Tsering Art School in Kathmandu, Nepal, as well as for a broader readership.[1] It is due only to the insistence of Konchog, and the blessings of Shechen Rabjam Rinpoche for the project, that I had the confidence to transcribe and edit an essentialized translation of Konchog's book, through extensive ongoing discussions with Konchog and additional research, published here as *The Art of Awakening*. This project began simply as lecture notes that I thought to type out and share with my fellow students.

Although I have done my best to follow the structure and contents of Konchog's book, many details are missing because of our limited skills in each other's language and the difficulty of finding sponsorship to do a word-for-word translation of the book. Therefore, this book is best understood as a presentation of the essential points and meaning of the original work. We were fortunate to receive the help of an experienced translator, Venerable Sean Price, to review and translate some of the most important sections. I also managed to find existing translations for some important sections of the book and received permission to paraphrase and quote from them, which has been very helpful.

Konchog feels that the most important subjects, the structure, and the essence of his writings are conveyed in the present work, and that the level of detail and repetition traditionally found in a Tibetan text is not necessary for a Western audience. Also, this book includes additional oral teachings and explanations given by Konchog, so that many points are clarified here in a way that was not done in his original work.

Yet, when this work is compared to the original Tibetan, there are sure to

be many mistakes, which I deeply regret and for which I sincerely apologize. I hope that where the meaning does not correspond properly with the reference texts, at least it is not incorrect with respect to the Buddhist teachings. And I hope that with the further help of qualified translators there will be revised editions in the future. Any errata, feedback, or comments can be sent to my e-mail (charlotte.e.davis@gmail.com) along with any expressions of interest in helping prepare or sponsor a future edition.

STRUCTURE AND STYLE

The Art of Awakening follows the same essential structure and content as Konchog's work *The Path to Liberation,* which is divided into three broad sections: preliminary teachings, main teachings, and concluding teachings. These correspond to the three noble principles of generating the altruistic motivation at the beginning of any virtuous activity, engaging in the main practice, and then concluding with the dedication of merit. The preliminary section contains essential teachings on the history of Buddhism in India and Tibet as well as a brief art history of India and Tibet. (Although the preliminary teachings are essentialized in this text, many of Konchog's original teachings were omitted. Therefore, the publication of a separate companion text is planned for the future.) The main teachings include guidelines for the artist, followed by teachings on relating the Vajrayana practice of visualization of the mandala and deity to supreme art practice. This section includes a translation of *A Supreme Liturgy for Artists* by the great Drukpa Kagyu master Ngawang Kunga Tenzin. The preliminary teachings and teachings on visualization are broadly presented according to the view and way of explanation of the Ancient Translation School (Nyingma). This is not out of any sectarian bias, but is because of the author's limited knowledge in the way of presentation of the Sarma traditions, and our appreciation that although the modes of explanation may differ, the essential meaning is the same. Mandala and deity iconometry are then explained, along with many other detailed teachings, including temple building, auspicious symbols, monks' accoutrements, composition, and other practical instructions on methods and materials. Finally, the concluding section consists of the teachings on mantra drawing for tangkas and statues, consecration, the benefits of the supreme arts, the importance of dedication, and how to dedicate. Extensive illustrations by Konchog Lhadrepa are placed at the end of the text, along with several appendixes, a

glossary, a list of translation equivalents, and a bibliography of primary and secondary texts. In an attempt to overcome the gender bias of the English language, when making general references to the artist (or practitioner and teacher), I alternate between genders, sometimes referring to "she" and "her" and sometimes to "he" and "him."

A Note on Tibetan

The field of supreme art contains many specialized terms, and knowing these Tibetan words will be useful for anyone training in Tibetan art. In general, I have translated these terms using common architectural and colloquial vocabulary. A few of the technical terms—for example, those for mandala drawing—I have left in phoneticized Tibetan so that the reader does not get bogged down by a profusion of lengthy translations. The glossary and the list of translation equivalents provide the Wylie transliterations for key terms, which are given in phonetic Tibetan when they first appear. Text names are given in English translation only; the Tibetan spellings in Wylie transliteration can be found in the bibliography. Where possible, Indian personal names are given in translated English or Sanskrit, and Tibetan names appear in Tibetan phonetics or English translation.

Acknowledgments

It is due to Shechen Rabjam Rinpoche's vision to preserve the sacred Tibetan arts that the Tsering Art School was established at Shechen Monastery in Nepal, providing me and other students with the precious opportunity to engage in this training under the guidance of such a rare and authentic teacher as Konchog Lhadrepa. Khyentse Yangsi Rinpoche[2] continues to support and further inspire us in this vision. Therefore, my thanks go first to Shechen Rabjam Rinpoche and to Dilgo Khyentse Yangsi Rinpoche. Konchog Lhadrepa, my teacher and dear friend, not only has extraordinary artistic talent but also embodies spiritual qualities, humility, and strength of devotion to which most of us can only aspire; my indebtedness to him is incalculable.

I would next like to express my heartfelt gratitude to everyone who helped me with this text: Ani Lodro Palmo, for her draft translation of sections of *A Supreme Liturgy for Artists,* and Venerable Sean Price, who later helped complete this translation along with patiently clarifying and

translating many other important sections of the text. Thanks also to Russell Shipman and to two others who wish to remain anonymous, who very kindly read through the text at the early stages and offered advice. I would like to thank Adrian Gunther for proofreading and making helpful suggestions and Steve Cline for his assistance with transliteration of Sanskrit mantras. My heartfelt gratitude to Fiona White for her invaluable skills, generosity with her time, and patience in editing the final versions of the book before it was sent to Shambhala Publications, and to my mother and my sister for their ongoing support throughout this lengthy process. Finally my gratitude and thanks go to Tracy Davis and the team at Shambhala Publications for believing in the value of these teachings and refining this work in a way that could not have been accomplished without their immense experience and expertise.

I dedicate any merit accrued through this activity to the long life and unimpeded activity of my gurus and all the realized teachers who manifest for the benefit of beings. I also dedicate this meritorious work to the well-being and enlightenment of all sentient beings, to the pacification of warfare, and to the healing of our planet's natural environment. May the supreme Vajrayana arts—an authentic and complete path to enlightenment—increase and flourish.

Charlotte Davis

2016

The Art of Awakening

Introduction

I HAVE CHOSEN THE teachings outlined in this text because most Tibetan art training does not include many Buddhist teachings, and the great art manuals from old Tibet assumed a certain level of scholarship that many aspiring artists today do not have.[1] For artists to understand how to practice their discipline according to the buddha dharma, they must have a good understanding of these teachings. In other words, the artist needs to know how to properly train in the two accumulations necessary to attain enlightenment—the accumulation of merit, which is the activity of body and speech, and the accumulation of wisdom, which is the mind's activity. In the practice of Buddhist art, the proper creation of supreme images is the accumulation of merit, and the accompanying attitude and motivation is the accumulation of wisdom.

Asanga's *Five Treatises on the Levels* categorizes Tibetan treatises or literature into nine divisions, presented in three sets of three: (1) general writings, (2) false propaganda, (3) *true meaning*, (4) opposing what is beneficial, (5) unloving writings, (6) *how to escape suffering*, (7) writings to increase knowledge, (8) debate, and (9) *how to accomplish dharma practice*. For the purpose of studying the buddha dharma, it is only necessary to learn the last of each set (in italics), called "supreme literature." Buddhists respect the treatises written by the Buddha's learned and accomplished followers as if they were the words of the Buddha himself, including the authentic literature on supreme art. Vasubandhu's *Reasoning for Explanations* explains the underlying meaning or etymology of the word "treatise," which in Tibetan is *tenchö,* where *ten* ("doctrine or teaching") refers to the Buddha's teaching in this world, and *chö* means "to transform or improve."

> To subdue the enemies of the afflicting emotions and be defended
> from the lower realms of samsara, the two virtuous qualities of

treatises are healing from the cause (the three negative mental afflictions) and protecting from the result (the suffering of cyclic existence and bad migrations). These two supreme qualities outshine all others.[2]

The purpose of the treatises is thus to change or improve our minds through the doctrine until complete enlightenment is attained.

With the aspiration that the teachings in this book will assist in carrying out this supreme intention, I have divided it into three parts, corresponding to the three noble principles of (1) the preliminary teachings, (2) the main teachings, and (3) the concluding teachings and dedication. The preliminary teachings explain how to establish the ground of our practice as dharma practitioners and artists, fostering our faith and understanding. The main teachings combine the teachings on the main practice with the practice of supreme art. The concluding teachings explain the benefits of these practices and how to dedicate the merit to the enlightenment of all sentient beings.

PART ONE
Preliminary Teachings

The preliminary teachings as outlined here correspond to the first noble principle of establishing the correct view and motivation according to the Buddhist teachings. This section is divided into two broad headings: common preliminary teachings, and specific preliminary teachings for the study of supreme art.

I. Common Preliminary Teachings

The common preliminary teachings consist of the basic historical, philosophical, and contemplative underpinnings of the Buddhist path to be studied by any aspiring Buddhist. These teachings are not outlined in detail in this text, as they are readily available in translation in works such as *The Words of My Perfect Teacher*[1] and so on.

In summary, the ground of the path is established first through contemplating the benefit of spiritual teachings in general and the unique view of the Buddhist path compared to other religions. Buddha Shakyamuni said it is very important not to take his teachings simply on faith; first analyze them like a goldsmith checks gold to see if it has any impurities. Contemplate the teachings on the four noble truths[2] and the four thoughts that change the mind, which helps generate the necessary attitude of renunciation toward worldly life. Once faith in the teachings has been developed through this critical analysis and application, the practitioner takes refuge in the path with a deep confidence based on personal investigation.

Once the decision to become a Buddhist is made, the next step is to take the refuge vow, while understanding its meaning and how to maintain it. Vows are taken in order to pacify our rough minds and purify the afflicting emotions that obscure our pure buddha nature. To do this, we need to train our minds. The basis or ground of this is known as the four thoughts that change the mind. This is the main contemplation of a Buddhist practitioner and is referred to as the outer or common preliminary practice. The four contemplations are very briefly outlined here, but students need to receive further teachings on them and contemplate them deeply.

A. The Four Thoughts That Change the Mind

The first thought is the contemplation of this *precious human life*. There are two kinds of human life; one is ordinary and one is precious. Whoever

comes into contact with the buddha dharma is considered to have a precious human life. The Buddha likened the chances of obtaining a precious human birth to the likelihood that a blind turtle coming up from the depths of the ocean once every hundred years could put its head through a wooden yoke being tossed about on huge waves on the surface. The chances of the turtle putting its head through the yoke are actually greater than the likelihood of our being reborn as humans, meeting the dharma, and having all the freedoms and advantages to practice it correctly. We must really make the effort to progress along the path in this life because we do not know when we will get this opportunity again, as we will just be blown by the winds of our karma into our next existence.

The second thought is the deep contemplation of *impermanence.* Even though we have this precious chance, this human life, we need to remember that our life is brief. Through contemplating this, we come to understand how important it is to practice now, as we do not know when we will die or when the circumstances that allow us the freedom to practice might change.

The third is the contemplation on *karma,* our actions and their consequences. Through this we come to understand what is to be adopted and what is to be abandoned in terms of our actions of body, speech, and mind. If we do something good, positive karmic seeds are sown to bring forth beneficial results, and the same is true of bad actions and negative results. The teachings on karma show us how to use the opportunities we have in the right way and how to put this life to its most beneficial use.

The fourth contemplation is of the *suffering of samsara,* which leads us to see how we are all actually suffering in samsara right now. Even if we have the good fortune to enjoy the apparent pleasures of samsara, they are still a cause for suffering because of our attachment to them. If we look deeply, they are themselves an experience of suffering. Therefore, we must endeavor to deeply understand the suffering of samsara. When we contemplate the suffering of samsara in this way, it is possible to see how all beings are suffering, even from the time we are in our mother's womb. In this world, pleasures are transient and few, and all our loved ones will eventually die. If we see the suffering inherent in every experience, we will not be so attached to the pleasures of this world.

When we contemplate these four thoughts, our minds really turn to dharma practice. Just as a house needs a good foundation to be stable, so too does our practice, and these four thoughts are the basis of all practice. Therefore, renunciation is what turns us against our usual samsaric tenden-

cies. But that is not enough—we need to achieve the third noble truth of the complete cessation of suffering, as taught by Buddha Shakyamuni in his first teaching on the four noble truths. If we do not achieve the cessation of suffering, or enlightenment, in this life, we do not know when we will have the chance again, as we all carry a heavy burden of negative karma from previous lives that is sure to ripen if we do not pursue the path now. At this time we are endowed with the eight freedoms and ten advantages,[3] so it is crucial to put the teachings into practice while we can, in this life.

B. The Foundation of the Path: Taking Refuge

Taking refuge and generating bodhichitta are contained within what is known as the inner preliminaries. The teachings here mostly come from Shechen Gyaltsap Rinpoche's *Chariot of Complete Freedom: A General Presentation of the Preliminaries for the Diamond Vehicle*.

The practice of taking refuge in the Three Jewels of Buddha, Dharma, and Sangha is the ground of enlightenment. Buddhists, or disciples of Buddha, are those who have taken refuge in the Triple Gem as their first step. When we take refuge in the Triple Gem, we are saying that we believe in the teachings of Buddhism and have become a follower of the Buddha, the Dharma, and the Sangha, and that we do not place our primary faith in another religion. In short, we are officially declaring that we are Buddhist. The companion to refuge is the altruistic wish to achieve enlightenment for the sake of others, which is the generation of bodhichitta and is explained in more detail later. As the purpose of practicing supreme art is the enlightenment of oneself and others, taking refuge and generating bodhichitta are essential for the artist. Taking refuge is essential in order to receive teachings, to engage in practice, to receive true blessings, and to bring the practice to fruition.

Just as refuge opens the gateway to all the other teachings and practices, faith opens the gateway to refuge; it is therefore important to develop a lasting and stable faith. There are many detailed teachings on these subjects in *The Words of My Perfect Teacher*, the *Treasury of Precious Qualities*, and other texts that are important to study. Kechok Pawo said:

> The precious wheel of faith
> Rolls day and night along the road of virtue.

The *Sutra of the Precious Lamp* says:

> Faith reveals the pristine wisdom
> Through which buddhahood is attained.[4]

In short, if faith is strong and pure, then wisdom will develop easily into enlightenment. But if we lack faith and devotion, then even if the Buddha were standing in front of us, he could not bring any benefit. Being without faith is said to be like trying to make a stone float or trying to steer a boat without a rudder; it is like an armless man in front of treasure, like trying to grow a plant from a burnt seed, or like a blind man trying to find his way in a temple.

Although there are many detailed categories and subdivisions, essentially there are two principal methods of taking refuge: the causal refuge of the Sutrayana and the resultant refuge of the Vajrayana.

1. The causal refuge of the Sutrayana

In the causal refuge of the causal vehicle, we seek refuge out of the threefold motivation: fear of samsara, faith in the Three Jewels, and compassion for those who are ignorant of where to turn. We take refuge in the Buddha as the teacher, the Dharma as the path, and the noble Sangha as our companions along the path.

According to the Mahayana, the object of refuge is the Three Jewels, understood as the Buddha endowed with the four *kayas*, or bodies, and five wisdoms, the sacred Dharma of transmission and realization, and the noble Sangha dwelling on the grounds of accomplishment. To elaborate on this view further: one takes refuge in the Buddha where the transcendent reality of perfect buddhahood is described in terms of two, three, four, or five kayas. Here we speak of the four kayas: (1) the svabhavikakaya, "body of suchness," which is the union of the other three kayas; (2) the dharmakaya, "body of truth," the absolute or emptiness aspect of buddhahood; (3) the sambhogakaya, "body of perfect enjoyment," which is the aspect of spontaneous clarity, perceptible only to beings of extremely high realization; and (4) the nirmanakaya, "body of manifestation," the compassionate aspect, perceptible to ordinary beings and appearing most often in human form.

The Dharma consists of the Dharma of Buddha's Teachings and the Dharma of Realization of the Words. The teachings of the Buddha are contained in the Three Baskets: (1) the Vinaya-pitaka, which consists of teachings on moral discipline and how to tame the emotions; (2) the

Sutra-pitaka, the discourses, summaries, and commentaries, which train the mind in concentration; and (3) the Abhidharma-pitaka, which is the training in knowledge and wisdom.

The realization of the words comes about through the threefold training: (1) moral discipline, (2) concentration, and (3) wisdom. These trainings lead to the five paths and ten bodhisattva bhumis and to the realization of the indivisibility of the two truths. This is the meaning of Dharma according to the Mahayana. Taking refuge in the Dharma achieves all the qualities of elimination and realization on the path to enlightenment.

The Sangha is the community of bodhisattvas who have attained the first bhumi. The Sangha can also be defined as those who are no longer reborn in samsara. Anyone who has realized the union of wisdom and emptiness is an example of the true Sangha. With the realization of emptiness, compassion for all sentient beings spontaneously arises. The bodhisattva does not remain in the peace of nirvana but progresses along the ten bodhisattva bhumis to full enlightenment; this is the meaning of Sangha according to the Mahayana view. Therefore, we take refuge in the Sangha of bodhisattvas.

Having taken refuge, one must see any representation of the Buddha to be the same as the Buddha himself. As explained in the *Root Tantra of Manjushri*:

> I will magically emanate in the form of statues and representations
> So that beings can be benefited through virtuous actions.

Consider the representations of the dharma, the texts, to be the Dharma, the second jewel of refuge. Similarly, take refuge in whoever studies the teachings of the Buddha and has taken the precepts of refuge, the Sangha. Vishvakarman, the divine artisan, was also a nirmanakaya manifestation of the Buddha, along with artists and artisans working with clay, stone, and copper; painters, draftspeople, and statue makers—all who work in the supreme arts for the benefit of beings, and even those making ordinary art objects for their livelihood—are magical emanations of the Buddha.

The *White Lotus Sutra* says:

> Anyone who commissions and anyone who actually draws the
> perfect form of supreme merit upon a wall—
> both will attain enlightenment.[5]

And in the *Sutra of the Multistoried House,* the Buddha said to Ananda:

> Ananda, the roots of virtue are threefold: Buddha, Dharma,
> and Sangha:
> Merit accrued in relation to them will never decrease and will
> ultimately lead to liberation.

In this way, all sentient beings can take refuge in the Three Jewels and practice the path of supreme virtue in countless ways. There are many texts and tantras that explain the vast benefit of refuge. When we understand how taking refuge in the buddhas and bodhisattvas protects and benefits us, our devotion will naturally increase. Therefore we are encouraged to study this subject. This completes the section on the causal refuge.

2. The resultant refuge of the Vajrayana

In the supreme Vajrayana, also known as the resultant vehicle, we take refuge in the Three Jewels in the ordinary way, and we also take refuge in the three roots. The three roots are the guru, deva, and dharma protector, which may be a dakini or dharmapala. In the Vajrayana, there are also three forms of refuge: the outer, inner, and secret. The outer form is the Three Jewels of Buddha, Dharma, and Sangha; the inner aspect is the three roots, and the secret form is the three kayas.

The *Assemblage of Secrets* says, "As their basic essence and activities are the same in their fundamental nature, the guru is equal to all the buddhas. However, in guiding sentient beings he is even greater than the Buddha." Therefore, the guru is said to be either the same as or even greater than the Buddha; the guru is the king of all the mandalas.

In *Relaxing in the Nature of Mind,* Longchen Rabjam says:

> The quintessential deity—Buddha, Dharma, and Sangha—is
> none other than the natural luminosity of your own mind,
> devoid of all elaboration; through purification this dharmakaya
> is revealed as the ultimate fruition.

a. Causal refuge of the resultant vehicle

How is the resultant vehicle of the Vajrayana divided into causal and resultant refuge? The resultant refuge of the causal vehicle is the aspiration to achieve enlightenment. Here, however, in the resultant vehicle, the fruit of

the Three Jewels, which is the dharmakaya, is the cause. One takes refuge in the nature of the three roots of guru, deva, and dharma protector, which is the dharmakaya.

b. Resultant refuge of the resultant vehicle
The resultant refuge of the resultant vehicle is taking refuge in your own enlightened mind, which is empty clarity. This is the definitive meaning of the Three Jewels. The mind is without defect from the very beginning and endowed with every perfect quality. There is nothing to purify and nothing new to gain; the mind itself is the Buddha. The mind's stainless ultimate nature, primordially unchanging, is the Dharma. The inalienable qualities of mind through which others can be benefited is the Sangha. This is the supreme refuge—your own mind.

In the *Transcendent Wisdom Sutra (Medium) in 25,000 Lines* Lord Buddha said to his disciple:

> Subhuti, the Buddha is impossible to truly apprehend or define;
> With this understanding, we should take refuge.[6]

Likewise, *Lotus Stages of Activity* says:

> Our true nature is enlightened from the beginning, the self-
> knowing state of awakened mind;
> When deluded apprehension of dualistic phenomena is purified,
> the nondual wisdom of buddhahood is attained.
> However, there is no truly existent delusion to purify or nondual
> wisdom to attain;
> This is the primordially enlightened nature.[7]

The Tibetan word for Buddha is *sangye*, which refers to one who has awoken (*sang*) from the deep sleep of ignorance and whose mind has blossomed (*gye*) like a lotus flower to the knowledge of all things. Through one's remaining in nondual awareness, the qualities of enlightenment are revealed, although in reality there is nothing to adopt and nothing to purify in the true nature of mind. As *Accomplishment of Wisdom* says:

> Clear luminous mind itself
> Is the essence of the three mandalas;

Having understood this, pay single-minded attention,
And the supreme fruition will be attained.

The specific precepts and benefits of taking refuge need to be studied elsewhere. This completes the teachings on how to go for refuge.

C. Generating Bodhichitta

The teachings on generating bodhichitta mark the beginning of the superior study of the greater vehicle, the Mahayana, which teaches how to train as a bodhisattva. There are three sections: the four boundless attitudes, the main practice of a bodhisattva, and the bodhisattva precepts and their benefits.

1. The four boundless attitudes

In the *Transcendent Wisdom Sutra in 20,000 Verses,* the Buddha said to Subhuti:

> To traverse the path of the bodhisattva mahasattva, one must practice
> Great love, great compassion, great joy, and great equanimity.[8]

The wish for others' happiness and benefit is *loving-kindness;* the wish that they be free from suffering is *compassion;* the wish that whatever happiness they have will continue and increase is *joy;* and, without attachment or anger, to consider all beings with the impartial wish for their benefit is *equanimity.* The practice of the four boundless attitudes is divided into the ordinary or mundane and the transmundane leading to nirvana.

In *Supreme Essence* by Ratnakarashanti, Buddha Shakyamuni said to Shariputra, "Having the thought of love, compassion, joy, and equanimity is not enough. Unless we encompass all sentient beings with this wish, it will not free us from samsara but only project us to the higher realms." Asanga explains in the *Bodhisattva Grounds* that if we extend ourselves in this way, sending love and compassion in an ordinary way toward sentient beings, this is no different from the teachings of any other religion. When we direct our practice toward a goal, this is the practice of the vehicles of the shravaka and pratyekabuddhas, but practicing without reference point is a supreme, special practice not for everyone. Therefore, to generate these four boundless thoughts combined with the view of emptiness is the main practice of the Mahayana.

Practicing the four boundless attitudes in this way is a quintessentially Mahayana teaching, as it includes the meditation on emptiness. The relative practice of extending our hearts toward others is common to all religions, but to practice this with the nonreferential view beyond the three spheres of subject, object, and action is specific to the Mahayana. This changes it from a mundane practice of virtue to one that is transmundane, in that it will lead to complete liberation.

The *Queen Shrimala Sutra* says:

> All who meditate upon the four boundless attitudes will attract the notice of the Buddhas.
> They will acquire limitless qualities surpassing the very vastness of the sky.[9]

2. The main practice of a bodhisattva

There are two points: the explanation of bodhichitta and the explanation of the practice of a bodhisattva.

a. The explanation of bodhichitta

In *Relaxing in the Nature of Mind,* Longchenpa says that bodhichitta, the mind of enlightenment, is obtained through repeated training in the four boundless attitudes. Similarly, the *Bodhisattva Pitaka* says, "Whoever aspires to swiftly attain enlightenment must train in bodhichitta."

To achieve complete enlightenment, one must purify the two obscurations and attain the two wisdoms through which omniscience is gained. The two wisdoms enable us to work effortlessly for sentient beings until samsara is empty; our body will be experienced as empty, our accumulation of merit will be ceaseless, and we will realize the dharmata. In sum, we will accomplish our own benefit and the benefit of others through the practice of a bodhisattva, the jewel of the dharma.

b. The practice of a bodhisattva

Here there are two subjects: the fortunate lineage and how to follow the way of a bodhisattva.

i. The fortunate lineage

Lineage generally refers to a bloodline, but here it refers to the enlightened potential, the natural inheritance of all sentient beings: the buddha nature.

There are many ways of explaining this, but here the Mahayana point of view is presented.

The *Sublime Continuum* says:

> Two kinds of lineage are spoken of: the *naturally abiding lineage,* which is likened to a treasure, and the *perfectly developed lineage,* likened to a fruit tree.[10]

The omniscient King of the Dharma, Longchen Rabjam, says:

> Lineage is the virtuous support of liberation; it is luminosity— the nature of mind—[known as] the *naturally abiding lineage,* free from all defilement. Its naturally abiding compassion appears as two kayas, which can be known by nine metaphors; this is what the awakened one meant when he spoke of the *lineage of fully developed potential.* The root of all virtue, awareness itself, is, essentially, natural luminosity free from the three poisons.

The omniscient Jigme Lingpa says:

> Everything is empty and free from bondage, the nature of this emptiness is luminosity, and within this awareness the kayas and wisdoms abide—like the sun and its warming light rays.

Although in fact one, lineage must be understood in these two ways. Essentially then, self-originated wisdom, the nature of your mind, is completely free from any elaboration. It is not established as anything at all, yet its radiance is unobstructed. This naked and utterly brilliant natural luminosity is the seed of omniscience, the buddha nature.

The *Sutra Revealing the Compassion of the Sugata* says, "Whether the Buddha comes or goes, all beings have buddha nature." Likewise, the *Kalachakra Tantra* says, "All beings are [by their very nature] awakened; there are none who are other."

The *Sublime Continuum* says:

> The cleansing of obscurations and the rendering evident of the ever-present qualities of dharmakaya are simultaneous; to possess

this potential is to possess the very lineage of awakening. Because of this all beings are said to be possessed of the very nature of buddhahood, or buddha nature.

And:

> If sentient beings did not have buddha nature, they would not strive to protect themselves from pain, nor would they make efforts toward their awakening. Seeing the unsatisfactory nature and faults of samsara, as well as the bliss and qualities of enlightenment, is a sure sign of their buddha nature; without it this discernment would not be possible.

We do not experience our buddha nature because it is hidden from us by our obscurations—the afflicting emotions, or kleshas. The *Sublime Continuum* says:

> Buddha nature has always been and will always be our very essence—pure and unchanging. It remains hidden from us by veils of obscuration, like gold under the earth.

It is like buried gold that we cannot see, but when our karma and obscurations are purified, the gold is revealed. Or it is like having a mirror in a box; it is there but no reflection can be seen. As Nagarjuna mentions in his *Praise of the Vajra Mind*: "Pure wisdom abides in the midst of emotion, just as pure water abides in the midst of the earth."

In this way, all sentient beings have buddha nature, but it is not possible to recognize it without the guidance of an authentic master. It is not enough merely to believe in our true nature; we must purify our afflicting emotions through practice, and generating bodhichitta is an indispensable part of that process. Nagarjuna's *Disclosure of the Awakening Mind* explains, "If the aspiration to awaken is not cultivated, there can be no enlightenment." The only way to enlightenment is through the generation of bodhichitta. There is no other method.

ii. How to follow the way of a bodhisattva

There are two points: the qualities of a bodhisattva and the meaning of bodhichitta.

(1) The qualities of a bodhisattva

There are many detailed categories, but the main point is that a bodhisattva needs the two qualities of strong devotion to the Buddha and compassion for all sentient beings. Having these two, aspiring bodhisattvas understand the benefits and therefore wish to receive the bodhisattva vow. These three are very important and integral to the bodhisattvas' practice.

(2) The meaning of bodhichitta
(a) Relative bodhichitta

There are two parts: the meaning of relative bodhichitta and the bodhisattva precepts.

(i) The meaning of relative bodhichitta

In the *Practice of the Three Vows*, Ngari Panchen Pema Wangyal says, "The basis of bodhichitta is kindness and compassion." The moisture of compassion ripens into the altruistic wish for others to attain enlightenment, and for that purpose we engage our body, speech, and mind in what to adopt and what to abandon; this is the bodhisattva's activity. Relative bodhichitta rests on two points: the first is the intention and the second is the application. The intention is the initial thought to bring all sentient beings to enlightenment. The application is training your mind in the six transcendent perfections in order to achieve this intention. Without these two, just helping others a little and being partial to those we like is not the Mahayana practice known as generating bodhichitta. In cultivating relative bodhichitta we need kindness and compassion, and when developing absolute bodhichitta through training in meditative absorption, we need the motivation of a bodhisattva. As stated in Maitreya's *Ornament of Clear Realization*, "The meaning of bodhichitta is the wish for all sentient beings to attain complete enlightenment."

(ii) The bodhisattva precepts

Here there are two points: bodhichitta in aspiration and action, and taking the bodhisattva vow.

1) Bodhichitta in aspiration and action

The *Way of the Bodhisattva* by Shantideva says of the two aspects of bodhichitta in aspiration and bodhichitta in action:

Wishing to depart and setting out upon the road,
This is how the difference is conceived.
The wise and learned thus should understand
This difference, which is ordered and progressive.[11]

The pledge to accomplish perfect enlightenment for the multitude of sentient beings is called bodhichitta in aspiration. Bodhichitta in action consists of undertaking the pledge to practice the six transcendent perfections for the sake of all sentient beings. To practice the two kinds of bodhichitta it is necessary to first take the bodhisattva vow.

2) Taking the bodhisattva vow

Absolute bodhichitta is experienced through meditation and does not depend on rituals. To generate relative bodhichitta, however, as beginners, we need to take the bodhisattva vow in the presence of a spiritual teacher. Once we have received this vow, it should be renewed over and over again, so that the bodhichitta we have aroused does not decline but becomes more and more powerful.

To take the bodhisattva vow, begin with the usual preliminary prayers, refuge, bodhichitta, seven-branch prayer, and mandala offerings. Then for the main practice, visualize all the buddhas, bodhisattvas, and other deities in the sky before you, as for the refuge practice. Take them as your witness and make the following prayer:

> All sentient beings are suffering in samsara, so how can I liberate only myself and leave others behind? For the sake of all beings I shall awaken the sublime bodhichitta. Learning to emulate the mighty deeds of the bodhisattvas of the past, I shall do whatever is necessary until not a single being remains in samsara![12]

In this way, recite the bodhichitta verse as many times as possible. On the last repetition, consider that you have received the bodhisattva vow for both bodhichitta in aspiration and bodhichitta in action. Visualize that by the power of your yearning devotion toward the deities of the field of merit, the whole assembly melts into light, starting from the outside, and finally dissolves into the guru in the center, the embodiment of the triple refuge. The guru in turn melts into light and dissolves into you, causing the absolute

bodhichitta present in the minds of the deities to arise clearly in your own mind. Rejoice in this and out of gratitude, offer the mandala again to all buddhas and bodhisattvas. Read through the rest of your text and at the end dedicate the merit to the enlightenment of all sentient beings.

The vow can also be received in front of a statue or supreme representation of the Buddha. Consider that all the buddhas and bodhisattvas are in the sky in front of you, and follow the ritual according to the *Lamp for the Path to Enlightenment* by Atisha Dipamkara.

(b) Absolute bodhichitta

Absolute bodhichitta is the realization of emptiness. How do we realize emptiness? By practicing and making the wish with great compassion that whoever has not realized emptiness will do so. Nagarjuna said that the compassion that arises through the realization of emptiness, absolute bodhichitta, is the same for all bodhisattvas. Emptiness and compassion are inseparable because their inner meaning or quality is the same. These two may be separated in words, but if they are separated in practice, the final result will not be attained. As the *Condensed Perfection of Wisdom* says, "If we practice emptiness without compassion, we will fall to the shravakas' level." Also, the *Sutra of Manjushri's Perfect Emanation* says, "One who practices emptiness but forgets sentient beings is practicing the path of demons." Likewise, if we think only of compassion without emptiness, it is also a demon's practice—both sutra and mantra vehicles hold that the combination of emptiness and compassion is the practice of a bodhisattva.

It is important to study the precepts of the bodhisattva vow and the benefits of upholding them, which are not included in detail here.

3. The bodhisattva precepts and their benefits
a. General precept

The general advice or precept of the bodhisattva practice is to be more concerned with the benefit of others. Everything is included within that. For ordinary people just starting the practice of a bodhisattva, it is not possible to actually benefit others, but with the understanding that our mental attitude is the most important factor, we train our minds, and slowly we can actually become of help and benefit. We train in understanding what to adopt and what to abandon and in maintaining the precepts.

b. Specific precepts

This has two points: the precepts of bodhichitta in aspiration and the precepts of bodhichitta in action.

i. Precepts of bodhichitta in aspiration

The bodhisattva Chandraprabhakumara (Youthful Moonlight) said that we must practice five points: (1) not to forget sentient beings; (2) to remember the benefits of bodhichitta and rejoice; (3) to practice the two accumulations; (4) to generate bodhichitta through practicing the four boundless attitudes, taking the bodhisattva vow six times a day, and engaging in the practice of equalizing and exchange; and (5) to know the eight black and white actions to adopt and abandon.[13]

He said that these five points encompass everything contained within the aspirational bodhichitta advice.

If you diligently practice such virtuous thoughts and deeds, you will always have the mind of a bodhisattva, your practice will progress from life to life, and your noble qualities will increase further and further. The four attitudes that strengthen bodhichitta and protect it from decline are set out in the *King of Concentrations Sutra* as follows: (1) to consider the master of the Mahayana from whom you receive the unmistaken teachings as a real buddha, (2) to consider his profound and vast teachings as the path, (3) to consider as your friends all other practitioners of the Mahayana path whose views and actions are in harmony with your own, and (4) to approach the infinite multitude of living beings with the same love that you would feel for your only child.[14] This completes the section on the precepts of bodhichitta in aspiration.

ii. Precepts of bodhichitta in action

There are two subjects: the two accumulations and the three noble principles.

(1) The accumulation of merit and wisdom

Buddha Shakyamuni said that all the precepts of bodhichitta in action are included within the six transcendent perfections, and anything that opposes these six should be abandoned.

All bodhisattva practices are included within the threefold training of moral discipline, meditative concentration, and wisdom, which can be further divided into the practice of the six transcendent perfections. How do the six transcendent perfections fit within the threefold training?

Generosity is the substance, discipline is the meaning, and patience is "special," or the fruit. These three are included in the training of moral discipline. Meditation is included in the training of meditative concentration, and wisdom in the training of wisdom. Diligence is the impetus behind the practice of all of them.

The six transcendent perfections can also be explained as the practice of the two accumulations. As the *Ornament of Mahayana Sutras* says, "Generosity and discipline are included in the accumulation of merit, wisdom in the accumulation of wisdom. Patience, diligence, and meditation are included in both of these. If we practice the six transcendent perfections without having concepts of the three spheres, it is the practice of wisdom."

The fruit, or result, of practicing the two accumulations is the attainment of the two kayas. Nagarjuna says in the *Jewel Garland*, "The accumulation of merit will give cause for achieving the rupakaya, and the accumulation of the king of wisdom gives us cause for realizing the truth body, the dharmakaya."

The two accumulations are discussed in more detail later in the text.

(2) The three noble principles

As previously mentioned, the three noble principles are generating the proper motivation at the beginning of our practice, the main practice itself, and concluding with the dedication of merit.

The first noble principle is establishing the correct motivation before starting your practice or any other endeavor. Begin by considering the kindness of all mother sentient beings, and then reflect that all beings wish to be happy and to escape suffering, yet, due to their deluded actions, they continue to experience suffering. Happiness eludes them because they are ignorant of the true causes of happiness. Then think, "I wish to help mother sentient beings attain enlightenment, so I will endeavor to achieve enlightenment and will certainly strive for that goal. Therefore, I will practice virtue and abandon all nonvirtue for the sake of all sentient beings."

It is important to have the three attributes of devotion, love, and altruism. Devotion is included in the cause and fruit of enlightenment. Extending our love to beings, we work for their happiness and benefit. Developing the altruistic wish for all beings' enlightenment, we adopt what needs to be cultivated and abandon whatever must be given up in order to achieve that aim.

With these in mind, if we offer just a single lamp or a single bowl of water, a single prostration, a single cup of tea, a one-day vow, or one mantra; if

we place one flower in the hand of a deity; or if we offer one syllable of the Buddha's teaching or one deity's hand implement, the benefit will never run dry and instead will increase until enlightenment is reached. Whatever virtuous practice we have done will increase each day until we achieve enlightenment, so the benefit is incalculable. In the *Transcendent Wisdom Sutra in 8,000 Verses,* Lord Buddha said:

> Venerable Shariputra, among gods and humans, whoever produces the root of virtue will achieve supreme awakening. Should you wonder why that is, through giving rise to bodhichitta, the virtue arising from the ten virtues, the four concentrations, the four formless absorptions, and the six perfect actions will remain without exhaustion until enlightenment is won.[15]

The second noble principle is actually engaging in whatever virtuous practice you are doing, without reference point. As said in the *Transcendent Wisdom Sutra,* at the time of accomplishing the practice, if you cling to things as real and have an object of reference, this is not a genuine Mahayana path. It also says:

> Subhuti, adhering to a point of reference will bring difficulties in this life. As such, what is the point of even mentioning achieving the highest level of enlightenment?

Therefore, we need to engage in our practice without a reference point or fixation on what we do as real. To cultivate virtue such as the six transcendent perfections means to do this without reference to the three spheres— the subject or person performing the action, the object or purpose of the action, and the action itself. In this way, practice with the attitude of considering everything to be like a dream or magical illusion. Although it is important to understand the purpose and nature of our practice, ultimately it is not real; it is just like a dream or an illusion and is empty of true existence. This is what is meant by "transcendent" practice according to Buddhism.

The *Cloud of Jewels Sutra* says:

> To gather an abundance of merit and wisdom, you should practice virtue, act, and endeavor in a way that is free of reference

point. View all as if an illusion, a mirage, a hallucination, or a magical emanation.

The *Sutra Requested by Upali* says:

> A magician can conjure up and slay hundreds of beings, yet none move from the realm of that illusion. Similarly, all in samsara, including all living beings, are illusory.

The *Sutra Requested by Druma* says, "A clear mirror will perfectly reflect all that is in front of it. In the same way, all phenomena are like a reflection in the mirror, apparent but without inherent reality."

For ordinary people it can be difficult to understand this, so we should just think, "Although phenomena are not truly existent, in the context of the relative truth karma and the results of actions are unfailing. Believing in the truth of the Buddha's teachings, I must have respect and devotion and practice with diligence. I will take care of the smallest acts of virtue and be mindful of the infallibility of the laws of karma."

The third noble principle is the dedication of merit. In the *Transcendent Wisdom Sutra (Medium) in 25,000 Lines,* Buddha said to Subhuti, "Concerning the root of virtue, one must dedicate the merit solely to the level of buddhahood, not to the shravaka and pratyekabuddha levels."

Likewise we should never aspire or direct our practice toward the attainment of the happiness of the god realms or any of the realms within cyclic existence. Instead we should dedicate our virtue in the same way as the buddhas and bodhisattvas of the three times, saying, "Just as they have dedicated, so too, I dedicate to complete enlightenment, buddhahood."

We can follow the dedications written in such prayers as Samantabhadra's supreme *King of Aspiration Prayers: The Prayer for Noble Excellent Conduct,* saying:

> For kalpas as many as the atoms of the universe,
> What little merit I have accumulated by obeisance, offering,
> confession, rejoicing, exhortation, and prayer—
> All of it I dedicate to the goal of enlightenment.[16]

And:

> Just as the warrior Manjushri attained omniscience,
> And Samantabhadra too,

All these merits now I dedicate
To train and follow in their footsteps.

It is wonderful to recite the entire seven-branch prayer from the *King of Aspiration Prayers,* which is easily found and has great blessings. This is the supreme aspiration prayer. Any other dedication prayers composed by Buddha Shakyamuni and other enlightened masters can also be recited. Such dedications will be faultless, and the merit accumulated will never be depleted or run dry until enlightenment is reached. The *Sutra Requested by Sagaramati* states:

As when a drop of water falls into the sea,
And will not dry until the sea itself runs dry,
So merit pledged to gain enlightenment
Is not consumed till buddhahood is gained.[17]

Chandragomin explains that even if the outcome of an action carried out with love and compassion is not good, there is no wrongdoing because the motivation was pure.

In possessing compassion, and out of mercy
There is no fault for a virtuous mind.[18]

There are many other similar quotes from the sutras and tantras.

4. The meaning of enlightenment

A buddha is one who is fully awakened to the enlightened nature, known in the Mahayana scriptures as the *tathagatagarbha,* which is the natural birthright of all sentient beings. The term *tathagatagarbha* is generally taken to mean that the *garbha* (womb or embryo) of a tathagata (buddha; thusly gone one) exists in all sentient beings without exception, and though temporarily contaminated by adventitious defilement, it is the cause that eventually leads sentient beings to enlightenment. In the Vajrayana, this enlightened buddha nature is referred to as the *sugatagarbha,* which is explained through the concept of the three enlightened bodies, or three kayas. As stated in Shantarakshita's *Ornament of the Middle Way:*

To accomplish one's own purpose is the complete enjoyment
body, the sambhogakaya; and to accomplish the welfare of others

is the emanation body, the nirmanakaya. These two come from the dharmakaya. These three kayas together are the inherently existing nature of buddhahood.

The three exalted kayas together are the buddha kaya [body of a buddha]. The three exalted kayas are the naturally present condition, embodied by the representation of the deity and the mandala. The expanse of the ultimate dimension (*dhatu*) is inherently pure and free from momentary defilement; it is the fundamental nature in which there is no conceptualization. Because it is spontaneously present, without hindrance, and full of wisdom and compassion, the benefit of sentient beings is naturally accomplished without hindrance. This is the wisdom kaya (*jnanakaya*) of timeless awareness.

The *Accomplishment of the Three Kayas* says:

> Undefiled suchness is the tathata fundamental nature.
> Nonconceptual exalted wisdom
> Is the only phenomenon of the sphere of the buddhas,
> With no inherent existence whatsoever.

The *Ornament of Mahayana Sutras* explains that the Buddha's nirmanakaya manifestations are inconceivable; he can manifest in innumerable ways, both as material objects and as life forms. The nirmanakaya emanations can be divided into three broad categories: (1) art emanation (material artwork), (2) birth emanation (incarnation as an ordinary sentient being), and (3) supreme emanation (nirmanakaya buddha or bodhisattva).

D. The Accumulation of Merit
This section is divided into the common teachings and the special teachings on the two accumulations.

1. Common teachings
The *Ornament of Clear Realization* says that one who wishes to attain the final result of complete omniscience must know that enlightenment can be attained only through the two indispensable accumulations of merit and wisdom. The heart of all practices is the transcendent wisdom that realizes

nonexistence, the profound emptiness. This is the ineffable coemergent wisdom. Therefore one must rely on the two accumulations.

Practicing the six transcendent perfections with the view of wisdom and compassion is the source of the accumulation of merit. According to the *Ornament of Mahayana Sutras:*[19]

> The accumulations of merit and wisdom are not the same;
> One creates the cause for the highest state in samsaric existence,
> While the other creates the cause for circling in nonaffliction.[20]

Also:

> Generosity and moral discipline are meritorious.
> The accumulation of wisdom is knowledge [the sixth transcendent
> perfection].
> The other three [patience, diligence, and meditation] are included
> in both.
> However, the fifth part, meditation, mainly belongs to the
> collection of wisdom.

Nagarjuna's *Jewel Garland* says:

> The Buddha's rupakaya arises from the accumulation of merit,
> Whereas the dharmakaya is realized through the majestic
> accumulation of wisdom.
> In this way, through the two accumulations buddhahood is
> achieved.

Three periods of time taken to accumulate merit are enumerated according to the capacity of beings. For the lowest-capacity being, it takes sixteen measureless aeons; for the medium-capacity being, eight measureless aeons; and for the highest-capacity being, it is possible to attain enlightenment in four measureless aeons. But Buddha Shakyamuni attained enlightenment in less than four measureless aeons because his intelligence was so sharp and his diligence so great. The highest-capacity beings can attain the level of nonreturner[21] as soon as they begin the path to enlightenment. Beings of medium capacity can reach this level when they attain

the first bodhisattva bhumi. The lowest-capacity beings can only achieve this level of attainment when they reach the eighth bhumi (or sometimes the ninth bhumi, depending on the person). Therefore, the Buddha of our time is really supreme because when he began the path to enlightenment, as Minister Gyatso Dul (Sand of the Sea), he had already achieved the level of nonreturner.

2. Special teachings on the two accumulations

There are three parts to this section on special Vajrayana teachings on the two accumulations: offering to the guru, the seven-branch prayer, and the essential king of teachings that alone is enough.

a. Offering to the guru

Wisdom is the most important goal, but whether we will achieve it depends on how much merit we have accumulated, as wisdom is the result and proof of the accumulation of merit. Along with this, it is also necessary to receive blessings from a realized master. As the *Sutra of the Pacifying Stream's Play* says:

> The ultimate, innate wisdom can only be experienced as a result of having accumulated merit, purified obscurations, and received the blessings of a realized master. To think there may be another way is folly.[22]

The Vajrayana path has many methods, is without great hardship, and is intended for those with sharp faculties. There can be no doubt that the single most excellent, secret, and unsurpassable field of merit is the vajra master, which is why the practice of accumulating merit is combined with guru yoga. The *Magical Web* says:

> The guru is none other than the one who protects you from the terrors of samsara and leads you to nirvana.

The *Precious Assemblage Tantra* says:

> The merit of recalling your guru for an instant is without measure; it far exceeds that of meditating upon hundreds of deities over countless aeons.

The *Great Ati Array Tantra* says:

> Whoever recalls their kind guru sitting upon their crown, in their palm, or in their heart will come to embody the qualities of a thousand buddhas.

The *Tantra of Realization in Three Words* says that whoever visualizes the vajra guru will receive the blessings of all buddhas. This is stated in many tantras.

The main practice from which spiritual accomplishments are received is guru yoga; it is the supreme practice. When we first enter the Vajrayana path, we must receive the empowerment from a vajra master, our guru, whom we need to consider as the main deity of the mandala. To think that the blessing of the deity of the mandala is separate from the guru is incorrect, and in that case we will not receive the siddhis. In the middle, the main practice of the development and completion stages comes from the blessings of the guru. Especially during the completion stage, the practice of wisdom without reference point can only be achieved by merging our mind with the mind of our guru. Also in the bardo, to see the guru's face, hear the guru's speech, and so on, comes from the meeting of the guru's blessing with our devotion. If we do not understand this, then receiving the empowerment, pith instructions, and introduction to the nature will not be enough. Also thinking that we receive the blessings and siddhis from the deity is the greatest obstacle, as is stated by the masters of all traditions, old and new. As Indrabhuti says in the *Accomplishment of Wisdom:*

> A boat without a rudder cannot sail you to the shore you so desire. Similarly, regardless of any and all great qualities you might possess, without a guru you will not reach the shore beyond samsara.

And the *Tantra of Supreme Samaya* says:

> Yearning devotion is the cause of realization; it springs from respectfully delighting the guru. Through this destructive emotions weaken, and all negative acts will cease.

Chetsun Senge Wangchuk's *Song of Spiritual Realization* says, "Experiences in meditation and spiritual blessings all arise through genuine devotion to your guru."

Rigdzin Jigme Lingpa says:

> Generally speaking, you can practice union with the guru's nature in a variety of ways: At the beginning of your practice, you can visualize the guru as your supreme object of refuge, the central figure in the merit field; an inner method for purification would be to visualize him upon your crown as the embodiment of all gurus and buddhas; a secret means to swiftly receive blessings is to meditate upon him seated within your heart; and the innermost secret method is to meditate upon the inseparability of your body, speech, and mind with the guru's—the practice of the development phases, where the yidam deity is recognized as none other then the guru's play.

He goes on:

> The ultimate practice is to recognize the inseparability of your mind and the guru's wisdom, within which there is nothing to be done.

According to the Sutrayana, the teacher and the Buddha can also be considered to be the same. Here it is enough just to remember Buddha Shakyamuni. In the *Treasure of Blessings: A Sadhana of the Buddha,* it says, "Guru, Teacher, Bhagavat, Tathagata, Arhat, Perfect Buddha, Glorious Conqueror Shakyamuni, I submit obeisance to you, I make offerings, I take refuge," which shows that we can consider Buddha Shakyamuni as the guru. However, in the Vajrayana, the vajra guru is most definitely considered the same as Buddha Shakyamuni—in fact, the guru is seen as an embodiment of all buddhas in one; therefore, we consider that the guru is the same as all buddhas or deities.

Mipham Rinpoche says:

> The guru is the embodiment of all buddhas. It makes no difference how you visualize him. Pick whichever aspect inspires the greatest devotion and thereby you will receive his uncontrived blessing.

When visualizing the refuge tree, knowing that all the deities are the same in kindness and realization, consider that they are all combined within the

mind of the guru. Then think that they look on you and all sentient beings with kindness and bestow the blessings. Within the refuge, the guru's body is the Sangha, the guru's speech is the Dharma, and the guru's mind is the Buddha. Likewise, the guru's body is the guru, the guru's mind is the deva, and the guru's qualities and activity are the dakinis and dharmapalas. In this way the three roots are included. The guru's body is the nirmanakaya, the guru's speech is the sambhogakaya, and the guru's mind is the dharmakaya.

The *Tantra of Secrets* says:

> All forms of the sugata are included within the vajra master; the guru is Buddha, Dharma, and similarly Sangha; the guru is the supreme heruka, sovereign over all.

And the great commentary to the *Kalachakra Tantra,* the *Stainless Light,* reads:

> Those desirous of liberation should view the vajra master who expounds the Kalachakra Tantra as Bhagavan Manjushri or as the first Buddha, Kalachakra.

Drigung Kyopa wrote:

> Unless the sun of devotion shines
> On the snow peak of the teacher's four kayas,
> The stream of blessings will never flow.
> So earnestly arouse devotion in your mind.[23]

Therefore we must have devotion to the guru. As Buddha Shakyamuni said, "Shariputra, you will realize the ultimate through devotion."

b. The seven-branch prayer

As previously explained, the most excellent field of merit is the vajra guru, and therefore this practice combines the accumulation of merit with guru yoga. The seven branches include all the innumerable methods for the accumulation of merit and wisdom. First is prostration, the antidote to pride. Next is the branch of offering, then confession, rejoicing, and requesting the turning of the wheel of dharma; the sixth branch is requesting not to pass into nirvana; and the seventh is dedicating the merit. Please consult dharma texts for more detailed teachings on this important practice.

c. The essential king of teachings that alone is enough[24]

Having established that the guru is the embodiment of all buddhas, and with this certainty, recalling his excellent qualities and kindness, take refuge in your guru as "the king of teachings that alone suffices." Generate strong devotion and surrender yourself to him completely. With this heartfelt yearning, chant the lineage supplications and praises, the verses of yearning from devotion, the mantra containing your guru's name, and so forth, accumulating the numbers. However, if you are not able to chant these prayers or do not know them, then while visualizing or imagining the guru as the jewel who embodies all, chant the king of supplication prayers, the seven-line prayer, which has the greatest blessing, and accumulate this. Accumulating great numbers of this prayer and making supplications will suffice. This is the advice from Vajradhara Khyentse Wangpo.

To think it is contradictory to make supplication prayers to Guru Rinpoche in the same way as the Vajrasattva meditation and recitation is incorrect. There is no conflict in doing this in the same way because the essential nature of all the victorious ones is the same in the expanse of wisdom. In whichever way they are perceived by beings, there is in fact not an iota of difference. Therefore, Vajrasattva is Guru Rinpoche and Guru Rinpoche is Vajrasattva. Moreover, the buddha has manifested as the infinite peaceful and wrathful forms of the three root deities for the benefit of beings to be tamed. All of these manifestations are the display of the single wisdom, the appearance aspect, the bliss-emptiness mind of one's root guru. Hence through the accomplishment of the preliminary and the main practice of approach and accomplishment of any one yidam deity, such as Vajrasattva, all the other deities are accomplished. The *Tantra Which Draws Out the Heart of Awareness* says:

> The dharmakaya is of one taste, and its activity for sentient beings
> is equal,
> Yet due to the different perceptions of individual beings it appears
> in multitudinous ways.
> Since all the forms are one in the space of wisdom,
> Thus meditating on one buddha is the same as meditating on all.[25]

Therefore, by praying to the guru, one prays to all the buddhas.
As Guru Rinpoche said:

Whoever sees me sees all buddhas, as I am the essence of all the
sugatas.

At the end of your practice session, if you have a visualization for the
extraordinary preliminary practice, that is supreme. If you do not have one,
then visualize your guru on the crown of your head and you melt into light
and become a mass of five-colored light, which shoots up and dissolves into
the heart of the guru, who then slowly rises up into the sky and dissolves into
space. Meditate for a while in the state of the inseparability of you and your
guru, without fabrication. Jamgön Kongtrul said this has infinite benefit.

How do we bring our formal practice into our postmeditation conduct?
When walking, consider that the guru is in the sky above your right shoul-
der; the benefit is the same as if you were circumambulating the guru. When
sitting or standing, think that the guru is in the sky above your head, which
serves as an object of your prayers. When eating and drinking, consider that
the guru is in your throat, and thus consider that you are offering the best
of your food and drink to the guru. When sleeping, consider the guru at
the center of your heart, and the benefit is that you will be able to recognize
luminosity.

In short, at all occasions and all times, always remember the guru. Some-
times practice guru yoga, merging your awareness with the mind of the guru
and maintaining the self-radiance of the ultimate view. Supplicating and
visualizing in this way with diligence is the practice of guru yoga.

Tsele Natsok Rangdrol said:

> Remembering the guru through yearning devotion is the relative
> guru yoga of effort.
> When your mind merges with the mind of the guru, this is the
> ultimate effortless guru yoga.

And:

> All buddhas are one in the essence of the guru. If you know this,
> you will effortlessly receive the blessings.
> Knowing all the deities as the manifestation of the guru will
> bring inexhaustible accomplishment.
> Dakinis and dharmapalas are the manifestation of the guru. If
> you know that, you can accomplish the four activities.

Also:

> If you do not recognize enemies, demons, and negative condi-
> tions as the guru, even though you may dodge one obstacle, you
> will meet with another. This is the fault of not discarding grasp-
> ing at the self. It is important to know whatever arises to be the
> blessings of the guru. If you do not remember the guru at the
> moment of death, although you know a lot and have done a lot,
> it is just a dream. When the consciousness wanders in the bardo
> alone, there is no other protector on whom you can rely. There-
> fore, do not leave this profound essential point of carrying the
> guru on the path as mere words and letters, but practice. This is
> the most profound point from among all the 84,000 teachings.
> Although the teaching is most profound, if you do not practice
> it there is no benefit. Therefore, place complete trust from your
> heart and mind in the guru. Thus, as it is said, persevere in prac-
> ticing the nature, as it is.

Not only in the preliminary practices, guru yoga is also the focal point
of the path of the main practice, such as the development and completion
stage meditations. Receiving empowerments and merging one's own mind
with the mind of the guru through guru yoga is indispensable.

The *Great Vastness of Space Tantra* states:

> Meditating on the guru is meditating on the dharmakaya.
> The merit of meditating on the forms of a billion deities cannot
> compare.
> Therefore, whatever virtuous dharma activities you engage in,
> such as hearing, teaching, meditating, comprehending, offering
> torma, and so on,
> Since guru yoga precedes these, the guru is the glorious buddha of
> the three times.

The benefits of practicing in such a way are that our devotion to the guru
will always increase, our meditation will gain clarity, and we will realize the
nature of mind without much effort. When you accumulate merit in this
way, it is also important to seal this with wisdom.

II. Specific Preliminary Teachings on Supreme Art

THERE ARE TWO main subjects: the category of supreme art, and the origins of art in this world.

A. The Category of Supreme Art

There are two sections: the five sciences and the supreme arts.

1. The five sciences

The five sciences are the five disciplines over which a bodhisattva must have mastery on the path to enlightenment. They are (1) dialectics, (2) grammar, (3) medicine, (4) arts, and (5) doctrinal studies.

Dialectics helps us to establish the correct view through debate and increases our knowledge and understanding to progress in our dharma practice. Grammar, or the study of language, helps our ability to communicate and explain the dharma. Medicine heals ailments and sickness and so alleviates the physical suffering of beings. Art, especially supreme art, adorns our world, enriches, and inspires. Doctrinal studies assist our understanding of the truth. This is the main point of all fields of knowledge and thus unites all the others.

Sakya Pandita said, "Grammar is to convey meaning, dialectics is to validate, arts and crafts are for knowledge of external aesthetics, [the study of] scriptural teachings is for internal awareness, and the science of medicine is relied on for medical cures." The fact that supreme art is included in these five sciences shows how important it is within the Buddhist doctrine.

2. The supreme arts

All art achieves one of two purposes: either wisdom or worldly aims. Of these, one is supreme and one is ordinary. Buddhist art imparts wisdom,

which makes it the supreme, foremost art form. There are four kinds of lineages of art:

1. Art lineage of realized blessings
2. Art lineage from scripture
3. Art lineage of skillful knowledge
4. Art lineage of unrestrained activity

The first two are within the category of supreme art, the subject matter of this text. This includes painting, sculpture, woodwork, stonework, metalwork, leatherwork, and tailoring. The supreme art image is that of the Buddha. The supreme offerings are also within the category of art. The accumulation of merit resulting from depicting the Buddha and sacred symbols makes this art supreme. This accumulation is needed to obtain the cause for achieving the Buddha's body. However, whether this activity is meritorious, in that it leads to enlightenment, also depends on the motivation. The motivation should not be to create art for money, power, or fame; it should be to accumulate wisdom and attain enlightenment for the benefit of oneself and others in this and in future lives. If art is not created with these aims, its sacred meaning is reduced.

For the accumulation of merit to be supreme, the artist needs to combine a correct aesthetic depiction of the enlightened forms with the altruistic motivation of enlightenment for all sentient beings. This is why our artistic knowledge must be informed by the science of doctrinal studies for it to be complete. The same goes for all the other disciplines according to our tradition. Someone who sees a beautiful image of the Buddha and responds with pleasure will create a positive karmic connection with the dharma.

Three main points are enumerated: (1) the meaning of supreme art, (2) the importance of following the supreme art traditions, and (3) summary.

a. The meaning of supreme art

The word for "supreme" or "precious" in Tibetan is *chok,* which refers both to the artist's pure motivation for the enlightenment of beings, free from negativity or selfishness, and to the artwork itself as a supreme nirmanakaya form.[26] Such an artwork has great blessings and the ability to benefit. It has the power to clear obstacles and sickness and to increase the good fortune and prosperity of the land in its vicinity. There are two kinds of accomplishments or siddhis: one is ordinary, the other supreme. Ordinary siddhi refers to the blessing of outer circumstances such as those just

mentioned, and supreme siddhi refers to the blessing of inner attainment, wisdom. The accomplishment of wisdom brings benefit not just in this life but also in future lives. If both siddhis are attained, this helps you and all sentient beings to achieve complete enlightenment. Supreme art can help provide these blessings because a properly executed image of the Buddha is a nirmanakaya manifestation; it has all the qualities of the Buddha in its design. Therefore it is a supreme source of the accumulations of merit and wisdom.

The benefit of practicing supreme art is limitless. Because of its supreme aim and meaning, we need to understand the meaning of the Three Jewels and to have taken the refuge vow before training in this art. Without this we cannot benefit from the teachings. We must also have received teachings on the four thoughts that change the mind: precious human life, impermanence, karma, and the suffering of samsara. It is not enough merely to know these teachings intellectually; they must be genuinely felt within our hearts.

Previously in Tibet, nearly everyone was Buddhist and brought up within the dharma from birth. Nowadays, however, many young Tibetans are losing contact with their culture as well as with the Buddhist teachings. It is now necessary to give these basic teachings not only to aspiring artists from foreign lands who are new to the dharma, but also to those from Buddhist countries. The loss of understanding of the Buddhist teachings is evidenced by the degradation of the artistic traditions. People are creating icons without proper knowledge of, or faith in, the buddha dharma. This will generate negative karma for these artists because if they make supreme icons without proper respect, that will cut off their path to liberation. This is why it is so important for the aspiring artist to have taken refuge in the Three Jewels and to endeavor to receive and assimilate basic dharma teachings before practicing this noble activity. Doing so will enable the artists to understand how to conduct themselves properly and how to progress on the path to enlightenment.

b. The importance of following the supreme art traditions

In Tibet, all art was Buddhist; there is no record of any other artistic tradition. Since Buddhism came to Tibet, many of the kings (except Langdarma) were bodhisattva emanations. The first sign of Buddhism coming to Tibet was during the reign of the twenty-eighth king, Lha Totori Nyentsen, when a pot containing a statue, a stupa, and two texts fell out of the sky onto the roof of his palace. He was sixty years old at the time, but after this happened

he became youthful, like a sixteen-year-old, and he lived for another sixty years. A few generations later, King Songtsen Gampo ascended the throne; he is considered to be an incarnation of the bodhisattva Avalokiteshvara (Chenrezig). That was when Buddhism became firmly established in Tibet. Later, when the great King Trisong Deutsen invited Guru Padmasambhava and Shantarakshita to Tibet, the dharma increased and flourished. Many laws were passed during the times of King Songtsen Gampo and King Trisong Deutsen based on Buddhist teachings such as the ten vows, which restrained people from the three negative acts of the body (killing, stealing, and sexual misconduct), the four negative acts of speech (lying, harsh words, divisive speech, and idle chatter), and the three negativities of mind (lack of faith, covetousness, and hatred). From that time until the current fourteenth Dalai Lama, all the leaders of Tibet have been bodhisattvas.

Rules were made stipulating that people study and practice the dharma and help anyone in need without asking for recompense. Laypeople were encouraged to make offerings to monks and practitioners and sponsor virtuous works so the dharma was empowered. The kings also sponsored many great artworks during that time. In this way, both artists and supreme artworks were highly respected in Tibet because it was understood that images of enlightenment accumulate great merit not only for the artist and sponsor but also for the viewer. The supreme arts were thus given prime importance in Tibet, which is why a folk art tradition did not develop, as it was not considered of any benefit in comparison. Likewise, we need to see our art-making activity as a means to create merit, not just for this life but also for our own and others' future lives. It should not be mixed with other aims and traditions.

During his reign, King Songtsen Gampo commissioned the most famous artists of the time to build 108 temples. Many temples and artworks also miraculously arose. It was not just the Tibetan kings who had special qualities. For example, Gyalwa Tsongkhapa and the first Dalai Lama both said that Menla Döndrup (acclaimed as the first artist to create a style that was uniquely Tibetan) was an emanation of Manjushri. In fact, all the bodhisattvas of the time studied and practiced the arts.

In summary, this section of teachings has shown how supreme Buddhist arts were established in Tibet from within the very pure traditions and were developed and propagated by the great bodhisattva masters. Therefore, this activity has such great blessings that it should not be mixed with worldly art,

and the artists should be respected accordingly. If our activity comes from the motivation of bodhichitta (the wish for all sentient beings to attain enlightment), everything will be auspicious.

c. Summary

The act of painting supreme images is the accumulation of merit of body, the recitation of mantra is the accumulation of merit of speech, and following teachings such as those outlined here is the accumulation of merit of mind. If followed in this way, practicing supreme art can be a great dharma practice for this life. If we consider it to be precious, it can be precious. It is a dharma practice that can lead us to buddhahood; this is very important to appreciate. It is clear that we need both thoughts and deeds, and tangka painting is an activity that utilizes both, thus purifying our negative karma from the past, present, and future. The *King of Concentrations Sutra* says:

> Whoever renders an outstanding representation of the Buddha—a likeness that brings joy to all who behold it—from their finest jewelry, or commissions one fashioned from the finest gold, silver, or sandalwood, molded in clay, or carved upon rock or in wood, will, before too long, come to acquire the finest of concentrations.[27]

The *White Lotus Sutra* says, likewise:

> Those who fashion representations of the precious form adorned with the thirty-two marks of perfection will come to win enlightenment.

Similarly, all the measurements and instructions on the supreme arts are found within the teachings of the sutras and tantras. So many instructions can be found; therefore, those who wish to practice supreme art must be Buddhist and study these teachings. Otherwise, they will be like a blind person, not knowing how to progress.

B. The Origins of Art in This World

This section has four divisions: the importance of supreme art on the Buddhist path, the origins of drawing, the origins of Buddhist art in India, and the history of art in Tibet.

1. The importance of supreme art on the Buddhist path

The Buddhist aspiration is to attain enlightenment, and supreme art is needed in order to reach the bodhisattva levels. The ultimate aim of the supreme arts is to help beings to attain enlightenment. Depicting images of the Buddha's body creates the cause to easily attain the thirty-two major and eighty minor marks of the Buddha. Therefore, artwork is indispensable for the attainment of enlightenment. One of the Buddha's teachings, entitled *An Explanation of Realization's Powerful Merit,* explains how uniquely the arts are respected by all:

> Even if the caste of the artisan be low, kings, ministers, Brahmins, and householders alike hold in esteem the images that person makes, as do all manner of humans and gods. Similarly, gods and humans can come to appreciate the supreme art made by even the basest person.

A major Abhidharma text, *Discourse on Designations,* says that the precious wheel was made by the divine creator Vishvakarman as an offering to the universal king, and the rest of the seven precious royal emblems manifested spontaneously from this precious wheel.[28] This kind of story exemplifies the power of art.

In one version of another Vedic story, Saranya, the daughter of Vishvakarman, was married to Surya, the sun god, but could not stay near him because of his extreme heat and radiance. She returned to her parents and asked them to take her back. Instead they reproved her, so she hid in the form of a mare at Mount Kailash. Her father, the divine artist, then requested permission to reduce Surya's radiance so that his daughter could live with him, and thus chipped off parts of his radiant energy so that his brilliance and heat were reduced. In this way she was able to return to her husband and live happily with him. This story is a metaphor to exemplify the transformative power of art.

King Ashoka built many stupas, monasteries, and temples in his endeavors to propagate the buddha dharma—of course, artists were needed to accomplish all of that. King Trisong Deutsen built the Aryapalo Ling temple at Samye, and when it was finished, he invited all the artists to the temple and made many offerings to them, which shows the importance of supreme art and of paying respect to the artist. The *Great Nirvana Sutra* says, "Just as

all of the four major rivers that stem from Mount Kailash must eventually be united in the sea, all phenomena are subsumed in the equal taste of the dharmakaya." In this way, the goal of supreme art, just like all dharma activities, is to be of benefit to sentient beings.

2. The origins of drawing in this world

The following is an ancient legend about how drawing began.[29] There was a king called Jiktul (He Who Has Conquered Fear) at the time that the human life span of one hundred thousand years was in decline. It was a time of great prosperity, so that even the life span of his subjects increased. This king worshipped Brahma, from whom he received the eight special powers, and thus was acknowledged as an equal of the gods. When the son of a Brahmin died prematurely, the grieving father blamed the king and, threatening suicide, demanded an explanation from him. The king tried to reason with the father to no avail, so they brought the boy's corpse before Yamaraja, the Lord of Death, and the king requested him to bring the boy back to life. The Lord of Death replied, "It was not my doing; his death came about because of the exhaustion of his own karma."

The king and the Lord of Death argued over this and began to fight. The king had divine weapons, and with his immense strength it looked as though he would defeat Yamaraja. Brahma in the heavens above, feeling the earth shake and hearing the clash of weapons, came to investigate. He commanded the king and Yamaraja to stop fighting. "When an individual's karma is exhausted, no blame can be assigned to the Lord of Death," he told them. Nonetheless, he asked that a likeness of the deceased Brahmin youth be drawn. The king then drew the boy's likeness on a piece of cloth, which Brahma blessed, magically restoring the boy back to life from this image. Humbled, the king and the Brahmin apologized and made offerings to Yamaraja. Henceforth the king was given the title of the "first artist."

Later the king visited the realm of Brahma and expressed his desire to continue drawing. Brahma told him, "The most excellent of mountains is the precious Mount Sumeru, the foremost among all the egg-born is the garuda, and the king is supreme among men. Likewise, among all the arts, the graphic arts are supreme." So the king devised a set of requirements for drawing, basing the correct proportions upon the ideal form of a universal monarch. He also explained the fault in drawing without the correct proportions and the virtue in drawing according to correct proportions. The

science of arts and crafts developed from this point, and that is how art began in the world.

3. The origins of Buddhist art in India

Two main divisions of art are traditionally enumerated in the Buddhist teachings: common and supreme art. Common art is ordinary worldly art, created to beautify and adorn, whereas supreme art has the capacity to take us out of the suffering of samsara. Therefore, it can benefit us not only temporarily but also in our future lives. Within supreme art, three main divisions are further enumerated: physical, vocal, and mental art. Physical art refers to art conveyed through material forms. Vocal art refers to art related to sound and words. Mental art refers to art symbolizing the mind of a buddha as well as the mental practice of assimilating the teachings into our mindstream through the various methods of meditation. The main subject of this book is physical art, which is further divided into physical art of supreme body, physical art of supreme speech, and physical art of supreme mind.[30]

In this fortunate aeon, the first of the supreme Buddhist arts to come into the world was the physical representation of the Buddha's mind: the art of stupa design and construction. Next was the physical representation of the Buddha's body, through the graphic arts of drawing and sculpture; and last was the physical representations of the Buddha's speech, the art of sacred writing and poetry (the written teachings).

a. The origin of stupas

Eight different kinds of stupa were first built, each referring to a major event in the Buddha's life. The first stupa was built by Buddha Shakyamuni's father, King Shuddhodana, to commemorate the Buddha's birth in Lumbini Grove. It was designed in a style known as "heaped lotuses," which was the first symbolic or supporting element inspired by Lord Buddha. Following the construction of this first stupa, further types were built, to make a total of eight stupas representing all the stages of the Buddha's life.[31] Dilgo Khyentse Rinpoche said, "The stupa that enshrines the teacher's physical remains is at once a reminder of the teacher and the embodiment of the pure and all-pervasive aspect of the awakened state."

The stupa's shape represents the Buddha, crowned and sitting in meditation posture on a lion throne. His crown is the top of the spire; his head is the square at the base of the spire; his body is the vase shape; his legs are the four steps of the lower terrace; and his throne is the base.

b. Drawing and sculpture

This category has two divisions: the origins of drawing (the graphic arts) and the origins of sculpture.[32]

i. The origins of drawing

The Buddhist graphic arts derived from two main Indian traditions. Both originated from tracings of the Buddha's reflection; one, from the story of King Utrayana, is known as "The Image of the Sage Taken from a Reflection in Water." The other arose at the request of Princess Pearl Throne and is known as "The Radiant Sage."

(1) The tradition of drawing from King Utrayana

The first example of a drawing of the Buddha originated from the country of Magadha in central India. King Bimbisara conceived the idea of presenting his ally, King Utrayana, with a painted portrait of their beloved teacher, Lord Buddha, but the artist was so overwhelmed by the sight of Buddha's splendorous body that he could not draw while looking at him directly. After the problem was presented to the Buddha, he said, "Let us go together to the bank of a clear and limpid pool." Then the Buddha sat by the bank of the pool while the artist sketched from the reflection on the water's surface. In the finished painting, the central figure is surrounded by designs symbolizing the twelve links of dependent origination. When Utrayana glanced at this portrait for the first time, he had an intuitive understanding of reality. He received the gift with great respect, placing the tangka on a gold throne and making many offerings to it. Many people were able to view this image, which depicted all the extraordinary signs and marks of a buddha, and were inspired by a feeling of great devotion, thereby achieving realization without effort. The king attained the meditative level of "continuous setting."

The style that originated from this image became known as "The Image of the Sage Taken from a Reflection in Water." It is said that the measurement for the Buddha's body proportion known in Tibetan as "[from the] *urnakesha*" (coiled hair treasure) is taken from this—in the measurement, the length of the Buddha's crossed legs is the same as the distance from the point where his ankles cross to the coiled hair on his forehead. This is the measurement used in the Karma Gadri tradition.

(2) The tradition of drawing from Princess Pearl Throne

When Buddha Shakyamuni was in Shravasti, a princess was born in Sinkara (modern Sri Lanka). A shower of pearls fell from the sky at the time of her

birth, and so she was named Pearl Throne. One evening some merchants stopped to rest by the water, and the next morning as they arose they began singing praises to Buddha Shakyamuni. Pearl Throne heard them sing and was deeply moved. She summoned the merchants, who explained that they were singing praises to Buddha Shakyamuni and reciting prayers. On hearing the name of the Buddha, the princess was spontaneously moved to a feeling of intense devotion and remained enthralled like a peahen transfixed by the sound of thunder, as the saying goes. She wrote a letter to Buddha Shakyamuni asking for something that she could use as an object of her devotion. Buddha Shakyamuni smiled when he received her letter. He projected the light of his body onto a canvas and told some artists to trace his portrait from the reflection. Above the image he wrote syllables in gold letters and the symbols of the twelve links of dependent origination and also wrote about the benefits of devotion and refuge in the Triple Gem. When she saw the image, the princess experienced a joy so intense that it was like a samadhi devoid of even the subtlest kind of discursive thought. As she reflected on the meaning of the message, the 112 hindrances to liberation discarded on the path of seeing fell away, and she became ready to eliminate all that has to be eliminated on the path of meditation. She had a gold throne built for the painting and made offerings to it. She later attained buddhahood without effort. She said that her attainment came from the power of the Buddha's compassion, kindness, and blessings, so she sent many jewels and pearls to Buddha Shakyamuni and his sangha to express her gratitude.[33]

When they heard of her swift attainment, Ananda and others marveled and asked the Buddha how it was possible to achieve realization with such ease. Buddha related the story of her previous life when she was a servant girl named Rohita during the time he was giving teachings at Kapilavastu. A king called Mahanama (Shakya Menchen) asked his queen Dawoma if she wished to hear the teachings of the Buddha. She said she would and went to the teachings dressed in all her finery and adorned with jewels. When she arrived, Ananda reproved her for attending a religious teaching wearing ornaments, so she sent her jewels back. While the Buddha was giving teachings on impermanence, Queen Dawoma noticed a pretty young girl constantly fingering and admiring a long string of pearls around her neck. Believing that the girl was deliberately trying to outshine her, the queen asked her serving maid, Rohita, to fetch her jewels again. Rohita had been listening attentively and set off home very disappointed to be missing the teachings. On the way, she was attacked and killed by a cow in labor. At the

moment of her death, Buddha Shakyamuni's teaching on impermanence came clearly to her mind, and that is why she was reborn as the princess.

In another previous life she had been a merchant's wife and had offered all her riches, including her pearl necklace, to a stupa after the death of her husband. That was why she always had pearls and was wealthy in her subsequent lives. However, because of a moment of miserliness, she was also reborn in many lives as a servant. This is why the Buddha said she could attain realization easily in her life as Pearl Throne, and he prophesied that she would soon reach complete enlightenment.

This is how the style of drawing known as the Radiant Sage came about. This type of drawing had a reputation for being clearer and more beautiful than the other. In the Radiant Sage tradition, which also spread to Tibet, in calculating the proportion of the Buddha's figure, the length of his crossed legs must be the same as the distance between his nose and the place where his ankles cross. This measurement, called "ranging from the tip of the nose," is used in the Tibetan Mensar, or New Menri, tradition. The Karma Gadri tradition follows the overall style of this tradition, as it is more defined and clear, but our proportional measurement for the Buddha's body comes from the first tradition.

ii. The origins of sculpture

Buddhist sculpture began in India when one of Buddha's wealthy patrons, Anathapindika, was making daily offerings of the midday meal to Lord Buddha and his disciples. Because of his religious duties, Lord Buddha was not always able to attend, so the patron respectfully requested his permission to commission a statue to be placed on his seat, as it seemed inauspicious to leave the seat empty. The Buddha agreed, and the statue was made with precious substances by divine artists, complete in every detail. This statue became known as the Precious Teacher. Another time, Buddha Shakyamuni had departed for the Heaven of the Thirty-Three to teach his mother, so the king of Varanasi made a sandalwood image of the Buddha for his personal devotions. It is said that when the Buddha returned to the human realm, this statue, known as the Sandalwood Lord, took six steps in welcome. These were the world's first two statues of Buddha Shakyamuni, and the many statues made thereafter were based upon these models.

Before passing into parinirvana, the Buddha gave permission for images to be made in his likeness, in order to guide holders of extreme views. Rahula, the Buddha's son and disciple, made a statue of the Buddha's sambhogakaya

form, Vairochana, from many precious jewels that came from the *naga* realms. This image is said to reside in the outer ocean of the universe. Indra also commissioned a statue of the Buddha made of five special substances, along with 521 precious jewels from the world of gods and humans.

When the celestial artisan Vishvakarman, intending to measure the Buddha's body, tied his measuring string to one of the Buddha's toes, no matter how high he stretched the string up the length of the Buddha's body, he could not reach the end. When he reached the heaven of Supreme Joy, the Buddha said, "Don't think you can measure the Buddha's body or conceptualize the Buddha in this way. Just meditate on the Buddha's body." Vishvakarman did as he was told and immediately arrived before the Buddha and was able to fashion his likeness perfectly. He made three images of the Buddha at different stages of his life: one as an eight-year-old, one as a twelve-year-old, and one as a twenty-five-year-old. After this, many statues were made, but these three are said to be the most exceptional, as they were blessed by the Buddha himself. The statue of the Buddha at the age of twenty-five was taken to the god realms, the statue depicting him at age twelve was taken to China, and the one at age eight was taken to Nepal. Many years later, the latter two were offered to King Songtsen Gampo in Tibet by his Chinese and Nepalese queens. Enshrined respectively in the Jokhang and Ramoche temples in Lhasa, they are the famed Jowo statues.

After the Buddha had passed into parinirvana, there were not many exceptional artists among ordinary human beings, so many divine artists emanated as humans to make fine statues. Eighty years after the Buddha's parinirvana, in the city of Magadha, three Brahmin brothers appeared. The eldest, named Jina, erected a temple and an image of the Buddha from precious stones at Sarnath, near Varanasi, where the Buddha first taught. The second brother, Sadhujina, built a temple and an image of the teacher made of earth from the eight great holy places of Buddhism, at the Bamboo Grove in Rajagriha. The youngest, the Brahmin Kusala, erected an image of the teacher at the moment of attaining complete enlightenment, in the sanctuary of Bodhgaya. This powerful statue was greatly blessed and had special jewels in its eyes. The only difference between it and the Buddha himself was that Lord Buddha's tongue was long, his clothes did not touch his body, and so on, but everything else was exactly the same. Seeing this statue is said to carry the same power and blessings as meeting the Buddha in person.

From the time of these three brothers over the next century, the traditions of Buddhist painting, sculpture, and temple design became wide-

spread, and Buddhist patrons commissioned many statues and structures, such as the eight stupas. During the reign of King Ashoka, many naga and *yaksha* artists, of nonhuman and semidivine form, developed innovative styles for statues and stupas, such as those at Bodhgaya and the stupas at the major Buddhist holy places. Many artworks were also made during the time of Nagarjuna. As explained in Gega Lama's *Principles of Tibetan Art*:

> Later during the reign of King Sangyay Chok an artisan named Bimbisara introduced marvellous styles of sculpture and painting reminiscent of those earlier divine artists. His numerous followers became known as the "lineage of divine artists," and he himself, having been born in Magadha, was called "the artist from the central country."
>
> Again, during the reign of King Ngangtsul appeared an artist from the region of Maru, known as Tenzin who was incredibly skilled in Buddhist iconographic art. His style of painting and sculpture, which resembled that of the yaksha artists, became known as the "western style" or "heart of the west."
>
> During the reigns of King Devapala and Sri Dharmapala, an artist from the region of Varenta named Dheman, and his son Vitsali . . . developed numerous styles in casting, relief work, and sculpture resembling the styles of naga artists . . . the son establishing himself in Bengal . . . and his style became known as the style of the God of the East (even though it spread throughout India). In painting, the father's school became known as the Central School since his followers were located in Magadha. In the lineages of Pukon and Southern India, three artists—Jina, Paranjaya and Vijaya—developed styles of painting and sculpture that were widely imitated. Thus many Buddhist sculptural styles developed but with the decline of the Buddha's teachings in India, these traditions also declined and eventually disappeared.[34]

c. The art of supreme script

The art of script or calligraphy is more difficult to talk about, as it can be interpreted in many different ways and there are many different Indian scripts. The Sanskrit scripts (Lentsa and Vartu) already existed at the time of the Buddha along with many other scripts. Many of these languages have

gradually disappeared over time. However, the sacred writings of the buddha dharma began when Buddha Shakyamuni turned the wheel of dharma for the second time and Indra wrote some of the teachings on transcendent wisdom with lapis lazuli ink on gold plate. When he heard the *Crown Ornament of the Victory Banner* prayer, Indra wrote it down on the cloth of a victory banner, which he raised to help pacify conflict between the gods and the demigods. This was the beginning of the art of sacred script. The Buddha also decreed that sacred texts could not be sold.

During the Three Councils of the Doctrine, disciples from different regions of India compiled the teachings of the Buddha in their own scripts. Later the teachings were translated into Tibetan and other non-Indic languages. A clear Tibetan script did not exist until King Songtsen Gampo sent Tönmi Sambhota with sixteen other students to India, where they learned many different Indian languages from the Indian teachers Simha and Brahmin Lijin. After returning to Tibet, Sambhota copied the alphabet of thirty letters from the original fifty Sanskrit letters. He created a system of grammar in eight chapters, following the Indian example (although six chapters were destroyed during the time of Langdarma, so now only two remain). That Tibetan script remains in use today.

The many different kinds of art, which are generally divided into eighteen, can all be included within these three categories: the art of supreme body, speech, and mind. The teachings on the art of statue and script are from Jamgön Kongtrul's *Treasury of Knowledge*.[35] This concludes the teaching on the history of Buddhist supreme art in India.

4. The history of art in Tibet
This section is divided into common and supreme art.

a. The common arts
The evolution of any of the fields of general knowledge is always difficult to speak of or document precisely because of the different perceptions of people, due to their individual karma. Added to this is the collective karma and perceptions of people from different cultures. This complexity needs to be kept in mind when one investigates the traditions of any culture. The evolution of styles and traditions of art similarly reflects the individual karma of the artists of a particular country, as well as influences from other cultures. But even the styles that emerge within different cultures will evolve dynamically and fluidly into something different over time.

The major cultural and artistic influences of Tibet came from China in

the east and India in the south, each of these having its own rich artistic traditions. Whenever different cultures make contact, a flow of influence develops between them. Also, within each country or province, an art form, culture, or language may evolve naturally without any outside influence while also evolving in another region, even though the two never had contact with each other. This cannot be explained by limited rational thinking. Thus we can see that the origins and history of the common traditions of art around the world can never be described exactly, and anyone who attempts to record a general art history should not expect to make a perfectly accurate rendition of events. However, it is actually possible to be much clearer and more specific about the origins and history of the supreme arts because this tradition follows the historical figure of Buddha Shakyamuni, and thus the supreme art traditions that originated from his teachings were consciously created as a part of his wish to benefit beings.

The word for "drawing" in Tibetan is *rimo* (*ri* meaning "mountain" and *mo* meaning "girl"). The origin of this word is explained in the following story handed down in Tibet over the ages. A long time ago, in a place called Yarlung in central Tibet, a nomad family had a servant, a shepherd boy called Lukdzi Agar. While watching the sheep graze, he would doodle with chalk and charcoal on pieces of slate and stone, sketching the scenes he saw around him. One day while he was herding the sheep along a grassy glade on a mountainside, there was a sun shower. A shimmering orb of rainbow lights appeared in the sky before him, in which a beautiful girl danced, smiling at him. Agar fell in love with her and ran toward the mirage, which slowly disappeared. This entrancing vision stayed vividly imprinted in his mind, and when he returned home he immediately copied her image on a slate with charcoal. The result was a very beautiful and clear image, just as he had beheld her. Afterward he etched the lines into the slate so that he could keep it with him to remember her by. When his friends saw this beautiful drawing and asked what it was, he answered, "ri'i bumo," which means "mountain girl," but they misheard him and thought he just said "rimo." His friends then told everyone that he had made a rimo, which is how this word became the noun for drawing. Since that time, the art traditions slowly evolved into the various traditions acclaimed today.

b. The supreme arts

This subject is divided into three: a general history of supreme art in Tibet, the Karma Gadri tradition, and the artistic activity of nineteenth-century Nyingma masters.

i. A general history of Tibetan supreme art

This subject is divided into five: (1) the influence of the kings of Tibet, (2) major artistic personages and influences from the 900s to the 1400s, (3) the painting lineages from Menla Döndrup, (4) the Khyentse painting lineage, and (5) significant figures in Tibetan art from the 1500s to 1700s.

(1) The influence of the kings of Tibet

In the *Sutra of the Immaculate Goddess,* Buddha Shakyamuni prophesied that after his parinirvana, his teachings would go to Tibet. This came true when the twenty-eighth king of Tibet, Lha Totori Nyentsen, was born in 374 CE as an emanation of the bodhisattva Samantabhadra. As related previously, when he was sixty years old, a pot containing a statue, a stupa, and two texts fell out of a rainbow-filled sky onto the roof of his palace, accompanied by a rain of flowers, the sound of exquisite music, and the scent of sweet perfume. This heralded the beginning of Buddhism in Tibet, and the statue, stupa, and text, representing the body, speech, and mind of the Buddha, were the first Buddhist art objects or symbols to arrive in Tibet. One of the texts, called the *Sutra of a Hundred Invocations and Prostrations,* contained a Buddhist sutra written with lapis lazuli ink on gold paper. Also in the pot were a twelve-headed Avalokiteshvara mantra block, a gold stupa the height of a forearm, and a mani block. A voice then resounded from the sky, saying, "After five more kings, the meaning will be understood." At the time there was still no written script in Tibet, so the king could not read the script, but, moved by immense devotion, he named the objects "Powerful Secret" and kept them respectfully as objects of his devotion. Through the merit accrued by devotions, he became as youthful as a sixteen-year-old and lived for another sixty years to the age of 120.

King Songtsen Gampo (c. 605–650) was Tibet's thirty-third king and the first of the three dharma kings (Songtsen Gampo, Trisong Deutsen, and Ralpachen). Under his reign the buddha dharma was established in Tibet. An emanation of Avalokiteshvara, he showed unusual brilliance from a young age and was also a great artist. When he was fifteen, a monk called Akarmatishila came from India to offer him a sandalwood statue of twelve-headed Avalokiteshvara, called Jowo Rangjung Ngaden. Songtsen Gampo married two princesses, one from Nepal and the other from China. The sacred statue of Buddha Shakyamuni at the age of eight (known in Tibetan as Jowo Mikyö Dorje), which resides in Ramoche temple to this day, was offered by Princess Bhrikuti Devi. The statue of Jowo Shakyamuni at the age

of twelve was offered by Princess Wencheng of the Tang court and resides in Jokhang temple. These three statues were very sacred, as they were made by the divine Indian artist Vishvakarman, and the temples were built by the king specifically to house them; however, when he began to establish the foundations of what was to be known as the Lhasa Jokhang, local spirits kept creating obstacles. One day a voice from the sky told him he should make a representation of his own body to prevent obstacles to his project, so he gathered precious materials, including sandalwood, and an eleven-headed, eight-armed Avalokiteshvara statue miraculously arose. (The tradition of the thousand-armed Avalokiteshvara began later in Nepal.) The local gods and demons were thus subdued and he could continue his work. He gathered a lot of wood and then magically manifested as 108 carpenters who built all 108 temples, including the famed Jokhang.

A story from that time recounts that Queen Bhrikuti Devi sent a serving girl to bring some beer to the king while he was working on the temple, but when the girl arrived she saw a multitude of identical kings working there. She had no idea whom she should give the beer to, so she returned to the queen in confusion and explained her predicament. The queen told her not to worry and brought the beer to the king herself. The serving girl secretly observed through a crack in the wall the queen miraculously multiply her body and serve beer to each of the kings! Out of sheer astonishment the girl laughed out loud, startling the king so that his hand slipped and cut the nose of the snow lion he was working on. This is why all 108 snow lions at the Jokhang have very short noses! Through his magical emanations, the king finished the lower temple in twelve days. Able to emanate in many places at once, the king, helped by artists from Nepal and India, also built 108 magically arisen temples all over Tibet.

The three main sculptors who worked on the Jokhang and other temples were Dramze Dunggi Nacha and Vishvakarma Sarva Jha Panchen Metok from India, and Kyura Lhachen from Tibet, who sculpted all the buddhas and bodhisattvas. Kyura Lhachen directed the others to follow the style of Nepal, but they changed some of the features and design a little to make them more Tibetan, which is why this style is called Kyura Lhachen. During King Songtsen Gampo's reign, most of the statues and art objects came from India. The great translator Sambhota also created the Tibetan alphabet and grammar at that time, so it was a period of major propagation of the dharma, including the supreme arts, in Tibet.

King Trisong Deutsen (c. 782–800) was the second of the three dharma

kings of Tibet and the fifth king after Songtsen Gampo. He was an emanation of Manjushri and played a pivotal role in the introduction of Buddhism to Tibet and the establishment of the Nyingma or Ancient school of Tibetan Buddhism. He invited the great Indian adept Shantarakshita and the tantric adept Padmasambhava "the Invincible" (Guru Rinpoche) to Tibet. It was with the help of Guru Padmasambhava that the king was able to complete the great Samye, Tibet's first monastery, as Guru Padmasambhava subdued the demonic forces that obstructed the project. During this golden period in Tibet's history, 108 teachers and translators came to help establish the doctrine, and many statues, shrines, and temples were built and painted. At that time Shantarakshita, Padmasambhava, and King Trisong Deutsen decided to incorporate three artistic and architectural traditions in Samye; the lower part was to be Tibetan and the upper stories were to be in Chinese and Indian styles.

Before building Samye, Shantarakshita advised the king to first build a temple to Tara, as she had helped him when he had first taken the bodhisattva vow in his previous life. She would also be the one to help him to enlightenment, by requesting his first dharma teaching. "She will help protect you and this temple, so build the temple to the south," Shantarakshita said. The king did so and called the temple Aryapalo Ling. A magically emanated lama called Lhaso Gyatsal Puchen appeared, claiming to be the best statue maker in the world, and offered his services, which King Trisong Deutsen and Shantarakshita happily accepted.

When creating a distinctly Tibetan style for the depiction of deities, they looked for an ideal prototype among the Tibetan people. Hence the male deity's figure was modeled on a handsome man called Kutak Tse and the female deity's shape on a beautiful woman called Chokrosa Lha Bumen. For the wrathful Hayagriva shape they took the proportions of a man called Masa Kong and for the deity Lhamo Özer Jemma from a woman called Chokro Nuchung. However, the actual measurements remained exactly as described in the tantric texts. Only the features were changed slightly from the Indian to become more Tibetan, and it was thus that the great sacred arts from India, Nepal, and China helped form a Tibetan style.

In this way it is said that the earliest Buddhist art, such as the statues that naturally manifested at Tangdruk temple, evolved in Tibet during the time of King Songtsen Gampo. Then, during the reign of King Trisong Deutsen, the supreme arts developed and blossomed, such as the architecture and art of Samye, which exemplifies the early styles of sculpture in Tibet.

(2) Major artistic personages and influences from the 900s to the 1400s
It is said that some of the first sculptures in Tibet were made by an artist
called Taktsang. Using saffron dye, he printed an image on cloth copied
from the Buddha statue in Bodhgaya and brought it back to Tibet, where it
was used to make many statues, merely changing the hands of Lord Buddha
to different mudras as required. The name of the print was Chulönma. The
finished work was not very attractive, however, as the measurements did not
compare well to those of the original sculpture, the neck being too short and
the body too stout. Nonetheless, this prototype was widely used.

In his *Treasury of Knowledge,* Kongtrul Yönten Gyatso says that the first
Tibetan painting tradition came from Nepal, which influenced the Menri,
Khyendri, and Chiwodri traditions. Even later, the Karma Gadri tradition
was propagated by the "Three Tashis"—Namkha Tashi, Chö Tashi, and
Kashö Karma Tashi—making a total of four main art traditions in Tibet.
Sculpture also improved with the arrival of many rupakaya representations
from India and Nepal. Most of the artisans came from Nepal, where Bud-
dhist art traditions were already established, but their apprentices were pri-
marily Tibetan.

In the dark age of the anti-Buddhist king Langdarma, there was no
supreme art practice for seventy years—no new statues or paintings were
made, and many old ones were destroyed. After 953, Buddhism started to
revive during the second propagation of the dharma. In particular, a teacher
called Lachen Gewa Rapsel—also known as Lachen Gongpa Rapsel (892–
975)—a skilled artist who had great faith in the dharma, tried to revive the
arts. Lha Lama Yeshe Ö was also a great artist and teacher who built and
repaired many temples. In 996, he made statues for the temple of Toting
Serkye Lhakhang, which he offered to Lochen Rinchen Zangpo, who was
also a skilled artist. Lochen Rinchen Zangpo painted the interior walls of
this temple with deities from the four classes of tantra along with images
of the buddhas and bodhisattvas, scenes reflecting the monastic Vinaya,
monastic clothing, and so on. Later Atisha and the fifth Dalai Lama praised
his work, saying that it would be extremely helpful for future generations.

The year of the Fire Rabbit, 1027 was significant because it was the year
the Kalachakra was first translated into Tibetan. From this tantra, the
astrological system based on sixty-year periods, each called a *rapjung,* was
adopted—thus every sixty years from this date is a Fire Rabbit year.

As mentioned previously, Atisha Dipamkara Shrijnana (982–1054) was
a Buddhist teacher from the Pala Empire who, along with Könchok Gyalpo

and Marpa, was one of the major figures in the establishment of the Sarma (New Translation) lineages in Tibet after the repression of Buddhism by King Langdarma. As prophesied, Atisha went to Tibet in 1040 and reestablished the doctrine clearly, so that once again the sun of the dharma shone brightly. He brought with him many statues and stupas from India and Nepal, especially the stupa known as the Kadam Chorten. He was also a skilled artist and art teacher. Atisha made many statues, so he was very helpful for the Tibetan supreme arts.

The great master Gampopa (Dakpo Lhaje, 1079–1153) was a skilled artist and built many stupas and temples. He was a particularly good draftsman and painter. Gampopa's disciple Je Pakmo Drukpa (b. 1110) never formally learned the arts but was a very skilled artist and painter, prolific in building temples and statues. Sakya Pandita Kunga Gyaltsen (1182–1251) was a great draftsman and statue maker, and he wrote a book on art. Karma Pakshi, the second Karmapa (1204–1283), was a patron of the largest statue of the time in Tibet, at Tsurpu Monastery. He invited an artist, Penyul Lhatsowa Pakshi, to Tsurpu to make the statue called Lhachen Dzamling Gyen. It was about seventeen meters (ten *dom*s) high and was completed in 1263.

Kunkhyen Butön Rinchen (1290–1364) was another significant figure in Tibetan art history. When he was seven years old he studied with his grandfather, Tsultrim Palsang from the Nyingma tradition, although he later practiced and studied at a New Translation monastery in central Tibet. He wrote many books and made many statues, stupas, and representations of the Buddha's body, speech, and mind. He wrote a book on art that included clear instructions on stupa measurement, mandalas, and how to draw the mahasiddhas.

In the fourteenth century, one of Tibet's greatest artists was born in Yardo. His name was Tulku Rikarwa, but he is best known as Tulku Chiu or Yardo Tulku Chiu Kangpa. He began drawing from a young age, carrying a slate, stick, and paints everywhere he went. Whenever he saw fine examples of art, he would copy them, even images in caves. As he wandered around sketching and copying, he earned the nickname Chiu ("bird") for the curious way he examined things. Both he and his student, Podong Chole Namgyal, became famous artists. In 1389, he worked on the Palgor Chorten in Gyantse. He created the wall painting in a style similar to that of the Nepali tradition, which is how we can approximate his dates.

In 1409, Je Tsongkhapa (1357–1419) founded Ganden Yangpachen Monastery. Among the many great artists he invited to work on the monastery

was a lama named Tulku Leu Chung, widely renowned as one of the greatest artists of the time, particularly in drawing and sculpture. The stupas, statues, and wall paintings created by the masters were based on the *Sharipu* and *Tsangpa Uti* tantras, the *Samvarodaya Tantra,* and the *Tantra of the Glorious Dark-Red Bhairava.* Tulku Leu painted the buddhas, bodhisattvas, and dharmapalas. As he was around fifty years old at the time, he was probably born around 1358.

Tangtong Gyalpo (1385–1464 or 1361–1485) was born at Olpa Lhartse in upper Tsang. He was a great Buddhist adept, a yogi, physician, blacksmith, architect, and pioneering civil engineer, famous for building bridges and boats as well as for establishing Tibetan opera. He is considered to be the patron saint of theater and became known as the Madman of the Empty Plain. He is associated with the Shangpa Kagyu, Nyingma, and Sakya traditions of Tibetan Buddhism. When he was only five years old, he would make stupas and ships from natural materials and bless other children while they played. He learned to read and write effortlessly, quickly attaining proficiency in the Sanskrit Lentsa script. Although he was an accomplished yogi who spent many years in retreat, among his many activities during his life, he also made fifty-eight iron bridges, sixty wooden bridges, and 118 boats. He fashioned more than one hundred statues from various precious metals and one thousand clay statues in fifty-three sizes. Even while eating breakfast, he would fashion statues out of tsampa. He also painted murals on the walls of the 120 temples he built. He printed the 161 volumes of the Kangyur eighteen times and the 260 volumes of the Tengyur fifteen times, one set with gold ink. He also made many stupas.

Dolpa Tashi Gyalpo was born at the end of the fourteenth century in Tsangto, central Tibet, probably around 1388. A disciple of Tulku Leu Chung, he was one of the great masters of Tibetan art, but very little is known of his personal history. He had many disciples, but two—Menla Döndrup (Lhodrak Mentangpa) and Gongkar Gangtö Khyentse (also known as Khyentse Chenmo)—surpassed him. He painted both Ganden and Tashilhunpo monasteries, which were built thirty years apart.

Menla Döndrup (also known as Lhodrak Mentangpa, after the place of his birth) was the famed founder of the first truly Tibetan painting tradition. He was born in Lhodrak Mentang in the same year history books record that *tsalka* (a red-colored treasure) was found, which was in 1400, and from a young age he showed signs of being special. He was exceptionally intelligent and gentle in nature. When he came of age he married, but

later he and his wife separated and he wandered off, disillusioned and alone. Arriving at Yardrok Talung, he found paint, a brush, and a drawing template with deity measurements and happily took it as a sign that he should begin to paint. He went to Tsang, where he heard about the great Dolpa Tashi Gyalpo, who was learned in all the artistic traditions of India, Nepal, and China as well as the different conventions of proportion. Becoming Dolpa Tashi Gyalpo's student, Lhodrak Mentangpa progressed quickly and became an exceptional artist. At one time, upon seeing a Chinese painting, he recalled memories of his previous life as an artist in China.

During the many highs and lows in the history of the spread of Buddhism in Tibet, many artists had been invited to the country, especially from India and Nepal. Magically emanated artists had also appeared, but while artists and artworks from other realms were common, no special Tibetan tradition existed. Menla Döndrup therefore wished to devise a purely Tibetan tradition of painting. He thoroughly studied the teachings on art from the tantric texts and wrote a book for Tibetan artists, which included some dharma teachings. This famous book, entitled the *The Wish-Fulfilling Jewel: A Book of Measurements for the Painting of Sacred Images,* was very helpful for future Tibetan artists' accumulation of merit and progress to enlightenment, as it included all the proper measurements and the teachings required to establish the proper view and activity. Due to this, Menla Döndrup became even more renowned than his teacher. A story from this time relates that the first Dalai Lama, Gendun Drupa, had a vision in which Tara told him that Manjushri was coming to see him. The next day, when Menla Döndrup arrived, the Dalai Lama pronounced that he was an emanation of Manjushri and invited him and his disciples to paint Tashilhunpo Monastery, further enhancing the painter's renown as the true founder of the Tibetan tradition of art. The style he developed, known as Menri (or Mendri), became the basis for the first truly Tibetan painting tradition, and all subsequent Tibetan lineages of art are derived from it.

(3) The painting lineages from Menla Döndrup: Old and New Menri

Two traditions originated from Menla Döndrup, one from his son (the family lineage) and another from his disciples. His son Mentang Jamyang and his nephew Önpo Mentangpa Shiwao continued his painting lineage at a place called E, which thus became the main place associated with the Menri tradition. Mentangpa and Önpo Mentangpa Shiwao are sometimes

referred to as Kuwön. The name Mentangpa Yapse (father and son) refers to Mentangpa and his son Jamyang. Mentangpa Gönpo Tsewang is another artist included in his family art lineage.

Other famous Menri artists worth mentioning here are Podrang Puntsok and Lhasa Rakawa Jamyang Wangpo. The most famous sculptors of the time were Tulku Hordarwa and Epapak Tro.

Menla Döndrup's main disciple from his lineage of students was Trengkhawa Palden Lodrö Zangpo. He was a great painting master and teacher, born during the reign of the third Dalai Lama, Sönam Gyatso (1543–1586) in Tsangto Tanak Rikar. Extremely learned in all five sciences, he wrote a book on art and deity measurement called the *Clear Mirror of Sutra and Tantra.* In the seventeenth century, during the reign of the fifth Dalai Lama, Lodrak Tenzin Norbu, Tsochen Chöying Rangdrol, and Natse Palden Gompo were the main holders of this lineage, which is now known as Lodrak Mentangpa's Old Tradition: Menri Nyingma or Men-nying.

The New Menri lineage originated in Tsang and was adapted from Old Menri. The most renowned proponent of this famous style was Tulku Chöying Gyatso from Tsang; it was also strongly propagated by Chamdo Trulpa Purbu Tsering. The Mensar (New Menri) lineage continues to this day, although Mentangpa's old painting lineage has died out.

In the *Crystallization of Practical Procedures,* the life story of Panchen Lozang Chögyen is detailed, and it mentions that Tulku Chöying Gyatso did the wall paintings during the repairs of Wengön Monastery in the year 1645, along with tangkas of the life stories of Tashilhunpo Gyalwa Lozang Döndrup and Khedrup Sangye Yeshe in 1647. He also painted murals in temples of the Potala Palace.

(4) The Khyentse painting lineage

Tulku Khyentse Chenmo was the second main disciple of Dolpa Tashi Gyalpo. He was born in Gongkar Gangtö (the year is unknown) and was a very talented apprentice, adapting what he learned into a unique style of his own. His style is considered particularly suitable for depicting the wrathful deities and Menla Döndrup's for the peaceful deities.

The Karma Gadri painting tradition will be discussed later, as it is the tradition emphasized in this book. Chronologically, the painting traditions in Tibet, not counting the first Nepali tradition, evolved in this order: (1) Menri, (2) Khyentse, (3) Chiu Kangpa, (4) Karma Gadri, and (5) New

Menri. These are the five main Tibetan painting traditions (or four if you count the two Menri traditions as one), although there were also many other stylistic variations and traditions.

(5) Significant figures in Tibetan art from the 1500s to 1700s

Some of the most significant figures in Tibetan art from the 1500s to the 1700s—both Tibetan artists and sponsors of art—are recounted here, but this list should not be considered comprehensive.

One of the major figures in the history of Tibetan art was Druk Kunkhyen Pema Karpo, the great master of the Drukpa Kagyu, born in 1527. He was learned in all of the five sciences, was a skilled artist, and authored a number of art treatises, such as *An Analysis of Metals* on metal statue making and *An Explanation on Deity Painting That Is Meaningful to Behold*.

The second Gungru Khandro, Lozang Chödrön, was born in central Tibet during the sixteenth century. At a young age she was recognized as the second incarnation of Queen Wencheng, the Chinese queen of King Songtsen Gampo. When she went to eastern Tibet to a Gelukpa monastery called Shelgön, a teacher named Chuzang Lozang Tenpai Gyaltsen asked her to help fulfill the wish of many sponsors to make a large statue of Tsongkhapa. She constructed the statue from cast metal, though the upper part manifested spontaneously. She also made many small statues. Although Lozang Chödrön is the only well-known female artist in Tibetan historical accounts, of course many other female adepts embodying all the qualities of realization, such as Khandro Yeshe Tsogyal, wrote books and made art objects. As the histories even of famous art masters such as Dolpa Tashi Gyalpo have been lost, many of these lesser-known histories are also, sadly, hard to find.

Desi Sangye Gyatso, one of the great teachers in the history of Tibet, was born in 1653. He visited the fifth Dalai Lama for the first time when he was eight years old. At sixteen he was instructed by the fifth Dalai Lama in the five sciences. At twenty-three he became the Dalai Lama's attendant until, at the age of twenty-seven, the Dalai Lama gave him responsibility for the Tibetan government. This was when he commissioned the construction of the Potala Palace, one of the most famous architectural structures in the world. The Dalai Lama passed away when Desi Sangye Gyatso was thirty years old, at which time he assumed complete political responsibility, and when he was thirty-one he began writing treatises esteemed for their clarity and profundity in all fields of learning.

The master artist of the Potala was Uchen Tenzin Norbu. Under him were eight foremen and two hundred painters. The artisans employed to build the Potala included 180 stonemasons, 160 carpenters, 256 wood-carvers, 35 sculptors, and many metalworkers, leatherworkers, and other kinds of artisans. The total number of builders came to 5,500, with a grand total of 6,743 workers on the palace. Seven artists were hired from China, 170 from Nepal, and 10 from Mongolia. Desi Sangye Gyatso commissioned sixty-five tangkas depicting the fifth Dalai Lama's life story and forty-six depicting his secret life story. He also commissioned one hundred gold tangkas and the printing of the Kangyur, the Tengyur, medical tantras, and 615 volumes of Tsongkhapa's books. Having written twenty books on the five sciences himself, he also commissioned and oversaw the painting of sixty-two medical tangkas, which he offered during the Dalai Lama's enthronement, and then he produced a further eighty medical tangkas. Although Desi Sangye Gyatso was only in his fifties when he died at the hands of a murderer, he had already offered all the books he had commissioned and written to the sixth Dalai Lama on the occasion of his enthronement.

Minling Lochen Dharmashri (1654–1717) was one of the great scholars of the Nyingma school and the younger brother of the *tertön* Terdak Lingpa, founder of Mindroling Monastery, from whom he received the refuge vow and novice ordination at a young age. He later took the *bhikshu* vows with the fifth Dalai Lama and became a great translator, learned in poetry and astrology. He learned the Nyingma lama dances and all the ritual arts. He is also famed as an artist because of the clarity with which he painted many of the mandalas and deities and was responsible for a number of the paintings on the walls of Mindroling Monastery.

Deumar Geshe Tenzin Puntsok was born in the eighteenth century, in the twelfth rapjung—a possible date would be about 1725, as he was one of the eighth Situ Rinpoche's teachers. At the age of eight he was already learned in medicine and other sciences, earning him the title of Deumar Panchen, and he became a very famous master of the Drukpa Kagyu lineage.' In Gojo Serkha in Kham he built the Dakpo Kagyu monastery Deumar Zapgye Chöling. He then went to Derge Lhatok, but the king of Lhatok tried to destroy his virtuous works by burning his books and so on. Weary of this, he left on a pilgrimage to India. When he returned, he went to Lhasa and stayed at Sera Monastery, where he wrote many books and translated a number of Sanskrit teachings and books on art, medicine, and astrology. In particular he authored a book on tangka painting and hundreds of medical

volumes, though most are now lost. A great artist, he had many disciples, including the great Situ Panchen and other high lamas.

This concludes the general section of art history, and now begins the history of the Karma Gadri painting lineage.

ii. The Karma Gadri painting tradition

The Karma Gadri tradition originated from the artistic experimentations of the eighth Karmapa, Mikyö Dorje (1507–1554), who was one of the most renowned of the Karmapas, a great meditation master as well as a prolific and learned scholar. Passionate about the arts, and himself an artistic visionary, he always encouraged his disciples to learn painting and other artistic traditions and rejoiced in this activity. He strongly encouraged the propagation of the various artistic traditions at his monastery at Tsurpu, although the name Karma Gadri (*gar bris*) came from the Karmapa encampments (*gar* means "encampment") set up when Mikyö Dorje and his entourage had to travel. This painting tradition, along with all the other arts, was also strongly maintained in a place called Karshöma, also in eastern Tibet, which is why the tradition is also known as Karshöma. Because the source of the painting traditions at Tsurpu and Karshöma is from the eighth Karmapa, they are both purely Tibetan traditions. Mikyö Dorje authored the great book on art entitled the *Great Sun Art Manual,* which was very helpful for future artists.

The source of Tibetan tangka painting in general is the Buddhist doctrine, so tangka painting always depicts sacred subjects and images. Therefore, artists in these traditions must be sure to follow the criteria as outlined in the original texts of the Buddha or as they have been adapted by authentic realized masters. It follows that one who practices the supreme arts should ideally be very learned in the dharma. Because of the sanctity of the origin of the deities' measurements and proportions, any adjustments or alterations to the tradition can be decided only by someone with great knowledge of the underlying profound meaning, which is why the traditions must be adhered to. Those who initiated and adapted the traditions were highly realized and learned Buddhist masters, so anyone who would like to train in this tradition should understand that it is not appropriate to change the traditions according to their fancy. If artists follow the traditions as outlined, no major mistakes will be made.

The Karma Gadri tradition ultimately originates from Menla Döndrup, the founder of Menri. The criteria he set down should be followed, as he was

the first Tibetan artist to outline a uniquely Tibetan tradition. An incarnation of Manjushri, he was the first to compile the supreme art teachings translated directly into Tibetan from the original Indian Buddhist texts. Because he translated them into Tibetan flawlessly, his work is hailed as the beginning of Tibetan art. Any artist from Tibetan art traditions must acknowledge the source of his or her lineage. For example, Tulku Leu Chung's disciple Tulku Chiu came before Menla Döndrup but is placed after him in most traditional historical accounts because Menla Döndrup is the first artist of a purely Tibetan tradition, and thus all other art traditions are counted after him. This also proves the importance of acknowledging him as the founder of all Tibetan painting traditions. Some people think, however, that if they acknowledge him in this way, then they are losing their unique lineages, but this is a small-minded attitude. Mentangpa himself drew from Nepalese and Indian traditions, while developing his style into something unique. It is the same as saying that all four schools of Tibetan Buddhism, although different, derive from Buddha Shakyamuni. Similarly, all the Tibetan tangka traditions originate from Menla Döndrup, and he should be appreciated accordingly. It is correct to call this a purely Tibetan tradition because, although the Tibetan traditions follow the guidelines and measurements of the Indian Buddhist texts exactly, these texts were nevertheless translated by a Tibetan native and adapted clearly and carefully into a distinctly Tibetan tradition. So, from this common source of Menla Döndrup evolved the Menri, Mensar, Tsangdri, Karma Gadri, and so on, which were all also distinctly Tibetan painting traditions.

Some authors attribute the origins of the Karma Gadri tradition to Queen Wencheng, the Chinese queen of King Songtsen Gampo, which would mean that the Gadri originates from a Chinese tradition. Although it drew influence from Chinese artistic traditions, the Karma Gadri painting does not ultimately originate from a Chinese tradition because it derived from the experimentations of the eighth Karmapa and from Yardo Tulku Namkha Tashi, who first learned Old Menri from E region and subsequently started the Karma Gadri tradition. He is acknowledged as the originator of the Karma Gadri tradition in all the authoritative texts, and he himself was trained in the Menri tradition, which is said to be the source of all subsequent Tibetan painting traditions. Therefore, although it has some stylistic influence drawn from Chinese painting, the Karma Gadri is a uniquely Tibetan painting tradition. This view is confirmed by Jamgön Kongtrul Rinpoche, who said that the first art lineage in Tibet was Nepalese

and after this came the lineages from Mentangpa, Khyentse, Chiu Kangpa, and the Three Tashis, which refers to the Karma Gadri painting lineage, as explained in the next section. Many other smaller traditions also evolved over this period.

(1) The Three Tashis

The Karma Gadri painting tradition was further expanded in the late 1600s or early 1700s through the experimentations of a disciple of the eighth Karmapa named Yardo Tulku Namkha Tashi. He is considered to be a manifestation of the eighth Karmapa, who said that Tulku Namkha Tashi was his art emanation. Born in Yardo, he followed many teachers and became very learned in the five sciences. He went to E and studied with Queen Wencheng's emanation, named Könchok Pende, who taught him the style of the Old Menri tradition. After this, the eighth Karmapa went to Beijing and brought back an embroidered tangka depicting his journey back to Tsurpu Monastery. When Namkha Tashi saw this beautiful embroidery, he had a memory of his previous life as a Chinese artist, and from that time started to change his painting style. Zhamar Könchok Yenlak and Gyaltsap Drakpa Döndrup also gave him the idea to change the landscape features in his paintings to a slightly Chinese style. But he kept the deities' bodies exactly as he had learned from the Old Menri tradition. Thus he founded the Karma Gadri lineage, which continues to this day.

Next was Chö Tashi, a great artist who studied, improved, and propagated the Karma Gadri tradition. Karshö Karma Tashi, also a great artist from the Gadri tradition, developed and propagated this lineage in the place named Karshöma. These three artists, the three great founding teachers of the Karma Gadri tradition, thus became known as the Three Tashis.

(2) Famed masters of the Karma Gadri tradition

One of the great artists of the Karma Gadri tradition was Dakpo Gopai Zhalngo, who was prophesied by the eighth Karmapa. He and Karma Rinchen became great sculptors, but their sculpture lineage no longer exists.

In 1604 the great tenth Karmapa, Chöying Dorje was born. He first learned Menri in Lhodrak Chukhyer from Tulku Tsering. Later he saw the Chinese tangka depicting the sixteen arhats known as the *Sitang Yerpa Rawa,* which he copied and then later replicated many times. From that he learned more about Chinese landscape and followed the Karma Gadri tradition but adapted it to his own technique, thus starting his own style of

painting. He was a great master and proclaimed that he was the greatest artist in the world, sent by Avalokiteshvara to create art and poetry. He wrote the *Radiant Victorious Sun Art Manual* and the *Detailed Explanation on Deity Painting, Which by Merely Being Seen Brings Success*.

Situ Panchen, Chökyi Jungne (1700–1774), the eighth Tai Situ Rinpoche, was born in Derge in eastern Tibet. One of the greatest masters of the Kagyu school, he was probably the most famous artist in the history of the Karma Gadri painting tradition. At five years old he already knew how to read and write. At the age of seven, he was given the name Situ Chökyi Jungne by the eighth Zhamarpa. He studied the five sciences thoroughly under the tutelage of Deumar Geshe Tenzin Puntsok and became one of the most famous and learned masters of the Karma Kagyu lineage, his name resounding as far as China, India, Nepal, and Mongolia. In 1727 he started to build Palpung Monastery, and when it was completed, he designed and oversaw all the interior murals. He wrote thirteen books, many on astrology and medicine, and notably commissioned and painted many tangkas, improving the Karma Gadri lineage and making it renowned in the world. He painted about forty tangkas depicting the tales of the past lives of Buddha Shakyamuni, as well as the Karma Kagyu lineage masters. These tangkas and his other artworks in the Karma Gadri style are famed around the world and held up as some of the greatest artworks this lineage has produced. He improved the lineage by closely investigating all the other Tibetan painting traditions and incorporating the best features from each in the original Karma Gadri tradition. One of his disciples, among many other high lamas, was the thirteenth Karmapa.

iii. The artistic activity of some of the Rimey masters of the 1800s

Jamyang Khyentse Wangpo (1820–1892) was a renowned teacher, scholar, and tertön of nineteenth-century Tibet, a leading figure in the nonsectarian movement known as Rimey. He was an emanation of Vimalamitra and King Trisong Deutsen, and from the time he was born he was protected by Six-Armed Mahakala and Ekajati. At a young age he showed exceptional brilliance, needing to read something only once to remember it and comprehend its profound meaning; he was truly incomparable. At the age of twenty-one he received full ordination from Minling Khenchen Rigdzin Zangpo at Mindroling Monastery. All in all he had more than 150 teachers from all four schools of Tibetan Buddhism, including Minling Trichen Gyurme Sangye Kunga, Shechen Gyurme Tutop Namgyal,

Sakyapa Dorje Rinchen, and the Khenpo brothers of Tartse, Ngorpa Tartse Khenpo Jampa Kunga Tendzin (1776–1862) and Tartse Pönlop Naljor Jampal Zangpo (1789–1864). He was knowledgeable in all five sciences, including art and Sanskrit. Receiving empowerments, oral transmissions, and commentaries from more than seven hundred volumes in thirteen years, he initiated a strong spirit of nonsectarianism and respect for all the traditions of Tibet.

Through his brilliance and diligence, Jamyang Khyentse Wangpo was able to follow perfectly the different views and activities of each of the four schools and achieve the realization of each. Building many statues and stupas as well as thirteen temples, he also authored many treatises, noting in his writings the details of deity measurements and how to build stupas. He also wrote fifteen volumes on art, medicine, and other subjects, including *An Instruction Manual for the Painting of Tangkas, Tsakli, Calligraphy, and So On, Covering the Entire Teaching of the Snowy Land.*

His writings are clear, concise, and neither too short nor too long. Among his disciples from all four schools, Jamgön Kongtrul Lodrö Taye and Chokgyur Dechen Lingpa were special, as they had a mutual teacher and student relationship with each other, and the three of them were major treasure revealers (tertön). They were so closely linked in their vast dharma activity that they became known in Tibet as Khyen-Kong-Chok-Sum meaning "Khyen(tse), Kong(trul), Chok(ling), the Three." Khyentse and Kongtrul in particular became known for their strong adherence to the Rimey or nonsectarian movement. After Jamyang Khyentse Wangpo passed away at the age of seventy-three, five emanations have continued in a lineage of incarnations still working strongly for the Buddhist doctrine today.

The coming of the first Jamgön Kongtrul Lodrö Taye (1813–1899) was prophesied in the *King of Concentrations Sutra.* He was born in Kham in the year of the Water Bird, at sunrise on the tenth day of the tenth month. When he was young he understood every text at first reading and even at the age of ten was already very learned in art and medicine. Later he also became highly proficient in the five sciences. In his early life, his main teacher was Shechen Gyurme Tutop Namgyal, under whom he became a brilliant scholar. Later his root gurus were the ninth Situ, Pema Nyinje Wangpo Rinpoche and Jamyang Khyentse Wangpo, although he had a total of more than fifty teachers. Learning from all schools and lineages, he compiled five collections of teachings from the different schools, known as the Five Treasuries. This was the first time in Tibetan history that such a col-

lection had been attempted. He cared very much about supporting the arts, writing clear compositions about the sacred arts. In particular his great text the *Treasury of Knowledge* includes numerous teachings on art. Many great masters, all themselves noted teachers, were his disciples—among them were the fourteenth Karmapa, the twelfth Situ Rinpoche, and Mipham Rinpoche. He passed away at the age of eighty-seven.

Jamgön Ju Mipham, or Mipham Jamyang Namgyal Gyatso (1846–1912), also known as Mipham the Great, was a master of the Nyingma lineage and one of the leading figures in the Rimey movement in Tibet. Mipham was born to an aristocratic family in the Derge principality of Kham. His first guru was his uncle, Lama Pema Dargye, who named him Mipham Gyatso. He was recognized as an exceptional child at a young age, memorizing texts as early as age six. By the age of ten he had already composed many texts. At twelve, as an ordinary monk, he entered Shechen Monastery, which is a branch monastery of the great Nyingma seat of the Okmin Urgyen Mindroling lineage.

He is said to have completely mastered the very difficult Mindroling system of chanting at fifteen or sixteen, after only a few days of studying and praying to Manjushri. In an eighteen-month retreat he accomplished the form of Manjushri known as Mawai Senge using a liturgy composed by the fifteenth Karmapa, Khakhyap Dorje. He made many medicinal pills blessed with Manjushri's mantra, and many miraculous signs were said to have manifested. After this, it was said that he could accomplish any sutra or tantra without any effort, and no text was unknown to him. He went to many lamas to obtain the necessary oral transmissions, but he needed no study or teachings for any texts. He was a special disciple of Jamyang Khyentse Wangpo, with whom he had been connected over many lifetimes, and also followed Jamgön Kongtrul Lodrö Taye. Just before passing away, Jamyang Khyentse Wangpo handed over the responsibility of his teachings and lineage to Mipham Rinpoche by symbolically giving him his hat. He instructed Mipham Rinpoche to especially take care of the Nyingma tradition. Mipham Rinpoche wrote thirty-two books without having to do any research—all five sciences were included. When he was sixty-seven years old, Rinpoche said that he was going to pass into the northern land of Shambhala and would not reincarnate in this world again.

These great teachers are mentioned because they were so helpful in developing and propagating the supreme arts. It is very beneficial to study their life stories. In particular, Jamgön Kongtrul Rinpoche was an accomplished

artist of the Karma Gadri tradition. Previously all the great masters studied the supreme arts, so it was not necessary to include instructions on the general Buddhist preliminaries when teaching art. However, in this time of the degeneration of the Buddhist doctrine, a teacher such as I—a mere ox—is explaining this, as I have learned this great supreme art but cannot understand its deeper meaning without such preliminary teachings.

This completes the section on the origins of art in the world, which also concludes the preliminary teachings, corresponding to the first noble principle.

PART TWO

The Main Teachings

In accordance with the three noble principles that provide the basis for our practice and the structure for these teachings (the preliminaries, the main practice, and the concluding dedication), this section corresponds to the second noble principle. It is divided into three broad subsections: (1) guidelines for the artist and patron of supreme art, (2) visualization of the mandala and deities, and (3) measurements for the mandala and deities.

I. Guidelines for the Artist and Patron of Supreme Art

T HERE ARE TWO sections: general guidelines and specific guidelines.

A. General Guidelines for the Artist and Patron

Here the diligent and enthusiastic artist and the noble patron of supreme art will be discussed. For art to be considered truly supreme, the artist and patron must (1) have devotion to the Three Jewels, (2) have taken refuge in the Three Jewels, and (3) generate bodhichitta.

It is important for both the artist and patron to understand that the primary purpose of depicting the physical, vocal, and mental symbols of the Buddha[1] is to accumulate merit for oneself and all sentient beings. This is the real significance of creating or sponsoring a supreme art object. If this is understood, the patron will make offerings to the artist with a faithful mind and a joyful heart, and the artist will also undertake the artwork joyfully, seriously, and with devotion. Such an artist has properly earned the title *lhadripa,* which is the title used for tangka painters, literally meaning "one who draws deities." Ngawang Kunga Tenzin[2] said that to see merely a part of the Buddha's body requires a vast accumulation of virtue; therefore, artists produce their work with a sense of great appreciation in their ability to accurately depict the Buddha's body according to the texts. He also said that the magical supreme arts help meet the needs of sentient beings, so anyone who has the rare and precious opportunity to practice the arts is very fortunate. This kind of opportunity occurs only because of a great accumulation of merit in previous lives. Therefore, the artist needs to maintain the proper attitude and conduct while creating an artwork, as it is a skillful means that will definitely lead to enlightenment.

The *Sutra That Gathers All Intentions* explains that the twelve links of

dependent origination propel this endless wheel of samsara. Supreme art provides us with a refuge that frees us from samsara, as statues and other supreme art objects are manifestations of the three kayas, emanated from the altruistic wish to put an end to this suffering.

Deumar Geshe Tenzin Puntsok said that one who practices the supreme arts is a nirmanakaya emanation. There are three categories of nirmanakaya emanation: (1) art emanations, (2) birth or incarnated emanations, and (3) supreme emanations. These three are all emanations of enlightenment. Art emanations are supreme artworks such as statues and tangkas and the artists who make them for the benefit of beings. Birth emanations take the form of monastics, hunters, prostitutes, animals, blacksmiths, officials, and so on, for the benefit of sentient beings. Supreme emanations return to samsara and fulfill the twelve deeds that all buddhas perform to bring others to enlightenment. All three types of nirmanakaya emanation appear for the sake of sentient beings and endeavor with skillful means to help them attain enlightenment.

The *Ornament of Mahayana Sutras* says of the three types of nirmanakaya emanation:

> Whether as artisans, incarnations, or supreme emanations, these nirmanakaya manifestations are the great means through which the ways of nirvana are continually shown.[3]

This means that anyone practicing the supreme arts, whether ordained or not, is not living an ordinary worldly life; in their previous lives they must have accumulated a great deal of positive karma. Such a person will quickly attain enlightenment in future lives. In this way, supreme art is practiced for the accumulation of merit and to purify negativity. So anyone with a sincere interest in practicing the buddha dharma is encouraged to learn supreme art.

Conversely, if an artist instead practices supreme art to accrue wealth, praise, or fame, or for any other worldly reason, it is a great downfall and a source of negative karma. Therefore, it is important to understand what to adopt and what to abandon. If the supreme arts are practiced or sponsored enthusiastically with this understanding, then the creation of stupas, statues, tangkas, books, and other art objects, along with accumulating merit and purifying negativities, will most definitely lead to complete enlightenment.

In this day and age, the teachings of the holy doctrine are rare to find, while false views are widespread. People think only about material gain,

and Buddhist religious articles, especially statues, stupas, and books, are sold for commercial purpose. This is a cause for great sorrow. For example, if we tried to sell a human being, everyone would cry out, "Shame!" and yet if we sell our refuge, the statues of the buddhas and bodhisattvas, people think it is astute and sound business. This is because they have completely forgotten the teachings of the Buddha, especially those on karma, cause, and effect. Patrons commission art images of buddhas and religious symbols for business and profit, and artists likewise produce these artworks simply for financial gain. In this way, the meaning of supreme art is really being lost because both the patron and the artist consider material gain to be more important than the refuge. In his *Aspiration for Rebirth in Sukhavati,* Karma Chakme said that if we compare the downfall of killing a sentient being in the three realms of samsara with that of slandering a bodhisattva, the latter is worse. Similarly, [for us Buddhists] negative actions arise from a lack of devotion toward the Buddha. Without this devotion, any sense of respect and delight in sacred art will be lost; our art will lose its sanctity and will become a crass, worldly support—with supreme art being sold, bartered, and used for social advancement.

In his *Treasury of Knowledge,* Jamgön Kongtrul said that it is fine to sell Buddhist statues, texts, stupas, and so on, for a fair price, but too often these days supreme art objects are sold in the same way that countries trade—for big profit or as a tool for bargaining. It is wrong to sell supreme art objects in this manner.

People therefore need to strengthen their devotion and protect the supreme arts by guiding others in their devotion to the Buddhist doctrine. If we have faith in the Three Jewels and help others develop faith, then the proper meaning of the patronage and practice of the supreme arts will not be lost. Please understand this and keep it in mind.

B. Specific Guidelines for the Artist and Patron

In his *Treasury of Knowledge,* Jamgön Kongtrul Rinpoche[4] says that artists of deity drawing should be intelligent, keep clean, and take precepts. They must have received Vajrayana empowerments and keep the samayas, as well as practice rituals to bless their art tools.

1. The conduct of the patron of supreme art

Whereas the activity is most important for the artist, the attitude of mind is paramount for the patron. There are three parts in this section: (1) what to abandon, (2) what to adopt, and (3) the precepts of the patron.

a. What to abandon

In his book on iconometry titled *Source of All Qualities: A Manual for Depicting Various Buddhist Representations,* Tsamo Rongpa Sönam Özer says:

> He does not avoid negative deeds or hold sacred art in esteem, rather endeavoring for this life's gain and renown. Short of temper and regretful of past virtue, shunning practice when effort is involved, ignorant of the dharma, he spends time in constant disparagement of the artist and his artwork.[5]

Anyone patronizing the supreme arts must abandon all traces of these traits.

b. What to adopt

Tsamo Rongpa Sönam Özer says of the proper attitude of the excellent patron:

> One who is faithful, reverential, and makes an effort;
> Compassionate and generous, delighting in virtuous deeds,
> Good-natured, stable, and not whimsical,
> The patron is respectful of the artist and his work.

Also:

> With a pure, radiant body of unceasing noble aspiration,
> Adorned with ornaments of modesty and decency,
> Clad in sincere faith and magnanimity,
> The patron presents a wealth of offerings to the deity and artist as
> inseparable.

c. The precepts of the patron

The *Tantra of Supreme Placement* says that the excellent patron's commitment to fulfill the artist's requirements has the power to bless the artwork. Therefore, when commissioning an artwork, the patron should ensure that the artist's needs are met. The *Unshakable Tantra* says that to commission a tangka properly, the patron should offer the artists whatever they require, within her means. Likewise, many tantras say that the main commitment of the patron is to endeavor to satisfy the artist's needs. If someone commis-

sions a beautiful tangka or statue only for worldly reasons and, when paying for the artwork, haggles and argues with the artist, it is the same as if she were displeasing or disrespecting the deity of the statue or tangka. Therefore, patrons should endeavor to please the artist, respecting and paying homage in the same way they would a guru.

2. The conduct of the artist

Three points cover the conduct of the artist: (1) what to abandon, (2) what to adopt, and (3) the precepts of the artist.

a. What to abandon

In *Source of All Qualities,* Tsamo Rongpa Sönam Özer says that someone who is unintelligent, easily distracted from his work, and unable to maintain harmonious relationships does not have a suitable character to practice supreme art. Heavy drinking, covetousness, dissatisfaction with offerings received, being proud and egotistical, and putting an exorbitant price on the artwork while being miserly with the materials used are all considered faults for an artist.

Whatever material gain and worldly renown an artist with these faults receives is simply a cause for great downfall, and his faults will also affect the devotion of the patron. It is similar to placing obstacles in another's path of virtue and is thus a cause for rebirth in the three lower realms. It is better not to develop a professional relationship with this kind of artist. An artist who has such tendencies should confess and fully abandon all traces of them.

b. What to adopt

The *Chakrasamvara Tantra* says that the superior artist is someone who has a gentle nature, is skilled in art, and engages in dharma practice. Similarly, *Dharma Activities* says that the artist is well studied, has a good hand, knows how to mix colors and prepare the basic materials, is knowledgeable in many different disciplines, is devoted to the doctrine, and does not put a price on her artwork. One who has all six of these qualities can be called *lhadripa,* or artist of deity drawing.

The *Exposition Tantra of the Two Segments* says that the artist should be humble, devoted, and youthful, with sharp sense faculties and mental clarity. Not lost in conceptualization or easily angered, she is honest and upright. Knowledgeable, she is compassionate, eager to engage in virtuous activities, and patient in the face of difficulties.

Likewise, Shechen Rabjam III, Rigdzin Paljor Gyatso, says that an artist should not be covetous but be content with whatever the patron offers. Intelligent, good-natured, and humble, he listens to the patron's requirements and endeavors to fulfill them. Respectful of the deities and with good conduct, a person with these qualities has the proper character to be an artist of deities. The *Root Tantra of Manjushri* also notes that artists need to be learned in their field as well as skilled in drawing and in the mixing and application of colors so that their artwork is both clear and attractive.

c. The precepts of the artist

The *Unshakable Tantra* says that artists should always be clean, washing daily. Ideally they are of a high caste such as Brahmin and have taken the bhikshu vows or novice ordination. For ordinary lay practitioners, the minimum requirement is to have taken the refuge vow and to take one-day vows on special days.

The famed eighteenth-century artist and scholar Deumar Geshe Tenzin Puntsok explained in his *Clear Explanation on Pigments [Entitled] Luminous Flower Radiating 100,000 Rainbows* that in order to fulfill the aim of furthering the doctrine and benefiting sentient beings, the artist needs to possess the following attributes: having the good fortune of being a Vajrayana practitioner, being both knowledgeable and experienced in dharma practice, always keeping the gurus of the three times in mind, and properly executing the deities' proportions.

This covers the basic qualifications of the artist. More specifically, on the path of the Vajrayana, the artist receives the four empowerments and keeps the sacred precepts while practicing the development and completion phases.

Next there are two sections: the downfall of not receiving empowerments and the benefits of receiving empowerments.

i. The downfall of not receiving empowerments

If one has not received the proper Vajrayana empowerment, engaging in sadhana practice will not lead to any accomplishments or blessings. It would be like trying to extract oil by pressing sand. The empowerments bestow the authority to do the sadhana practices. Without them, however diligent we may be in our endeavor to teach, listen to teachings, practice meditation, and so on, the only outcome will be to fall to the lower realms. In this way it

should be clearly understood how harmful it is to practice sadhanas without having received the appropriate empowerment.

ii. The benefits of receiving empowerments

An artist or person who receives a Vajrayana empowerment and puts it into practice is a son or daughter of the noble family of bodhisattvas. This person is authorized to view the mandalas, the blessing of which purifies obscurations and brings him to the bodhisattva path, so that he will always be reborn in the higher realms. After seven lifetimes the tenth bodhisattva level can be reached.

The door to the Vajrayana is the receiving of empowerments. To become free from samsara, it is necessary to practice the development and completion stages of the practice, and the companion of these two is the samaya. These three comprise the main path of the Vajrayana: (1) the empowerment is the preparation for the path; (2) the development and completion practices lead us out of samsara; and (3) the samaya purifies these. It is important to listen to this advice, understand it well, and practice mind training. When all concepts are dispelled, our buddha nature can be recognized and the awakened qualities revealed. Before practicing or depicting deities or mandalas of the outer or inner tantras, it is necessary to first receive the empowerment and then follow the samayas and the practices accordingly. It is important for the artist to practice at least one deity sadhana every day.

In his *Treasury of Knowledge,*[6] Jamgön Kongtrul says that before depicting the outer tantra deities, the artist should observe the one-day vows and perform ablutions. To depict the deities of the inner tantras, the artist should receive the empowerment, keep the samayas, and be engaged in deity yoga practice in secret, making the relevant offering tormas and other ritual materials. The artist also needs to practice self-visualization as Vairochana or Vighnantaka and consider the art tools as Vairochana.[7] Before the measurement lines of a mandala are made, the strings should be blessed according to the appropriate ritual from the mandala. Similarly, calligraphers should visualize themselves as Amitabha and consecrate the pens and ink in the same way as for a *mala* (rosary). These are important preliminaries before first commencing an artwork.

As *Tantra of the Emergence of Chakrasamvara* states, when the deities are drawn properly, the peaceful deities should appear very peaceful, beautiful, and kind, with a smiling radiance and attractive shape. The wrathful deities should appear frightening and powerful.

A yogi needs an image as a support for her visualization, and the tangkas assist us in receiving accomplishments more easily. If the artist cannot visualize the full entourage as it is described in the main practice of a sadhana, she should first concentrate on visualizing the main deity only, but even that will be impossible without referring to an image. So any serious practitioner must have a tangka of the deity as a support. Therefore, depicting the deities beautifully and according to the tenets is a source of great merit. Jamyang Khyentse Wangpo quoted many similar statements from the tantras emphasizing the importance of art practice to receive the siddhis.

Practicing a sadhana while properly depicting its deity is said to accumulate more merit than painting many buddhas. The *Root Tantra of Manjushri* says that painting a tangka, whether elaborate or not, has great benefit. The *Vinaya Pitaka* says that the best offering is the use of gold, silver, and precious pigment, whether for painting or calligraphy. A mediocre offering is color pigment, and ink is the lowest offering. Whatever materials are used, the most important thing is to try to draw the deities clearly, correctly, and beautifully.

It is also important for the patron and artist to understand what to adopt and what to avoid. Our attitude or way of thinking is most important in determining the quality of our actions. Both the patron and artist need to learn the practice of a bodhisattva and generate bodhichitta, the wish to enlighten all sentient beings. This training is what brings all ultimate and relative benefit.

II. The Stages of Visualization

THESE TEACHINGS mostly come from Kunkhyen Tenpe Nyima's *Compendium of Oral Instructions: General Notes on the Rituals of the Development Stage* and Shechen Gyaltsap Pema Namgyal's *Illuminating Jewel Mirror: A Brief, Clear, and Comprehensible Overview of the Development Stage.*[8] There are two parts: the preliminaries to visualization practice and the main practice, which consists of the development and completion stages; however, this text emphasizes the development stage. The complete texts should be referred to, under the guidance of a teacher, for a full overview of these practices.

A. The Preliminaries to Visualization Practice

The preliminary teachings have two parts: (1) establishing the ground for visualization practice and (2) preliminary preparations.

1. Establishing the ground for visualization practice

Before we embark on the path of Vajrayana practice, it is crucial to have a firm grasp of the ground from which to understand these teachings and practices. To begin with, a genuine dharma practitioner needs to develop renunciation of worldly life by contemplating the suffering of samsara and the benefit of leading a spiritual life. It is necessary to seek and follow an authentic guru from whom we can receive teachings, especially the teachings on the four thoughts that change the mind, as mentioned in the preliminary teachings. Contemplate these until they become inseparable from your mind. Then the refuge vows are taken as our basis, which is the cause. The practice of bodhichitta is the condition to guide our lives in the right direction. The companion of these two is the accumulation of merit through such practices as recitation of the seven-branch prayer, which we should try to do as much as possible.

The skillful means that increases the power of these three is visualization: the development and completion stages which, when practiced as a unity, constitute the accumulation of wisdom. The inner meaning of the main practice is to do the development and completion stages without a reference point. This, combined with the correct measurement of the deity, produces the cause for both oneself and others to attain enlightenment. Combining these practices with our artwork, and then dedicating the benefit to the enlightenment of all sentient beings, is the correct practice of an artist.

In his *Wish-Fulfilling Jewel of Proportions,* Menla Döndrup says:

> In this regard, anyone who wishes to accumulate merit for one-self and others must possess the unsurpassable altruistic intention, the attitude of the Great Vehicle. Here the yogi of great capacity trains in the mind generation of enlightenment for the sake of all sentient beings. It is necessary to abandon arrogance, prejudice, seeing faults in others, and so forth. Instead, strive to uphold the teachings of the Victorious One with body, speech, and mind. The precious images and statues are the objects of support for meditation, so practice the visualization of deities through the development and completion stages to receive the accomplishment. This cannot be achieved without the support of supreme images.[9]

The *Condensed Realization of the Gurus* says:

> Your self-originated and self-perfected radiant form is limitless;
> Possessing the supremely beautiful marks and signs of
> buddhahood,
> You send forth emanations and appear to beings in numerous ways,
> Inspiring their devotion from seeing representations of the
> Conqueror;
> I respectfully prostrate before you.

Deumar Geshe Tenzin Puntsok says:

> The principal methods of relying on the stages of the path are, in the morning, to begin with taking refuge and generating bodhichitta. Invite the deities and do the seven-branch prayer and the supplication and aspirational prayers while meditating on the

meaning, and then strive in your activity with diligence. In the evening, recite the protection and consecration prayers, or you can do the abridged versions of these and conclude by dedicating the merit.

Trengkhawa Lodrö Zangpo's *Treatise on the Fine Arts Entitled "Clear Mirror of the Sutras and Tantras"* says:

> Artists should begin their work with the following preliminary preparations: First, wholeheartedly take refuge in the Three Jewels. Then, bringing to mind all mother sentient beings, for the twofold benefit, generate the supreme altruistic mind of bodhichitta. Contemplate the empty nature of all phenomena in cyclic existence, completely devoid of inherent existence. From within emptiness, like the appearance of a rainbow in the sky, the deity arises, and you are also the deity. Consider the cotton support of the tangka and so forth as Prajnaparamita and the art tools as retinue deities. Make offerings and recite verses of praise and wish-fulfilling prayers. Due to that, light shines from the deities and they dissolve into the tangka cloth, tools, and so on, blessing the artwork.

There are said to be three levels of artist: superior, middling, and lesser. The superior artist is free from conceptualization, abiding in the nonreferential wisdom of the dharmakaya. It is not necessary for such an artist to pay attention to traditional proportions or styles. The artist of middling capacity dwells in emptiness. Because she has no self-grasping, all her activity is for the benefit of others. The artist of lesser capacity attempts to transform the ordinary appearance of phenomena into the pure vision of the deity.

The essence of the deity is emptiness from which appearance, with its various symbolic meanings, manifests. This skillful means of the Vajrayana is not very difficult to practice; we simply need to see ourselves as the deity and transform gross appearance into pure appearance. Although the artist must enter the door of the Vajrayana through empowerments and instructions, that alone is not enough. He needs to follow the instructions properly by taking vows, keeping the samayas, and understanding the significance of the deities being visualized. If the artist trains in this, it will not be so difficult to depict the deity, so it is important to train with concentration on these teachings.

Some people believe that it is unnecessary to practice visualization in daily life and that this practice is only for retreat. This means that they have not properly understood the supreme teachings or the benefit of the three noble principles. The visualization practice utilized in retreat is exactly the same as the visualization that should be practiced by the artist when creating an artwork. When drawing an image, we are basically copying the image from our mind's eye onto the drawing surface, so the clearer our visualization, the better our drawing will be. There are a huge variety of different artistic traditions, and the artists have developed their visualization skills in this way. This is how naturalistic art is made and how the image comes to life and appears vivid and real. However, even the most skillful worldly artist is not creating supreme art. Buddhist practitioners combine their artwork with the view of emptiness and appearance as indivisible. Worldly art practitioners do not train in developing this view, which distinguishes supreme art from worldly art.

Therefore, the visualization of the yogi artist needs to follow the same guidelines as the visualization of the deity in the development phase of practice, which will be discussed in more detail later. It is a mistake to visualize Guru Rinpoche as solid, as if another person had appeared, for this will only increase attachment to appearance. Visualizing a wrathful deity as solid will likewise increase aggression. What we *tsampa* eaters[10] know is that tangka painting is for the accumulation of merit, and the accumulation of merit is for the purpose of enlightenment. If we only increase our attachment and aggression, enlightenment is not possible. The main aim of Buddhist art is to help us out of samsara through the study and practice of deity drawing, and all supreme artwork is for the accumulation of merit. If this accumulation is combined with the view of emptiness, it also becomes the accumulation of wisdom. These two together create the cause for the enlightenment of all sentient beings—this is why we need to learn correct visualization practice through the development and completion stages.

In their art treatises, both Lhodrak Mentangpa and Deumar Geshe spoke about the three noble principles of beginning with the proper motivation, engaging in the main practice in the middle, and concluding with the dedication. Artists today have the proper measurements and histories easily at hand, but to learn about these three noble principles, they must refer to the Buddhist texts. The new generations of art students are often too lazy to look up this information, so this important understanding is being lost. That is why these teachings are given here: to establish the correct understanding of supreme art practice. Enlightenment will be attained through

the practice of the supreme arts with these three principles in mind. Of course measurement, proportion, and design are all important, but these three principles are even more important, so please endeavor to understand their importance and practice them diligently.

2. Preliminary preparations

This section introduces us to the development-stage practice through the four doors of the secret teaching and then outlines the structure of the preliminary practices for most sadhanas. These teachings are not comprehensive, as they refer only to the aspects that are more important for artists. It is necessary to undertake further study of sadhana practice with a teacher.

a. The four doors of the secret teaching

The practice of Vajrayana is entered through what is known as the four doors of the secret teaching. Words are needed to convey meaning, which is the door of words. To awaken the heart of the deity, mantra is recited, which is the door of mantra. The practice of visualization is entered through the door of meditative concentration. To experience the inner meaning, there is the display of actions, signs, mudra, dancing, and music, which is the door of the display of mudra. These four doors are essential when doing sadhana practice.

To elaborate a little: When reading a sadhana, it is important to recite the words clearly, following the proper sequence of the text while concentrating on the meaning. This is done inseparably from the visualization. If you get a bit tired or it becomes difficult, you can recite mantras and rest your mind. You can also chant, make musical offerings, and perform mudras. This is how these four are practiced during sadhana practice.

Jamgön Kongtrul Rinpoche said that in this world, the supreme words are the teachings of Buddha Shakyamuni, which have the power to bless those who read or hear them even if they do not understand what they hear. Sakya Pandita said whether the words are pleasant or unpleasant, whatever the buddhas and bodhisattvas have written has the power to bestow great blessing and should thus be recited as prayers.

b. The common preliminaries

Tenpe Nyima says:

> The path of liberation is rooted in the genuine attitude of renunciation, while the four mind-changings are the method that

engenders this attitude. The path of the Great Vehicle is rooted in the precious mind of awakening, while the four immeasurables are the method that engenders this mindset. When these trainings have transformed your mind and conviction has arisen within you, focus on the practices of going for refuge, generating the mind of awakening, and reciting the seven-branch prayer. In particular concentrate on the meditation and recitation of Vajrasattva to purify the obscurations, on the mandala offering to gather the accumulations, and on guru yoga to receive the guru's blessings. . . .

Imagine a blue HŪṂ syllable in your heart as the essence of the innate, awakened mind. Light radiates out from this syllable, invoking from the natural abode the essence of your root guru in the form of the deity of any class of tantra: the principal figures, the three jewels, the gurus of the lineage, dakinis, and Dharma protectors surrounded by all the objects of refuge without exception. Visualize them all gathered in the space before you, like cloud banks in the sky.

Imagine yourself going for refuge, over and over, together with all sentient beings. Doing so with your body, speech, and mind is the relative act of going for refuge. The ultimate act of going for refuge is to take refuge in the dharma body, the inconceivable true nature of reality in which the objects of refuge are inseparable from your own mind.

Next recite the verses for generating bodhichitta, the mind of awakening. Tenpe Nyima says:

> The relative mind of awakening involves thinking, "I will practice this profound path to establish all sentient beings in the state of complete enlightenment." The ultimate mind of awakening involves resting evenly in the true nature wherein nothing ultimately exists.

After this, recite the seven-branch prayer.

To conclude, dissolve the field of accumulation into yourself and then rest for a moment in the state wherein your minds mingle

inseparably. More elaborately, you can consecrate the vajra, bell, purifying water, and other articles at this point, following the instructions of other texts.[11]

Further details about these common preliminary practices should be learned from other sources.

c. The uncommon preliminaries
i. Expelling obstructors

The elimination of obstructors through offering torma is done at the beginning of every sadhana (sometimes alongside the white torma offering to local field protectors and owners of the land to request supportive activities). This ritual is performed either prior to or just after the refuge and bodhichitta prayers. The term "demon" is understood both literally and metaphorically. Demons can be actual malevolent spirits that intend mischief and harm, but ultimately this refers to the ego demon of our own negativity and dualistic mind.

Tenpe Nyima explains:

> In front of your doorway, place the torma for the obstructing forces adorned with flesh, blood, garlic, onions, and so forth.
>
> With the pride and overwhelming, radiant confidence that comes from visualizing yourself as a wrathful protector deity, such as the heruka Hayagriva, focus on the torma and utter the three syllables. The syllable OM cleanses and purifies all impure defilements. The syllable ĀH multiplies the substance such that it increases and expands infinitely. The syllable HŪM transforms it into sublime sense pleasures that manifest as precisely whatever one desires. Finally the syllable HOH consecrates the torma by transforming it into the nectar of undefiled wisdom.
>
> Next, imagine countless wrathful Takkirajas emanating from your heart center. They are pink in color and have one face and two arms. Brandishing hammers in their right hands and hooks in their left, they summon into your presence all the mischievous spirits, obstructing forces, and elemental spirits, all of whom are powerless to disobey you. Issue your command to these beings, then offer them a torma and send them off to their respective dwellings. Visualize that all those who ignore your command

and set out to make obstacles are, in a single instant, threatened, chased away, and crushed by wrathful weapons and powerful flaming rays. As you imagine all this, recite the verses for expelling obstructing forces from your sadhana, burn some resin incense, throw wrathful mantras and charmed substances, and seal your practice by remaining free of reference point.[12]

ii. Establishing the boundary

Once the obstructors have been expelled, a boundary is established to prevent them from reentering. The establishment of the outer boundary involves placing images or mantras of the four guardian kings at each of the four cardinal directions outside your retreat dwelling or land. This is normally done when doing retreat.

Regarding the inner, visualized boundary, Tenpe Nyima says:

> For the inner boundary, visualize the entire base of the protection dome as a ground composed of vajras and the entire upper part as a vajra dome and canopy. Completely surrounding this, in both the cardinal and intermediate directions, is a vast, spacious and elevated circular vajra fence. The fence is devoid of gaps; instead, every opening is patched with small conjoined vajras that seem melded together. The exterior is covered by a lattice, which is completely bound by crossed-vajra cords. The top of the dome is covered by half-vajra tips and the midsection braced by strings of vajras. The whole dome is blue and is shaped like a helmet. Wisdom fire of five colors radiates out from this dome, spreading in all directions. . . .
>
> Thus, having established a boundary with the protective dome, imagine that all demons and treacherous spirits are prevented from approaching, while you and all those in need of protection are safe inside. As you imagine all this, chant the verses for establishing the boundary. This comprises the inner boundary.

Concerning the secret boundary, *Commentary on the Secret Essence* states:

> Subdue the king of demons, discursive thoughts,
> With the king of boundaries, nonconceptual wisdom.

Within the state of innate luminosity, which has never been tainted by the dualistic delusion of a perceiver and perceived,

seal your practice by seeing the lack of inherent nature of all the demons, obstructing forces, and adventitious conceptual imputations. This constitutes the extraordinary protective dome. Sealing the practice nonconceptually, in this way, establishes the secret boundary.[13]

iii. The shower of blessings

Tenpe Nyima says:

> For the shower of blessings to take place, with fervent devotion visualize yourself as the deity and imagine rays of light emanating from your heart center. Accompany this with specially prepared incense, melodious chanting, and music. In this way, invoke the assembly of deities of the three roots. From the natural expanse imagine all their blessings of wisdom, love, and ability, as well as their spiritual accomplishments, in the form of rays of light, rainbow-hued clouds, flowers, spheres of light, and so forth. Their enlightened bodies appear as divine forms, their enlightened speech as seed syllables, and their enlightened minds as symbolic implements. Imagine that all of these dissolve into you, your dwelling place, and all the ritual articles, endowing you with the nourishing power of glorious, great wisdom.[14]

iv. Consecrating the offering articles

Regarding the consecration of the offering articles, Tenpe Nyima says:

> According to the sutras, the vehicle of characteristics, the actual offerings are consecrated and emanated through the recitation of dharani mantras, knowledge mantras, the power of devotion, and the power of truth. In the mantra vehicle, however, they are consecrated by five practices: going for refuge, deity, mantra, meditative absorption, and mudra. With this in mind, visualize yourself as the deity and imagine the syllables RAM, YAM, and KHAM emanating from your heart center.
>
> Transforming respectively into fire, wind, and water, they incinerate, scatter, and wash away all the impure stains, faults, and defects of believing that the offering articles are real, until nothing remains. From the state of emptiness the syllable BHRŪM then appears and transforms into a vast, open, jewel

vessel. Within this vessel the syllable OM gives rise to the flowers of divine substances and the rest of the five common outer offerings, to the unique inner offerings, including the self-arisen flowers of the five sense faculties, to the wrathful offerings of the charnel grounds, and so forth. Every desirable thing throughout samsara and nirvana is present, without anything missing. Imagine that clouds of countless offering goddesses, each carrying her own individual offering, radiate out from each of these offerings and fill the entirety of space.[15]

v. Blessing the inner offerings: amrita, rakta, and torma

First is blessing the inner offering of amrita. Visualize the letters YAM, RAM, and KHAM, which transform into wind, fire, and a tripod made from three human heads supporting a vast skull cup, which emerges from a syllable ĀH or BHRŪM containing the five meats and five nectars. In the middle is human flesh and excrement. To the east is bull meat and semen. To the south is dog meat and brain. To the west is horse meat and sweat. To the north is elephant meat and urine. Above these offerings visualize the syllables HRĪH and BAM in the middle and to the other four directions HŪM and LAM, TRĀM and MAM, OM and MUM, and ĀH and TĀM. These paired syllables transform into the buddhas of the five directions in union with their consorts. From their point of union white and red bodhichitta nectar flows into the skull cup, filling it. At the conclusion, the deities dissolve into light and into the offering substances. Imagine that this becomes a swirling ocean of wisdom nectar. It foams and sparkles with lights, and from each droplet offering goddesses arise and make offerings to the main deity.

Generally it is said that these five amritas are the same in the new (Sarma) and old (Nyingma) traditions of Tibet, but the five meats are slightly different in the Nyingma tradition, the meats being lion, elephant, horse, peacock, and garuda, and the skull cup is human. In the new traditions the five meats are human, bull, dog, elephant, and horse, as above.

Regarding the offering of rakta (blood), Tenpe Nyima says:

> For the inner offering of rakta, atop the wind, fire, and skull stand described above, visualize a vast, open vessel made from a fresh skull with the hairs still on it. Next, imagine that all the concepts of craving and attachment related to the three realms coalesce within it in the form of blood. In the middle of this swirling blood visualize the rakta goddess Gitima. Red and naked, she

holds a knife and skull cup. From her bhaga a stream of nectar flows down, mingling inseparably with the substances of the skull cup and filling it completely. Finally, the goddess melts into light and dissolves into the articles. This creates surging waves within the ocean of rakta, which is essentially detached great bliss, and causes clouds of sense pleasures to emanate forth.[16]

Torma in this context is a food offering—*tor* means "taking out" (our concepts); *ma* means an offering substance that is sacred, supreme, and powerful. It symbolizes the offering of our concepts. Tenpe Nyima says:

> For the inner offering of torma, visualize a vast, open skull cup or jewel vessel. Within this vessel is a torma made of various foods, a divine nectar endowed with a hundred flavors and an inexhaustible treasure made of a mass of desirable things. Imagine that countless clouds of offering goddesses emanate from the torma, each carrying delightful and appeasing offering articles for all the outer, inner, and secret guests.[17]

These Vajrayana offerings, such as blood and so on, are symbolic representations expressing the nondual nature of absolute reality.

B. The Main Practice

This section consists of (1) the introductory teachings, (2) the development stage, (3) mantra recitation and additional points, (4) dissolving the visualization, (5) the samayas, (6) *A Supreme Liturgy for Artists,* and (7) *A Ritual to Repair Artworks.*

1. Introductory teachings

First the individual classes of tantra are briefly described, followed by an explanation of how the habitual tendencies for the four kinds of birth are purified through deity meditation. Deity meditation, as outlined in the sadhanas and their commentaries, is practiced only after one has received the empowerments, vows, and instructions from a guru or qualified teacher.

a. The individual classes of tantra

There are different methods of visualization in sadhana practices, and these depend on the class of tantra from which a practice comes. In the Nyingma tradition, nine vehicles or yanas are spoken of. The first three consist of the

Shravakayana and the Pratyekabuddhayana associated with the Foundation Vehicle and the Bodhisattvayana of the Greater Vehicle. There are six further divisions corresponding to the three outer and three inner classes of tantras of the Vajrayana, or Diamond Vehicle. The three outer tantras are action or kriya tantra, performance or charya tantra, or upayogatantra; and practice or yoga tantra. The three inner tantras are mahayoga, anuyoga, and atiyoga. Each has its own unique entry point through empowerment, view, meditation, conduct, and result, which need to be properly studied and practiced under the guidance of an authentic master.

Tenpe Nyima says:

> In *Resting in the Nature of Mind,* Longchenpa explains the three outer classes of tantra in the following way:
>
>> In action tantra the practitioner is seen as inferior and the
>> deity as supreme;
>> You receive the spiritual accomplishment of the practice
>> In the manner of a master and a servant.
>> In performance tantra the practitioner and the deity are seen
>> as equals;
>> With the wisdom deity before you as the samaya being,
>> You receive spiritual accomplishment as though from a
>> friend.
>> In practice tantra the two are indivisible during the main
>> practice,
>> Yet in the preparatory and concluding stages they are two, as
>> the deity is invoked and later departs.
>> The spiritual accomplishments are received nondually, like
>> water poured into water.
>
> As outlined here, in action tantra generally the practitioner does not imagine himself as the deity. However, in particular instances, the deity, or wisdom being, is regarded as a king and you, the samaya being, regard yourself as his subject. With this approach you emphasize acts of ritual purity and other outer actions through which you receive the spiritual accomplishments. . . .
>
> In performance tantra the view is the same as in practice tantra while the conduct is the same as in action tantra. Here

you receive the spiritual accomplishments as though you and the deity are siblings or friends. This occurs through a state of equality between you as the practitioner, visualized as the samaya being, and the wisdom deity that you have visualized in front of yourself. . . .

In practice tantra you meditate on yourself as the deity and, by invoking and dissolving the wisdom deity, you and the wisdom deity become indivisible. At the conclusion of performing offerings, praise, and recitations, you receive the spiritual accomplishments and the deity is required to depart.[18]

Tenpe Nyima also says:

The meditations of the three inner classes of tantras are also described in *Resting in the Nature of Mind*:

> *Maha* stresses the energies, the development stage, and
> skillful means.
> *Anu* emphasizes the elements, the completion stage, and
> knowledge.
> *Ati* highlights that everything is nondual wisdom.
> All three practice with the knowledge
> That all phenomena are primordial equality.

In mahayoga the emphasis is on gradually developing the mandala based on the three samadhis, whereby you meditate on the indivisibility of deity and concept. In anuyoga it is held that all phenomena are, by their very nature, indivisible from the three mandalas and that the root mandala of the awakened mind is primordially enlightened. As such, the form of the deity emerges as an expression of the unceasing play of Samantabhadra. *The Magical Key to the Treasury* explains:

> The anuyoga of completion holds that
> The aggregates, elements, and sense sources
> Are not developed, but perfect
> As the mandala of male and female deities.

According to atiyoga the spontaneously present appearances of the Direct Crossing manifest from the primordially pure basic

space of the Thorough Cut as the gathering of divine forms. These forms are the expression of awareness, the natural manifestation of unceasing dependent arising. This accords with the approach of most of the practice manuals in the tradition of the key instructions of the heart essence.[19]

Atiyoga is the highest yana within the classification of nine yanas of the Nyingma school and is synonymous with Dzogchen. It involves the realization that all phenomena are nothing other than the appearances of the naturally arising primordial wisdom, which has always been beyond arising and ceasing. Appearance is described as the male of skillful means and emptiness or wisdom as the female. *Rikpa* (awareness) is the child of these two. The practice of primordial purity reveals the emptiness aspect. The practice of spontaneous presence reveals the apparent aspect. The teachings of atiyoga contain the quintessential pith instruction of the innermost essence.

Mipham Rinpoche's *Commentary on the Scriptures of the Eight Sadhanas* says that during mahayoga all phenomenal appearance is meditated on as the mandala. In the anuyoga, the meditation is on the mandala of the vajra body. In atiyoga, all mandalas are understood as mind.

The *Condensed Realization of the Gurus* also says:

> In terms of ornaments, deities of the outer tantras have jewel
> crowns,
> While in the inner tantras they wear bone ornaments and other
> such things.
> In the outer tantras you offer the three white substances,
> Whereas in the inner tantras the five meats and five nectars are
> offered.
> In the outer tantras you use a jewel vessel,
> While a kapala is used in the inner tantras.
> Tormas, fire offerings, consecration, clay statues, and vase rituals
> Are common to the outer and inner tantras alike.[20]

b. Deity meditation and the four kinds of birth

The four kinds of birth that manifest within samsaric existence are egg birth, womb birth, birth from heat and moisture, and miraculous birth. No other type of birth is possible in cyclic existence. These four kinds of birth are puri-

fied through the different methods of visualization from the three different classes of inner tantra. The mahayoga approach purifies birth from egg and womb. The anuyoga approach purifies birth from heat and moisture, and the atiyoga approach purifies miraculous birth. The development stage of each different class of tantra resembles the particular kind of birth that it purifies.

2. The development stage

There are three divisions: the yoga of the body, which is form; the yoga of speech, which is chanting; and the yoga of mind, which is clarity. Only the first, the mudra of the divine form, is discussed here. The tantras say that to practice the completion stage properly, the yogi must begin with the skillful means of the development stage, generating the visualization of the supportive mandala and supported deities. In his *Lord of Secret's Oral Advice*, Lochen Dharmashri says:

> In brief, impure perception is transformed by meditation on the mandala and supported deities through the development stage, which must be encompassed by three contemplations: All objects of appearance lack true existence, like a magical illusion, which is the visualization like a magician's display. This empty appearance is essentially pure, which is the profound visualization. The mudra of the divine form is the magically emanated visualization.[21]

There are six parts outlined in this section, corresponding to the development stage: (1) the cause, the three samadhis; (2) the fruit, visualizing the mandala support; (3) the three main points; (4) the four stakes that bind the life force; (5) invoking the wisdom beings and requesting them to remain; and (6) homage, offering, and praise.

a. The cause: the three samadhis

The system of explaining the development stage by means of the three samadhis is found in the inner tantras of mahayoga and above. These three should be understood to be different phases of a single meditation practiced throughout the sadhana. The samadhi of suchness is first, followed by the samadhi of total illumination and then the causal samadhi.

i. The samadhi of suchness

At the commencement of the main practice, after reciting the emptiness mantra, rest in the samadhi of suchness. Tenpe Nyima says:

> First, relax your mind and do not chase after any confused thoughts. Then let go for a moment and rest in the simplicity of reality—the state of empty awareness that transcends words and concepts. This is the samadhi of suchness, also known as "the practice of great emptiness," "the vajralike absorption," and "the absorption of emptiness." This samadhi eliminates the extreme of permanence and purifies the habitual tendencies associated with the formless realm. It also purifies the death state into the dharma body. Hence this is classified as the essence of awareness, the inconceivable aspect. In this context, you rest without visualizing the protection dome and the other elements outlined above. However, you must understand that they are not entirely absent either.[22]

Shechen Gyaltsap Rinpoche says:

> The result of purification is the dharma body of enlightenment, a wakefulness that is utterly free of conceptual constructs. The process of purification is the meditation on all phenomena as being empty and devoid of self-entity. Moreover, apart from all phenomena of samsara and nirvana being merely the self-display of mind and wisdom, they do not possess an atom's worth of true existence. Wisdom, moreover, is the true nature of mind and cannot be found elsewhere. Thus, the intricate nature of our minds right now is unconfined wisdom, empty and lucid, the equality that is, by nature, free from any marks of conceptual elaboration.[23]

ii. The samadhi of total illumination

The second phase of meditation, which will be indicated in the next line of the sadhana, is called the samadhi of total illumination. Tenpe Nyima says:

> Out of this state of emptiness, meditate for a brief moment with nonreferential illusory compassion towards all sentient beings

who do not realize their own in-dwelling wisdom. This is the samadhi of total illumination. The practice of illusory compassion is known as "the absorption of the heroic gait" and "the absorption of wishlessness." It eliminates the extreme of nihilism and purifies the habitual tendencies connected to the form realm. It also transforms existence in the intermediate state and perfects it into the enjoyment body. Hence, this samadhi is classified as the radiance of awareness, the aspect of the unobstructed nature of compassion.[24]

Shechen Gyaltsap Rinpoche says:

> The samadhi of total illumination purifies the intermediate state, the view of nihilism, fixation on emptiness, and the form realms. It sets in place, moreover, a link for perfecting the resultant enjoyment body. Finally, it matures you by creating the foundation for great compassion, which is the cause for emerging in the unified, luminous state of the deity.[25]

iii. The causal samadhi

The third is the causal samadhi. Tenpe Nyima says:

> Once compassion has stirred the mind out of this nonconceptual state, the essence of your mind assumes the form of a seed syllable, such as a HŪM or a HRĪḤ, which manifests brilliantly in the unsupported, empty expanse of space. Focusing on such a seed syllable is the causal samadhi, the training in the subtle syllable that is one aspect of the single mudra. The causal samadhi is known as "the illusory absorption" and "the absorption of no characteristics." It purifies the view of a self and the stains of apprehending characteristics. It also purifies the habitual tendencies connected to the desire realm, thereby ripening birth into the emanation body. It is therefore classified as the expression of awareness, the aspect that manifests as objects.[26]

This is the beginning of the development phase of visualizing the deity. Depending on the class of tantra the sadhana belongs to, there will be some variation in how the visualization of the deity develops from the seed syllable:

sometimes gradually, sometimes instantaneously. In the higher classes of tantra you visualize yourself first as the commitment deity and then invite the wisdom deity to dissolve into you. The various forms of the visualized deities will be described in the next sections, and inviting the wisdom being is described briefly later in the text. This meditation on the causal samadhi and then developing into the deity creates the cause for the attainment of the nirmanakaya because the understanding of emptiness at this time has an object of reference, a form.

iv. Summary and benefits of the three samadhis

The first meditation, the samadhi of suchness is the dharmakaya meditation, from which the next two meditations derive, corresponding to the sambhogakaya and nirmanakaya, which are the fruit, the mandala and deities.

Shechen Gyaltsap Rinpoche says:

> In this way the three samadhis purify their objects: the habits associated with death, the intermediate existence, and rebirth. Their collective process of purification and the identity of their path as a whole is compassionate emptiness, which is, in fact, the single mainstay of the entire Great Vehicle path. It is vital that we focus our energy wholly on this at the outset since, in its absence, any path is just artificial. Whether or not we practice the later aspects of the development stage ritual in all their details is unimportant compared to having some degree of understanding and experience of this principle, as every key point is included within it.[27]

It is very important to consider the three samadhis as different phases of one meditation that are maintained in the background of the entire sadhana practice. The meditation of emptiness suffused with compassion is the basis for the visualization of the mandala and deity, which begins with the third samadhi, the visualization of the seed syllable that transforms into the deity. All three are automatically brought together as the unity of clarity and emptiness, which is another way of saying the unity of the development and completion phases. At the basis is the great heart essence of compassion, the main point of the Mahayana, indivisible from emptiness.

If the three samadhis are practiced in this way, then the two bodies, two accumulations, and two truths are all unified. Practicing with this proper

attitude and understanding is a special Vajrayana practice. If we do not practice the three samadhis, instead believing in the development-stage visualization as an actual entity with characteristics, it does not matter how clear our visualization is; it will not be the practice of a bodhisattva. Instead it will be a further cause for rebirth in the lower realms. Tenpe Nyima explains:

> Meditating with the belief that peaceful deities exist, in their own right, will cause you to be reborn as a god in the form realms, while meditating on wrathful ones with this belief will cause you to end up like the yogi in India who, after practicing Vajrabhairava, grew fangs and developed a layer of nine boils in the form of nine heads. Similarly, it is said in *The Root Tantra of Manjushri* that this belief will cause you to be reborn as a demon or the lord of death in the guise of whichever deity you have meditated upon.[28]

b. The fruit: visualizing the mandala support

Next are the instructions on visualizing the supportive celestial palace and the supported deities, which belongs to the path of the Secret Mantra Vajrayana. The development stage is explained in many tantras and instruction manuals, such as the *Assemblage of Secrets* and the *Appendix to the Recitation Manual of the Embodiment of All the Sugatas* and so on.

i. Visualizing the peaceful and wrathful mandalas

Tenpe Nyima says:

> As explained in the *Appendix to the Recitation Manual of the Embodiment of the Sugatas,* begin by imagining that the syllables E, YAM, RAM, BAM, LAM, SUM, and BHRŪM emerge, one by one, within the space of a vast protective dome. They emerge from the previously visualized seed syllable of the causal samadhi. The letter E completely purifies all clinging to reality and then transforms into a blue triangle[29] of limitless size whose nature is the empty expanse of space. Above the upward-facing wide opening of this triangle is the syllable YAM, which transforms into a wind mandala shaped like a dark-green cross[30] rimmed with dark-green light. Above this cross the syllable RAM transforms into a fire mandala shaped like a red triangle rimmed with red light. Above

this, the syllable BAM transforms into a white spherical[31] water mandala rimmed with white light. Further up, the syllable LAM becomes a golden ground shaped like a yellow square rimmed with yellow light. On top of the golden ground, the syllable SUM transforms into Mount Meru composed of four types of jewels and with four terraces. Upon Mount Meru is a multicolored crossed-vajra in the center of which is BHRŪM. . . . This syllable then transforms into a square celestial palace of precious wisdom. To indicate that reality itself is free from elaborations, its center is spherical. Its four walls represent the four truths, and it is surrounded by a gallery that represents the unity of these two truths. As a sign that each of the wisdoms is endowed with the four superior wisdoms through which the wishes of those to be tamed are fulfilled, beautiful bejeweled ledges with the colors of the four families jut out from the four walls.[32]

Shechen Gyaltsap says:

At the outermost level is an immense and vast protection dome. Inside of it is the central mountain, the top of which is a perfectly even ground consisting of miniscule vajras. At the periphery is a vajra enclosure resembling a fence of iron mountains, which emanates masses of five-colored fire. Within that enclosure, forming a perimeter, are the eight charnel grounds composed of all their awesome attributes, including stupas, trees, fires, clouds, rivers, spiritual adepts, the guardians of the directions, gods, and nagas. In the center of these is a thousand-petaled lotus made of a variety of jewels; its center is round, green, and level, and its red pistils are moist with dew. This lotus supports a bright and resplendent sun disc that spans the width of the pistils. At the center of the sun is a double vajra. The hub of the vajra is a deep-blue square, and its spokes are the color of their respective direction—the three extending eastward, for instance, are white. The celestial palace, which is perfectly square in shape, rests on this foundation. It has five consecutive layers of walls, each made of different types of jewels, the innermost of which is the color of the family of the main deity. A ledge of red jewels surrounds the

external foundation of the celestial palace, which protrudes at the base. On this ledge, the "platform of delights,"[33] are the offering goddesses, gathered in pairs and facing inward. Beginning at the far northern corner of the eastern side and continuing clockwise, they are: the blue lute goddess, the yellow flute goddess, the red round-drum goddess, and the green clay-drum goddess. Each of them holds her particular implement. Then, continuing to the southern side are: the blue goddess of beauty and the red goddess of laughter, both bearing their emblems; the yellow goddess of song, holding miniature cymbals; and the green goddess of dance with the emblem of dance. To the west are: the yellow goddess of flowers, the black goddess of incense, the red goddess of lights, and the green goddess of perfume, all bearing their emblems. To the north are: the red goddess of visual form bearing a mirror; the red goddess of taste with a tray of food; the green goddess of texture, carrying garments; and the white goddess of basic space, holding a triangular "source of phenomena."[34] They are all adorned with silks and jewelry and have a serene and graceful countenance.

At the corners of the porticos and in each corner—the southeast, southwest, etc.—of the palace itself there is the seal of half-moon and vajra. At the top of the palace walls runs a yellow frieze trimmed with inlaid jewels resembling frost.[35] Above that run beams, which are supported by posts, also called pillar stabilizers.[36] On top of these are the rafters that support the roof, on the tip of each of which is a "face of glory." From the mouths of these hang garlands and tassels made of jewels,[37] as well as flower garlands, silk streamers, mirrors, crescents, and tail fans, all fluttering in the breeze. The roof rests on the rafters and extends out to the edge of the external foundation. Beneath, on the underside of the roof, is a line of rainspouts made of white gemstone which look like anointing vases turned upside down.[38] Between them run garlands fastened directly to the lower ends of the rafters. Holding down the base of the roof from above is a parapet,[39] also called a *lenken,* which has a stupa design and consists of three or four levels of upright, white jewel planks. This is also referred to as the "half-lotus petal."

Inside the celestial palace there are eight pillars that support four interlocked beams, upon which twenty-eight rafters rest. The rafters support the ceiling, which is made of jeweled planks, except for a skylight in the center. A layer of jewels covers this entire level. The so-called "central chamber" is formed by an arrangement of pillars or wooden posts at each of the four corners of the skylight. They support the roof, the peak of which is adorned with a jewel-vajra top ornament.

In the exact center of the walls in each of the four directions there is an entrance with an outer vestibule. The upper parts of the vestibules have two protruding corners, while the lower corners connect with the external foundation. Each has four pillars, upon which are four interlocked beams. Each vestibule also has an architrave consisting of two parts, one "causal" and one "resultant." The causal architrave consists of stairs leading into the entrance. There are eight of these, two at the left and right sides of the roofed entranceway, and four at the midway point of the entrance itself.

The resultant architrave[40] rests on top of the four interlocked beams mentioned above, and may consist of either four or eight constituent parts. If we consider one with eight, they are, sequentially: the horse ankle, lotus, casket, lattice, cluster ornament, garlands, rainspout, and roof. The horse-ankle ledge[41] consists of a row of upright golden vajras set against a blue background. The lotus ledge[42] is a row of lotus petals made of red gemstone. The casket ledge[43] is a flat box made of various jewels inserted between small pillars. The lattice[44] is a net of white jewels hanging down from the ledge of hanging clusters. The cluster-ornament ledge[45] is similar to the frieze. The garland ledge[46] consists of jewel garlands and tassels which hang from the mouths of lions against an even background.

The rainspouts and roof of the portico are similar to those described above, but the portico roofs[47] furthermore are adorned with garuda heads at their four corners. From the necks of these garudas hang bells with strikers that make them ring in the breeze. In the middle of the architrave's facade there is a trefoil-shaped gap resembling an elephant from the back[48] decorated on the inside with jeweled garlands and tassels.[49]

On top of the small flat portico roof, seated on a lotus, is a golden eight-spoked wheel flanked by a horned male and hornless female deer, symbolizing method and wisdom. Above is a white parasol.

He also says:

> Beyond this, the space in and around the palace is decorated with a variety of beautiful things such as jeweled canopies, banners, pennants, tail-fans, and bells strung on golden thread that ring as they flutter in the breeze. All of this is clear, translucent, and unobstructing.[50]

Tenpe Nyima says:

> Encircling the outer enclosure are lotuses, along with charnel grounds encircled by vajra fences and blazing fires.[51]

Peaceful deity mandalas have eight gardens, two in each direction, with trees, swimming pools, offering goddesses, jewels, and animals.

This concludes the general description of the mandala of a peaceful deity.

As for the characteristics of the wrathful deity's mandala, Tenpe Nyima says:

> The specific characteristics of wrathful mandalas are as follows. There is an ocean of rakta, a ground of human skin, and Mount Meru, which is composed of skeletons. On its summit is a multicolored crossed-vajra resting within a great mass of wisdom fire. At the center of this crossed-vajra is a square celestial palace with four doors. Its gallery is composed of either gold or blood, whichever is appropriate, and its walls are made of fresh, dry, and shriveled skulls that are nailed together with nails of meteoric iron and glued together with blood. On top of the wall is a border of various types of skulls with garlands of intestines and hearts. On the streamers of the top border are lattices and tassels made of snakes and garlands of skulls. The rainspouts are made of hands and feet; the ledge is made of backbones and ribs; and the lower part of each door is made of turtles, with upper parts made of sea monsters (*chu srin*). There are poisonous male vipers

that constitute the planks on either side of the door, while the planks of the door itself are made of human skin. To the right and left of the Dharma wheel are baby crocodiles resting atop the architraves. Above them are parasols made of human skin. The ceiling is also made of human skin. The central chamber has a skylight for the sun and moon and is made from the overturned skull of Mahadeva, which is surmounted with a top-ornament of a heart, and so forth.[52]

These are general descriptions of the peaceful and wrathful mandalas. The mandala of each deity or sadhana is unique, and there are many variations. Sometimes they are round with eight doors, sometimes semicircular with one door. Most of the dakini mandalas are in the shape of a hexagram, but sometimes they are in the shape of an eight-petaled lotus.

ii. The seats of the mandala deities

There are many different thrones and seats, such as the precious lotus seat unsullied by samsaric defects, with its center covered by anthers; the sun and moon seats of method and wisdom; and so forth, together with the eight main wrathful beasts.

Shechen Gyaltsap says:

> Otherwise, in the *Magical Web* for example, the central deities of the five buddha families have seats with five layers: an animal throne with a surface of jewels surmounted by a sun, a moon, and a lotus. The bodhisattvas have a seat of three layers: a sun, moon, and lotus. The six sages merely have a lotus for a seat,[53] while the wrathful gatekeepers only have a sun. Finally, the doer and deed[54] have a four-layered seat made of a sun, moon, lotus, and jewels.
>
> This is just one example, however, and we must follow our own particular text. Wrathful deities have their own distinct thrones, which may consist, for instance, of Rudra, Mahadeva, male and female direction guardians, the major and minor bases of deliverance, and beasts.[55]

Regarding the purity of the various thrones, they represent guiding beings in the following ways: the throne of snow lions represents the four

fearlessnesses. The elephant throne represents the ten strengths. The horse throne represents the four legs of miracles. The peacock throne represents the ten powers. The *shang-shang*[56] throne represents the four activities.

The sun and moon seat represents the clear and luminous nature of mind, the union of means and knowledge. The lotus seat represents flawlessness. A jeweled throne represents the fulfillment of wishes.

iii. The symbolic meaning

Even if we cannot remember every detail, the most vital thing to understand when visualizing the mandala is the symbolic meaning. Every aspect represents the enlightened qualities of buddhahood; if we do not understand this, our visualization will fall into ordinary discursive thinking.

Shechen Gyaltsap says:

> When practicing in this manner, if you fail to recall the purity of each individual element of the visualization, the object of your meditation will stray into your ordinary state of mind. Therefore, keep in mind that it is the qualities of enlightenment—the phenomena related to complete purification, consisting of inconceivable compassion and activity—that appear as the celestial palace in order to guide disciples. Composed of a variety of jewels, it is enlightened wisdom manifesting in shape and color in order to fulfill disciples' wishes.
>
> The fact that the palace is square in shape shows there is no unevenness whatsoever in the basic space of phenomena. Its four doors represent the four activities of pacifying, increasing, magnetizing, and subjugating, or else, the way that the four boundless activities, love and the rest, lead into the palace of great bliss. They also represent entrance into the palace of the nonarising basic space of things from the levels of the four liberations: the emptiness of cause, result, action, and essence.
>
> The eightfold raised architrave entranceways represent the eight vehicles: of gods, humans, listeners, self-realized buddhas, bodhisattvas, action tantra, performance tantra, and yoga tantra. Otherwise they may symbolize passage through the eight effortful vehicles up to anuyoga and onto the effortless nondual vehicle of ati. The four resultant architraves represent the four

means of magnetizing: giving, speaking nicely, behaving consistently, and acting meaningfully. The eight parts of each of these symbolize the perfection of the qualities within the systems of the eight vehicles to complete liberation, or else, if there are four, the four vehicles of listeners, self-realized buddhas, bodhisattvas, and Secret Mantra. The uninterrupted spinning of the wheel of the Dharma is shown in the wheels and other such things.

The "platform of delights" represents the four applications of mindfulness: of the body, sensation, mind, and mental objects. The four pillars in the architraves symbolize the four right exertions: to prevent nonvirtue from happening, restrain existing nonvirtue, create virtue where there is none, and increase existing virtue. The four vestibules represent the four bases of miraculous powers: intention, diligence, attention, and discernment.

The five-layered walls symbolize the five faculties that govern complete purification: faith, diligence, mindfulness, concentration, and knowledge. The frieze, top border, rainspouts, eaves, and central chamber symbolize attainment of the five strengths. . . .

The decorative jewel lattices, tassels, flower garlands, silk streamers, mirrors, half-moons, and tail-fans symbolize the seven factors of enlightenment: mindfulness, discernment of phenomena, diligence, joy, pliancy, concentration, and equanimity. The eight internal pillars symbolize the eight aspects of the path of the noble ones: right view, thought, speech, action, livelihood, effort, recollection, and concentration.

The pillar capitals symbolize the eight emancipations. . . . The four beams symbolize the four types of fearlessness: to proclaim that all has been abandoned and realized for one's own benefit and to show the path and its obstacles for others' benefit.

The twenty-eight internal rafters symbolize the eighteen types of emptiness and the ten perfections. . . .

Otherwise, the twenty-eight rafters can be said to symbolize the buddha's ten powers along with their eighteen unique qualities. The upper flat panels symbolize inconceivable qualities. The four posts supporting the central chamber symbolize the four correct discriminations. . . . The crowning ornament symbolizes that all mandalas of the enlightened ones coalesce in the expanse of naturally aware wakefulness.

Furthermore, the canopy represents the utter purity of true reality. The parasol symbolizes protecting beings with great compassion, while the pennant symbolizes great compassion itself. The banner represents victory over the demons and the prevailing of the Dharma. The bells resound with the sounds of the teachings of emptiness. The light that radiates in all directions represents the eternal adornment wheel of enlightened body, speech, and mind. The palace's nonobstructing appearance, utterly clear and bright while at the same time translucent, shows how everything is none other than the expression of wakefulness.

The crossed-vajra that forms the ground symbolizes wakefulness whose nature is indivisible from emptiness. The twelve enclosures[57] symbolize the complete purity of the twelve links of interdependent origination....

The sun seat represents the natural luminosity of true reality. The lotus garlands show that true reality is unstained by any faults. The eight charnel grounds represent the innate purity of the eight collections of consciousness.... The vajra fence symbolizes nonconceptual wakefulness, by nature utterly indestructible. The masses of flames symbolize the fire of wakefulness consuming wayward demons and disturbing emotions.

All of these qualities mentioned here—from the application of mindfulness onward—are part of the extraordinary transformation that constitutes the undefiled state of enlightenment. Although it is important to remember the purity of each symbol as well as what it represents, as a beginner you may not be able to bring all of this to mind in a single practice session. If this is the case, you can approximate the recollection of purity by thinking to yourself that all the features of the celestial palace represent the buddhas' inconceivable qualities of abandonment and realization. We visualize the supporting mandala, in short, so that we may take the self-manifest palace of the buddhas as our path. Through this process—by feeling confidence in perfect purity, the fusion of the ground and fruition—we take the realms of all buddhas as our path as well.[58]

iv. Visualizing the mandala deity

Tenpe Nyima quotes the *Condensed Realization of the Gurus:*

> Gradually generate the celestial palace from the outside.
> Gradually generate the deities from the inside.

As indicated here, to visualize the supported deities imagine that the previously visualized seed syllable descends onto the central seat. This syllable then . . . transforms into the form of the deity, complete with all of its ornaments and attire. You may then gradually visualize the main deities and their retinue in their entirety, as spelled out in the particular ritual text you are using.[59]

Deity visualization begins with a seed syllable, the heart syllable of the deity. This syllable first descends to the seat of the deity and transforms into the deity, which is visualized exactly as described in the sadhana, whether in stages or immediately.

If the complete visualization is quite elaborate, with many details and a large retinue, it is acceptable to visualize just the main deities. If this is still difficult, it is enough to visualize just the central deity. If it is difficult to visualize all the details of the central deity, it is also enough to visualize the seed syllable. The tantric teachings say that wherever the main deity abides, the retinue abides with it, so it is not necessary to visualize everything. The analogy given in *Stages of Meditation of the Assemblage of Sugatas* is that of a king: when he is invited somewhere, his retinue will always naturally follow.

c. The three main points

This section outlines the three main points of visualization: (1) vivid appearance, (2) stable pride, and (3) recollecting purity. The section on vivid appearance provides many details of the accoutrements and appearance of the deities, which are also very helpful for the artist's training.

i. Vivid appearance

Vivid appearance refers to the generation of a clear, vivid, and stable visualization during the development stage. The support of a tangka is required to help develop a clear visualization. A properly drawn and consecrated icon actually embodies the deity; therefore, offerings and supplication prayers can be made to it during our practice.

Tenpe Nyma says:

> In general, the matured practitioner should begin by placing offerings in front of an authentic painting of the deity, crafted

by a skilled artisan, and do the preliminary practices in either an extensive or abbreviated form, whichever is appropriate. Then, as is taught in the *Condensed Realization of the Gurus,* visualize Guru Vajradhara—the embodiment of all refuge objects—above your head, seated on a lion throne on a lotus and on sun and moon discs. Filled with devotion, offer your body and all your wealth and enjoyments to the guru. Then offer the following supplication with one-pointed concentration: "Essence of the buddhas of the three times, truly kind, precious root guru, I supplicate you. Please bless my mind, especially so that the genuine absorption of the development stage will arise in my being right now!" The guru then smiles joyfully, melts into red light, and dissolves into your crown. Mingling your mind inseparably with the guru's, rest for a while in that state.

Next, look at the image of the deity in front of you. Sometimes close your eyes and check if you can visualize the image just as clearly as when you see it. Once you are able to visualize the deity, even with your eyes closed, transfer the visualization to your own body. Work at familiarizing yourself with the visualization by alternating between periods of meditating with your eyes open and closed. Having accustomed yourself to this practice, strengthen your training by visualizing the deity as being either large or small, single or multiple, by sometimes focusing on the main deity, then sometimes on the retinue and so forth. Likewise, alternate between visualizing the entire body of the deity all at once and visualizing each individual aspect of the body and adornments one by one.

At first, keep your mind focused on the main deity alone, visualizing each and every detail, from the top of the deity's crown to the lotus seat upon which he or she sits. Clearly visualize the color of the body, the face, hands, ornaments, garments, the pupils and whites of the eyes, the signs on the hands and feet, the appearance of the major and minor marks, the projection and absorption of light, and so forth.

The deity should not be flat like a wall painting or slightly protruding like a relief. In other words, it is neither a material entity nor insentient like a rainbow. It should be clearly defined in every respect—its front and back, left and right sides, proportions, and so forth. Yet, at the same time, it should be devoid of internal

organs or any sense of materiality. Train as though the deity were actually present in the form of a body of light endowed with wisdom, knowledge, love, and capacity.

Once you are able to focus your mind on the visualization, gradually bring forth the vivid appearance of the retinue, the palace, and the arrangement of the celestial realm, all the way up to the protective dome. At times focus on the visualization as a whole; at other times focus on specific details. Training in allowing the entire supportive and supported mandala to arise clearly in your mind is called "vivid appearance." This is one of the primary functions of the development stage; it is a unique method that will allow you to practice calm abiding by focusing your mind on the deity. For this very reason it is important to meditate by assiduously keeping your awareness on the vivid appearance of the deity. As you grow accustomed to this, the five experiences will arise in turn.[60]

(1) The peaceful sambhogakaya deities

In this context, the specific details of the deity, such as its color and symbolic implements, can be learned from the ritual text you are using. Although there are a huge variety of visualizations according to the different sadhanas, here a general explanation of the deities' ornaments and aspects is given, which will be helpful to artists for both their artwork and their visualization practice.

The nine traits of the peaceful deities

The *Awesome Flash of Lightning* states:

> Each of their supreme forms
> Possesses nine traits:
> They are soft, well-proportioned,
> Firm, supple, and youthful;
> Clear, radiant, attractive,
> And blazing with intense presence.

These are the nine traits of the peaceful deities. Their bodies are soft because they have purified pride. Having purified anger, their bodies are well-proportioned. Having purified desire, their bodies are not loose, but firm. Having purified jealousy, their bodies

are straight and supple. Having purified stupidity, their bodies are youthful. Having abandoned ignorance, their bodies are clean and clear. Due to the blossoming of wisdom, their bodies are bright and radiant. Having perfected the major and minor marks, their bodies are resplendent, appealing, and, therefore, attractive. Having subjugated everything through their great qualities, they are endowed with a great intense presence. The first five of these are the essential qualities, whereas the latter four are aspectual qualities.

The deity should be seated within the expanse of clear and pure multicolored light that radiates out in the ten directions. As a sign of purifying the suffering of the negative emotions of those to be tamed, the deity wears the five silk Dharma robes made of celestial silk. As a sign of fulfilling the wishes of beings by not abandoning the sense pleasures but perfecting them as an ornament, there are eight precious ornaments. Thus the deity is adorned with thirteen ornaments.[61]

The peaceful sambhogakaya deities wear thirteen adornments, which comprise the five silken garments, symbolizing taming sentient beings to alleviate their suffering, and the eight jewel ornaments, which represent the taking of the objects of the senses into practice. These can vary according to the particular text. They are explained by Tenpe Nyima as follows:

The five silken Dharma robes consist of a white silk shawl with golden embroidery; a *dhoti* which is a multicolored skirt; a yellow sash or Dharma robe; a green dancing blouse that resembles a short-sleeved vest; multicolored silken streamers that are worn under the crown of the five families, and blue silken ribbons that hang down from the back. In some cases the belt or Dharma robe is omitted and the streamers and ribbons are counted separately.[62]

The eight ornaments are a jeweled crown, earrings, a short necklace, a belt, bracelets, anklets, a long necklace that reaches below the navel and is a garland composed of jewels, and a shorter necklace that reaches to the breast. Alternatively, symbolizing the seven branches of enlightenment, the deity wears the seven precious ornaments: a crown, a long necklace, bracelets, earrings, armbands, a medium-length necklace, and a flower garland.[63]

Shechen Gyaltsap says:

> These ornaments are sometimes counted in slightly different ways. For instance, some count the necklace and long necklace together, or the bracelets and anklets together, while counting the rings [on the fingers] separately. Some even exclude the rings and instead count each of the first eight individually. . . .
>
> Moreover, in terms of the seven factors of enlightenment, the jeweled necklace represents mindfulness, the crown represents the discernment of phenomena, the bracelets represent diligence, the earrings represent pliancy, the armbands represent concentration, the long necklace represents equanimity, and the flower garland represents joy.[64]

This completes the description of the peaceful sambhogakaya deities.

(2) The accoutrements and aspects of the wrathful deities

Wrathful deities display the nine expressions of the dance. Tenpe Nyima quotes the description from *Heruka Galpo:*

> Captivating, heroic, and terrifying,
> Laughing, ferocious, and fearful,
> Compassionate, intimidating, and tranquil:
> Assume these nine expressions of dance.[65]

These consist of three aspects of wisdom body, three aspects of wisdom speech, and three aspects of wisdom mind, described by Shechen Gyaltsap as follows:

1. The first of these is *captivating,* which is an expression of passion. It refers to the essence of Vairochana, which is the deities' seductiveness, as they are adorned with jewelry, the male and female consorts are embracing, etc.
2. They are also *heroic,* an expression of wrath, referring to the essence of Ratnasambhava, the fact that they are so powerful as to be invincible.
3. They are *terrifying,* an expression of stupidity, referring to the essence of Akshobhya, the way that they instill fear merely on sight.

These first three are their three physical expressions.

4. They are *laughing,* the essence of Amitabha, emitting sounds of laughter like "Ha ha!" due to their state of passionate, haughty glee.
5. They are *ferocious,* the essence of Amoghasiddhi, berating with abusive words like "Capture! Strike!"
6. They are *fearsome,* the essence of Mamaki, as they overwhelm with fierce roaring sounds similar to thunder cracks.

These three are their verbal expressions.

7. They are *compassionate,* the essence of Samayatara, taking ignorant beings and realms under their care with nonconceptual compassion.
8. They are *intimidating,* the essence of Pandaravasini, meaning they are capable of anything necessary to tame incorrigible beings with their wrath, their state of mind being overcome by passionate wrath.
9. Finally, they are *peaceful,* the essence of Lochana, referring to their nonconceptual realization that everything is the same taste in true reality.

These are their three mental expressions.[66]

The eight attributes of the Glorious One

Shechen Gyaltsap says:

> The eight attributes of the Glorious One are so called because they are primordially and intrinsically present on the body of the Great Glorious One. It seems, however, that there are some slight discrepancies in the ways these are identified. Nevertheless, *The Divine Realization Tantra* describes these clearly and also mentions their symbolism. According to this scripture they are:
>
> 1. Hair tied in a knot[67] for reversing cyclic existence
> 2. Vajra garuda wings of method and knowledge
> 3. A dark-blue diadem[68] for overpowering eternalism and nihilism.
> 4. A vajra at the crown indicating supreme awareness
> 5. A mighty coat of armor to advance in splendor

6. The knowledge consort with whom the deity is in nondual union
7. The iron of a hero for repelling harm and malevolence
8. Vajra fire for incinerating disturbing emotions[69]

These ornaments are also explained as the eight liberations.

The eight charnel ground ornaments
Shechen Gyaltsap explains:

> The eight charnel-ground ornaments are decorations representing triumph and heroism. In the past they were the spoils of the liberation of Rudra, donned by the Great Glorious One as ornaments on his body. They include three worn garments, two fastened ornaments, and the three smeared things.[70]

The *three garments to be worn* are as follows:

1. An elephant-skin cloak symbolizes the destruction of ignorance by means of the ten strengths.
2. Flayed human skin at the waist symbolizes having conquered desire through the awakened mind.
3. The tiger-skin skirt symbolizes having conquered anger through heroic, fierce and wrathful activities.

The *two fastened ornaments* are as follows:

1. Skull ornaments, dry and fresh
 a. A crown of five dry skulls
 b. A long necklace of fifty fresh dripping heads
 c. Armlets made of human skull fragments[71]
2. The snake ornaments as described by Shechen Gyaltsap
 a. A white hair band of the royal naga caste
 b. Yellow earrings of the merchant caste
 c. A red short necklace of the priestly caste
 d. Green bracelets and anklets of the peasant caste
 e. A black necklace of the untouchable caste[72]

The *three smeared substances* are as follows:

1. A clot of human ash on the forehead
2. Drops of blood on the cheeks or, alternatively, on the cheeks and the tip of the nose
3. Smears of grease on the chin (or throat)[73]

Adding the surrounding mass of wisdom fire and vajra wings to these eight makes ten glorious ornaments. These can all vary somewhat. Sometimes a garuda and wings are included, according to the Nyingma Kama[74] teachings. There are jewels on the tips of the feathers of the left wing and vajras on the right wing. Sometimes a blue garuda is depicted to the right and a white garuda to the left.

Tenpe Nyima says:

> The light of the sun and moon, radiating from his left and right earrings, are the two ornaments of clarity. The six bone ornaments are a necklace, representing generosity; bracelets, representing discipline; earrings, representing patience; a wheel on the crown of the head, representing diligence (this is a thousand-spoked wheel at the center of which his hair is piled in a topknot); a belt, representing meditative concentration; and a long garland called "held aloft to make offerings," representing wisdom.
>
> The five bone mudras are these six, minus the long necklace. These represent the five wisdoms.
>
> In the past, when Heruka liberated Rudra, he claimed Rudra's wrathful ornaments and wore them as a sign of his heroism. These have come to be known as the eight wrathful ornaments.[75]

The six bone ornaments of the male deities

The six bone ornaments symbolize the six transcendent perfections.

1. A wheel-shaped bone ornament with thirty-two cross-meshes and bone pendants hanging from the ushnisha[76] symbolizes the perfection of diligence.
2. A bone necklace with sixteen cross-meshed arrangements symbolizes generosity.

3. The double-stringed bone girdles in one hundred pieces symbolize wisdom.
4. A bone latticed skirt with sixty-four crosshatches over a tiger-skin skirt symbolizes meditation.
5. Bone bracelets, armlets, and anklets symbolize discipline.
6. Bone earrings symbolize patience.

Sometimes the double-stringed bone girdle is described in more detail, according to which jewel shapes are depicted where the bone girdle goes over the shoulders, and on the chest is a lotus, on the central backside is a vajra, and in the center at the front is an endless knot or a dharma wheel. Crosses can also be depicted along the belly. These are the usual bone ornaments for the male deities and lamas.

The five bone ornaments of the female deities
The five bone ornaments of the female deities are as follows:

1. The wheel on the crown of the head symbolizes the dharmadhatu.
2. The necklace with sixteen cross-meshed arrangements symbolizes equanimity.
3. The bone skirt with sixty-four crosshatches symbolizes discriminating wisdom.
4. The bone bracelets, armlets, and anklets symbolize mirrorlike wisdom.
5. The bone earrings symbolize the wisdom of accomplishment.

In other words, the ornaments are the same as for the male deity, but without the girdle. A latticework of bone ornaments hangs from the belt. These symbolize the twelve links of dependent origination or the twelve scriptural categories of the Buddha's teaching.

(3) The accoutrements and aspects of the semiwrathful deities
The semiwrathful deities like Kalachakra wear some of the clothing and ornaments of the wrathful deities, such as the elephant hide and tiger-skin skirt, but they wear a silken scarf rather than human hide.

Shechen Gyaltsap says:

> Certain deities are of a semiwrathful type. They wear an elephant skin upper garment, symbolizing the defeat of ignorance

by means of the ten powers of knowledge. They are swathed in a tiger skin skirt, representing the defeat of anger by means of heroic wrathful activities. They are adorned with silk streamers, symbolizing the defeat of desire by the mind of awakening. They have a crown of five dry skulls, the identity of the five buddhas, which represents the defeat of pride. They wear a necklace of fifty fresh heads, strung together as a garland, symbolizing the purity of the fifty mental states after envy has been defeated. Finally, their bodies are adorned with the bone ornaments, which have the nature of the six perfections. You should visualize all this as it is described in your particular text.[77]

Tenpe Nyima says:

> It is generally taught that wrathful ornaments are not suitable for peaceful deities, whereas peaceful ornaments are not disallowed for wrathful deities. However, although there may be slight variations in the color of the body and the ornamentation of the deity in different ritual manuals, it is, in fact, suitable for the deity to appear in whatever way accords with the wishes of those to be tamed, as the compassion and activity of the deity know no limitations. Therefore, though there is no contradiction here, it is important to follow along with the context of whatever ritual text you are using.[78]

(4) The proper way to visualize

Deities of a particular sadhana can even vary somewhat according to a particular master's lineage of that sadhana.

Tenpe Nyima says:

> Also, here in the context of generating the deity, according to the *Magical Web* the deity of each single mudra has a wisdom being similar to itself, but without any ornamentation, at its heart, the deities of the five buddha families as a crown, and the blessing deities in its three places wearing the ornaments of the enjoyment body. When these nine subsidiary deities are added to the main deity itself, this makes ten deities in all. Alternatively, because the single lord of the family on the crown embodies them all, they

are counted as one. In this case, the term "the body of the deity endowed with the five branches of mantra" is used.[79]

Guru Padmasambhava said that when we visualize the deity's seat—the lotus, throne, and so on—it should be large, to increase our life span. When we visualize the standing deities, their legs should be wide apart, which gives a stable mind. The deities should be visualized as attractive and youthful to help prevent sickness. If we properly visualize the sadhana's description of the deities' postures and hand implements and so on, our wishes will be fulfilled, and visualizing their ornaments will result in increased wealth. Visualizing the mouth, teeth, and skin color clearly will ensure that your words will be listened to and you will feel content. In this way, correct visualization creates auspicious connections while cutting through the very root of our samsaric attachment to ordinary appearances as real.

ii. Stable pride

The second of the three main aspects of the development stage is stable pride. This is a firm pride, a stable confidence in our own enlightened nature. A clear and vivid visualization is not enough; we must also have a strong conviction in ourselves as the deity. It is also referred to as vajra pride and has nothing to do with ordinary pride or arrogance. Stable pride in this context is reminding ourselves of the truth of our sacred true nature, the primordial purity or buddha nature.

Tenpe Nyima says:

> The deities, who are the objects of meditation, are not simply supports for mental visualization; the appearance of the deity you meditate upon and you the meditator are not different. When you train without losing touch with the thought that you are the deity, this confident outlook will serve the unique function of destroying self-grasping and preventing obstacles from taking hold. On this point *The Condensed Realization* explains:
>
>> There is no imputation
>> In equipoise or subsequent attainment.
>> To have stable pride is a vitally important point,
>> Though your visualization may be clear or unclear.
>> Think, "I am the deity,"
>> And do not hold on to your ordinary perceptions.

While Tsele notes:

> It is indispensable to know how the world and its contents
> Are the primordially pure deity and mantra.

And *Resting in the Nature of Mind* explains:

> Your mind has been the nature of the deity from the start.
> Your body is the mandala; and sounds and words, Secret
> Mantra.
> Within this great wisdom, where everything is
> spontaneously perfected,
> The samaya and wisdom beings are indivisible.
> There is no one to invite or who remains, nor is there any
> need to request someone to leave.
> Not good or bad, beyond accepting or rejecting, it has been
> the mandala from the very start.
> In the visualization where you know this is its identity
> You are not creating something that is not already there.[80]

The correct way to practice is to visualize from the basis of three samadhis as described earlier and at the same time to remember the meaning of the symbolism of the deity while thinking, "This is me." Chögyal Terdak Lingpa says we need to think with conviction that we are the deity's body, speech, and mind. Without deviating from this contemplation, recite mantras, pausing after each round of the mala to arouse compassion. Remember the guru with fervent devotion, supplicating: "O guru, please grant your blessings so that my being is purified." In this way, we beseech the yidam deity to care for us. The blessings will then ripen swiftly and without much effort.

iii. Recollecting purity
The third of the three main points of the development stage is recollecting purity, which means remembering the pure symbolism of the deity.
Tenpe Nyima says:

> Such visualizations should not be clung to as true, as entities with
> their own characteristics. In actuality they are the self-appear-
> ance of the wisdom mandala. As such they are devoid of concep-
> tual constructs of color, shape, face, hands, and the rest, yet the
> various attributes of the support and supported do manifest as

signs that symbolize the qualities of self-appearing buddhahood to those who are to be tamed.[81]

(1) The symbolism of the deity

Tenpe Nyima says:

> As a symbol of all phenomena being one taste in suchness, deities have one face. Three faces symbolize three liberations, or the three bodies. Two hands symbolize means and knowledge, while four hands symbolize the four immeasurables. Six hands can symbolize the six wisdoms (five wisdoms along with self-arising wisdom) or the six perfections. Four legs symbolize the four means of magnetizing and two legs symbolize ethical discipline and meditative absorption. The cross-legged position symbolizes the equality of existence and peace, while the standing position symbolizes being unflagging in the service of beings. Three eyes symbolize seeing throughout the three times and four fangs symbolize uprooting the four types of birth. Male and female consorts symbolize the union of means and knowledge.
>
> The nakedness of the female consort symbolizes the freedom from the overlay of the concepts connected with phenomenal characteristics. The consort being sixteen years of age symbolizes her being endowed with the sixteen joys pertaining to immutable great bliss. Her flowing hair symbolizes the boundless expansion of wisdom from basic space. Union with her secret space represents the fusion of calm abiding and insight.[82]

Shechen Gyaltsap says:

> When the deity has a male appearance it represents skillful means and immutable great bliss, while a female appearance represents knowledge and emptiness suffused with the excellence of all aspects. The union of male and female symbolizes that bliss and emptiness are beyond unity and separation.[83]

(2) The symbolism of the colors

Tenpe Nyima says:

> In terms of the consort's complexions,[84] white symbolizes being unstained by blemishes, yellow represents the development of qualities, red symbolizes the welling up of compassion, green indicates unobstructed activity, and black symbolizes the immutability of reality.[85]

(3) The symbolism of the hand implements

The symbolism of the hand implements of skillful means is as follows: The five-pronged vajra symbolizes the five naturally occurring wisdoms. The vajra is uncompounded, while the bell symbolizes the expanse of unoriginated emptiness. The wheel cuts the center of the afflicting emotions. The jewel symbolizes the source of desired qualities. The lotus symbolizes being unstained by defects. The crossed vajra represents unimpeded activity. The ritual bladed weapons symbolize the destruction of wrong views. The curved knife symbolizes the cutting-through of coarse concepts. The skull cup symbolizes the bliss of continuous nonconceptual wisdom, and the blood it contains symbolizes destroying the four demons. The sword symbolizes uprooting birth and death, and the trident symbolizes the attainment of the three kayas through the destruction of the three poisons.

This does not include everything; nevertheless it is important to understand that there is a profound meaning to all of the implements and forms described in the sadhanas.

(4) The symbolism of the musical instruments

Chögyal Terdak Lingpa said that the white conch symbolizes eliminating the afflicting emotions. The long musical horn symbolizes wisdom of infinite manifold qualities. The reed pipe symbolizes the magnetizing of appearance, and the thighbone trumpet symbolizes the annihilation of faults. Thus it has been taught.

As beginners, we will not be able to contemplate all the symbolic meanings of a visualized image at once; however, we can simply think, "Whatever form this deity (or mandala) has, they are all signs of the compassion, loving-kindness, and wisdom of the Buddha." This will prevent the error of considering our visualization to be solid and real, like ordinary appearance.

Shechen Gyaltsap says:

The main point is that the qualities of enlightenment are naturally and spontaneously present within our innate nature. Whatever qualities a deity may have, they are pure as the essential nature of that deity. . . . You should, therefore, keep in mind that the deity you are concentrating on in meditation is pure and free from the slightest concrete, material existence.[86]

Tenpe Nyima says:

Jamyang Khyentse taught, "You are trained and habituated when the perception of each aspect of purity and its real meaning emerges naturally whenever the form of the deity is seen." Beginners, however, are not able to do this. They adhere to a belief whereby they set up the visualization of the deity and then think, "These elements are the play of great wisdom, the enlightened mind of buddhahood, manifesting as symbols that represent the qualities of enlightenment." Adhering to this belief brings about an approximation of the recollection of purity and invites the pitfall of clinging to the deity as existing in its own right.

In summary, developing your training in the illusory play of empty appearance, wherein you do not veer from the nature of the dharma body even while appearing as the form bodies, is called "recollecting purity."[87]

iv. Summary and benefits of the three main points
Tenpe Nyima says:

In all those contexts the development stage purifies clinging to ordinary appearances and is the very goal of meditation while on the path. Thus, since the features of form, sound, smell, taste, and texture, manifesting as objects of the five sense faculties, and the features of phenomena, manifesting as mental objects, constitute "appearances," then visualizing such features as pure is taught to be what purifies them. Once the universe and its inhabitants are visualized as the celestial mansion and the deities, and sounds are naturally perceived as mantra, the mind will no longer gravitate toward objects.

"Clinging" is twofold: clinging to the self and clinging to

things. The first of these, clinging to self, is the self-grasping that has occurred since beginningless time, whereby you think, "I." Stable pride is taught to be the antidote to this form of cling-ing. . . . In clinging to things you cling to the universe and its inhabitants, rigidly believing they are real and permanent. This is termed the "self of phenomena." The recollection of purity is taught to be the antidote to this form of clinging.[88]

Also:

The deity should be clear, insofar as the apparent aspect of its enlightened body is visualized in precise detail, down to the pupils of its eyes. The deity should appear lucidly present, rather than clouded by one's experience of dullness devoid of the crisp clarity of awareness. It should possess the vitality of awareness, which is clear, empty, and vividly awake. It should be vibrant, since deities are not rainbowlike forms of lifeless matter, but are suffused with the wisdom of omniscience down to the very pores of their bodies and the strands of hair on their heads.[89]

d. The four stakes that bind the life force
The four stakes that bind the life force are unique to the Nyingma school's way of explanation.

The *stake of unchanging realization of reality* is utilized whether you are meditating on a deity or mantra and refers to abiding in the unfabricated state, the dimension of suchness. Merely observe the thoughts that arise, without following them or assessing your practice. Completely abandon any conceptualization during your practice and maintain the unfabricated state.

The *stake of absorption in the deity* refers to the meditation upon the body of the deity, encompassed by the three samadhis, seeing the deities and man-dalas as illusion-like empty appearance. When practicing visualization of the deity, be careful not to try too hard or be too tight, and do not worry if the visualization does not come easily, in which case just leave your mind open. If too many thoughts arise, stop your meditation and instead peace-fully recite mantras. You can also do the practice of clearing the stale air and then let your mind relax. Turn your attention inward and stare at your own mind. Then, rest your attention lightly on the heart syllable. If this is

difficult, do not worry; just leave your mind open and relaxed. However, this does not mean to say that it is all right to be lazy. Try to find a balance between concentrating too hard and being too relaxed. As we train in these two concentrations, at first we alternate them, but slowly we will be able to practice them simultaneously.

During the appropriate stage of the sadhana, the mantra needs to be recited continuously while you keep the mind focused on the clear and illusory enlightened form, in particular the seed syllable in the heart of the deity surrounded by a mantra garland, the deity's heart mantra. This is the *stake of the essence of the mantra.*

Finally, at the end of the meditation or during the final stage of retreat, you meditate on the emanation and aborption of light rays from the deity's body and mantra garland, achieving the twofold benefit. This is the *activity stake of projection and absorption.*

Tenpe Nyima says:

> These "four stakes that bind life force" are the Dharma terminology of the Old School of the Early Translations. Patrul Rinpoche said that since this is a unique pith instruction from the Second Buddha of Uddiyana, it is of the utmost importance.
>
> Likewise, it is said in a tantra:
>
>> A practitioner who possesses this stake can practice
>> An evil demon in a charnel ground, and still,
>> Whichever results he seeks, supreme or mundane,
>> Will automatically, spontaneously emerge.
>> Without realizing this stake, he will mistake the deity as
>> concrete.
>> In that mindset he may practice a wisdom being,
>> And perhaps reach some temporary, trifling result,
>> But an authentic fruition will be nearly impossible.[90]

The supreme methods of the Vajrayana utilize skillful means and knowledge and the supreme accumulation of merit and wisdom. Generating all appearances as the deity through the development and completion stages, encompassed by the three samadhis, the three things to remember, and the four stakes, incorporates both of these, through activity of body, speech, and mind. The artist must properly depict the Buddha's body and mandala

in her artwork, which is the physical activity. At the same time she practices visualization according to the development and completion stages, which accumulates merit and is the mental activity. The accumulation of wisdom comes from deepening the understanding that everything visualized and depicted by hand is by nature empty—a manifestation of enlightened qualities—until the profound inner realization of this truth is reached.

The *Oral Instructions of the Heruka* also says that visualization of the deity is the accumulation of merit. Understanding it to be illusory purifies attachment and accumulates wisdom, the realization of emptiness. This is the practice of the union of the development and completion stages, which has a profound meaning; in fact it is essential. It is also important to understand that there are many methods of visualization. It is not that one is correct and the others wrong. The main point is to follow whatever is said in the sadhana to the best of your ability.

As Gotsangpa explains:

> It is not the case that, having trained in one visualization, it is unacceptable to then train in another. All of this is the display of your mind. It is, however, unacceptable to be narrow-minded, thinking things like, "This and that do not fit together." This is the most important general point.

Jigme Lingpa also notes:

> You will go astray if you harbor doubts about the deity being a solid entity that can be touched and felt, and think that this one and the other cannot fit together, or that having taken up one, you must give up another. All such doubts are unnecessary![91]

Blessing and empowerment

After generating the visualization of the commitment being, one receives blessings and empowerments, and then the wisdom being is invited into the visualization. Along with the rest of these teachings, this needs to be studied and practiced in more detail under the guidance of your teacher in consultation with the texts and commentaries.

A common sequence that this might follow is described by Tenpe Nyima as follows:

In the bone mansion at the crown of the main deity, as well as in those of all the deities of the retinue, imagine a white OM syllable resting upon white discs. Red ĀḤ syllables rest upon red eight-petaled lotuses in the center of their throats. In their heart centers blue HŪM syllables rest upon sun discs in front of their hearts. Thus the visualized deities are sealed by clearly visualizing these three syllables as the essence of vajra body, speech, and mind. In some contexts, you may imagine that they are sealed by visualizing that the three syllables emit and absorb light and then transform into Vairochana, Amitabha, and Akshobhya, each of whom wears enjoyment-body ornaments. You then recite mantras, perform the gestures at each of your own three places, and generate the confidence of the three vajras.

Next, for the bestowal of empowerment, light radiates out from the seed syllable at your heart center, or from the heart center of the wisdom being, and invites all the sugatas, in the form of male and female empowerment deities of the five families, to come from their natural abode. Joined in inseparable union, the fire of their passionate desire creates a stream of the five wisdoms, which melts and flows down onto the five places at your crown, conferring empowerment and purifying the stains of the five afflictions. The liquid that overflows from the top of your head transforms into a crown endowed with the adornments of the five emanation-body families, with your own family in the position of the lord. By purifying the five aggregates, give rise to the confidence of the buddhas of the five families.[92]

The five buddhas abide on the jewel on the five-tiered crown, both of the peaceful deities and wrathful deities. If the deity has many heads, each head has the five buddhas. When inviting the five buddhas, if the yogi practices with great devotion, then through his heartfelt supplication, the deities of the three roots will naturally bestow their blessings.

e. Invoking the wisdom beings and requesting them to remain
The invocation
The invocation of the wisdom being is described by Tenpe Nyima:

From the letter HŪM at your heart center countless red light rays shine forth. These light rays, which are bent slightly inwards at

the tip like hooks, invoke the assembly of deities, the mandala of the victorious ones of the three roots who abide in manifold buddhafields that pervade all of space. As the embodiment of the manifold aspect of the dharma body, the deities are invoked along with their retinues, which include the guardian deities and Dharma protectors. . . .

Generate intense devotion and recite the words of the invocation melodiously while playing music and offering incense. With these words imagine countless wisdom beings identical to the deities of the visualized mandala—the supportive celestial palace together with its protective dome—along with whatever peaceful or wrathful deities are being invoked. Like snowflakes in a blizzard, they gather like clouds in the space above the samaya mandala, all the way out to the mountains of flames. These wisdom beings represent a display of illusory wisdom and an overwhelming mass of wisdom, love, and capacity.[93]

The request to remain
Tenpe Nyima also says:

> At this point you supplicate the entire wisdom mandala to merge indivisibly with yourself as the samaya mandala. Imagine that, with loving delight, the wisdom mandala dissolves into you like snowflakes landing on a lake and merges indivisibly with the samaya mandala. . . .

Jigme Lingpa writes:

> You must understand that the invocation, and so on, enable you to recall the primordial indivisibility of the samaya and wisdom beings; it is not as though you are placing one into another.

Moreover, Tsele Natsok Rangdrol explains:

> When making the invocation, it is not as though something "other" is invoked and then arrives from some other place. To purify impure deluded perception, we do indeed recite words that invoke particular deities by name, mention the places where they reside, and do other such things.

Nevertheless, in fact there is nowhere in the world of appearance and existence that is not pervaded by the magical display of self-aware awakened mind. Since this is the case, the innate awareness that is the samaya being is indivisible from the wisdom being; these are not two different things. Thus the wisdom being is invoked *as being indivisible* from the samaya being.[94]

In this context we recite the syllables JAḤ HŪṂ BAṂ HOḤ to summon, dissolve, and bind and for the wisdom being to joyfully remain with the samaya being. This stabilizes the merging of the samaya and wisdom beings.

The wisdom beings are requested to remain for various lengths of time, depending on the context: In our practice, it is until we attain the accomplishment of the practice. For a sand mandala, it is until the dissolution of the sand mandala. For a tangka or other artwork, it is until it becomes irreparably damaged.

f. Homage, offering, and praise

After the invitation to the wisdom beings and the request for them to remain come the verses of homage, offering, and praise. There are four sections: the homage, outer offerings, inner offerings, and praise.

Homage

Tenpe Nyima explains:

Ultimately, your mind and the deity are indivisible. Knowing this is the homage of meeting the view, and is the true homage. On a symbolic level, however, you still recall the qualities of the deities and respectfully pay homage, make offerings, and so forth in the following way. . . . Here you imagine that four knowledge goddesses emerge from your heart center as the main deity. From the four gates they exclaim, "ATI PU HOḤ" and the deities of the mandala respond "PRATĪCCHA HO." The goddesses are then gathered back into your heart center.

Alternatively, with a frontal visualization, the four emanated goddesses emerge from the heart center of yourself (visualized as the deity) and then pay homage to the deity visualized in front

of you. Meanwhile, four goddesses also emerge from that deity's heart center and offer homage back in response. To conclude, they are all gathered back into the heart centers from which they came. That is how Jigme Lingpa explained it. Patrul Rinpoche teaches that paying homage can simply mean showing humility and respect with your body, speech, and mind, and that it is not necessary for there to be a particular object to which homage is paid and one who pays the homage, regarding these as two different things.[95]

Offerings
The outer offerings
Tenpe Nyima says:

> First, to make the outer and inner general offerings imagine countless offering goddesses, in the form of the Vajra Lady and so forth, emanating from your heart center. Holding the seven enjoyments, the five sense pleasures, and other offering substances, they sing and dance. Each particle of the offering emanates inconceivable clouds of desirable objects that please and satisfy the deities. More specifically, the offering goddesses offer drinking water endowed with the eight qualities to the deities' mouths; clear, cool, and pleasing water to refresh their hands and feet; excellent garlands of divine flowers for their heads; the scent of natural and produced fragrant incense for their noses; jewels, butter lamps, and other lights for their eyes; medicinal waters scented with sandalwood and saffron for the deities' bodies; delicious and nutritious foods for their tongues; and the melodious sound of beautiful music that is blown, played, beaten, and so forth for their ears. To conclude, imagine that the goddesses dissolve into the very places to which they made offerings.

Jigme Lingpa explains further:

> In the context of offerings and praises, it is as if the deities are making offerings and praises to themselves. This, however, is indeed suitable, as it purifies impure worlds and beings into pure worlds and beings. When transformed into the development stage of emanated pure realms and

pure beings, where would you find someone ordinary to make offerings, anyway?[96]

Additionally, there are also beautifully arrayed offering substances; the offerings of absorption whereby the arrayed offerings are visualized and offered as the offering clouds of Samantabhadra; the offering of melody whereby you recite the verses of offering in a melodious manner; the offering of symbolic mudra, meaning gestures that are respectfully offered by means of the "revolving lotus"; and offerings of mantra, meaning ARGHAM and the other mantras of the offering verses.[97]

Inner offerings of amrita, torma, and rakta
The three inner offerings are amrita, torma, and rakta, as already described.

Amrita
Tenpe Nyima says:

> The inner offering of medicine [amrita] is a samaya substance that is composed of eight primary and one thousand subsidiary substances. It is derived from the realization that all phenomena are equal and are not to be accepted or rejected. As such, it is an elixir that dispels the demon of dualistic concepts. The unsurpassed great medicine has the nature of the four accomplishments and three ways of being.[98]

The *Heart Accomplishment of the Northern Treasures* says that the blessing of amrita purifies all breaches of samaya. When it is sprinkled on tormas and other offering substances, it purifies them, and when sprinkled on ghosts and demons, it banishes them.

Torma
The torma is symbolic of a special food offering, visualized as being offered in a large bowl made of precious substances.
Tenpe Nyima says:

> Visualize a vast and open jewel vessel. Inside is a torma made of various types of food and drink. Although it is made of all

kinds of desirable objects, in essence this torma is wisdom nectar. Imagine that the deities imbibe and partake of the torma with tongues that are hollow, made of light, and have the form of three-pronged vajras. This delights them. Next, imagine that countless torma goddesses of the sense pleasures, having aroused delight in the deities, dissolve into you. In actuality, here the food of the five objects and the drink of the five consciousnesses are enjoyed within the expanse of luminosity.[99]

Rakta

Rakta, or blood, is an offering that symbolizes the gathering of the afflicting emotions, especially miserliness. Tenpe Nyima says:

> Here you imagine the negative emotions, the root of the suffering of existence, coalescing in the form of blood. This is offered within the expanse of great bliss, free from attachment, to liberate intractable beings through compassion. To this end, imagine that this blood is completely consumed and samsara is liberated into unborn basic space.[100]

Offering of melodious praise

Tenpe Nyima says:

> Here praises are offerings of vajra songs. To offer praise, imagine that goddesses emanate from your heart center and devotedly call out melodious praises enumerating the ocean of qualities of the deities of the mandala. . . . These praises should be offered with the knowledge that the object of praise and the one praising are beyond meeting and parting.
>
> Alternately, you may also imagine that Brahma, Indra, and other great gods offer praise from the courtyard surrounding the celestial palace. Jigme Lingpa teaches:
>
> > Since the purpose of offering praise is to recall purity, you should be certain of the fact that the deity does not exist in and of itself.[101]

3. Mantra recitation

After the offering of praise is the section for mantra recitation, the yoga of enlightened speech. There are special visualizations associated with the mantra recitations. The details of these vital sections are not explained here; complete teachings should be received from an authentic guru after the empowerment is received.

4. Dissolving the visualization

The concluding section of the sadhana includes the recitation of vowels and consonants, the confession, and the dissolution of the visualization, referred to as the practice of radiant mind, which is part of the completion stage and is one of the extraordinary practices of the Vajrayana. Having performed the practices of enlightened body during the development stage and enlightened speech, the recitation of mantra and prayers, you now engage in the practice of enlightened mind, which corresponds to the purification of the bardos of dying, the moment of death, and the intermediate state.

Shechen Gyaltsap Pema Namgyal says:

> The steps in the process of purification are as follows. First, train as much as possible in the practices of deity and mantra as explained above. Then, when you are no longer able to continue the practice, perform the dissolution stage. It is said that if you did not cling to thoughts of a sublime deity during the preceding development stage, you can perform the dissolution stage all at once: simply let the entire mandala of support and supported vanish instantaneously like a rainbow fading into the sky. Then rest evenly within the great and supreme dharma body of the indivisible two truths, holding nothing in mind.
>
> If the case is otherwise, however, you will have to subsequently dismantle the mandala. In that case, first imagine that light from your heart center causes the entire pure external universe and its inhabitants to dissolve into light, which merges with the protection circle. Next, the inner layered elements gradually dissolve into the protection circle, which in turn dissolves into the charnel grounds. These dissolve into the celestial palace, the palace into the retinue, and the retinue into the primary male and female consorts, who dissolve into the wisdom being in the center of the heart. The wisdom being dissolves into the absorption being,

the seed syllable of the awakened life force, which itself dissolves gradually upward until reaching the tip of the syllable. After that fades away, rest evenly in the expanse of original purity, free of constructs, thoughts, and reference points. This eliminates the extreme of eternalism.

Afterward, utter the mantra by which you reappear in the form of the main deity, like a fish leaping out of the water. Bless the three places of your body, don "the armor for physical protection" and so on, and proceed to bring all experiences and activities onto the path as the play of the enlightened bodies and wisdoms. This eliminates the extreme of nihilism. Strive then to make your daily activities a continuous stream of practice.[102]

5. The samayas

Samaya means sacred commitment or vow. It is a term specifically used for the commitments taken when embarking on the Vajrayana path, which commences with your receiving an empowerment. The empowerment authorizes you to practice the sadhana of that deity, while you must maintain the commitments or samayas, which are profound, extensive, and difficult to keep. It is important to study and receive advice from your teacher on how to keep and repair the vows. Although there are many categories of vow, according to Jamyang Khyentse Wangpo they can be condensed into six that, if maintained, are adequate. These six samayas are (1) to see your guru as a fully enlightened buddha; (2) to do whatever will aid meditation and dharma practice; (3) to abandon anything that creates obstacles to practice; (4) to remain mindful while sleeping, walking, working, and so on; (5) to have no partiality for one sadhana practice over another and never forget that you are the deity from the time you begin the practice until the conclusion; and (6) to not divulge the mantra and other specifics of your practice to others.

6. Introduction to *A Supreme Liturgy for Artists*

The following *Supreme Liturgy for Artists*[103] is a ritual practice for artists composed by the great Drukpa Kagyu master, the third Khamtrul, Ngawang Kunga Tenzin. It is composed in a way similar to a sadhana but includes specific practices for artists such as blessing the pigments and consecrating the supreme art object. It is designed to be practiced alongside your sadhana practice while you do your artwork. You should first receive the oral trans-

mission for this text and have taken refuge in the Buddhist path, taken bodhisattva vows, and received Vajrayana empowerment. You can engage in the meditation instructions indicated within it according to the level of meditation teachings you have received. Following the liturgy for artists is a ritual to repair artworks, composed by the omniscient Jigme Lingpa.

In these liturgies, a double vertical line beside a section of text or square brackets indicate that the enclosed mantra or text is not present in the original Tibetan but is explicitly or implicitly indicated for inclusion or inserted according to tradition.

A SUPREME LITURGY FOR ARTISTS
By the third Khamtrul, Ngawang Kunga Tenzin

First is giving rise to bodhichitta:
Do not begin your art activity without the following consideration: First wash well and clean your work area, then be comfortably seated. Allow your mind to settle peacefully, and then recite the following verses without distraction, while integrating the meaning with your mind.

NAMO GURU RATNA TRAYĀYA

O powerful guru, Triple Gem, devas, dakinis, Mahakalas, and gods of wealth, I supplicate you.

Call out to the guru from your heart.

In all my lives from beginningless time until now, I have been caught in this endless cycle of birth and death. All my past actions have created inconceivable karma leading only to suffering. Not having taken refuge in the Three Jewels, I was unable to engage in the supreme practices of virtue. Thinking of this, I feel sad and weary.

Thus are the imperfections of samsara.

Now that I have obtained this precious human life, with all my faculties intact and with a clear mind, I can rejoice in my good

fortune. I have found the Buddhist doctrine and the authentic guides from whom I can learn the correct spiritual path and training. In particular, I am incredibly fortunate to have discovered the supreme arts. It is so rare to behold the body of Buddha Shakyamuni, and therefore I rejoice in my good fortune!

Thus contemplate the precious human life.

I contemplate impermanence: This precious life I now have is temporary, and it is impossible to know exactly when I or my loved ones will die. In addition, all that we enjoy and value in this life is as illusory as a magician's display, and still we fixate on the objects of the world and our lives as real and permanent. There is no doubt that these fixated attachments are misleading.

Thus contemplate impermanence.

I realize that we will infallibly reap the consequences of all our negative deeds. Through our deluded actions, samsara continues endlessly, as does our suffering.

Thus contemplate the causes and consequences of karmic actions.

Supreme art is a nirmanakaya display, through which faithful disciples can be transformed. The devout artist scholars have such great fortune, rare to find over many aeons. I have achieved this noble occupation through my former great accumulation of virtue, along with any diligent undertaking of good works performed in this life.

[Go for refuge:]

Through this excellent practice of skillful means, may I traverse the supreme path to enlightenment by drawing the supreme forms of the buddhas and bodhisattvas—not for the lower aims of acquiring food and gifts, nor for gaining happiness in future lives, but purely for the noble aims of the glorious tradition of the Buddhist teachings to increase; for the lives of the lord

gurus, holders of the teachings, to be long; for the holy dharma
to spread far and wide; and for the noble sangha to increase!

[Generate bodhichitta:]

May all mother sentient beings from the six realms of ignorance
inspired to faith through seeing a representation of the Buddha
be freed from their present suffering, along with its cause
and fruit, without exception! May their joy, happiness, and
prosperity increase like an ocean! May they quickly achieve the
final result of buddhahood!

For myself, my patron, and all beings, may negative
circumstances be dispelled, and may whatever auspiciousness is
desired arise in excellent abundance! May we be propelled out
of samsara and attain supreme enlightenment!

For the sake of swiftly achieving all relative happiness and
ultimate enlightenment, through this activity, may this
supreme intention be unceasing, and may virtuous actions be
unobstructed until the achievement of complete and manifest
enlightenment.

Through the power of this truth, may this true accomplishment
come to be!

Second is the blessing:
Take some new, clean white cotton cloth and wash it with pure water and
milk mixed with ghiwang and gandabhadra, along with scented pow-
ders, medicinal roots, and other pure substances. Stretch the cloth on the
frame and apply the white gesso mixed with earth from sacred places such
as in India, China, or Tibet and blessed substances of body, speech, and
mind. First anoint it with scented waters, and then give rise to divine
pride.
Summon the obstacle makers and offer torma with:

You who may cause obstacles to my crafting a likeness of the
victorious ones,

Their children, or other noble beings, whether in painting or
 sculpture,
Take this torma possessing the five desirable qualities, stop
 causing obstructions, and get out!
If you don't listen you will be annihilated; leave before we
 destroy you!

OM SUMBHANI SUMBHANI HŪM
GRIHNA GRIHNA HŪM
GRIHNĀPAYA GRIHNĀPAYA HŪM
ĀNAYA HOH BHAGAVAN VIDYĀRĀJA HŪM PHAT

*Thus recite the wrathful mantra of the four HŪMs while throwing white
mustard seed and burning frankincense.*
Meditate on the protection wheel with:

VAJRA JÑĀNA RAKSHA BHRŪM

*Then, as stated below, prepare a table facing east and place your canvas
upon it. Sprinkle it with clean water while reciting RAM YAM KHAM and
then recite the following [purification] dharani twenty-one times:*

NAMAH SAMANTA BUDDHANĀM / BODHISATVA APRATIHATA
GATI MATI PRACHĀRINI / NAMAH SAMSHODHANA
DUHKHA PRASHAMA INDRA RĀJAYA / TATHĀGATĀYA
ARHATE / SAMYAKSAMBUDDHĀYA / TADYATHĀ / OM
SHODHAYA / SAMSHODHAYA / SARVA VIGHNAN / GATAKA /
MAHĀKARUNIKA / KUMĀRA / RŪPA DHARINI VIKURVA /
VIKURVA / SAMĀYA / MANU SMARA TISHTHA HŪM HŪM
PHATRA PHATRA SVĀHĀ /

*You, the artist, should remain in a virtuous frame of mind and, after wash-
ing, anoint your body with saffron and sandalwood, cleanse your mouth
with camphor, and put on clean clothes. You should feel lighthearted and
free from hunger and thirst.*
*Upon the pure ground of this canvas that is naturally adorned with
marvelous qualities, using clean water mixed with relics and other blessed
substances, paint the outline and composition of whichever deity you are*

going to depict. In particular, paint a white OM *at the crown, a red* ĀḤ *at the throat, a blue* HŪṂ *at the heart, and below that the particular seed syllable of the deity you are painting. Then at the navel write a yellow* SA, *and at the secret place a green* HA. *You should also paint other syllables connected to the particular ritual you are undertaking or to the specific deity to be painted.*

Third is inviting the deity:
Recite the liturgy while visualizing that light radiates, inviting the wisdom deities—the awakened ones' wisdom body, speech, mind, qualities, and activity—from myriad buddha fields. They arrive in the aspect of five-colored light rays that dissolve into the canvas through the seed syllables.

HŪṂ

The impure outer phenomenal world transforms into vast infinite purity. In the middle of these pure lands of sublime qualities, perfected through the power of the aspirations of the buddhas and bodhisattvas, abides a celestial palace made from various precious jewels, in the center of which are seated, on vast, multicushioned thrones, together with the holy dharma and classes of sangha, the nonsectarian root and lineage gurus; all the mandalas of deities of the old and new traditions; dakas, dakinis, and great dharmapalas; wealth deities; and terma guardians. With sincere faith I invite and request you all to come to this place. May you all joyfully be seated in your respective places.

Please accept these pure offerings, cleansing water for the feet, and other offerings. With great respect of body, speech, and mind, I continuously prostrate. To the limitless oceanic pure lands, I offer cloud banks of outer, inner, secret, and suchness offerings, both actual and manifested by mind, accomplished through an inconceivable, inexhaustible accumulation of merit and wisdom.

With great faith and rejoicing, I offer praise with pure, devoted mind to the unceasing ornamented wheel of the body, speech, mind, qualities, and activities of all the buddhas.

Contemplate in that way, and recite the mantra of your main practice. If you have a special practice mantra, you can recite this at the end. Then recite the mantra of vowels and consonants.

A Ā / I Ī / U Ū / ṚI ṚĪ / LI L̥Ī / E AI / O AU / AṂ AḤ //
KA KHA GA GHA ṄA / CHA CHHA JA JHA ÑA / ṬA ṬHA ḌA ḌHA
ṆA / TA THA DA DHA NA / PA PHA BA BHA MA / YA RA LA VA /
SHA ṢHA SA HA KṢHAḤ //

Fourth is the supplication and aspiration prayer:
With your hands folded, recite the following supplication and aspiration prayers one-pointedly:

> All buddhas and bodhisattvas dwelling throughout the ten
> directions and three times,
> The holy dharma and the noble sangha, all the nonsectarian
> gurus of India and Tibet,
> The venerable precious one of great benevolence and
> unrepayable kindness,
> All the yidam deities of the mandalas of the old and new
> traditions,
> Along with the dakas, dakinis, dharmapalas, protectors, wealth
> deities, and terma guardians,
> I beseech you, please heed my call:
> Accept and enjoy my performance of this ritual, and shower
> down your blessings.

Recite this supplication prayer three times, then the following aspiration prayer. This is generally how it is done. However, you can also recite the prayers from your own daily practice.

> Through the merit of my drawing the supreme form of the
> Buddha, bodhisattvas, and sangha,
> May we always be taken into their care and never be apart from
> them until attaining the ultimate fruition,
> And may we have the power to guide sentient beings through
> our enlightened manifestations.
> By the supreme blessing of my depicting the root and lineage gurus,
> May my and others' mindstreams be liberated.

Through my drawing images of the peaceful and wrathful
 yidams,
May the supreme and mundane siddhis be attained.
Through my creating images of dakas, dakinis, and
 dharmapalas,
May all activities be accomplished without obstruction.
Through my depicting wealth deities, protectors, and local
 deities,
May all noble aspirations be accomplished.
In short, whichever forms of buddhas and bodhisattvas I depict
 at this time,
May all objectives become manifest.
Through my supplication prayers recalling the qualities
of enlightened body, speech, and mind,
May we all attain enlightenment in the great equanimity.
I offer all compounded worlds and universes with their
 contents,
Depicting the ground, the precious mountain, the vast and
 even oceans,
Rocks, mountains, and forests,
So that we may be reborn in a pure buddha field.
May I and all beings—gods, demigods, humans, nonhumans,
 animals,
And the infinite variety of sentient beings inhabiting samsara—
Attain the excellent support of a pure body.
Through the power of my depicting the beings of the six realms
 of unending suffering [the Wheel of Existence],
May all sentient beings be liberated from experiencing the
 ripening of their karma
And, without exception, be purified of all negative karma, its
 causes, and its results.
Through my depicting the excellent jeweled palaces and
 pleasing thrones and cushions,
Beautiful clothes, myriad designs, necessary articles, and various
 offering substances,
May I and all sentient beings attain the perfection of the two
 accumulations.

Through my depicting the entire glorious wealth of both
 samsara and nirvana, whatever there is,
May I and others be able enjoy at all times and in abundance all
 the sublime desirable wealth.
Through my depicting an array of objects to do with the four
 activities of
Pacifying, increasing, magnetizing, and subjugating,
May beings' performance of the four activities be accomplished
 spontaneously without obstruction,
and may they arrive at the excellent level of the four vidyadhara
 stages.
In this way, may these fortunate ones be purified of their
 afflicting emotions,
Karma, and cognitive obscurations.
May they possess the power of virtue of body, speech, and mind
And thus perfect the two accumulations of merit and wisdom,
Swiftly achieving the sublime fruition of the two kayas.

*Thus it is said. The wisdom deities arise from their respective places on
the tangka cloth and dwell a forearm's length above the tangka. They cast
their shadows on the cloth as the form deity, like a reflection in a mirror,
and this gives rise to the appearance of the empty form of the deity to be
committed to the canvas.*

Fifth is the ritual to bless the pigments:
*In front of you prepare a clean, elevated space. In its center, place the white
pigment and, surrounding it, to the east, the blue; to the south, yellow;
to the west, red; and to the north, green pigment. Each is surrounded by
its associated pigments. Arrange the cleansing water of camphor, frank-
incense, and sandalwood. All should be pure of color, unblemished, and
surrounded by the sevenfold offerings and tormas.*

In the middle is a white OM, to the east a blue HŪM, to the
south a yellow TRĀM, to the west a red HRĪH , and to the north
a green ĀH. Clearly visualize yourself as your yidam deity, and
from the three syllables in your three places lights radiate to all
the buddha fields in the ten directions, inviting all the buddhas

in the form of the five family buddhas along with their retinues.
Like a swirling blizzard they descend and dwell in the sky in
front of you.

Present the offerings by reciting the following along with playing music:

OṂ VAJRA ARGHAṂ PĀDYAṂ . . . up to . . . SHABDA PRATĪCCHA
SVĀHĀ.

Praise with:

Inseparable from the sky-like expanse of the dharmakaya,
The rainbowlike rupakaya appears in full radiance.
I pay homage and prostrate to the buddhas of the five families,
Who have unified method and wisdom!

OṂ HŪṂ TRĀṂ HRĪḤ ĀḤ

*Recite twenty-one times. Then, joining your hands together, recite this
prayer:*

The pure wisdom of the dharmata
Is none other than the great victor Vairochana.
Liberator of beings,
You embody the buddha family.
The pure mirrorlike wisdom
Is none other than the great victor Akshobhya.
Liberator of beings,
You embody the vajra family.
The pure wisdom of equanimity
Is none other than the great victor Ratnasambhava.
Liberator of beings,
You embody the ratna family.
The pure wisdom of discernment
Is none other than the great victor Amitabha.
Liberator of beings,
You embody the padma family.

The pure all-accomplishing wisdom
Is none other than the great victor Amoghasiddhi.
Liberator of beings,
You embody the karma family.
Buddhas of the five families,
Pray come from your pure abodes
In your radiant wisdom kayas,
The very expression of emptiness.
Transform through the five syllables
These five samaya pigments
Into the five precious substances
And abide therewith.

With JAH HŪM BAM HOH they become inseparable.

With this, the wisdom beings dissolve into the seed syllables, which in turn dissolve into light and then dissolve into the pigments, which become inconceivable heaps of precious substances, blessed as being the nature of the five inexhaustible wisdoms. From here prepare and sift the pigments, keeping them in a clean place.

When you begin to paint the outline of the deities, imagine your right hand to be method (the father) and your left hand to be wisdom (the mother). You should consider whatever you paint to be the child of their union. Then if you want to depict buddha realms and palaces and so on, imagine that you are the universal monarch and that you offer the contents and container (universe and beings) to the mandala. Make aspiration prayers in the same way as before. Similarly, when depicting ornaments and cloth, visualize that you are the patron and offer these to the deity.

Imagine that the pigments are made from pearls, conch, silver, crystal, indigo, vaidurya, sapphire, bhurlen, gold, cat's eye, coral, ruby, brown ruby, emerald, turquoise, and so on. Through the perception of the pigment as extraordinarily precious, the two accumulations are accomplished and obscurations purified. Also, whoever sees, hears about, or simply thinks of this

object of veneration will achieve the two kayas; therefore, it is imperative to visualize in this way.

Sixth is the consecration of the supreme image:
There are two rituals, one brief and one extensive. The brief one is suitable to do in the evening. With the arrival of dusk at the end of the day, the wisdom beings in the sky are dissolved into their depicted form (the commitment beings). After doing the supplication prayers as above, recite the additional verses [below]: the mantra of dependent origination and the supratishta mantra for stabilizing the blessings. Then scatter flowers and present offerings.
 Verse of transformation:

Please abide with these objects of veneration I have made,
And may your blessings continuously remain, I pray.

The Essence of Dependent Origination Mantra:

OM YE DHARMĀ HETU-PRABHAVĀ HETUM TEṢHĀM
TATHĀGATO HYAVADAT TEṢHĀM CHA YO NIRODHA EVAM
VADI MAHĀSHRAMAṆAḤ SVĀHĀ

Recite many times, then the mantra for abiding:

OM SUPRATIṢHṬHA VAJRAYE SVĀHĀ

Scatter flowers.

The next morning, commence with the usual prayers, and before starting your drawing, invite the wisdom beings into the sky as explained previously. When the tangka is completely finished, you can perform a brief or an extensive consecration ritual. For the extensive consecration, you will need to consult another text. For the brief consecration, you need to prepare the offerings and bless the object with ritual materials, vase, and so on. If, however, you are unable to do this, you must at least visualize it. After reciting the refuge and bodhichitta prayers, dispel the obstacle makers and perform the cleansing ritual with the mirror and vase.

Although the body, speech, and mind of the buddhas are free of
 imperfections,
In order to purify the obscurations of the body, speech, and
 mind of sentient beings,
Through my performing these purification rites of sprinkling
 with pure water, medicines, and incense,
May the obscurations of the body, speech, and mind of all
 sentient beings be purified.

OṂ SARVA TATHĀGATA KĀYA VISHVA DHANAYE SVĀHĀ /
VAKKA SHĪSHVA DHANAYE SVĀHĀ / CHITTA SHĪSHVA
DHANAYE SVĀHĀ / OṂ MALA SAṂVĪSHVA DHANAYE SVĀHĀ /

*[While reciting the above mantra, cleanse the object of veneration by
pouring water from the vase onto the reflected image in the mirror.]*

Let us dry you with cloths beyond compare,
Immaculate and well anointed with perfumed scent.

Then the mantra:

OṂ HŪṂ TRĀṂ HRĪṂ AKĀYA SHĪSHVA DHANAYESHVĀHĀ

*[While reciting the above mantra, "dry" the reflected object of veneration
with a white scarf].*
 Purify with the practice [dharani mantra] as quoted before:

NAMAḤ SAMANTA BUDDHANĀṂ / BODHISATVA
APRATIHATA GATI MATI PRACHĀRINI / NAMAḤ
SAMSHODHANA DUḤKHA PRASHAMA IṆDRA RĀJAYA /
TATHĀGATĀYA ARHATE / SAMYAKSAṂBUDDHĀYA /
TADYATHĀ / OṂ SHODHAYA / SAṂSHODHAYA / SARVA
VIGHNAN / GATAKA / MAHĀKARUṆIKA / KUMĀRA / RŪPA
DHARIṆI VIKURVA / VIKURVA / SAMĀYA / MANU SMARA
TIṢHṬHA HŪṂ HŪṂ PHAṬRA PHAṬRA SVĀHĀ /

[Repeat three or twenty-one times]

Then invite and request them with the words: "The impure outer phenomenal world transforms into vast infinite purity."

The impure outer phenomenal world transforms into vast infinite purity. In the middle of these pure lands of sublime qualities, perfected through the power of the aspirations of the buddhas and bodhisattvas, abides a celestial palace made from various precious jewels, in the center of which are seated on vast, multicushioned thrones, together with the holy dharma and classes of sangha, the nonsectarian root and lineage gurus; all the mandalas of deities of the old and new traditions; dakas, dakinis, and great dharmapalas; wealth deities; and terma guardians. With sincere faith I invite and request you all to come to this place. May you all joyfully be seated in your respective places.

Visualize the deities and with ARGHAM ... present offerings and with the supplication prayer "All buddhas and bodhisattvas dwelling throughout the ten directions and three times ... ," request them to be seated, and make further supplications using the previous prayers.

All buddhas and bodhisattvas dwelling throughout the ten
 directions and three times,
The holy dharma and the noble sangha, all the nonsectarian
 gurus of India and Tibet,
The venerable precious one of great benevolence and unrepayable
 kindness,
All the yidam deities of the mandalas of the old and new
 traditions,
Along with the dakas, dakinis, dharmapalas, protectors, wealth
 deities, and terma guardians,
I beseech you, please heed my call:
Accept and enjoy my performance of this ritual, and shower
 down your blessings.

Burn incense and pay homage:

> Pure Vajra Tathagata,
> Sovereign of all families,
> I pay homage and sing praises.
> Vajradhara, to you
> I offer what I am able.
> This supreme support of body, speech, and mind
> Consecrate in order to benefit beings.
> Lord protectors, the embodiment of great compassion,
> Please all dwell here now.
> Consider us with love and affection.
> Compassionate ones, please always remain.

Thus supplicate three times, mingling the commitment being [the support] and wisdom beings.
 With JAH HŪM BAM HOH the commitment and wisdom beings become inseparable.
 Now for the supreme cleansing ritual:

> This is the supreme, most glorious cleansing.
> The water of compassion is unsurpassed.
> With this consecrated wisdom water,
> Grant us whatever accomplishments we desire.

OM SARVA TATHĀGATA ABHISHEKATA SAMĀYA SHRĪYE HŪM

In this way cleanse [with the vase and mirror] and recite the mantra.

> The five aggregates are thus completely purified,
> Through which the five afflicting emotions are cleansed.
> This pure water is the very nature of the five wisdoms.
> Thus may all be completely purified through this cleansing ritual.

OM SARVA TATHĀGATA ABHISHEKATA SAMĀYA SHRĪYE HŪM

[Cleanse with the vase and mirror, and again during the Vajrasattva mantra]

Recite the hundred-syllable mantra.
 Joining your palms, supplicate in the following manner:

> Revered precious lord gurus
> And the precious Triple Gem,
> Host of deities of the great mandala,
> The quintessence of all *guhya* mantras, *vidya* mantras, dharani
> mantras, mudras, and samadhis,
> May this receptacle for which I, the vajra holder, perform
> consecration
> Become an object of obeisance and offering for all sentient
> beings.
> May it actually function as the symbol of the nirmanakaya.

*Repeat three times and, as explained previously, recite the words of praise
with: "Please accept these pure offerings . . ." Recite praises and the sev-
en-branch prayer, then perform offerings.*

> Please accept these pure offerings, cleansing water for the feet,
> and other offerings. With great respect of body, speech, and
> mind, I continuously prostrate. To the limitless oceanic pure
> lands, I offer cloud banks of outer, inner, secret, and suchness
> offerings, both actual and manifested by mind, accomplished
> through an inconceivable, inexhaustible accumulation of merit
> and wisdom.

> With great faith and rejoicing, I offer praise with pure, devoted
> mind to the unceasing ornamented wheel of the body, speech,
> mind, qualities, and activities of all the buddhas.

> In the same way as the supreme Samantabhadra made
> aspiration prayers,
> With an immeasurable cloud of offerings that delight the
> conquerors,
> I also offer with a mind full of devotion.
> May you, sublime objects of offering, accept it!

OṂ SARVA TATHĀGATE ARGHAṂ . . . SHABDA PRATĪCCHA
SVĀHĀ ĀH HŪṂ

Offer praise with the following verse:

> With bodies as numerous as atoms in the universe
> We offer prostrations.
> With supreme devotion we pay homage
> To all those worthy of praise.

Recite the mandala offering prayer. Then, placing your hand on the sacred image, recite the following prayer:

> Until the destruction at the end of the aeon by fire, water, and
> wind,
> May the merit of the patron increase.
> For the sake of all sentient beings,
> Just as the perfect Buddha
> Remained in the supreme abode of Tushita,
> Then magically entered the queen's womb,
> Likewise here now, please reside!
> Lord protector, always remain!
> Please accept these flowers and offerings
> For the sake of all sentient beings.
> Please grant the mind of enlightenment.

Recite this three times and thereafter the supratishta (mantra of support), the mantra of dependent origination, and the mantra of vowels and consonants. Recite auspicious verses and verses expressing the truth of the Three Jewels.

Seventh is the meditation on the protection circle:
From the beginning of your enterprise through to the consecration at its completion, meditate on the region and mountains as Vajrapani, his form reaching from the four winds at the base of the universe up to its highest peak, the celestial realms.

Within his heart, our abode, is Lord Avalokiteshvara, as vast as Mount Sumeru.

Inside his heart are the tangka composition and the learned artist, indivisible from Manjushri.

This is the stacking of the threefold sattvas.

You, the artist, should never be separate from this visualization until the artwork is brought to its conclusion. It is crucial to remind yourself of this.

The middling visualization is to meditate upon the protection canopy, fence, and ground—your abode, environment, and everything between—as composed of vajras, a mountain of fire, and weapons.

At the very least you should paint while visualizing your brushes as vajra weapons—arrows, swords, and the like, filling space as an uninterrupted, vast treasury.

The tangka composition together with the paint and brushes must remain together inseparably until the final consecration of the artwork.

Previously, in the holy land of India, all the panditas and scholars practiced the three sattvas, protection substances, and so on. The tradition of Sinchung Tulku is that of visualizing the paint, brushes, ritual weapons, tent, and so on. After that Kura Lhachen's tradition is that of visualizing the protection tent and so on. Now in Tibet the wise and learned ones choose in various ways from these three protection visualizations and state that if the artist remains unseparated from her tangka, the deity will not be possessed by a demon. These words are agreed upon by all.

Conversely, if left without protection, even the smallest deity drawing will be possessed by demons, which are ever waiting. Just as a fisherman watches attentively at the ocean shore for his catch, they also eagerly watch for any opportunity to inhabit the sacred image, causing terrible harm to this virtue.

If this happens, in this very lifetime the nine misfortunes will occur. Therefore it is crucial to protect the artwork from obstacle makers in this way.

Previously we mentioned the consecration, which is the supreme protection circle, superior to the rest. Anyway, I have written here on the subjects of these traditions, for the sake of their preservation.

Eighth is the main practice, which includes the essential heart point:

From the point of taking refuge and generating bodhichitta,
This teaching shows the proper way to implement the practice
 of the ultimate truth, intrinsic reality.
All phenomena of samsara and nirvana are your own mind;

Mind itself recognizing its nature.

This is the heart essence of all dharma practice.

Unmistaken and undistracted, look at it!

When thoughts arise, even then, recognize this as your own mind.

This meditation is enough; other meditation practices alone
will not suffice.

Now have determination, and with mindfulness rely only on this.

Concentrate on the point of the brush in this mode, and

Without wavering from this meditation, conduct your drawing.

Awareness may be unchanging, or many different concepts may
arise.

Similarly, the design of your drawing also comes from
conceptualization;

Whatever arises, however things appear, maintain your practice
of mindfulness.

Remind yourself of this practice when distracted, again and
again.

During any activity, do not be distracted.

Whether awareness is clear or diminished, let it be.

Whatever meditative experiences arise, leave things as they are.

Whether outer or inner, good or bad, happiness or suffering,

In this way all defects are brought to the path.

All this being understood through your diligence is excellent.

All the teachings of Mahamudra, Dzogchen, and Madhyamika
are contained herein,

And it will lead to the increase of experience and realization.

The cornucopia of appearances created by drawing is
manufactured by hand.

So too, the explanation on mind:

Samsara and nirvana, good and bad—all experiences are one's
own mind.

Whether mind is abiding or wandering, high or low,

Any experience, however it may manifest, is simply the activity
of awareness.

Therefore, at all times practice in the manner of absolute
evenness;

Leave things as they are, unaltered.

Maintain this spontaneous self-recognition.

This is the path of the supreme essential point.
The main point is the primordially pure nature, dharmadhatu,
 basic space.
The inherent potentiality, the spontaneous natural expression,
 is the unceasing nirmanakaya display.
From the unity of these two arises the great bliss of the
 enjoyment dimension of awakening,
the sambhogakaya.
May the majestic realm of the three kayas be accomplished!

*In this way, recite these verses, and incorporate the meaning into your
experience.*
 Thus continuously practice this path of activity.

Ninth is the condensed teaching:

In this way, the former and latter explanations give the principal method to
rely on for following the stages and experience of the path.

 First, in the morning session before practicing anything else, take ref-
uge, generate bodhichitta, and do the invocation and the seven-branch
prayers. Recite and meditate upon the supplication and aspiration prayers
in sequence, and then with diligence incorporate this with your mind.

 In the evening, safeguard the image with the detailed protection visual-
izations and consecration ritual or with the abridged versions, using which-
ever visualization is suitable.

Tenth is the virtuous dedication:

Light rays radiate from the three secrets of the objects of refuge
 in the merit field.
They converge and dissolve into my three places and those of all
 sentient beings of the three worlds.
Our obscurations cleared, we are blessed as possessed of the
 three vajras.
Dissolving into luminosity, I and the support become nondual.
I dedicate my meritorious deeds performed through earnest
 diligence.

May all the virtue performed by the buddhas, bodhisattvas,
 and all beings in the three times of samsara and nirvana come
 to fruition!
May whatever we long for and desire be accomplished!
Finally, may the victorious state be accomplished!

*In this way, request blessings and perform the abridged dedication at the
end. The dedication, aspiration prayers, words of auspiciousness, and the
like, I request you to please complete.*

*This is the exalted speech of the third Khamtrul, Ngawang Kunga
Tenzin.*

A RITUAL TO REPAIR ARTWORKS
By Jigme Lingpa

*This [ritual] is done when statues, stupas, temples, or any kind of broken
sacred object of veneration needs to be repaired or is made with inferior
materials that you would like to improve. It is also performed when a
sacred object is relocated to a better place or, in short, when anything is
done to improve or enhance it. This "restore and repair" ritual is thus
explained here.*

*Whichever sadhana you wish to use, it is necessary to perform it com-
pletely. In front of the sacred object, arrange the substantial offerings
along with tormas for the Mahakala and local deities in an elaborate
way. On the table in front of you place a clear mirror. The sacred object to
be repaired must be placed so that it is reflected in the mirror. Think in
the following way: "I am going to invite the wisdom being from the object
to be repaired into the mirror to improve it for the benefit of all sentient
beings." With that, hold the vajra and bell and recite the following words:*

NAMO

Gurus, buddhas, and bodhisattvas gathered and abiding within
 the oceanic myriad of buddha realms throughout the ten
 directions,

All who have gone to bliss, victors along with your offspring and
entourages in all your infinitude, kindly pay me heed.
I make offerings and request that you kindly come from your
excellent abode so that I can restore [the tangka or statue];
please abide with your blessings in this reflected image.

Recite three times.

Hook-shaped light rays radiate from my heart to summon the
wisdom deity from the support in the aspect of the three
syllables, which become nondual with the image reflected in
the mirror.

Recite:

JAḤ HŪṂ BAṂ HOḤ

*Thus bind with the four mudras. Recite the hundred-syllable mantra,
then recite the essence of dependent origination mantra many times.
Stabilize with the supratishta mantra. Make offerings with OM VAJRA
ARGHAṂ, etc. Recite praises as appropriate, and scatter flowers during the
verses of auspiciousness.*

*Take the mirror, ensuring that it is not turned upside-down, and wrap
it with red or yellow cloth, then tie it behind and seal it. Respectfully
place the mirror in a shrine room or a high place worthy of offerings, and
continue to supplicate it as an object of veneration.*

*Once the restoration is complete, at the time of the actual consecration
of the repaired sacred object, place the mirror on the shrine and uncover
it. The time has come for the wisdom being [in the mirror] to return to its
[original] support; so, as before, with the radiating and retracting of light
rays, the four immeasurable mantras of increase and stability, invite and
request the wisdom beings to permanently abide with the restored object
so that they are inseparable. Thereafter, from inviting the wisdom beings
to the consecration [supratishta], as in the customary consecration ritual,
continue the sadhana to the end.*

*[When repairing the image] one should try to mix as much as possible
of the old material with the new. If this is not possible, then one should
not use the old material for something ordinary, but use it to make stupas
or tsatsa or the like, and perform a consecration ceremony. These are the
words of Jigme Lingpa.*

III. Mandala Measurement
and Iconometry

THESE TEACHINGS are mostly relevant for those training in this discipline under the guidance of a teacher. Mandala and deity drawing cannot be learned entirely from a book and should be studied with a teacher, starting with the preliminary teachings and drawings. These teachings and the accompanying glossaries and illustrations are intended to clarify and broaden an artist's working knowledge or to provide a basis from which a beginner can work with a teacher.

There are two main topics: the preliminary measurements and the main measurements. Each has further subtopics.

A. The Preliminary Measurements

There are two parts to this teaching: drawing the preliminary eight lines and the measurement for the naga king. These are taught as preliminary drawings because the eight lines are required before beginning your drawing, and the naga king measurement is required as a preliminary to various important activities.

1. The preliminary eight lines

Here there are two main elements: the sky lines and the working lines. These are necessary for both mandala and deity drawing.

a. The sky lines

The sky lines refer to the preliminary eight lines ritually "drawn" in the sky above where the mandala is actually going to be drawn. They are sometimes called sky lines and sometimes wisdom lines.

The tantra known as the *Lotus Stages of Activity* says that the string used to draw the sky line for peaceful-deity mandalas should be made from

flowers or other natural substances. The string for a wrathful-deity mandala is made from human or animal skin. More commonly, ordinary cotton string is used, but it must be clean and of good quality. It is best not to haggle when buying the materials for a mandala (or any religious offering or artwork). The string should ideally be made by a young girl of sixteen years or less and spun from five or twenty-five different colors, in cotton or wool. There are many ways to bless the five-colored string, so it is best to follow the directions given in the sadhana that is being practiced. One method is to consider that the five-colored string embodies the seed syllables of the five wisdom buddhas in union with their consorts. Invite them into the sky above and from their point of union five-colored lights radiate and dissolve into the string, becoming inseparable with it. Another way is given in the *Union of the Buddhas Tantra,* which says to place the string in a skull cup, considering it to be inseparable from the five wisdom buddhas. Invite the buddhas to be seated on lotus, sun, and moon disk seats, then recite verses of offering and praise along with the mantra of the main deity.

It is explained in the *Heruka Galpo Tantra* that when the sky lines are made, one person is designated as the vajra master and another as the consort. They stand at opposite sides of the area where the mandala is to be drawn and generate a firm conviction in themselves as the deity. Reciting the syllables JAḤ JAḤ, they pick up the string with thumb and index finger and stretch it tautly across the area where the mandala is going to be drawn. They then pull the string downward a little and let it go so that it springs upward, in the same way as is done when actually making a line,[104] and snap their fingers in the sky above that. In the sky above the string a large wisdom mandala is visualized. The second line is made in the same way, except that the string is pulled upward and let go, and they visualize a mandala of the world below the wisdom mandala. These first two lines are made without moving to either side.

The vajra master and consort then begin "drawing" the eight lines, holding vajra and bell along with the string. The first central line, called the *tsangtik*—literally, "Brahma line"—is drawn across the center from "east" to "west." In drawing a mandala or tangka, the east is always symbolically designated directly in front of the viewer/artist, that is, at the lower edge of the mandala or tangka. The first line of the mandala, which is a map of the cosmos, is named after Brahma because ancient Indian cosmology says that Brahma was the first being in this universe, from whom all other beings derived. All subsequent lines are measured from this central line.

The vajra master stands directly to the west and the consort to the east, and they snap the string in the air in the same way to make this first east-west Brahma line (the central line). Each time they snap the string in the air, the vajra master rings the bell. Next the vajra master goes to the south and the consort to the north, and they make the second Brahma line (the horizontal axis). Then they commence the outer square border lines: The vajra master goes to the southeast corner and the consort to the northeast, and they make the eastern line of the square. The vajra master then goes to the northwest corner and the consort to the southwest, and they make the parallel western line of the square. The vajra master remains there and the consort moves to the northeast corner, and they make the northern line. Then the vajra master moves to the southeast and the consort to the southwest, and they make the southern border line. To make the diagonal lines from corner to corner, the vajra master remains in place and the consort moves to the northwest, and they make the diagonal line across the center. The vajra master moves to the southwest and the consort to the northeast, and they make the last diagonal line, thus completing the eight sky lines. This concludes the teaching on making the eight ritual sky lines or wisdom lines.

b. The working lines

The material required for the working-line string is the same as for the sky line. Lochen Dharmashri says the length of the string should be double the width of the mandala from the outer parapet,[105] or double the diameter of the mandala. When one is making the eight lines, marks should not be left by the chalk string on the outer areas of the mandala, which is why it is important to make the length of the string precise. However, he also said that it is not really necessary to have the string any longer than the span between the door archways because the lines are not needed for the other areas. The thickness of the string is said to be one-fifth of one *chatren*,[106] that is, one-twentieth of the mandala door width.[107]

For the mandala of a peaceful deity, the string is made from white cotton or wool. For the mandala of a wrathful deity, it is to be made from the hair of a dead person or from animal or human skin or intestines. If the mandala includes both peaceful and wrathful deities, wool and cotton can be used. Use either three or nine colors, among only white, red, blue, black, orange, yellow, light red, light blue, and light green. *Lotus Stages of Activity* says that the material for the working line should be made from clean and pure white cotton or wool, made by a young girl. The string should be smooth

and without knots. The length should be double the width of the mandala and the thickness one-twentieth of the mandala door's width. The size of the string is the same as for the wisdom lines.

The string is blessed by your considering it to embody the syllables OM ĀH HUM and inviting the buddhas to come and bless it. From their body, speech, and mind centers, white, red, and blue light rays radiate and dissolve into the string. Through this blessing, the string becomes inseparable from the body, speech, and mind of the Buddha. If the string is made with nine different colors, just consider that the syllables OM ĀH HUM are multiplied by three.

For the working lines, first you prepare the base for your mandala drawing. Take some amrita made from five substances and mix this with white pigment and water. Dip the string in the amrita and then strip any excess from it. This time it is the artist and helper who consider themselves to be the deity and his consort. The line is the deity's body, speech, and mind. When making the eight working lines, the artist does not hold the vajra and bell, but other than that the process is the same as before. However, it is easier to make the square lines if the diagonal lines are made first. Of course, this time the lines are made in actuality, not symbolically in the sky above as for the sky lines.

When making either the sky or working lines, it is important not to make any mistakes, such as dropping the string or stepping on it. When the lines are complete, make offerings to the string and request the buddhas of the five directions to leave it. In this way negative karma will not be accumulated if the string is accidentally left on the ground or stepped over. If, when marking the lines, you sometimes need to step over the string or the lines of the mandala, first chant the syllable HRĪH in a sonorous voice and visualize the deity of the lines rising into the sky above you. Then you can step over the string. The wisdom or sky line is considered to be wisdom, like a vessel or mandala, and the working line is the skillful means, like the deity. Both are emanated from the dharmakaya.

c. Two methods for drawing the eight lines

There are two methods for drawing the eight lines: finding the center from the outside and finding the outside from the center.

i. Finding the central point from the outside

Depending on the required size of the mandala, first roughly estimate the center and draw the Brahma line. Then divide the Brahma line evenly into

four, from the outer edges. Take a compass and open it to the length spanning two of these points. Using this measurement, place the compass point on the first quarter mark from the outside and make light marks to the right and left of the central line, corresponding to the area across from the center, and then repeat this from the first quarter of the other side, so that the marks from each direction cross over. From the central point of these precise crosspoints, draw a straight line; this will be at a right angle to the central line, creating the second Brahma line, or horizontal axis. Where these two lines intersect is the central point. This way of drawing is referred to as "finding the central point from the outside." From here any shape can be drawn, such as a square, a triangle, and so on. These two cross-lines—the Brahma line and the horizontal axis—are at a perfect right angle and are the basis for all other lines. It is always necessary to draw these lines as the starting point. The rest of the eight lines can be drawn in the same way as described below.

ii. Finding the outside points from the center

In the second method, you first draw the Brahma line and then choose where you want the central point on that line. On the central point, place the compass tip and make equal marks along the Brahma line on either side of the central point. From there you open the compass to the width of those two points and then put the compass point on those marks and make crossmarks to either side, roughly across from the central point as before. Then draw the horizontal axis from the center of those cross-marks, which will also exactly cut through the central point. Then make equal marks again, about halfway across each of these four lines, by placing the compass point in the center. Then, keeping this compass span, place the compass point on those outer marks and make small cross-marks again, this time in the area between the lines to each side so that they cross over each other. From there you draw the diagonal lines and then the outer square border lines, which complete the eight lines.

d. The importance of the eight lines and summary

It is important to draw these eight lines for every mandala and tangka, as they are the doorway to the blessings. They must be drawn precisely and accurately. If these lines are accurate, the drawing will also be correct, so great care and precision are necessary at this preliminary stage. When you draw the working lines for any artwork, from the eight lines onward, they must be very fine and precise, using a fine marking chalk string or a very sharp pen or pencil. Then the lines and points will be very accurate. The

artist must be meticulous at all times. It is important for the point of the drawing instrument to be sharp. Even the compass point needs to be very sharp, otherwise the measurement becomes imprecise. Most mistakes come from using a blunt pencil, which then leaves room for error with the subsequent marks. From an initial error the mistakes multiply as more lines are drawn. Great care is essential in this; it is important not to err when drawing the lines, otherwise why would the measurement need to be calculated at all? There are some very great realized masters who can draw without measurement, but even they use measurements when making very big or very small drawings. The eight lines are equally important for drawing a mandala and for a deity drawing. The mandala is not like an empty vessel; the deity abides inside it. The purpose of the mandala is to serve as a container or vessel for the deity. Similarly, during empowerments, the reason the vajra guru shows us the mandala is to show us the deity. When anyone who practices supreme art is depicting a deity of any size—even a very good artist who does not technically need to make this measurement or rely on it—the eight lines are necessary because they bring the blessings into the artwork. This is the advice of many realized masters.

Many of the art teachers and students of the past were both learned and accomplished in the dharma. Therefore, most of the texts on the supreme arts are not very detailed and do not describe the processes clearly. An example of this is Mipham Rinpoche's work *The Brilliant Sun: Iconographic Proportions,* in which he wrote only about the instructions on measurement and gave no other teachings. However, this is no longer the case today, and people like me need to learn the ABCs of supreme art. Therefore, this book includes a lot of detail for those who wish to study the supreme arts from the beginning, with an emphasis on the importance of the three noble principles that must encompass all our practices.

2. The naga king drawing and ritual

There are three subjects: making the calculations for the drawing, the actual drawing, and performing the naga king ritual.

a. Making the calculations for the drawing

According to the tantras, a powerful deity, the king of nagas known as Sadak Toche, dwells under the ground. Before the start of any building project—a temple, a retreat house, or other building—and before any Vajrayana initiation, large ceremony, or teaching, or before the start of a retreat, a ritual is

done to appease the naga king. Particularly if the land is new to the buddha dharma, this kind of ritual is crucial. When the buddha dharma is brought to a new land where the local deities have not yet been subjugated, one must request permission from them, otherwise they may become upset and create serious obstacles to the project. It is especially important not to upset this very powerful naga king. Whoever conducts the ceremony should be an authentic guru, and the one doing the drawing should be properly trained in the supreme arts, as it involves creating a precise drawing of the naga king on the ground where the event is to take place.

The upper part of the naga king's body is in the form of a beautiful deity, and the lower part of his body has a serpent's tail. Around his head there is a crown of nine snakes with their heads raised. He lies under the ground with his right side up. He can vary in size from an area of many kilometers to as small as a hand. Each day he pivots in a clockwise direction, completing a full rotation in one year, which is counted as 360 days.

It is crucial to consult a Tibetan calendar in order to ascertain the exact direction his head is pointing at the particular time of year that the drawing is being done. Here the astrological calendar of Mipham Rinpoche is used. The names of the months correspond to the names of the zodiac signs. A circle is drawn and the divisions made corresponding to the days and months.[108] There are three months for each direction. After the drawing of the eight lines, a square is drawn in the usual way and then divided according to the months by calculating the divisions along the edge of the circle. There are ninety divisions in each direction, and each direction corresponds to 90 days (i.e., three months), making a total of one year (here counted as 360 days). From the eighth to the tenth month, the head of the naga king is in the eastern quadrant, and his face turns to the south. From the eleventh to the first month, his head is in the southern quadrant, and his face is turned to the west. From the second to the fourth month, his head is in the western quadrant, and his face is turned to the north. From the fifth to the seventh month, his head is in the northern quadrant, and his face is turned to the east. Fifteen days into the ninth, sixth, third, and twelfth months of the Tibetan calendar, his head is exactly at the center of the four cardinal directions: east, north, west, and south.

Different astrological systems put the season in different months; some systems place the beginning of autumn in the eleventh month, others in the eighth month. The astrological systems are a bit complicated; they are not explained here but only mentioned in passing.

It is important to be very careful and respectful of the naga king, as he can be extremely powerful and dangerous. He is the king of all nagas and also of all the eight classes of demons and spirits of the six realms. If anyone sees or touches him or if he breathes on someone, it is poisonous and causes serious obstacles. If any project is started, even ordinary construction, without this ritual being performed first and his body is touched anywhere, a lot of obstacles will be created and the task will fail, and even sickness or death can result. Therefore, it is important to follow these instructions carefully first and to check his location in the way described here before building a house, holding a festival, or other important events. If a house is built without this being done, then it is said that the house becomes more like a tomb, full of bad omens.

b. The actual drawing

Before commencing the naga king drawing, make sure the drawing surface is very flat. Then calculate the east-west meridian line very precisely from the sun or using a compass, and draw the Brahma line along this line and then the rest of the eight lines. Divide into five the area from the central point to the edge of the square lines, and draw concentric circles at those points. Divide each quarter of the outermost circumference into ninety (for three months of thirty days each), making a total of 360 chatren. Here one *chachen* consists of ten chatren, so there are nine chachen in each direction. It is easiest to divide each quarter into nine sections (chachen) first, and then divide each of those into ten chatren. See figure 1 for the details, as it is a complex drawing, understood more easily if you see an example. Draw lines through the points and then calculate where the body is facing according to the calendar, as explained previously. Then, draw the central line for the naga king's body.

It is important to note that for the naga king's body measurement, each chachen consists of nine chatren (not ten as for the circumference). The naga's body is ten chachen long, with the central point located at his secret place halfway along his body, at the fifth chachen. His secret place never moves from the center. The snakes around his head are one chachen high; his face is one chachen long; and from his face to his heart, from his heart to his navel, and from there to his secret place are each one chachen in length, making a total of five chachen, or forty-five chatren. The snake tail below his secret place is five chachen long, making a total of ten chachen. His body is two chachen wide, one to each side of the central line, with another chachen

measured to the side, where the place of accomplishment will be found. So the measurement width for his body is a total of three chachen. His body and features must be drawn very precisely and attractively.

This way of finding the place of accomplishment is according to Drigung Chödrak and Mipham Rinpoche. To find the place of accomplishment, which is where the earth is cut for the first time, count three chachen down from the top of his central line to mark the first point, and then count down again by one chachen. Measure out to the right from these two points, by one and one-half chachen (or thirteen and one-half chatren). Then go out again by half a chachen (four and one-half chatren). This gives the rectangle where the ground is first cut, as shown in the diagram. It is crucial to calculate this area very precisely. This completes the teaching on how to draw the naga king.

c. Performing the naga king ritual

The naga king ritual referred to here is one composed by Drigung Chödrak. Here only a rough outline of this sadhana is given; it is not an actual translation of this text. This ceremony should be conducted only by an accomplished practitioner.

First complete the iconographic measurements, drawing, and color for the naga king. Once the calculations and artwork are complete, an altar is placed in front of the image and torma offerings are made, as usual, then the seven-branch prayer is recited. It is best to have an authentic guru carry out the ceremony. Whoever does it must take one-day vows not to eat meat on the day of the ritual. (Never offer meat or fish products to this deity. The white offerings, such as milk, butter, and honey, are best. It is very dangerous if these instructions are not followed.) The person conducting the ceremony faces the drawing of the naga's face, takes refuge, and generates bodhichitta in the usual way and then considers everything as emptiness.

The naga king should be visualized in the following way: His upper body is pure white with the features of a god, adorned with many beautiful ornaments. Nine snakes of different colors rear up from behind his head to form a crown. His right side is uppermost, and his left hand rests under his ear with his right hand holding a jewel at his hip. His serpent tail is green, beautiful, and glistening. Other small nagas reside at various places on his body. At his crown chakra is a white naga called Taye. At his throat chakra is a red naga called Jokpo. At his ear is a white naga called Pema. At his heart is a blue naga called Norgye. At his shoulder is a yellow naga called Pema

Chenpo. At his navel is a light-yellow naga called Tungkyong. At his secret place is a green naga called Topgyu. At his tail is a blue naga called Rikden. All of these nagas dwelling on his body look exactly the same as him, except they are different colors, there are only seven (not nine) snakes above their heads, and they all hold different colored jewels.

Next, the vajra master visualizes that from the seed syllable in the center of his heart emanate light rays that invite the actual naga king and his retinue to come. At JAḤ HŪṂ BAṂ HOḤ all the nagas dissolve into the drawing. The vajra master performs the vajra mudra and recites a mantra three times while doing this, which pacifies the naga king. After this, offerings are made with the recitation of "ARGHAṂ PĀDYAṂ . . ." and so on, following the usual sequence. There is a special offering torma that is blessed with milk and offered with the appropriate mudra while the correct mantra is recited twenty-one times. After offering the torma, request in the following way:

> O king of nagas, I pay homage to you and endeavor to please you.
> I will endeavor to assist you in all your needs.
> As I wish to be of benefit to sentient beings,
> Please grant me the accomplishment of this place and permission
> to use this ground.

The king of nagas grants permission, replying:

> Master, I grant you permission to do as you please.

To receive the accomplishment, the vajra master generates himself as a wrathful deity and takes the spade, considering it to be made of precious material such as gold. Holding it with both hands, the right hand uppermost, he faces the naga's head, with his back to the naga's tail, and digs the spade into the place of accomplishment five times. The earth from the first four cuts is placed to the southeast. The earth from the fifth cut is placed in a pot and kept as a blessing from the naga. The quality of this fifth shovelful of earth is then analyzed; if the earth is rich and wholesome, with many colors, this is an auspicious sign. If there is bone and hair in it, this is inauspicious. It is very dangerous to cut in the wrong place, so great care must be taken to calculate the measurement correctly. A naga vase can then be buried in this place of accomplishment and other verses recited; again, make offerings and praise to the nagas and request them to accept our apologies for any

mistakes that may have been made. After that, consider that all the nagas dissolve from the drawing into the ground. Finally the area is sprinkled with milk and water and the drawing is swept away. Now the work can begin, and the house, temple, mandala, stupa, or whatever is planned can be built there. The fifth shovelful of earth can be mixed with clay and thrown on the site, which will clear away negativity and inauspicious signs. This completes the section on preliminary measurements.

B. The Main Teachings on Measurement

The main teaching on measurement encompasses three broad headings: mandala measurement, iconometric proportions, and various additional small measurements.

1. Mandala measurement

The teachings here, unless otherwise specified, are from *A Delightful Illumination: A Handbook of Mandala Measurement and Color* by Minling Lochen Dharmashri. The Mindroling tradition of the Nyingma school is practiced at Shechen Monastery, which is why it is the primary reference here. Lochen Dharmashri's teachings include mandalas from both the Nyingma Kama and terma (revealed treasure) texts. Additional mandalas have been included by the author, also divided into Kama and terma, in particular from the termas of Kyapje Dilgo Khyentse Rinpoche, and a few other mandalas that are useful for the artist to know.

This section has three broad divisions; mandala size, height, and measurement.

a. Mandala size

Two different mandala sizes are spoken of: the visualization size and the actual size. The visualization size is immeasurable, many leagues, filling the sky. For depicted mandalas, traditionally three sizes are enumerated: A small mandala is said to be the length of a forearm or a human body. A medium-sized mandala is about three to eight body lengths, and the large size is twenty to twenty-five body lengths. Although the smallest is said to be the length of a forearm, in reality a mandala can be made as small as the palm of a hand. The *Treasury of Precious Qualities* says that basically a mandala can be as small or as big as it is possible to make it. If it is too small to draw by hand, then it can be visualized. The main point is that mandalas can be visualized or depicted in any size.

b. Height for three-dimensional and sand mandalas

The mandala height refers to sand mandalas and three-dimensional mandalas. Generally the center should be slightly raised and the sides slightly lower. The sides should all be the same height. If the east side is higher than the other sides, our life span is shortened, and if the north side is higher, our wealth and possessions will decrease, so make sure that the north and east are not raised; they can actually be slightly lower than the other sides.

c. Mandala measurement

In general, the training in mandala measurement should be undertaken only by someone who has taken the three levels of vows and has received or is undergoing training in mandala drawing under the guidance of a teacher.

This section is divided into six main points, each with its own subheadings: (1) a general explanation, (2) measurements for the archways, (3) specific mandala measurements from Lochen Dharmashri, (4) additional mandalas, (5) mandala color teachings from Lochen Dharmashri, and (6) some useful additional subjects.

i. A general explanation

The following is a general explanation of some of the measurements common to all mandalas.[109] Figure 2 is especially useful for calculating the four different levels of archway to the mandala doors and for mandalas with and without charnel grounds, as well as how to make the measurements. Figure 5 also shows examples of different measurements.

This section is divided into three parts: the measurements for the celestial palace, the measurements for inside the palace, and the measurements for the surrounding areas.

(1) Measurements for the celestial palace

For the celestial palace, first draw the eight lines and an outer square using one of the methods explained previously. Then calculate and draw the square-shaped lotus parapet known as the *dayap*. Note the useful system for doing this, illustrated in figures 2 and 5, of making an inner square at an angle to the outer square border, with its corners touching the central points of the outer square (marked by the two Brahma lines). The inner square is made by drawing lines across from those points, which divides the diagonal lines exactly in half from the center to the corner of the outer square border, which marks the measurement point for the parapet line (*datik*) for most

mandalas, such as the mandalas with eight- and four-leveled archways.[110] The total area between the outer border corner and the center is divided into twelve, which is twelve chachen for this mandala; therefore the parapet line is drawn at the sixth chachen. This way of measuring the parapet line can also be used for a mandala with eleven-leveled archways if it does not have the charnel grounds; if it does have charnel grounds, then the parapet line is marked closer to the center by one chachen. To do that, divide the area from the outer border corner to the center into thirteen, and mark the parapet line at the sixth chachen from the center, which leaves seven chachen outside this, to include enough space for the charnel grounds.

The artist needs to understand, however, that extra space will be required outside the square outer border that has been drawn for this calculation, so that the outermost mandala circle does not look cramped. This initial outer square border is really drawn just as a measurement device, and space should be left to make the final decorative border later.

After drawing the parapet line, divide the diagonal line in three from the corner of the parapet line to the center. Draw lines from the outer marks to make another square inside the parapet line square. The name of this line is the wall line (*tsatik*), which is the innermost line of the five-layered walls (*tsikpa*). Then halve the area between the wall line and the parapet line, making two chachen. Refer to figures 2 and 5 for clear examples of these and other measurements.

The inner chachen is then divided into four chatren.[111] The first chatren from the inside is for the five-layered walls, then two chatren for the platform of delights (*dönam*) and one chatren for the jeweled architrave (*pagu*). The outer chachen is divided into two chatren for the pendant garlands (*drawa drache*), and one chatren each for the rainspout cornices (*sharbu*) and parapet.

The names and measurements in more detail are as follows, from the inside to the outside: (1) the five-layered walls: one chatren; (2) the platform of delights, a protruding ledge for the offering goddesses: two chatren; (3) the jeweled architrave at the top of the walls: one chatren; (4) the dark hollow space with pendant garland ornaments: two chatren; (5) the beams forming the roof, with decorative rainspout motifs: one chatren; and (6) the parapet that runs right around the edge of the mandala's flat roof: one chatren.

This all fits within two chachen. Their lines are drawn horizontally across from the diagonal line at the corners to the T-shaped doorway below the

archways at the center of each side. That is, for the upper section (total five chatren), from the jeweled architrave up to the parapet, the lines are drawn horizontally across to touch the vertical side of the pillar ornament (*kagyen*). The five-layered walls are the innermost lines and extend all the way around the T-shaped doorway. The platform of delights also extends into the lower area of the doorway. These make up the lower three chatren.

The names of the vertical sections or portico of the doorway, between the dönam and dayab line are, from the outside to the inside: (1) pillar ornament (multicolored); (2) pillar (direction color); (3) *langgyap* (or *munpa*), which is black with pendant garland ornaments; and (4) five-layered walls. The measurements for some of the small sections of the mandala are not given here, but they can be understood by referring to figures 2 and 7. This is the main measurement for the celestial palace.

The most important measurement lines, which contain the drawing for the celestial palace, are the innermost wall line (*tsatik*) and the outermost parapet line (*datik*). The area at the center, inside the celestial palace, comprises the inner courtyard and the pedestal and seat for the main deity.

(2) Measurements for inside the celestial palace

As for the measurements inside the celestial mansion, as explained previously, the inner square line where the five-layered walls begin is called the wall line. Measure one more chachen from the corners of the wall line toward the center along the diagonal line and draw square lines across for the outer tier of the layered square pedestal (*druche*) on which the main deity abides. Then, from the central lines measure out by one chatren and to each side by two chatren to draw the small decorative boxlike rectangular projections (*lombur*) at the four central edges of the pedestal. Then, halve the central line, from the pedestal line to the very center, and draw a circle from this point with the compass tip at the center. Draw another circle that just touches the edge of the pedestal line. Then measure again by one chatren inside each of these circles and draw two more circles from these points, so that there is a circular double rim (*mukyu*) to each of these circles. The outermost rim is where the circular vajra beam (*dorje dung*) is, forming part of the roof above the deity's head.

Sometimes the outer rim is referred to as a spoke-rest (*tsipden*), where the spokes or tips of the inner wheel come to (whether it is a peaceful jewel wheel or a wrathful knife wheel, as explained in more detail below.) In both

these cases, although they are in the same location as the vajra beam, they are at ground level, as is the wheel of whatever type.

The innermost rim usually symbolizes pistils (*zedru*) when it is a lotus wheel. In a wrathful mandala, the inner rim is just an inner part of the knife wheel.

The central circle is the seat of the main deity. As mentioned, the circular sections around it are for the four- or eight-petaled lotus or jewel wheel for a peaceful deity or the knife wheel for a wrathful deity. When the outermost circle is drawn, it should just touch the pedestal line, but when the spokes (*tsip*) of the knife or jewel wheel are drawn, their points should not quite touch the outer rim.

The area of the court between the square pedestal platform and the walls is the courtyard (*khyam*), a term that can also refer to any empty area of the mandala. The inner courtyard refers specifically to the area between the square pedestal and the walls. This does not include the space within the T-shaped door. In a mandala that has more than one courtyard, such as *Wrathful Deities of the Magical Net,* the second courtyard is called the midway courtyard. The area outside the parapet is refered to as the outer courtyard. If there are no retinue deities to be depicted here, however, then the courtyard between the square pedestal and walls is not required, so in this case the outermost circle of the inner abode of the deity can instead touch the wall line directly, and this area is then refered to as the pedestal only. In that case the four boxlike projections are not depicted (see figure 9). This concludes the general measurements for inside the celestial mansion.

(3) Measurements for the surrounding areas of the mandala

The following are the general measurements that apply to the outer surrounding areas of a mandala (*khoryuk*). These circular areas are sometimes measured from the parasol that ornaments the top of the archway and sometimes from the diagonal line, depending on the mandala. If measuring along the diagonal, from the corner of the square parapet line, first measure two chatren to draw the first circle for the multicolored lotus ring. However, sometimes before the lotus ring, a circle is drawn, either for the lotus pistils (*zedru*) in a peaceful mandala or for a sun disk in a wrathful mandala. In that case, first measure one chatren to draw the circle for the pistils or sun; then the second chatren is for the lotus ring. Measure another two chatren to draw the outer circle for the thirty-two lotus petals, then two chatren for the vajra fence. Eight gold vajras are drawn on a blue ground representing

the element of space. These vajras are interspaced by circular vajra symbols, with an undulating line known as the vajra thread connecting them.

Outside the vajra fence, measure one chachen and draw another circle for the outermost protective fire ring. This has twenty-five banks of five-colored flames that circle in a clockwise direction. If there are eight charnel grounds, measure one chachen between the lotus ring and vajra fence.

Although there can be other variations, such as the dharmapala ground, this is the common measurement for the outer sections, so if it is not clearly described in the sadhana, you can follow this, but the differences between the mandalas for peaceful and wrathful deities must be understood.

ii. Measurements for the archways

There are three kinds of archways in layers of eight, four, and eleven (and two different kinds of eleven-layered archways). The measurements for these are clearly shown in figure 2, which also shows the compass points for drawing the empty space in the middle of the archway, called the rear area with three elephant's-back hollows (*lang gyap miksum*), which is black with loops of pendant pearl-garland ornaments. This diagram also indicates the compass points for the underground vajra.

(1) The resultant eight-leveled archway

The resultant eight-leveled archway refers to the eight horizontal levels to the door's archway, each one chatren in height. They are as follows, from lower to upper, including the decorative drawing:[112] (1) takang (with vajra uprights), (2) chukye (lotus motif), (3) drombu (beam with box beveling), (4) zartsak (pearl pendant ornaments), (5) nachang (jeweled beam), (6) chunchang (tassels and garlands), (7) sharbu (rainspout cornice), and (8) khyungo (small flat roof with garuda or eagle motif).

On the rooftop of the eight-, four-, or eleven-leveled archway is an eight-spoked dharma wheel on a lotus seat with a parasol above, flanked by two deer. Sometimes there is an underground vajra that is indicated, or wheel spokes. The measurements can be clearly calculated by referring to the illustration in figure 2.

(2) The four-leveled archway

The following are the usual names of the different sections of the four-leveled archway. Lochen Dharmashri suggests two possible color schemes, from the lower to upper levels, although these color arrangements are

not fixed: (1) sernam is red (or yellow); (2) sharbu has a rainspout motif and is blue; (3) rinchen is green (or red); and (4) dayap is yellow (or green).

(3) The eleven-leveled archway
There are two main traditions of mandalas with eleven-leveled archways: One is the tradition known as the Stainless Two (*Drime Namnyi*), which are two kriyayoga mandalas called *Immaculate Ushnisha* and *Spotless Rays of Light*. The other tradition is that described in both the *Condensed Realization of the Gurus* and *Rosary* (*Trengwa*). See the drawings in figure 2. They are the same except that in the Stainless Two mandalas, the roof is extended and the elephant's-back hollows are of different proportions.

(a) The Stainless Two tradition
This tradition of eleven levels is from Sherap Tentar, a vajra master from Mindroling Monastery. These are the names and colors of the eleven levels, from lower to upper: (1) sernam, blue; (2) sharbu, red; (3) rinchen, green; (4) mikpa, yellow; (5) munpa, red on outside and blue on inside; (6) varanda, red; (7) munam, red on outside and blue on inside; (8) sharbu, yellow; (9) rinchen, light blue; (10) mikpa, red; and (11) dayap, white.

(b) The *Condensed Realization of the Gurus* and *Rosary* traditions
The eleven levels are the same in the *Condensed Realization of the Gurus* and *Rosary* traditions. They are named as follows, and colored from lower to upper: (1) sernam, yellow; (2) sharbu, blue; (3) rinchen, red; (4) mikpa, green; (5) munpa, blue; (6) varen, yellow; (7) munam, blue; (8) sharbu, blue; (9) rinchen, red; (10) tamik, green; and (11) dayap, white.

iii. Specific mandala measurements from Lochen Dharmashri
The following are some of the measurements for specific mandalas from *A Delightful Illumination: A Handbook of Mandala Measurement and Color* by Minling Lochen Dharmashri.

(1) Mandalas with eight-leveled archways
The following are some of the most common or useful mandalas with eight levels to the archways. The *Peaceful and Wrathful Deities of the Magical Net* in particular can serve as a basis for many other mandalas, as they contain elements common to most mandalas.

(a) *Peaceful and Wrathful Deities of the Magical Net*

The *Peaceful and Wrathful Deities of the Magical Net* mandalas come from the Nyingma Kama. See figure 3 for *Wrathful Deities of the Magical Net* (*Gyutrul Trowo*). The drawing for the *Peaceful Deities of the Magical Net* (*Gyutrul Shiwa*) mandala is exactly the same as for the wrathful one, except that it has no charnel ground and no second inner courtyard. Instead, the parapet line of the second inner courtyard for *Wrathful Deities of the Magical Net* is the pedestal line for *Peaceful Deities of the Magical Net*. Figure 4 depicts the drawing for the abode of the deity for *Peaceful Deities* (top) and the abode of the deity in the center of the second courtyard in *Wrathful Deities* (bottom). The *Peaceful Deities* is a practice of the five peaceful buddhas and the *Wrathful Deities* a practice of the eight herukas.

(i) *Peaceful Deities of the Magical Net* color

The central inner circle is blue and its rim is "radiant" (*özer*), so depict the rim in yellow or orange. The rest of the inner abode of the deity is all in the colors of the four directions,[113] and the outer circle's rim is blue with vajra drawing. The inner courtyard and four doors are also in direction colors. The five-layered walls, starting with the inner wall, are blue, white, yellow, red, and green.

The colors for the rest of the mandala are as usual: The platform of delights is red with drawing of gold ornamental curlicues (*pata*). This substitutes drawing the eight goddesses, as the space is too small for this. The jeweled architrave is yellow with gold jewel drawing, the pendant ornaments are white pearl-garland drawings on black, and the rainspout cornice is light blue with white drawing. The parapet is white with a stupa motif drawn with blue line or, more usually, with a square-shaped half-lotus motif (figure 7).

In general, all the dark empty spaces are depicted as black ornamented with the white pearl pendant drawing. The pillars are in direction colors. The pillar ornaments are depicted in alternating colors with hanging ornament (*phen*) drawing.

The colors for the different levels of the eight-leveled archway are as follows: The takang is blue with vajra drawing in gold or yellow. The chukye is red with lotus petal motif. The drombu (jeweled tiles) are in alternating colors. The zartsak is black with white drawing. The nachang is yellow ornamented with jewel drawing; basically it has the same ornamentation as the jeweled architrave. The drilchang (or chunchang) is black with white

drawing. The rainspout cornice is light blue with white drawing. The roofed canopy (*gyapup* or *khyungo*) is blue. On top of the archways, the lotus cushion is white with red shading, the eight-spoked dharma wheel is yellow, the parasol is white, and the deer are golden. The underground four-spoked wheel and the first outer rim are filled with the colors of each direction. The outer courtyard is green. The remaining surrounding areas are colored as follows: The lotus ring is multicolored. The vajra fence is dark blue with gold drawing. The fire is five-colored and turns to the right.

(ii) *Wrathful Deities of the Magical Net* color

The central inner circle is colored blue and its rim is green. The four-spoked wheel is yellow. The empty area between the four-spoked wheel and the spoke-rest is called the *tsipchen* (or *gong-re*), which is colored red. The spoke-rest is blue. The pedestal is green, and the four boxlike projections are colored according to the four directions.

Wrathful Deities of the Magical Net has two palaces, one inside (above) the other; the inner court's courtyard is yellow, while the T-shaped doorways are direction colored. The three-layered walls for the inner mandala are colored, from the inside, blue, red, and white. The rest of the inner celestial palace, from the platform of delights to the parapet, is colored as usual.

The outer celestial courtyard is called the queen's courtyard (*wangmö khyam*); it is colored red with blood drawing. The rest is the same as for *Peaceful Deities,* except there is a charnel ground, which is colored black with white or gold drawing.

(b) *Gathering of the Great Assembly*

The mandala of the *Gathering of the Great Assembly* (*Tsokchen Dupa*) from the Nyingma Kama is an important sadhana of the principal text of the anuyoga called the *Sutra That Gathers All Intentions*. There is both a peaceful and a wrathful mandala; the measurement for the peaceful mandala is the same as the *Peaceful Magical Net*. The one explained here is the wrathful *Gathering of the Great Assembly* mandala, which consists of eight inner courts and one outer court (figure 5).

Because this mandala is so large, the parapet line has to be calculated differently so that everything fits. After drawing the eight lines, divide into ten along the outer border from the corner to the center and draw the parapet line using the sixth mark from the center. Then measuring from the parapet line to the center, divide the Brahma line (or the diagonal line) in three and

draw the lines across. Then divide the section between the innermost mark and the parapet line into five along the diagonal lines and draw the square lines across again. Halve the innermost four of these five sections, making eight parts, and draw the lines across for the eight inner courts. Divide the fifth section, for the outer mandala, into three parts, which are one chachen each, for the outer court. The eight inner sections are then also divided into three parts each, which is their chachen size; that is, the chachen size for the inner mandalas is smaller. The innermost chachen for each of the nine mandalas is for the courtyard. The second chachen is for the walls, platform of delights, and jeweled architrave. The third is for the pendant garlands, rainspout cornice, and parapet. The main outer court has an eight-leveled archway, with an underground vajra.

For the surrounding areas, from the parapet line corner along the diagonal line, measure one chatren for the sun disk; two chatren for Rigdzin's abode,[114] which is yellow with many drops; two chatren for the lotus seat; one chachen for the eight charnel grounds; two chatren for the vajra fence; and one chachen for the fire ring.

(i) The central abode

From the wall line of the innermost court, measure one chachen for the pedestal and draw the lines. Draw a circle just inside the pedestal line, with a rim one chatren inside that for the spoke-rest. Divide in half the section from the spoke-rest to the center and draw a circle for the eight-spoked wheel. Divide again to the center into three and draw circles through each of these points (without a double rim). These three inner sections are the abode of (from the center): supreme heruka Mahottara, Heruka of Supreme Power, and Vajra Heruka.

(ii) The color

The three innermost circles are colored blue. The eight-spoked wheel is colored yellow, and the space between the spokes and spoke-rest is red. The spoke-rest is blue, and the pedestal and its four boxlike projections are in the colors of the directions. There are nine courtyards in total. The first three innermost courtyards are successively colored yellow, white, and red. The next three courtyards are yellow, red, and white. The seventh courtyard is black but is painted light blue; the eighth is colored in each quadrant according to the directions; and the ninth, outermost courtyard is green. The eight inner courtyards have a single green wall.

The ninth courtyard's walls, archways, and so on are the same as for the *Magical Net* mandalas. For the outer area, the first outer rim is for the sun disk, which is green. There is an underground vajra in direction colors. The eight charnel grounds, fire, and so on, are depicted and colored as usual.

(c) *One That Stirs from the Depths*

The mandala for *One That Stirs from the Depths* (*Dongtruk Gyaden*) is also known as *Shitro Narak Dongtruk* and is from the Nyingma Kama. From the eight-leveled archway to the wall line it is the same as *Peaceful Deities of the Magical Net*. The outer area is the same as *Wrathful Deities of the Magical Net*.

The central area is drawn as follows: Draw a circle touching the inside of the wall line. Measure one chatren inside that for the vajra beam. Divide into six parts from there to the central point and draw circles through each mark. One chatren inside the innermost circle, draw another circle for the inner rim. From the inside to outside, draw successively a four-, eight-, sixteen-, thirty-two-, and forty-petaled lotus.

The center is colored blue, with a yellow rim to indicate lotus pistils. The four-petaled lotus is in the colors of the four directions, and the subsequent lotus petals are of the same color as the retinue deity residing on the petal. (These details are not included here.) Alternatively, the artist can choose colors for the petals. The circular vajra beam is colored blue, and everything else is the same as *Peaceful Deities of the Magical Net*.

(2) Mandalas with four-leveled archways from revealed treasure texts

The mandalas with four-leveled archways described here all come from treasure texts (*terma*). There is usually no need for the inner courtyard area in these mandalas, although there are exceptions. Lochen Dharmashri said that if it is not stated clearly in the sadhana, the artist can decide. As explained previously, it depends on whether space is needed for a retinue. Specifically, he said that the first four examples (*Peaceful Guru*, *Wrathful Guru*, Amitayus, and Vajrasattva) do not have the inner courtyard, but the rest do.

This section outlines the drawing and color for the following mandalas: (1) *Peaceful Guru* from the *Heart Essence of the Vidyadharas* sadhana, revealed by Minling Terchen Terdak Lingpa; (2) *Minling Wrathful Guru*, revealed by Terdak Lingpa; (3) *Heart Essence Amitayus That Embodies All*, revealed by Terdak Lingpa; (4) *Minling Vajrasattva* from the Nyingma

Kama (and also a terma revealed by Terdak Lingpa); (5) *Yamaraja the Destroyer* from the *Lord of the Dead Who Destroys Arrogant Spirits,* revealed by Terdak Lingpa; (6) peaceful and (7) wrathful versions of the *Eight Sadhana Teachings: Assemblage of the Sugatas* mandalas, revealed by Nyang Ral Nyima Özer; and (8) *Vajrakilaya from the Razor Scriptures* mandala, from the *Most Secret Razor Kilaya* sadhana, revealed by Guru Chöwang and clarified by Terdak Lingpa.

(a) *Peaceful Guru*

The central abode of the *Peaceful Guru* (*Lama Shiwa*) mandala is drawn as follows: Draw the first outer circle as usual, inside the wall line. Measure one chatren inside this for the outermost rim. Divide the area from the rim to the center into five parts (by making four marks), and draw the circles. Mark one more chatren inside the central circle for its rim. From the inside draw, respectively, a four-petaled lotus, an eight-spoked ratna wheel,[115] an eight-petaled lotus, and an eight-spoked wheel and its spoke-rest.

The central circle is colored blue, with a green rim. The four petals of the lotus are colored according to the directions. The eight-spoked ratna wheel is colored blue. The eight-petaled lotus is in alternating colors. The eight-spoked wheel and its spoke-rest are blue. For the space between the spokes and rims, you can use a slightly different shade of blue, although this is not stated in the text. The four archway levels are colored, from inside to outside, red, blue, green, and orange. Alternatively, yellow, blue, red, and green can also be used.

(b) *Wrathful Guru*

The drawing for the central abode of the *Wrathful Guru* (*Minling Gurdrak*) mandala is done as follows: Draw the first circle just inside the walls, then measure one chatren inside this circle for the outer circular rim. Divide the area between this mark and the center into three and draw the circles. Measure inside each of these again by one chatren and draw the circles for the rims, which are all blue. The innermost rim has a skull drawing, with the top of the head pointing inside. The first section is for a four-petaled lotus in the colors of the directions. Next is a blue four-spoked wheel. The space between the spokes and rim is in the colors of the directions. The outermost rim is the blue spoke-rest. Inside the central circle draw an equilateral triangle, with the three points just touching the inner rim. The uppermost point is on the central east-west Brahma line (which means to the mandala's west), making the opposite edge of the triangle parallel to the eastern side (the

lower edge of the mandala). The triangle and semicircular spaces between the triangle and its encompassing circle are colored red.

(c) Amitayus and *Minling Vajrasattva*

The *Heart Essence Amitayus That Embodies All* and *Minling Vajrasattva* mandalas are both termas of Terdak Lingpa. To draw the central abode of the Amitayus mandala, draw the first circle inside the wall line, then mark one chatren inside for the circular rim. Divide from there to the center in half, draw a circle, and then draw another circle inside for the rim. Draw an eight-petaled lotus between the two rims.

The Vajrasattva mandala is the same as this Amitayus mandala, except that it has eight-leveled archways like *Peaceful Deities of the Magical Net,* with an underground vajra.

The central circle is colored red for Amitayus and white for Vajrasattva. The eight-petaled lotus is multicolored (as in a tangka), and the rim is blue with vajra drawing for the vajra beam. Otherwise they are the same as usual.

(d) *Yamaraja the Destroyer*

The mandala of *Yamaraja the Destroyer* (*Shenje Jomje*) has an inner court-yard for the retinue deities. Draw the first circle touching the pedestal line as usual, then mark one chatren inside that for the rim. As usual, divide from there to the center in half and draw the circles from those marks. However, this time mark one chatren *outside* the innermost circle and draw the inner rim there. In the center draw an equilateral triangle, in the same way as before, with the point along the Brahma line to the west. Draw a skull garland on the inner rim. Then draw the four-spoked knife wheel with the outer rim as the spoke-rest for the wheel blades. Although the circle itself always touches the pedestal, remember that the points of the wheel blades should not quite touch the spoke-rest.

The inner triangle is colored blue, the semicircle is red, the inner rim is white, the four-spoked wheel is blue, the space between the knife blades and rim is in direction colors, and the spoke-rest is blue.

(e) *Eight Sadhana Teachings: Assemblage of the Sugatas*

This section explains the drawing that is the same in both the *Peaceful Assemblage* (*Dedu Shiwa*) and *Wrathful Assemblage* (*Dedu Trowo*) manda-las. The differences will be explained separately. Outside the pedestal they are the same as usual.

In the central area there are nine mandalas in one, which are drawn in the

following way:[116] Divide the pedestal line into three parts along all four sides; the central part will have the Brahma line cutting through the middle. Then draw lines between the marks horizontally and vertically, which divides the square of the pedestal into nine smaller squares. Then mark one-quarter chatren to the outside and inside of all the inner squares and the pedestal lines. They all now have double lines, separated in the middle by their original lines. This is for the vajra beam. This is necessary; otherwise when the eight lines are drawn for the mandalas in the four cardinal directions, the lines will not cut properly through their centers.

The eight lines of the main mandala (i.e., the vertical and horizontal Brahma lines and the diagonal lines) become the first Brahma line for each of the small nine mandalas. Only the central inner mandala has its own eight lines from the start.

For the eight lines of the small mandalas in the four cardinal directions, draw lines diagonally across from each small mandala's corner, straight across the next mandala's corner to the outer edge (i.e., across two small mandalas), which makes the diagonal lines for the small mandalas in the four directions.

For the four small mandalas at the corners, draw their horizontal axis. Please note that for the corner mandalas, their Brahma line is along the main mandala's diagonal line, so the horizontal axis crosses its Brahma line from corner to corner. Then draw lines across the middle points of the Brahma line and horizontal axis line. In this way draw the eight lines for all the inner mandalas. This is the same for the peaceful and wrathful *Assemblage of the Sugatas* mandalas.

(i) *Peaceful Assemblage of the Sugatas*

The inner nine mandalas for the peaceful mandala are different to the four cardinal directions compared to the four corner squares. In the first set of five squares, the inner rim of the square lines that were previously drawn is their parapet line. In the case of the four corner mandalas, the parapet lines are drawn across from where their diagonal line touches the middle of each outside edge. This creates an even smaller inner square, diagonal to the outer square. This small inner square is the parapet line for the corner mandalas.

In the usual way, for all nine mandalas, divide into three along the diagonal line from the parapet line to the central point for the direction mandalas (again, for the small mandalas at the corners, note that the diagonal lines are the lines parallel to the main Brahma line and the horizontal axis). Then,

from the outer third mark, draw lines across to form another square; this is the wall line. Then divide in half the area between the parapet line and wall line on all the mandalas and draw another square line. These halves are each mandala's chachen, as usual. This is for the walls, platform of delights, jeweled architrave, pendant garlands, rainspout cornice, and parapet. Draw a circle from the wall line. Divide from this line to the center in half, draw another circle, and then draw the rim for each of these, one chatren to the inside as usual. Draw a four-spoked wheel in the same way as the *Peaceful Deities of the Magical Net*. The main mandala has a four-leveled archway. The outer area is the same as for *Peaceful Deities of the Magical Net*.

The colors for the central circle of the nine inner mandalas are as follows: The central mandala is white. The mandalas to the east and southeast are blue. The south and southwestern mandalas are yellow. The western and northwestern mandalas are red. The north and northeastern mandalas are green. The inner rim of each mandala represents light, so green or yellow can be used. The four-spoked wheels and four doors are direction colors (i.e., with each direction indicated by the diagonal lines of each of the nine mandalas). The walls for each of the nine are the same as their central deity's color (the central circle's color). The outer circular vajra beam is blue. The vajra beams (consisting of the straight double lines crossing between each mandala) are also blue.

The outer courtyard and doorway outside the nine mandalas are the colors of the four directions. The main mandala's five walls are colored, from inside to outside, white, blue, yellow, red, and green. The rest is the same as usual, but the rainspout cornice is light green, not light blue. The four-leveled archway is alternating colors, such as yellow, blue, red, and green, as in the *Peaceful Guru* mandala. For the outer areas, draw the first ring of the innermost rim touching the parapet line corners, then measure two chatren from there and draw another circle, which is white for the guardians of the four directions. The lotus seat is alternating colors as usual, the vajra fence is black, and the fire is alternating red and yellow-colored flames.

(ii) *Wrathful Assemblage of the Sugatas*

Draw the beams and eight lines for the nine central mandalas in the same way as before. For the wrathful mandala, draw a circle in each of the nine squares that just touches the square beam. Then mark one chatren inside this and draw another circle for the rim, which is the place for the oath-bound protectors. Draw the parapet square from the diagonal axis lines inside the

circle (for the corner mandalas, the Brahma line is again the diagonal line, so the diagonal axis line is parallel). This means that the squares at the corners are again at an angle to the sides, as in the previous mandala. But this time they are all first surrounded by a circle within the square. Then, as for the peaceful mandala, divide from the parapet line to the center into three, to create the wall line from the outermost mark and so on as before. Mark one chachen to the inside of the wall line, which is for the pedestal line. Draw the square pedestal, then draw the two circles as usual, one touching the parapet line and the other halfway to the center; then draw the rims for each circle one chatren to the inside, as usual. Draw the wrathful four-spoked knife wheel as for the *Wrathful Guru*. Draw a triangle in the center of each small mandala, with the point facing to the east (according to its Brahma line, which always goes east-west).

The outer area is the same as for the *Magical Net* mandalas, with courtyard and eight-leveled archway, but it can be drawn with four-leveled archways. If you are drawing a four-leveled archway, it is necessary to replace the dharma wheel with a vase-shaped stupa drawing (the parasol is incorporated in the stupa as usual) flanked by the two deer in the same way. As for the *Magical Net* mandalas, there is no underground vajra; there is an underground four-spoked wheel.

The measurement for the surrounding areas or ramparts (*khoryuk*) of the mandala is as follows: Draw the first circle from the top of the parasol along the Brahma line. Then measure two chatren, another two, four, and again two, two, and four chatren, and draw the rest of the outer circles. The first circle is for the attendant deities, then the lotus, eight charnel grounds, thousand-spoked wheel (*tsiptong*), the vajra fence, and the fire, as usual. This is for an eight-leveled archway mandala.[117]

Lochen Dharmashri says that this way of measuring is from the tradition of his guru, Terdak Lingpa, where the nine inner mandalas do not have archways and the outer mandala has an eight-leveled archway.[118]

The triangle at the center of each of the nine inner mandalas is colored as follows: The central triangle is blue; to the east, blue; southeast, light blue; south, yellow; southwest, white; west, red; northwest, blue; north, green; and northeast, black. The semicircular area just outside the triangles is blood red. For all the mandalas, the four-spoked wheel is (light) blue; the rims (for beams, spoke-rest, and the like) are all blue. The pedestal, courtyard, and four doors are direction colors, as is the space between the wheel spokes and the spoke-rest. The three walls are colored, from the

inside, blue, red, and white.[119] The rest for the inner mandalas, from the platform of delights, is the same as usual. The rim, for the oath-bound protectors, is black. The outer ground for the small mandalas (between the parapet line and oath-bound protectors' area) is colored according to the four directions. The vajra beams separating the nine mandalas are blue, as usual. The empty (corner) areas between the oath-bound protectors and the vajra beams are a medium blue. Decorate with all the wrathful ornaments.

Outside the nine inner mandalas, the queen's courtyard is direction colored. Everything else is the same as for the *Magical Net* mandalas, except for the surrounding outer areas, as here there is an abode for the attendant deities, which is depicted as blood red, and the thousand-spoked wheel is yellow. The rest is the same as usual.

(f) *Vajrakilaya from the Razor Scriptures*

For the *Vajrakilaya from the Razor Scriptures* (*Purpa Pudri*) mandala, draw a circle just touching the pedestal, as usual. Then draw four more circles inside this circle, marking one chatren, then one-half chatren, five and one-half chatren, and again one chatren; the total width from the edge to the innermost circle is eight chatren. The innermost circle should measure four chatren (or one chachen) to the center. Inside the central circle draw an equilateral triangle pointing along the Brahma line to the west. The previously mentioned circular areas are for the following, from the center to the outside: The first rim is a skull garland. Next is an eight-spoked ratna wheel and its spoke-rest, and the ring of fire.

Outside the pedestal, measure one chatren and draw border lines around it, including skirting around the four boxlike projections. Here three walls are drawn, symbolizing a skull, dry head, and wet head wall, as for *Wrathful Deities of the Magical Net*. This mandala has four-leveled archways.

For the surrounding areas, measure along the diagonal line from the corner of the parapet: two chatren, then four, one, and four, and draw the circles from these points. From the inside, these are for the oath-bound protectors, eight charnel grounds, vajra fence, and fire ring (no lotus ring is specified in the teaching).

The central triangle is colored dark blue, the semicircular area between the triangle and the circular skull rim is red (blood), and the skull rim (*töra*) is white, with skull garland drawing. The eight-spoked wheel is blue, the space between the spokes and the spoke-rest is red (blood), and the spoke-rest yellow. The inner and outer fires are both five-colored. The space

between the inner fire ring and walls is dark red. The inner three walls (skull and head) are, from the inside, white, red, and blue. All the outer areas—the midway courtyard and four doors and walls—are the same as usual. The surrounding areas are the same as usual except for the area for the oath-bound protectors, which is blood red.

iv. Additional mandalas

The following mandala measurements have been included as they are also useful for the artist to know. There are two subjects: mandalas from the Nyingma Kama and additional mandalas from old and new terma lineages. The mandalas from the Nyingma Kama and old treasure teaching both have eleven-leveled archways, as no samples of eleven-leveled archway mandalas are included in the teachings from Lochen Dharmashri. There is a common misunderstanding that there are no mandalas of this type in the Nyingma canon, but here we see examples of eleven-leveled-archway mandalas from both the Nyingma Kama and terma teachings. The examples from the new treasure lineages are all from Kyapje Dilgo Khyentse Rinpoche.

(1) Mandalas from the Nyingma Kama

The *Spotless Rays of Light* (*Özer Drime*) and *Immaculate Ushnisha* (*Tsuktor Drime*) mandalas are kriyayoga tantra deities and are needed for placing inside stupas. These mandalas come from the Nyingma Kama. Their descriptions are from Lochen Dharmashri, but they are found in a sadhana he wrote for these practices, not in the book on mandalas that is the source of the previous teachings.

(a) *Immaculate Ushnisha*

The *Immaculate Ushnisha* and *Spotless Rays of Light* mandalas are similar; both are from kriyayoga tantra. The illustration in figure 8 shows how to adjust the drawing for each. Instead of one door, as in the *Spotless Rays of Light,* there are four doors with eleven-leveled archways. The pedestal has no boxlike projections. The outside surrounding area only has the lotus and vajra fence, and instead of fire there is a garland of light (*ötreng*). Therefore, do not make the drawing for fire; just make radiant light (*özer*) shading and drawing. This mandala has an underground crossed vajra.

For the inner abode, at the pedestal line draw a circle and its rim. Then measure one chachen to either side of the Brahma line and the horizontal axis and draw parallel lines across to the edge of the circle. Then mark one

chatren to the inside of these lines and draw that for the beams. The sadhana states that each of the nine sections has a lotus seat for the deities. Therefore, a multicolored eight-petaled lotus is drawn in each of the nine sections, but the center can be kept as the color for that section, rather than white for a moon disk seat. There is no need to draw the rim for these lotus seats.

The sections within the circle are colored as follows: The center is white, the east is blue, the south is yellow, the west is red, and the north is green. The intermediate directions are colored white to the southeast, blue to the southwest, red to the northwest, and green to the northeast. The beams of the inner circle and its sections are (light) blue with vajra drawing.

The outer courtyard parapet line is green. The quadrants of the inner courtyard, four doors, and pedestal are colored according to the four directions: the eastern quadrant is blue, the south is yellow, the west is red, and the north is green. The five-layered walls from the inside are white, green, red, yellow, and blue. Everything else is the same as usual.

The deities are colored as follows: Inside the corners of the pedestal in the center of the diagonal line are four offering vajra goddesses: a white drop at the southeast corner for the body goddess; a yellow drop to the southwest for the sitar goddess; a red drop to the northwest for the vajra goddess of fragrant water; and a green drop to the northeast for the green vajra goddess of taste, holding a bowl of fruit.

The inner courtyard has the eight bodhisattvas, seated two in each direction, symbolized by drops of color as follows: to the east, two white; to the south, two yellow; to the west, two red; and to the north, two green. At each of the four doors there is a gatekeeper, represented by a white drop at the eastern door, yellow at the southern door, red at the western door, and green at the northern door, holding respectively a hook, lasso, chain, and bell, as usual. The colors of the deities in the nine central areas are the same as the color of that section, so just draw a circle on the cushion in the center to indicate that deity.

(b) *Spotless Rays of Light*
The *Spotless Rays of Light* mandala is drawn in the usual way, except that there is only one door to the west with an eleven-leveled archway. Divide the pedestal into three horizontal sections by marking one and one-half chachen inward to the east and west, then draw the lines horizontally across to the sides of the pedestal to the north and south. The buddhas are seated along the east side, and the gods are seated along the west side (see figure 8).

The pedestal is colored white. On the east side are seated four wisdom buddhas in a row. On the west side are three worldly deities in a row. The buddhas to the east are indicated as follows: A small yellow square seat with an eight-spoked dharma wheel drawing represents Buddha Shakyamuni. To his left is a white circular cushion with an orange jewel representing the bodhisattva Sarvanivaranavishkambhin. To the left of Sarvanivaranavish-kambhin is a white circular cushion with a blue vajra symbolizing Vajrapani. To Buddha's right is a white circular cushion with a white lotus representing Avalokiteshvara. The symbols all sit on a lotus and moon disk seat.

On the west side, the three circles where the worldly deities abide are also colored white: the conch represents Vishnu, the trident represents Shiva, and the right-turning swastika represent Ganesha (Ganapati). These symbols are all colored blue of varying shades (the conch is the lightest).

If you wish to draw the deities in full, it is described by Lochen Dharmashri as follows: On a yellow square base, lion throne, lotus and moon disk is seated Buddha Shakyamuni, golden yellow, with his hands in the teaching mudra. To his left is Sarvanivaranavishkambhin, golden colored with sambhogakaya ornaments, holding a jewel in his right hand. To Buddha's right is white Avalokiteshvara, his right hand in the mudra of giving and his left hand at his heart holding a lotus. To the left of Sarvanivaranavishkambhin is blue Vajrapani, holding a yak-tail tassel (*ngayap*) in his right hand and his left hand at his heart holding a lotus with an upright vajra on top. These three deities are all sitting on white circular disks, with a lotus seat and moon disk. They are all sitting in the bodhisattva's posture.

To the west, the worldly deites are as follows: Opposite Vajrapani is a circular seat, where black Vishnu sits on an eagle. He has four arms: His first right hand holds a wheel and the other holds a conch; his left hands hold a staff (*bechön*) and sword (*raldri*). To his left is Shiva, riding a bull. His body is white, and his head from the neck upward is blue. His right hand holds a trident (*dungze*) and his left a sword. To the left of Shiva on a white disk seat is Ganesha, blue in color, his right hand holding a vajra and his left hand extended, displaying the wrathful mudra. His head is bowed slightly down with his trunk held upward.

(2) Additional mandalas from terma lineages

This section includes the *Condensed Realization of the Gurus* (*Lama Gongdu*) mandala from the old treasure teachings and a few examples of new treasure mandalas from the termas of Kyapje Dilgo Khyentse Rinpoche.

(a) Old terma mandala: *Condensed Realization of the Gurus*
This mandala comes from the *Condensed Realization* cycle of teachings, revealed by the tertön Sangye Lingpa. It has the *Rosary*-style eleven-leveled archway, as in the previous two stupa mandalas. The celestial palace and outer areas are the same as usual, with a vase stupa instead of the dharma wheel on top of the archway.

In the inner area, a circle is drawn touching the wall line, with a rim one chatren to the inside as usual. Measure out from the Brahma line and horizontal axis by one and one-half chachen in each direction and draw lines across to form a cross shape, similar to the center of the *Immaculate Ushnisha* mandala. Mark inside the outer line by one chatren and again draw lines across for the beams, making a total of nine spaces within the inner circle. Inside each of the nine spaces, draw an eight-petaled lotus seat with its rims.

The corners and doors outside the pedestal are in the four direction colors. The rims and beams are all light blue, and the nine sections are all blue. The lotus seat is multicolored as usual, and the centers of the lotuses are colored as follows: the center is red, east is white, south is yellow, west is red, and north is green. The centers of the lotus seats in the intermediate directions are red in the southeast; blue in the southwest; dark red in the northwest; and dark blue in the northeast. There are many deities in this mandala, which will not be explained here.

The measurement for the surrounding areas of the mandala is a bit different: The lotus ring[120] and eight charnel grounds are each one chachen wide. The vajra fence is two chatren. Sometimes there is a shimmering circle of light (*ökhor*) that is one chatren. The outermost fire ring is one chachen.

(b) New terma mandalas discovered by Dilgo Khyentse Rinpoche
This section contains the measurement for the *Heart Essence of the Self-Born Lotus, Heart Essence of the Self-Born Lotus: Mother Queen of the Ocean, Vajrakilaya According to the Nyak Tradition,* and *Padmasambhava's Heart Essence of Longevity* mandalas, all discovered as treasures by Kyapje Dilgo Khyentse Rinpoche, whose tertön name is Pema Dongak Lingpa. Dilgo Khyentse Rinpoche's complete collection of rediscovered treasure texts fills five volumes.

(i) *Heart Essence of the Self-Born Lotus*
The *Heart Essence of the Self-Born Lotus (Rangjung Pema Nyingtik)* is a mind treasure of Dilgo Khyentse Rinpoche, a practice of the three roots.

This was first revealed in Tibet when Khyentse Rinpoche was with Jamyang Khyentse Chökyi Lodrö. The revelation was kept secret and the texts were left at Mindroling Monastery and later lost. Years later, in exile in Nepal, Trulshik Rinpoche heard about this practice as he was receiving the oral transmission for the Kangyur from Khyentse Rinpoche, and he requested Khyentse Rinpoche to reveal it again. They went to Yangleshö, and after seven days of practice, Khyentse Rinpoche revealed the practice for a second time. Later, when a copy of the original text, which had been found in Tibet, was brought to Nepal, it was found to be identical. In this practice one visualizes oneself as Hayagriva in union with Vajravarahi. At one's forehead is Pema Tötreng Tsal and the eight vidyadharas. At one's heart center is Mahottara Heruka. At the navel is Vajravarahi and at the secret center, Ekajati.

The measurements and color of this mandala are the same as the usual eight-leveled-archway mandala; the only difference is that there is an underground crossed vajra. The outer surrounding area of the mandala is the same as for *Wrathful Deities of the Magical Net,* except the spoke-rest here is a yellow sun rim. The measurement for the inner abode is the same as for Vajrasattva except it has a four-petaled lotus rather than an eight-petaled lotus.

The center is blue, the lotus pistil rim is orange, and the lotus is in the direction colors or it can be multicolored. The outer rim is a blue vajra beam. The rest of the courtyard, the four doors, and other empty areas are in the colors of the four directions: to the east is white; to the south, yellow; to the west, red; and to the north, green. The five walls, from the inside, are blue, white, yellow, red, and green.

(ii) *Heart Essence of the Self-Born Lotus: Mother Queen of the Ocean*
For the mandala for the *Heart Essence of the Self-Born Lotus: Mother Queen of the Ocean* (*Rangjung Pemai Nyingtik Yumkha Tsogyal*) (figure 10), draw the eight lines and parapet as usual. Divide along the diagonal lines into three from the parapet line to the center, and draw a circle from the innermost mark. Then divide along the Brahma line from this circle line to the parapet line into five sections. This is the size of one chachen for this mandala. Draw circles at the first three marks from the inside. Then draw a square from the outermost circle mark, for the wall line. This means the outer two marks from the five marks along the Brahma line are the size of the chachen for this mandala. Therefore, these two become the mandala measurement for the wall line, door, and so on. This mandala has four doors

with an eight-leveled archway. There is an underground vajra, and everything else is the same as for the *Heart Essence of the Self-Born Lotus* mandala.

In the inner abode, the three circles each have four-petaled lotuses, the outer representing body, the middle one speech, and the innermost mind. Inside the central circle, mark one chatren for its rim. Inside this, draw a hexagram from two interlocking equilateral triangles. Inside the hexagram draw another circle, then divide in half from there to the center and draw another circle. Draw another four-petaled lotus here. The rest is the same as usual, but the outer fire rim turns to the left, not the right.

The central circle is white, and the lotus petals are all multicolored or direction colors, however the artist wishes to do it. The hexagram is red, with direction color directly outside the hexagram. The courtyard and other empty areas are also in the direction colors. The five-layered walls are, from the inside, white, blue, yellow, red, and green. On each lotus petal are two deities: the eight blue drops for the mind deities are on the inner lotus's petals. The deities on the middle lotus petals are red (the speech deities), and the deities on the outer lotus petals are white (the body deities).

(iii) *Vajrakilaya According to the Nyak Tradition*[121]

This is the mandala for *Vajrakilaya According to the Nyak Tradition* (*Nyakluk Purba*) (see figure 11) and is Dilgo Khyentse Rinpoche's main Vajrakilaya treasure teaching. The outer areas are the same as in the usual eight-leveled-archway mandalas, but with an underground vajra. Draw the first circle for the outer rings measuring two chatren from the parapet line's corner along the diagonal line. Count again two chatren and draw another circle. This is the area for the outer lotus ring. Measure two more chatren and make a circle for the area where the dharmapalas abide. Draw another circle one chachen out for the charnel ground, then two chatren for the vajra fence, and one chachen for the outermost fire ring.

For the inner areas, starting from the outside and measuring inward, count one chachen from the wall line on the diagonal lines for the pedestal and four doors. Then measure again one chatren inside and draw a square from here with the four doors projecting out by one chatren (the same drawing as for the boxlike projections, also measuring two chatren wide to each side of the central lines, a total of four chatren wide). Draw the lines around for the inner three-layered walls. Mark two chatren from the outermost wall line and draw lines all the way around in a square, dividing the courtyard into two equal parts.

Draw a circle just touching the pedestal line as usual, then another circle one chatren inside that for the five-colored fire ring. Draw another circle a half chatren inward from there for the spoke-rest. Inside this, mark five and one-half chatren toward the center and draw another circle for the eight-spoked knife wheel. Then draw another circle one chatren for the skull garland. This leaves four chatren (one chachen) to the center. Within the central circle is a triangle pointing upward.

The central triangle is colored blue, with red for blood between the triangle and its surrounding rim. Its rim is white for the skull-garland rim, the eight-spoked wheel is dark blue, the space between the spokes and the spoke-rest is red, the spoke-rest is yellow, the fire is five-colored, and the inner three walls are light blue, then red, then white. Between the fire ring and the walls is red. The inner courtyard, which is divided into two, is red for a blood inner courtyard, and the outer is yellow for gold. The four outer doors are colored according to the directions.

(iv) *Padmasambhava's Heart Essence of Longevity*

The mandala for *Padmasambhava's Heart Essence of Longevity* (*Pema Tseyi Nyingtik*) is an inner sadhana, the Amitayus treasure revealed by Dilgo Khyentse Rinpoche.[122] The outer areas are the same as the eight-leveled-archway mandalas, except there is an underground crossed vajra. There are no charnel grounds. For the inner areas, draw a circle inside the wall line, then halve this to the center and draw another circle. Draw two more circles one chatren inside each of these for the rims, as usual. From the outside, first is the vajra beam, second is for a twelve-petaled lotus, third is for the lotus pistils, and then there is the central abode. The central circle is colored red, the lotus is multicolored, other areas are direction colors, and everything else is the same as usual. The mandalas for the outer and secret sadhanas are the same, except they have an eight-petaled lotus.

v. Mandala color teachings from Lochen Dharmashri

These teachings come from Lochen Dharmashri's *Delightful Illumination: A Handbook of Mandala Measurement and Color.* There are four subjects: (1) categories of color, (2) blessing the pigments, (3) a ritual to commence the color application, and (4) how to depict the deities of the mandala.

(1) Categories of color

There are four points for this section on the categories of color: outer color, inner color, secret color, and sand color.

(a) Outer color

There are three points: most precious pigments, middling-quality pigments, and low-quality pigments, depending on the means of the patron.

It is said in the tantras that the best offering of color, given by great benefactors such as a universal king, is made from the finest gemstones, such as sapphire, ruby, lapis lazuli, crystal, *pusharaka*, coral, and malachite.

Mediocre pigments, traditionally said to be offered by the ministerial class, are dyes made from the powders of various grains or seeds and medicinal herbal pigments, such as the five great fruits, which are (1) rice; (2) *drawo*, a kind of bean found inside a triangular-shaped fruit plentiful in Tibet, Nepal, India, and Bhutan; (3) *rambu*, or the seeds from the *Polygonum viviparum*, commonly known as Alpine bistort; (4) *demar*; and (5) *senma*, a green lentil. *Heruka Galpo Tantra* says that different seeds can be used.

The lowest-quality pigments, offered by ordinary people, are mineral pigments prepared from flowers or red earth gathered from a clean or sacred place. *Heruka Galpo Tantra* says that natural pigment color can be used. This is the traditional substance used to paint tangkas.

(b) Inner color

The inner color is the color used in painting a wrathful mandala. Traditionally the artist can obtain ash from a cremated body, dust, sand, or charcoal from a charnel ground, and then mix a small amount of this with some of the pigment color.

(c) Secret color

Secret color refers to the Vajrayana substances such as a small amount of the five great fruits (see outer color). This can be used for both peaceful and wrathful deities. For wrathful deities, it is said that the menstrual blood from a great female practitioner can be mixed with the pigment. Rakta can also be used.

(d) Sand color

This section contains a few essential teachings for the preparation of the colored sand used for sand mandalas. According to Tibetan color theory, the basis of all colors is white. The best pigment for white is crystal, and the next best is a white pigment called *chongshi* (possibly calcite). This is pounded and pulverized into a fine powder, then mixed with water and strained through muslin cloth. To make a red color, a vegetable dye called

martsi is mixed with yogurt, then left to dry in the sun. When it is nearly dry, it is mixed with clay to make red. Before it is completely dry, lime (*dozho*) is added to make blue. Indigo (*ram*) is added to make light blue. Gentian blue is made from *pangyen,* a medicinal plant, which should be cut before the frost has started. Only the leaf tips are used and pounded until very fine, with clay in the heat of the sun. When this process is repeated a few times, a very beautiful gentian blue comes forth. To make green, this is mixed with a more processed kind of dozho. This more refined lime is added to the pangyen, then rubbed and dried again in the heat of the sun, to make green. Tumeric (*yungwa*) is used to make a golden-yellow. It is pounded fine, then mixed with yogurt and white chalk powder and left to dry in a dark place. This can also be mixed without yogurt, for another shade of yellow. If dozho is mixed with a kind of soda from Tibet called *bultok,* it becomes orange-yellow pigment. Fermented grain pounded and mixed with oil and heated in a pan is used for black. This is just a rough guideline. It can only be learned properly from a teacher, as there are many subtle points that can only be shown by example.

Surface dimensions apply to sand mandalas only: the ground surface should be as thick as one wall, and the sand should be as thick as half a wall. The sand mandala needs to be made on a flat, stable surface.

(2) Blessing the pigments

The pigments are put in clean, attractive containers and then placed according to the correct color for the buddha of that direction: blue in the center, white to the east, yellow to the south, red to the west, and green to the north. The heart syllables of the five buddhas can be written on pieces of paper, also placed in the corresponding directions: The buddha family syllable HŪṂ is in the center. The vajra family syllable OṂ is to the east. The ratna family syllable TRĀṂ is to the south. The padma family syllable HRĪḤ is to the west, and the karma family syllable ĀḤ is to the north. Consider that the five buddhas with their consorts arrive and dwell in the union of great bliss. From their place of union, wisdom nectar flows and dissolves into the colors, which are transformed into supreme precious pigment.

(3) A ritual to commence coloring a sand mandala

When drawing the mandala, the artist begins from the outside, with the parapet, but when applying the color she begins in the center. The following ritual is conducted at the beginning of the color application for a sand man-

dala: The vajra master faces east and, considering her five fingers to be the buddhas of the five families, with the thumb and ring finger of her left hand she takes a pinch of the colored sand, which is placed in the northeastern direction, at the five walls. She then takes a pinch of each of the five different colors to make a small section of the wall lines, the length of an index finger, applying the sand very smoothly and evenly. Then a skull cup is placed over this patch of color to protect it for one night, as it is inauspicious for it to be disturbed. Once this is done, the rest of the sand color can be applied.

The colors white, red, yellow, green, and black (represented by blue) are used to represent the five buddha families. All sentient beings are naturally endowed with pure buddha nature; it is merely obscured by the five poisons. Therefore, these five colors are used to create an auspicious connection to realize the five wisdom buddhas within our own being.

(4) How to depict the mandala deities
The deities of the mandala should be indicated as follows: It is best to draw the deity completely, if this can be done well. If the space is too small to draw the deity beautifully, then draw the deity's heart syllable or hand implement. If this is also too difficult to do well, then make a drop or circle the color of the deity. *Awesome Flash of Lightning* says:

> Depict the principal deity in full.
> Draw the pure hand implements for the retinue
> And seed syllables to indicate the outer retinue.

The Lerim says:

> Regarding the three kinds of mandala
> Clearly elucidated in the original text,
> You can draw the full deity's form or heart syllable
> Placed on a lotus, sun, and moon.
> This is the attribute of the mandala's body.
> The hand implements are the clear display of the mind mandala.
> Moreover, draw the supreme body or alternatively the syllables
> such as HŪṂ or MUṂ [the speech mandala].
> This is the difference between the supreme and mediocre.
> This is the manner of distinguishing the three kinds of mandala.

In any case, follow the explanation of the sadhana. Regarding the preparation and application of the color, one must be careful to have the correct consistency. Do not make the color too thick or thin or apply it improperly, leaving gaps or overlapping. For example, if the color applied is too thin, it creates a cause for the artist to become poor. If it is roughly applied or too thick, the artist can become sick. Artists must concentrate and be mindful during all aspects of making their artwork, whether in the stages of preparation, drawing, or application of color. Artwork should be executed very carefully and respectfully from beginning to end. If we are agitated when applying color, mistakes will be made, in which case prayers should be performed. It is important to understand that the meaning of the mandala of the deity is so vast that it is beyond our ordinary conceptual comprehension. Therefore we need to follow the advice from the tantras and gurus and not create our own compositions. This comes from the advice of Lochen Dharmashri.

vi. Some useful additional subjects

Although most of the advice here on mandala measurement and color comes from the writing of Lochen Dharmashri, there are some small sections where I have elaborated slightly from my own experience and from the advice received from my teachers. This section of teachings includes more of these points as well as some brief additional subjects that were not included in Lochen Dharmashri's mandala book.

(1) An easy drawing method

Here is an easy drawing method to begin your mandala drawing. First draw the eight lines as usual, then choose the mandala size you need and draw the square outer border lines. Divide the area from there along the diagonal lines into twelve parts, each the size of one chachen. Then draw the square lines of the parapet from the halfway point. Two marks inward, draw another line for the wall line and divide the two chachen between into four chatren each to draw the rest of the mandala as usual. Draw another square one chachen inside the wall line for the pedestal lines. The innermost four marks of the twelve divisions are not used. Continue the mandala drawing as usual.

(2) Mandala teachings from Jigme Lingpa

These teachings mostly come from Jigme Lingpa's *Treasury of Precious Qualities*. The circular central seat of the deity is blue. Check as to whether

the seat of the deity (*lhanam*), which here refers to the inner courtyard, is required; this will depend on whether or not there are retinue deities. The circular rims, which are sometimes a garland of light; wheel spokes; pedestal and four boxlike projections; midway courtyard; doorways; and pillars are all usually the colors of the four directions. There is sometimes a gold courtyard (*serkhyam*) or a red blood courtyard (*trakhyam*). The circular vajra beams, spoke-rest, and the like are blue. The platform of delights is made from different materials, such as gold, crystal, or *padmaraga,*[123] but it is always colored red. The precious jeweled architrave is yellow. The pendant garlands are of pearls and jewels to beautify, on a black ground. Both the rainspout watercourse motif and the stupa-shaped ornaments along the parapet are drawn in white on a light-blue ground. The dark area surrounding the T-shaped door and elephant's-back hollows are black, to indicate hollow spaces. The doorway's pillars are in the direction colors.

The colors of the four-, eight-, and eleven-leveled archways can vary according to the sadhana. On top of the archway, the lotus seat is red, and the dharma wheel and deer are gold. The parasol is white. At each door and at the corners, there is a joined crescent moon with vajra handle, twelve in total.

The vajra fence is blue with white or yellow vajra drawings. The outermost fire ring has flames in five colors. The underground vajra is varicolored with a black center, or it can be the color of the deity. To elaborate: In each direction the central prong of the vajra is the color of that direction's deity. The right and left prongs of a three-pronged vajra are colored according to the direction deities to either side. If it is a five-pronged vajra, it should be colored according to the deities of five directions. Anyway, as we can see only three prongs, just do what you can, according to these instructions. Generally the vajra prongs to each side are all colored according to the deity of that direction. On either side of the archways are a gold vase and wish-fulfilling tree, palmyra tree, bathing pool, and mound of precious jewels, one on each side of the archway in each direction.

The empty area between the square parapet and the surrounding circle is called the outer courtyard and is usually colored green. The sun rim is yellow and the surrounding lotus ring is multicolored with a red background. At the time of meditation, the protective vajra canopy must be understood as coming from the wind that forms the base of the universe. It forms a protective canopy extending from this base, surrounding the entire mandala up to Akanishta heaven. This vajra fence is made of many different colors. The

vajra canopy radiates a garland of brilliant five-colored wisdom light. This completes the outer areas. Now a discussion of the inner area.

Each quadrant inside the wall line is colored according to the wisdom buddha's direction. At the time of meditation, the entire mandala and celestial palace should be visualized as that direction's color. This includes above and within the roof, the pillars, and so on. The circular vajra beams are always blue, with the vajras in the color of that direction. Generally, the central color is blue and the sides colored according to the directions, signifying the five wisdom buddhas. However, if this is not clearly outlined in the sadhana, then the central color should relate to the body color of the central deity, or the lord of their particular buddha family, and the colors for each direction are changed accordingly. The center of the eight-petaled lotus seat is green. The petals are colored differently: southwest is green, northeast is black [blue], southeast and northwest are yellow, and the petals to the four cardinal directions are all red. This is in general, but the various tantras will all be different. Whichever one you want to follow, you should first study very well before measuring a mandala; do not just pursue your own ideas. This advice comes from *Awesome Flash of Lightning*.

(3) The eight charnel grounds

In his autocommentary to the *Treasury of Precious Qualities* called the *Chariot of Two Truths,* Jigme Lingpa quotes again from *Awesome Flash of Lightning* with a concise teaching on the symbolic meaning of the eight charnel grounds, summarized here as follows: The eight charnel grounds symbolize the eight collections of consciousness. The eight accomplished ones symbolize the eight wisdoms. Eight fires symbolize the eight extreme torments. Eight trees symbolize the eight inherent afflicting emotions, or kleshas. Eight ponds symbolize the eight practices of a bodhisattva. Eight gods symbolize the eight doors to siddhi. Eight nagas symbolize the eight collections of qualities. The eight local guardians (*lokapala*) symbolize the eight collections of merit and wisdom. This completes the teaching on the eight charnel grounds from Jigme Lingpa.

In addition, sometimes eight stupas are depicted. Many masters advise that when there is not enough space to depict the eight gods, they can be represented by eight clouds. The local guardians can be represented by eight rock mountains, which preserves the meaning.

The *Heart Accomplishment of the Northern Treasures* gives an elaborate description of the charnel grounds, summarized here as follows: In the

surrounding areas of the mandala in the four cardinal and four intermediate directions are the eight charnel grounds. The eastern charnel ground is called Savage. The southern charnel ground is called Blazing Fire. The western charnel ground is called Skull Destroyer. The northern charnel ground is called Dense Wilderness. The southeastern charnel gound is called Cool Grove. The southwestern charnel ground is called Unending Darkness. The northwestern charnel ground is called Chattering Voices, and the northeastern charnel ground is called Roaring Laughter.

There are eight stupas in the center of the charnel grounds. Their names are, clockwise starting from the east, Descended from the Heavenly Realms, Radiating Light, Stack of Wheels, Pile of Jewels, Heaped Lotuses, Nonsuffering, Many Doors, and Thousands of Stupas.[124]

The names of the eight trees of the eight charnel grounds, circling from the east, are Shirsha, Ashvasata, Kakola, Karentsa, Salasa, Satio, Bhataka, and Shi-tsuti. At the base of each tree, starting from the eastern tree, emerges a local guardian with only half its body protruding from the trunk. They are Langshok, with an elephant face; Kunsek, with a goat's face; Söje, with a buffalo face; Zaje, with a cannibal demon face; Gaje, with a crocodile face; Kyeje, with a deer face; Nordziren, with a horse face; and Nöjin, with an oxen head. They all have one face and two arms, holding a hooked knife in the right hand and a blood-filled skull cup (*tötrak*) in the left hand. They are adorned with jeweled ornaments and are slightly wrathful.

The guardian kings of the eight directions are usually depicted standing near the tree. Clockwise from the east they are as follows: Indra is white and rides an elephant, with a vajra in his right hand and bell in the left. Agnideva, the god of fire, is red and rides a goat (or sheep), holding a hearth and round-bellied urn. Yama is dark blue and rides a buffalo, holding a stick (*yupa*) and blood-filled skull cup. Wrathful Rakshasa is maroon and rides a zombie, holding a sword and blood-filled skull cup. Varunadevi, the water goddess, is white and rides a crocodile, with a snake and lotus in her hands. Vayu, the god of the wind, is smoke colored and rides a deer, holding a banner and lasso. Yaksha is yellow and rides a horse, holding a victory banner and a mongoose vomiting jewels. Bhuta demon is light blue and rides an ox, holding a lance and blood-filled skull cup. They each wear a jeweled crown and are adorned with bone ornaments. They have a consort holding a baby, seated to the left side of their lap.

There are eight ponds with eight nagas, each with names. The nagas each have nine snakes rearing above their head, with a snake tail from their waist

down. They are adorned with jeweled ornaments, and their body colors are the same as the local guardians. The right hand holds a snake lasso and the left holds a jewel. Their crown is ornamented by a jewel.

Eight clouds arise from the steam above the eight ponds, starting from the east as follows: Sounding (Dratok) is blue, Gathered (Trikpa) is fire colored, Noisy (Draden) is yellow, Shower (Charbep) is green, Fierce (Drakpo) is white, Mist (Mukpa) is brown, Hidden (Sangwa) is gold, and Savage (Tumdrak) is variegated.

There are also eight fires, starting from the east: Burned (Tsekpa), Scorched (Tsekche), Flaming (Barwa), Swift Point (Nonyur), Intensive (Raptu), Heat (Drowa), Sun (Öden), The Fire at the End of the Kalpa (Tuteme).

There are also eight great yogis: Starting from the east, Indrabhuti; then to the south is Guhyachandra; to the west, Nagarjuna; to the north, Powerful Vajra Wrath (Dorje Drakpo Tsal). To the southeast is Vajra Humkara; to the southwest is Padma Vajra; to the northwest is Manjushrimitra; and to the northeast is Raksha Kamala. Their body color can vary, and they do not have prescribed ornaments or postures.

Many blessing dakinis abide in the charnel grounds. The grounds are littered with corpses, old and fresh; severed body limbs, skin, blood, hair, bones, skulls, fat, and intestines are strewn in all directions. Zombies and strange beasts roam the grounds, such as tigers, leopards, bears, yeti, wolves, vultures, crows, owls, sea monsters, fish, sable, and other similar creatures. There are houses made from bones and skulls, laughing skeletons, every terrifying thing imaginable, human and nonhuman, all with ferocious temperaments.

Karmapa Tekchok Dorje said that there are eight mountains: Starting in the east is Mount Sumeru, with variegated colors; to the southeast is Maheshvara (the Mighty), black; to the south is Malaya, yellow; to the southwest is Rising Fragrance, yellow; to the west is Kailash, the snowy mountain or Himalaya, white; to the northwest is Snowy Mountain, white; to the north is Mandara, green; and to the northeast is Glorious Mountain, blue.

(4) Depicting the mandala deities

It is best to draw the main deity in full, but sometimes the area is too small. In that case, one can draw the deity's heart syllable or hand implement. If the mandala is too small for this, then the color of the deity's body is painted in

a small drop or circle to indicate the deity, or a small heap of sand is placed if it is a sand mandala. Another method is to draw the central deity fully, with the inner retinue deities of the mandala symbolized by their hand implements and the outer retinue deities as syllables or drops. It is better to use this method if the mandala is too small for each deity to be drawn clearly.

When it is not possible to depict the deity in the center, make the central drop or circle the largest and the retinue circles smaller. If the deity is in sexual union with a consort, the circle for the main deity is depicted larger and the consort is smaller, just overlapping the larger circle. The circle is always filled with the deity's body color. For deities that are bicolored (half and half), the circle should be colored the same way. This is very important so that we can understand where the deities are, how many, which are in union, and so on. This advice comes from Dilgo Khyentse Rinpoche and Jamyang Khyentse Wangpo.

(5) The semicircular magnetizing-activity mandala

It is important to understand how the different shapes in the central area of the mandala relate to the four activities. A round shape is for peaceful activity, a triangular shape is for wrathful activity, a square shape is for increasing, and the semicircular shape is for magnetizing. This section gives instructions for drawing a mandala with a semicircular center, which is added here as it was not included in Lochen Dharmashri's teachings and is useful for the artist to know. Refer to figure 6 for the drawing of a semicircular mandala.

First draw the eight lines, then make the outer border and divide the diagonal lines in half for the parapet line, as usual, and then draw the square lines for the parapet in light pencil on all four sides. Divide the parapet line from the corner to the center into three. From the outermost of these three marks on the diagonal lines of the eastern quadrant only, draw a straight line horizontally across for the wall line. Span your compass to the length of two of these marks and then, placing the compass tip in the center, draw the circle around from the straight edge of the wall line on the eastern side to meet the other side. This creates the semicircular shape and the entire wall line.

Span your compass to the measure between the wall line and parapet line along the Brahma line (the central vertical line) on the eastern side, then place the tip on the Brahma line on the western side and make a mark for the parapet line from there. Then again place your compass point in the middle and span it to this mark and draw the semicircular parapet line around. It will cross a little to the inside of the eastern quadrant on both

sides to meet the straight lines of that edge. Then make a straight line on each side between the wall line and parapet line where the semicircle meets the straight edge of the palace along the eastern side. Halve this line and again draw the circle and straight lines around, which is one chachen to each side. Then, as usual, halve the outermost chachen and draw the lines around and across, and from there make the other lines for the five-layered walls, platform of delights, jeweled architrave, and so on.

Make the door, archways, and underground vajra according to an eight-leveled-archway mandala. From the top of the parasol on the eight-leveled archway, draw the surrounding circles. If you need more space for the outer courtyard, then mark two chatren from the parasol, instead of having the first circle drawn from there. Most dakini mandalas will have a fire turning the opposite way, to the left.

The inner abode of the deity sometimes has a hexagram and sometimes an eight-petaled lotus; it depends on the sadhana, so this needs to be checked. Whichever it is, since the inside of the mandala is not symmetrical because of the straight edge on one side, the center is located by dividing in half the area between the eastern side of the wall line (the straight edge) and the western side. This is the central point. Then draw a circle to make the lotus petals or the hexagram or whatever is required.

This concludes the teachings on mandalas.

2. Iconometric proportions
The teachings that follow are divided into general and specific explanations on iconometric proportions.

a. A general explanation of iconometric proportions
Out of the Buddha's immense kindness toward all sentient beings, his vast activity continuously manifests, which is why there are so many different forms and postures of the buddhas—large, medium, small, and immeasurable in scope. Buddha can be as vast as the sky or as small as a dust mote. Whatever size the Buddha is, the proportions need to be measured correctly.

It is important to begin an artwork on an astrologically auspicious day. The best-quality art materials should be purchased, within the means of the artist or patron. Whether a statue, a drawing, or any other type of supreme art object, it needs to be correctly proportioned and pleasing in appearance, with an appealing shape and natural, flowing posture. According to the *Condensed Realization of the Gurus,* the outer meaning is that no fault

or defect can be seen and it is attractive to the eye. The inner meaning is that it depicts the splendor and beauty of the Buddha's thirty-two major and eighty minor marks. Having correct proportions is not enough; the peaceful deities need to appear calm and smiling and the wrathful deities very angry and terrifying. The ornaments should also be clearly and beautifully rendered, with nothing missing or added.

There are two points regarding the images used as support for our practice, such as statues and tangkas: where iconometry is used and the systems of iconometric proportion.

i. Where iconometry is used

Iconometry, as defined in the sutras and tantras, is necessary when depicting the forms of buddhas, bodhisattvas, and deities, whether in statues, drawings, or tangkas, as this conveys the blessing of the work. When the proper proportions are followed and the work is consecrated (*rabne*), this supreme art object will be a nirmanakaya emanation of great benefit to beings.

ii. Systems of iconometric proportion

There are two main systems of measurement of iconometric proportion used in tangka and mandala measurements. The first is from the *Kalachakra Tantra* and the other from Chakrasamvara and other tantras. The first system calculates one *zhal* ("face" size, also called *to, talmo, til, dong,* and *chachen*) as 12½ *sor* ("finger" size, also known as *chatren* or *chachung*). In the other system, one zhal equals 12 sor. (See appendix 2 for a table of these measurements.) One-fourth of one sor is one *kangpa* ("leg" size). One-half of one kangpa is one *ne* ("grain" size; 8 ne are equal to 1 sor).

The Karma Gadri tradition uses the first system of measurement. These systems are used for calculating the proportions for all the various buddhas, bodhisattvas, and deities. Lhodrak Mentangpa said that in one ordinary human life, every time a person reaches 8,100 breaths, a wisdom wind arises. As our mind becomes purified, these wisdom winds will start to arise more often. Therefore, as our mind is purified and we traverse the levels of accomplishment (*bhumi*), our body size also increases correspondingly. For this reason, the body sizes of the buddhas and bodhisattvas vary accordingly. At the first bhumi the bodhisattva's body measures 108 sor. From then until the ninth bhumi, the body size will increase by 2 sor for each bhumi, so that it reaches 124 sor. On the tenth and eleventh bhumis, they increase by half a sor each, to 125 sor.

There are different ways of summarizing the proportions. One is the five main body measurements for standing deities:

1. A fully enlightened buddha is 125 sor (10 zhal at 12½ sor).
2. A bodhisattva is 120 sor (10 zhal at 12 sor).
3. A female deity is 108 sor (9 zhal at 12 sor).
4. Wrathful deities (*trowo*) are 96 sor (8 zhal at 12 sor).
5. Wrathful rakshasas such as Gönpo Lekden are 72 sor (6 zhal at 12 sor), according to the *Mighty Black Yama Tantra*.

Ratnarakshita and some Newar teachers said that Mahakala Ganapati (see figure 59) can be 5 zhal. The tradition of Mahakala Bernakchen as 3 zhal in size (see figure 62) comes from Tibet.

The measurements for the first four categories are described clearly in the tantras; therefore, artists must follow these measurements carefully when depicting the male and female buddhas and bodhisattvas, the wrathful female and male deities, nirmanakaya monks, and so on.

For the three different classes of wrathful spirits (yama, yaksha, and rakshasa), the measurements of 96 and 72 sor can be used. However, the measurement for a standing buddha should be 125 sor, where the length of his body from the top of his head to his feet is the same as the span of his arms.

The vertical measurement for a standing buddha is explained in the *Kalachakra Tantra* as follows (see figure 16): From the crown protuberance (ushnisha) down to the coiled hair between the eyebrows (urnakesha), there are three divisions (ushnisha, hairline, and urnakesha) coming to a total of 12½ sor or 1 zhal. The next four measurements, from the urnakesha to the lotus of his throat, and then from the throat to the heart, the heart to the navel, and the navel to the secret place, are 12½ sor or 1 zhal each. This comes to a total of 5 zhal for the upper part of the body.

For the lower part of the body, the measurement from the soles of the feet to the ankles is 4½ sor. The calves, knees, thighs, and hips are respectively 25, 4, 25, and 4 sor, coming to a total again of 5 zhal. This is not mentioned in the *Kalachakra,* but the knee can be 4½ instead of the foot. So the body length measures a total of 10 zhal.

For the horizontal measurements, each half of the chest is 12½ sor, while the upper arm, the forearm, and the hand are respectively 20, 16, and 12 sor, for a total of 121. There is a further 1 sor above each elbow and wrist, coming to a total of 125 sor. This is the system using 12½ sor for one zhal. The

correct size for the standing Buddha is 125 sor or 10 zhal. Further details can be seen in the illustration or by referring to Kongtrul Rinpoche's *Treasury of Knowledge*.[125]

Conversely, the Chakrasamvara tantra called *Binder of Chakras* and some other tantras and commentaries say each zhal consists of 12 sor, and therefore the total body length of a buddha is 120 sor. However, Jamyang Khyentse Wangpo has explained that the *Chakrasamvara Tantra* also mentions 125 sor for the Buddha's measurement.[126] Similarly, Lhodrak Mentangpa says that 125 sor is for buddhas and 120 sor is for bodhisattvas. So, according to our tradition, this is the standard size from the top of the head to the feet and the same for the arm span.

The measurement for a female buddha is the same as that for a bodhisattva, but some parts of the body are shorter and slimmer, by one sor in each place, so it ends up slightly less, at 108 sor. This is the correct size for female buddhas and bodhisattvas. The wrathful deities are 96 sor. This measurement can also be used if a deity is somewhat short and stout. Dwarfs are 72 sor, or 6 zhal. Human measurement is 84 sor, with an arm span of 96. This is also used for shravakas and pratyekabuddhas.

Jamyang Khyentse Wangpo said the following: (1) The height of a standing buddha is 10 zhal plus 5 sor (if each zhal is only 12 sor; otherwise it is only 10 zhal at 12½ sor per zhal). (2) The body height of a standing sambhogakaya buddha or bodhisattva is 10 zhal. (3) Female buddhas are 9 zhal. (4) Wrathful deities are usually 8 zhal. (5) Wrathful Ganapati and dwarfs are 6 zhal. (6) Humans, shravakas, and pratyekabuddhas are 7 zhal (84 sor) with an arm span of 8 zhal.

The measurement for a guru is 125 sor, the same as for a buddha because, although the body is human, the guru's mind is that of a buddha. Gurus should appear youthful; even if they are old, it is better not to make them look decrepit, otherwise the interdependent connection is inauspicious.

Rigdzin Jigme Lingpa said that artists should not draw the supreme enlightened forms entirely from their own creative inspiration. They must follow the proper conventions of proportion according to the tantric texts. A fully realized and accomplished yogi such as Mahasiddha Tilopa killed fish without suffering any karmic effects. But for ordinary people like us, such actions would bear negative karmic results; therefore, the proper traditions should be followed, whether it is drawing, color, or ornamentation and accoutrements. Lord Buddha said that art, medicine, and Vajrayana

practice are too profound for ordinary people to understand. For this reason, it is important to follow the tenets rather than our own deluded ideas. Otherwise, serious mistakes can be made.

b. A specific explanation of iconometric proportions

This section has four points: (1) how to begin the drawing, (2) drawing the lines and calculating the areas, (3) the eight types of deity, and (4) the karmic consequences of making errors in measurement.

i. How to begin the drawing

If time permits, the artist should check for an auspicious day to begin the work, and the best-quality materials, such as gold and silver, should be gathered according to one's means.

To begin the work, first say prayers and do supplications, take refuge and generate bodhichitta, and practice the sadhana of the deity being portrayed. A more essential preparation is simply to visualize yourself as the deity. Above the tangka cloth, visualize the female wisdom consort Prajnaparamita. Above the art-making implements, visualize the retinue of the deity, and above the color pigments, visualize the five wisdom buddhas in union with their consorts. Then recite a short offering prayer, verses of praise, and requests. After this, visualize the deities dissolving into you, the art implements, the tangka, and the pigments beneath them. Now consider yourself, the tangka cloth, the art tools, and the pigments as inseparable from the deity. While working, consider your thumb to be skillful means and your forefinger to be wisdom. Joining these two together while holding the brush is skillful means and wisdom in union. From the point of their union, many buddhas issue forth and dissolve into the tangka. Then start drawing. The deities, accoutrements, colors, and surrounds need to be reproduced exactly as described in the sadhana. At the end of each day, dedicate the merit.

ii. Drawing the lines and calculating the areas

When drawing the initial eight lines for a tangka, it is easiest to draw the diagonal lines first from corner to corner to locate the central point. These lines are traditionally made first with a fine chalk string, then using a ruler and pencil. From the central point, stretch the compass toward the edge along the diagonal lines and make marks at each corner to the width you prefer. Draw lines across to make the border lines. The proportion of the rectangle is traditionally two parts to three. Divide each side in half, then

draw the Brahma line and horizontal axis. These eight lines must be perfectly even.

In painting a mural, first it is necessary to assess the size of the area for the image and sketch out the composition based on this. Then make the central line using a plumb and chalk string. This is the Brahma line, which for a mural is called the *namtik*.[127] There are a few different names for this line, whether for a tangka or mural: *tsatik, utik,* and *kyiltik.* Any lines parallel to this are called the *zhungtik, chutik,* or *gyentik.* There are also other names for these. The second of the eight preliminary lines that cross the Brahma line at 90 degrees is often simply referred to as the horizontal axis, but the real name for this and any other horizontal lines is *tretik.* The diagonal lines of the eight lines are known as *zurtik* (literally, "corner lines"). Lines that cross the central line at an angle are called *gyingtik,* such as for drawing a head at an angle. Any other lines that are at various angles are called *kyutik.* These are the names for the basic measurement lines for deity drawing; there are names for the other lines, but it is not necessary to list them here, as they are logical and easy to understand, for example, "head line" and so on.

To choose the size of the area for the main deity, first check whether it is a standing or seated deity. Choose the area for the deity and then divide this area into six. One-sixth is the size for one *zhaltse.* For standing deities, divide the area you have chosen for the deity in ten along the Brahma line, for each zhaltse. Then commence your measurement and drawing.

iii. The eight types of deity

This is an explanation of the division into eight types of deity: (1) buddhas, (2) sambhogakaya buddhas, (3) semiwrathful deities, (4) bodhisattvas, (5) female deities, (6) deities in the class of wrathful yama, (7) deities in the class of very wrathful rakshasa, and (8) shravakas, pratyekabuddhas, and humans.

In this discussion, the deity measurements are included in the illustrations toward the back of the book; however, the details of those measurements are not explained, as it is easier to simply refer to the drawings. Some of the discussions of these eight groups overlap. The first three all have the same measurement of 125 sor.

(1) Buddhas

A standing buddha's measurement has been explained as 125 sor (or 12½ sor for one zhal). The measurement for a seated buddha, without a lotus seat, is in figure 13. For a standing buddha, see figure 16, which shows the

front and back. Buddhas' measurements and drawings can be seen in figures 12–16. Figures 17–20 are for depicting a guru, using the same measurement as a buddha.

(2) Sambhogakaya buddhas

Sambhogakaya buddhas with ornaments have the same iconometric proportions as a buddha, but with the ornamentation for peaceful sambhogakaya deities. The example of a sambhogakaya buddha, Guhyasamaja, is given in figures 23–24. The measurement for Vajrasattva is the same as for Guhyasamaja, but his right hand holds a vajra to his heart and his left hand holds a bell at his left hip. The measurement is the same for gurus (figures 17–20).

(3) Semiwrathful deities

Semiwrathful deities have the same measurement as a buddha, but with the five or six bone ornaments and so on. The example given in the illustrations is Chakrasamvara (figures 21–22). Although the measurement does not change, the posture and ornaments change according to the sadhana. This concludes the categories concerning buddhas' measurements.

(4) Bodhisattvas

The supreme bodhisattvas, such as the eight close sons,[128] are usually 120 sor (10 zhal). They can be in many different aspects and are also usually depicted with sambhogakaya ornaments. Therefore, the artist needs to understand how to distinguish the levels and ornamentation of different deities. For example, when Manjushri is depicted as Buddha's disciple, he is drawn according to the bodhisattva measurement, but otherwise he is depicted using the same measurement as a buddha. For the twelve-headed Avalokiteshvara with one thousand arms, the bodhisattva measurement is used (figures 25–26). The measurement for Manjushri is shown in figures 27–28.

(5) Female deities

There are peaceful and wrathful female buddhas and deities. The drawing and measurements for the following female deities are shown in figures 29–41: Naro Khachö (figures 29–30), Vajrayogini (figures 31–32), Kagyu lineage Vajravarahi (figures 33–34), Wrathful Black Vajravarahi (figures 35–36), White Tara (figures 38–39), and Green Tara (figures 40–41). A female head measurement is shown in figure 37.

Padmaraja is one of the eight manifestations of Guru Rinpoche; although this is a male deity, he has the same measurement as Tara, except that 3 sor is changed to 4 sor along the vertical sides.

The female protector Shri Devi is shown in figures 66–67 and the wealth and protector deity Achi in figures 68–69. There are many different measurements for Vajravarahi. When she is extremely wrathful, her body is shorter, so it is not possible to speak of only one measurement for the deities. Sometimes they are fatter and sometimes thinner. The measurement for peaceful female deities like Tara does not change, but their posture can change.

(6) Deities in the class of wrathful yama

There are three main types of wrathful deity: the yama, yaksha, and rakshasa. Yama can also refer to all wrathful deities. The wrathful deities known as wrathful yama are depicted as short with a big belly and a fierce open mouth. Their body is usually 8 zhal. Vajrapani is the prototype yama wrathful deity. However, Vajrapani the Conqueror (figure 46) with one head and two hands, has the yaksha wrathful deity ornaments and posture. This kind of distinction has to be understood.

See figures 42–52 for the yama wrathful deity examples: Wrathful head (figure 42); Vajrapani head (figure 43); Great Wrathful Vajrapani measurement (figure 44) and Vajrapani with adornments (figure 45); Vajrapani the Conqueror measurement (figure 46) and with adornments (figure 47); Achala (figures 48–49) with ornaments and posture from the inner tantra, as described for mind Achala from *Relaxing in the Nature of Mind*; Vajrakilaya (figures 50–51); and Kilaya with end part (figure 52). The Lord of Secrets, Vajra Hungchen Kara, Vajrakilaya, Mahottara Heruka, Red Bhairava Vajra Ushnisha, Hayagriva and the Ten Wrathful Ones, Dorje Drolö, Wrathful Guru, Dharmaraja, and Yamantaka all also use the Vajrakilaya measurement, but there are no examples of these drawings here. Also yaksha and rakshasa deities sometimes use this measurement.

(7) Deities in the class of very wrathful rakshasa

The very wrathful rakshasa forms are usually 5 or 6 zhal high. Those with 6 zhal include Four-Armed Mahakala (figures 53–54), Six-Armed Mahakala (figures 55–56), and Rahula (figures 57–58).

Gönpo Gur, Gönpo Lekden, and Gönpo Maning are also 6 zhal, although in some artistic traditions they are 8, 5, or 3 zhal. There are no illustrations here.

The measurement of 5 zhal includes Mahakala Ganapati (figures 59–60). Mahakala Bernakchen (figures 61–63) has a body height of 3 zhal.

This concludes the part on the very wrathful rakshasa style of deity. Other measurements for wrathful deities that are not included in either of these categories are the four guardian kings (figures 64–65) and Shri Devi (figures 66–67). The other examples of wrathful females are included in the section on female deities.

(8) Shravakas, pratyekabuddhas, and humans
The shravakas, pratyekabuddhas, and humans are shorter than the deities, usually 7 zhal, with their arm span a little longer at 8 zhal (figure 70).

iv. The karmic consequences of making errors in measurement
If an artist does not follow the proper proportions according to the tantric texts, instead just following his own ideas when depicting a deity, the karmic consequences are negative. This is also a waste of time and the sponsor's money, as the work will contain no blessing. The artist first needs to thoroughly investigate the tradition. If the correct measurements are followed according to tradition, then the benefit is immeasurable.

To explain in more detail, the karmic consequences of making errors in measurement are as follows: If the chin, neck, or calves are drawn too long, this is a cause for creating obstacles for the artist. If the ear, nose, or fingers are too short, this is a cause for the depletion of siddhi and merit. If the calves, face, or cheeks are too big, this is a cause for loss of merit and for obstacles in life. If the jaw, chest, or waist is too thin, it is a cause for our aims to be unfulfilled and for serious obstacles. If the male chest or female breasts, ears, or nose and forehead are skewed, it is a cause for having enemies. If the thighs, hips, upper chest, or buttocks are too small, it is a cause for being robbed and mugged, or even killed. If the ears, lips, forehead, nose, or eyes are out of proportion and skewed, it is a cause for many different obstacles, even untimely death. If the eyes are looking in the wrong direction, or if the body looks tense or like it is rising from its seat, this is a cause for us not being able to remain in one place. If the hand implements are incorrect, this is a cause for great suffering. If the halo, parasol, or lotus is too small, this is a cause for our loved ones to have obstacles and our merit to be depleted.

With this in mind, one must carefully check for and correct any mistakes in the drawing. If there are no mistakes, this is obviously very beneficial. If the deity's measurement and size are incorrect, then the wisdom bless-

ing cannot remain. In addition to this, the place where this faulty image is placed will not have good influences and signs and instead will attract misfortune. It is better to dispose of it in a clean place; it cannot just be thrown in the garbage. A tangka can be ritually burned. In Tibet it would be placed in a special stupa for this kind of object. If the measurement is not correct but it still has an ushnisha, eyes, a robe, and bare feet, then it is still a buddha. These are the basic signs of a buddha that cannot be changed, so care must be taken in how they are disposed of.

3. Various additional measurements

There are five main subjects: (1) throne and monastic accoutrements, (2) temple building and decoration, (3) further important points, (4) various additional subjects, and (5) various practical guidelines.

a. Throne and monastic accoutrements
i. Short throne

Refer to figure 71 for the measurement and drawing of the short throne.

ii. Wooden gong

The gendi is a wooden gong used to call the congregation of monks and nuns to the bimonthly sojong ceremony and other rituals. It should ideally be made from sandalwood. It is a long, rectangular shape and is held over the left shoulder of the monk or nun and struck with a short, swaddled wooden stick. A newly made gendi needs to be properly blessed before it can be used and should be kept in a place of respect. Only ordained sangha and those who have taken one-day vows can use it, according to the Vinaya rules. In the sutras it is said that the benefit of using the gendi is that whoever hears its sound can easily achieve enlightenment. Whoever pays respect to and appreciates this gong can reap great benefit. If it is not respected or the rules for its use are not followed, there will be negative karmic consequences such as sickness. The proper measurement for this should be followed.

iii. Various robes and items of the ordained sangha

After the first Buddhist sangha was formed, Buddha Shakyamuni initially told his monks to wear whatever cloth they could find, of subdued, natural shades, rather than fine or precious cloth. However, one day an ordinary person was wearing cloth that looked the same as that worn by the ordained disciples of Buddha, so King Bimbisara mistook this person for a monk and

went to pay him respect. When the king realized that the man was not a monk, he was concerned and went to Buddha Shakyamuni to request that a special kind of cloth be made for the Buddhist monks so that they could be distinguished from ordinary people. Buddha agreed and said that they must use only cloth that has been cut and sewn. From then on there was the tradition of the thirteen requisites of a monk.

(1) The thirteen requisites of a monk

The thirteen requisites of a monk are prescribed in the Vinaya. The first four are the main robes for the ordained sangha. They are made using the *tru,* a cubit measurement calculated either from the elbow to the tip of the fully extended fingers, or to end of the hand with the fingers closed (this is the one used for the *namjar* and so on). In the tantras it says that the human measurement is seven tru from the top of the head to the feet. Therefore, the measurements differ according to the size of the person for whom the cloth is being made, as the units are based on an individual's body size.

(1) The namjar is the patched upper robe worn only by fully ordained sangha. There are three sizes and elaborations of namjar: elaborate, medium, and small. The outer edge of the elaborate namjar is measured as 3 tru along the short side and 5 tru along the long side. The medium-sized namjar is 2¾ by 4¾. The smallest is 2½ by 4½. Then a border piece is calculated going all the way around. The width of this is the span from the outstretched finger to the thumb of the person for whom the namjar is being made.

The middle section consists of rows of overlapping pieces (across the short side of the namjar). The rows are called *namtren.* Each individual small rectangular overlapping piece or patch is called a *lekbu.* The large namjar always has 4½ lekbu across the short side. The medium namjar always has 3½ lekbu, and the smallest always has 2½ lekbu. This is calculated simply by dividing the area accordingly.

The namtren rows across the long side of the namjar can have different amounts, explained below, and always begin from the middle. In the tradition explained here, each row changes direction and is staggered.

Regarding the largest, elaborate namjar, it can have 25, 23, or 21 namtren. The medium-sized namjar can have 19, 17, or 15. The smallest can have 13, 11, or 9 namtren. But the sections along the short side are always the same, according to the previous explanation.

(2) The *chögö* or *lagö* is another upper robe, 3 by 5 tru in size, with the border the same span as the namjar. It has 7 namtren with 2½ lekbu across

the short side. This is worn by the ordained sangha, including novice monks and nuns.

(3) The *tengö* or *shamtap* is the outermost lower robe (like a long skirt), prescribed in Vinaya texts. It is 2 by 5 or 4 tru. It only has an upper and lower border, as it is sewn together on the sides. It has five namtren with 1½ lekbu across. (4) The shamtap is like the tengo except plain. It is worn by all ordained sangha. (5) The *ngulzen* (petticoat) for absorbing sweat from the lower body is the lightweight skirt worn inside the shamtap and is the same size. (6) The "real ngulzen" is the lightweight upper garment for absorbing sweat (literally, "belonging to the armpit"), which is the same size as a *zen*. (7) The zen, which is the plain robe or shawl worn around the upper body and over the left shoulder, is the same size as the chögö. The zen can also be worn as a sign of respect by any Vajrayana practitioner. (8) The *dongchi* is a square cloth or towel the size of one tru each side, for washing the face. (9) The *nakzen* ("illness cloth") is a special cloth, the same size as a chögö, used for boils or other ailments. (10) The *gyengap* is a large, thin outer robe, cover, or sheet, used to protect the robes during illnesses, such as skin rashes and irritations. It is 6 by 3 tru in size. (11) The *traze* ("hair receptacle") is a cloth used to catch the hair when the monk's head is shaved once a month. It is 1½ by 3 tru in size. (12) The *dingwa* is a mat used for prostrations, kneeling, or sitting. It is 2¼ by 3 tru. The sides are open. (13) The *yargyi görechen* is a cotton summer robe, 9 tru long by 3 tru and 8 sor wide.

The material used for monastic cloth should be of medium quality: not too fine and not too coarse. Wool and cotton are good, as is cloth made from vegetable products. Monks and nuns cannot use cloth that has tassels or is green. Blue, red, and yellow can be used, but not very flashy reds, yellows, or oranges; the color should be a bit dull. Animal hides should not be used. The ordained sangha cannot wear a piece of cloth that has been bought directly from the shop; it must be cut and sewn before it is worn. In particular the chögö and namjar must be cut and sewn properly. Therefore we call the main robes for monks (namjar, lagö, and tengö) "the three robes," and the monk is thus called a "triple robe wearer." The chögö should always be worn together with the zen and shamtap. Also, once sewn, the robes need to be blessed by the abbot before they are worn. After this, monks must always keep their robes with them—they cannot be separated from them for even one night. These robes were given to the ordained sangha by Buddha Shakyamuni, so it is important to respectfully follow the rules of their use and wear them properly. When a monk's robes become too old, they can be

given to another monk, but they cannot be given to laypeople—if there is no one to give them to, they can just be left in a clean place.

(2) The begging bowl

The begging bowl should be egg shaped—larger at the top than the bottom—and the bhikshu's bowl is slightly bigger than the bhikshuni's. The color should be black. It can be made from clay, stone, or iron, but not from gold, silver, copper, or other precious materials. It cannot be square or triangular.

(3) The monk's staff

The monk's staff (*kharsil*) has upper and lower parts made from iron, and the handle at the center is made from wood. It has four prongs at the top facing the four directions. The prongs are called *ra,* which means "goat," because they are shaped like horns. Three rings hang in a chain from the bottom of each prong. It is has two small stupas, one in the middle of the top section between the prongs and one at the top. There are two iron stops above and below the central wooden handle, with a hook on the upper stop. The lower iron section of the staff is seven sided; the upper one is eight sided.

The meaning is as follows: (1) The lower stop symbolizes the prevention of rebirth in the three lower realms. (2) The three parts of the staff symbolize the threefold training. (3) The seven-sided lower staff symbolizes the sevenfold path of a bodhisattva. (4) The eight-sided upper staff symbolizes the eightfold noble path. (5) The four prongs symbolize the four noble truths. (6) The two stupas symbolize the two kayas. (7) The twelve rings symbolize the twelve scriptural categories. (8) The hook symbolizes the hooking of beings from the three lower realms.

b. Temple building and decoration

The next subject that is useful for the artist to know about is the building and decorating of a temple. These teachings come from *The Collected Writings of Chobgye Trichen Rinpoche* and my own textual and practical investigations and experience based on the advice of my teachers.

i. Suitable building sites

A most auspicious site for building a new temple according to geomancy is to have a mountain to the rear, at an elevated height, with level land and lower mountains to the front. It is very favorable if two rivers flow to the right and left of the site, meeting in front. The central mountain (the site

of the temple) should have rocks and open fields. It is best for the land to be more open to the east and raised to the south. The northern mountain should be elongated. If there is a road to the east, this is quite favorable, unless it runs along a cliff. A river running to the south is good, unless it has a waterfall or a very steep decline. A big rock to the north is positive, unless a river runs above it. Roads that run southeast are favorable, but roads that run northwest have a negative influence. If there is only a single tree behind the temple or to the left, it is not a favorable sign. A large tree below the temple has positive influence. A spring below or behind the temple site is not favorable, but to the right of the temple is favorable. Even if you cannot find a site that has all these factors, if you consider it to be auspicious then it will be. All the laws of the country should be followed properly when the land is purchased. When the building is going to commence, dharma texts and statues need to be purchased and a fragrant smoke offering ritual and other rituals and offerings should be conducted along with the Sadak Toche puja as previously explained.

ii. How to build a temple according to the different yanas
(1) Sutrayana temple design
In the Sutrayana tradition, the size and design of the temples is the same for bhikshu or bhikshuni sanghas. The design can be round, square, or octagonal, made from stone, wood, bamboo, or other natural materials. There must be a shrine room with a lion throne and a brocade ceiling hanging (*ladre*) above the throne. There needs to be a double wall around the shrine room. There should be windows at the center of the walls, and the front courtyard can have a pool with trees around it. The breeze blowing across the pool helps cool down the temple. The entrance outside the shrine room has depictions of the Buddha's life story.

(2) Vajrayana temple design
For the Vajrayana tradition (which is also part of the Mahayana), the temple design ideally follows that of Lhasa's Samye Temple, which was built under the guidance of great realized beings such as Guru Padmasambhava. However, the design will depend on what is needed and on the available sponsorship. If funding is not an issue, the monk's hall should have fifty pillars. Small temples can have two, four, or eight pillars. Under each pillar there is a large foundation stone. The pillars always used to be made from wood, so this stone prevented damp from rising.

The upper part of the pillar has a bow design (*tre*), which helps to

support the beams. The lower part of the bow design is called the short bow (*zhutung*) and the upper part is called the long bow (*zhuring*). The beams have a ledge that has a lotus design above it, then a design made of small squares called *chötsek*. Then there is another ledge. This is the usual design, although it can be much more elaborate. Special brocade, materials, sacks of grain, statues, and *tsa-tsa* are housed in the empty spaces above the beam. When the main roof is finished, the peaked uppermost roof can be made and the *gentsira*[129] placed on the top, with a victory banner at each corner, or for a dharmapalas' temple, a wrathful black victory banner.[130] These are filled with mantras and other special blessed substances. A large consecration ceremony is performed when the building is finished.

Outside the temple, a large courtyard or garden area is constructed for the monastic dance and other rituals to be held. Next to the temple there is a library, a printing press, a guesthouse, a room for the temple keeper, and a small temple to house the Kangyur. In Tibet there was usually a room for the Dalai Lama. On the other side is a storeroom for the monastic dance costumes and masks and other ritual objects, musical instruments, and so on.

iii. The interior design

The standard requirement for the Mahayana temple is to have three doors inside and a statue of Buddha Shakyamuni seated on a throne. Behind the Buddha there are the six ornaments (*gyen druk*) (elephant, naga, and other auspicious beings). To either side are statues of Buddha's disciples, or the seven buddhas or seven disciples if there is enough space. The temple should have paintings of the sixteen arhats, the life of Buddha Shakyamuni, the one thousand buddhas, or any other appropriate images. On the walls of the alcove at the temple door, there are descriptions of either the monastic robes and accoutrements or the stages of shamata practice. Outside the front door the Wheel of Existence and the mandala of the cosmos are usually painted. At the door to the storeroom there is a painting of the wealth deity Nöjin with one hand holding a mongoose spitting jewels and the other hand holding a bundle of wheat stalks. Another Nöjin is depicted in the kitchen, holding a vase and wheat stalks, for abundance. If there is a medical clinic, the Buddha's life story can be painted, with scenes from his life when he aided the sick. At the toilet door, the eight charnel grounds and skeletons can be depicted. These instructions come from the sutras.

The interior design of the Vajrayana temple is mostly the same as the

Mahayana temple, but bodhisattvas stand to either side of the main Buddha Shakyamuni statue, such as Samantabhadra to purify our obscurations and Akashagarbha to purify any disrespect toward the Vinaya. Statues of the eight bodhisattvas can also be placed around the main statues. At the main door of the temple are the wrathful deities Amrita Kundali and Achala, to protect the monastery from negative influences. If the temple is very large, it is best to depict many gurus, devas, and dakinis. An additional Tara temple should be built to protect from obstacles.

iv. Atsara and the elephant

Atsara and the elephant are painted at the entrance to the monastery store-house, showing a man leading an elephant carrying many jewels. This comes from a story about the Indian yogi Atsara, and the elephant is Ganesh. This image provides the auspicious connection for the increase of wealth and material necessities.

v. The Mongolian man and the tiger

At the main monastery gate, it is auspicious to do a mural depicting the Mongolian man with a tiger. The man is an emanation of Avalokiteshvara, the tiger he holds on a chain leash is Manjushri, and the chain is Vajrapani. It is important for their faces to be turned toward the monastery. Sometimes a rabbit is depicted under the tiger's feet, representing the subjugation of malicious demons. Painting this creates the interdependent auspicious connection to protect the monastery. The four guardian kings or Hayagriva can also be depicted.

vi. How to show proper respect to the artisans

During the construction of a temple, it is important to understand and follow the proper customs of respect for the artisans. Lhodrak Mentangpa said that whoever is involved in this kind of virtuous aspiration, whether working for or sponsoring the building of a temple, must respect and make offerings to the artisans, as if they were deities. This is said to be the first part of the consecration ceremony. Picnics and gifts are offered out of respect for the artisans. Especially at the time an artist is "opening the eyes" of the deity, the patron should make an offering of at least a hundred butter lamps, conduct a puja, and give a picnic, presenting white offering scarves and gifts to the artist. The patron accumulates a lot of merit by doing this.

Some specific ways to show respect to the artisans when the temple is

being built are the following: Before the building starts, first sponsor a picnic for all the workers and offer them *chemar* (tsampa mixed with butter) to create auspicious connection, along with fruit, white scarves, and gifts. Then the building can commence. When work begins on the foundation, another picnic needs to be given for the stonemasons and bricklayers. Before the pillars are carved, a picnic is offered to the wood-carvers. When the door is being made, white scarves and gifts are again offered to the wood-carvers. The first picnic needs to be for a full day—breakfast, lunch, and dinner. In the morning the lamas should offer *sang* (smoke purification) and a fire puja, and in the evening there should be entertainment such as singing and dancing. These things can vary somewhat but are generally conducted in this way. Also on special anniversaries there is a holiday, and a picnic is offered to the workers. When the temple is half finished, another big picnic is given. When the temple building is completely finished, an elaborate picnic is offered to all the workers.

vii. The benefit of building a temple

The *Sutra on the Application of Mindfulness* says that *ten* (the container) refers to the temple or building, and *tenpa* (the contents) refers to the statues and paintings. The benefit of offering a room or building for the ordained sangha and other general items for monasteries and temples will always increase, so for ten million aeons this merit will not be lost, the benefit is so great. The *Sutra on Cause and Effect* says that anyone who has sponsored the building of a monastery or stupa will definitely be reborn as royalty and be able to turn others to the way of noble conduct. They will be respected members of whatever community they are born into.

If the proper instructions on how to build a temple are followed, the benefactor and abbot will accumulate great merit. It helps the monastic sangha to remain comfortable and to thus practice well; therefore, the sponsor assists in the expansion of the buddha dharma. Even merely having the thought to help build a monastery and taking a single step toward doing so has immeasurable merit.

viii. Explanation of the gentsira

The gentsira is placed at the pinnacle of the roof of every temple, whether large or small. It symbolizes the buddhas of the five families. The wheel symbolizes Vairochana. The upper bell shape symbolizes Amoghasiddhi. The eight-petaled lotus symbolizes Amitabha. The vase symbolizes Akshobhya,

and the jewel symbolizes Ratnasambhava. If the gentsira needs to be smaller, it can be made less elaborately, in which case the bell shape and wheel are omitted and there are just the lotus seat, then the vase, an eight-petaled lotus, and a jewel. This is called the *bumzuk gentsira* (vase-shaped gentsira). Here the vase symbolizes Vairochana, the lotus symbolizes Amitabha, and the jewel symbolizes Akshobhya, the buddhas of body, speech, and mind.

ix. Explanation of the Wheel of Existence

An image explaining the Wheel of Existence was first commissioned by King Bimbisara and given to the king of Utrayana. Buddha Shakyamuni gave another image to Pearl Throne, the princess of Sri Lanka (see stories on page 41. In that drawing, Buddha Shakyamuni was depicted seated on the lion throne in meditation, with an explanation written beneath, in Lentsa script, on how to take refuge in the Buddha, Dharma, and Sangha and on the twelve links of dependent origination. Lord Buddha said that all our mental afflictions come from the three root poisons of attachment, hatred, and ignorance, and attachment and hatred come from ignorance. A cock representing attachment, a snake for hatred, and a pig for ignorance are painted at the center of the wheel to show that they are the root cause of samsara. The pig is holding the snake's tail, the snake is holding the cock's tail, and the cock is holding the pig's tail. The rim surrounding the central circle is half white and half black, which represents the two possible ways of being: white for the way of virtue and black for the way of nonvirtue. In the white section people are shown going up and in the black section people are being dragged downward with their hands and feet bound. Around this, the six samsaric realms of the gods, demigods, humans, animals, hungry ghosts (*preta*), and hell beings are depicted. Outside this, the twelve links of dependent origination are painted as follows:

1. *Ignorance* is symbolized by a blind man walking with a stick, because, just as a blind man cannot see the path ahead, because of ignorance we do not see the path of virtue and are continuously trapped in samsara.
2. *Formation* is symbolized by a man making a clay pot, to indicate that everything comes together to produce a result. Just as a potter can form an object of any size or shape, we create many karmic consequences, good, bad, or indifferent.
3. *Consciousness* is symbolized by a monkey playing in a tree,

which means that just as the monkey jumps from one tree to the next, the consciousness of sentient beings jumps from one life to the next.

4. *Name and form* is symbolized by a boatman on a boat, for just as the boat can cross from one side of the river to the other, our body is a vessel for our mind.

5. The *six senses* are depicted by an empty house, symbolizing the "house" of the body, with the six senses being the medium through which the body relates to the outside world.

6. *Contact* is symbolized by a man and woman kissing, which means that, just as kissing is not completely satisfying, we are not fully content but always in a state of becoming.

7. *Feeling* is symbolized by a person with an arrow stuck in his eye, referring to the fully ripened sensation when the senses meet the sense object.

8. *Craving* is symbolized by a man drinking alcohol. Just as an alcoholic can never be satisfied, we continuously crave various samsaric phenomena.

9. *Grasping* is symbolized by a monkey taking a piece of fruit, because, when we desire something we try to obtain it, and once it is obtained, even though it is temporary, we find it hard to give up.

10. *Becoming* is symbolized by a pregnant woman, which refers to the new formations that arise due to our karmic actions.

11. *Birth* is symbolized by a woman giving birth to a baby, which refers to karmic actions coming to fruition.

12. *Old age and death* is symbolized by a dead body being taken to a charnel ground, which refers to the fact that everything that is born is also subject to death and decay.

The Wheel of Existence is being held by the Lord of Death in his hands, feet, and mouth. This means that as long as we remain in samsara, we cannot escape Yama, the Lord of Death. In this way, the endless cycle of the six realms of samsara is depicted.

A moon is drawn at the upper right side, with the Buddha depicted to the upper left, pointing with his right hand toward these words and the moon above them, to indicate that we can never be free from the suffering of

samsara unless we attain enlightenment, and thus all sentient beings should strive toward this goal. Underneath the moon, one of these stanzas must be written:[131]

> From the beginning until completion, continually reflect upon the teachings of Buddha: how the Lord of Death can at any moment destroy your fragile life, like an elephant in a house of reeds. Act well and with care, thoroughly abandon samsara, and put an end to perpetual dissatisfaction.

Or:

> Those bound to birth and death by the fetters of emotion need only emerge from the cocoon of confusion and seek refuge in the dharma of Buddha and thereby give up the fear of samsara.

According to the Vinaya, the Wheel of Existence is divided into only five parts, as the god realm and demigod realm are combined. According to the Nyingma, these are separated and there is a different buddha abiding in each of the six realms.

x. The story of the four harmonious friends

Buddha Shakyamuni told this story of the four harmonious friends to show the importance of respecting one's elders. It is traditionally depicted somewhere at the entrance to a temple as an auspicious sign.

A long time ago in Varanasi there was a king called Complete Giving, whose realm was happy and prosperous. There were four special animals living in the forest: a partridge, a hare, a monkey, and an elephant, who were all friends. They did not know who was older, so they looked at one of the oldest trees of the forest and the elephant said, "When I first saw this tree, it was as big as my body." The monkey said, "When I first came, the tree was as big as my body." The hare said, "I first saw this tree when it was just a sprout and I licked the dew from its leaves." The partridge said, "I planted this tree with a seed that I brought here and fertilized." Therefore, with the aid of this tree, their relative ages were established. Accordingly, the younger animals respected the older ones, and they sat one above the other, with the eldest at the top. The partridge, being the eldest, established

laws for the others to follow, such as no killing, lying, stealing, or eating bad food, and they all followed this accordingly. Soon all the animals adopted their ways, and the country became very happy and prosperous. The king thought that his kingdom had attained peace and prosperity because of his own good rule, until a yogi told him that this happy reign was not due to him but was because of these four animals. The king felt a bit unsettled to hear this, but when he went to see the animals in the forest, he saw that it was true, and he also followed the way of these animals. Peace and happiness prevailed in the land.

Buddha said that he was the partridge in one of his previous lives. The hare was Shariputra, the monkey was Maudgalyayana, and the elephant was Ananda. He said, "Because of what we did then, everything was harmonious. In the same way, the monks need to be harmonious and respect one another."

xi. Six symbols of longevity
There are six symbols of longevity, which are depicted for auspicious interdependent connection.

1. The rock of long life: Because the realm of China was formerly blessed by the buddhas, the indestructible rocky mountain of vajra nature was produced, possessing the seven qualities of changelessness, indestructibility, and so on. This rock mountain is shaped like a right-turning conch and is a sacred place of Amitayus.

2. The yogi of long life: This is a yogi who remained in retreat for a thousand years and was not affected by the five elements. He has a long white beard and white hair and eyebrows, but his face is very pink and his appearance youthful, as he has attained the siddhi of long life. In his right hand he holds a stick with a long-life gourd attached with a scarf. With the other hand in the gesture of giving, he holds a miraculous peach that took one thousand years to ripen.

3. The water of long life: This is the same long-life yogi and rock mountain, and flowing from behind the mountain is a stream of immortality with the eight qualities of precious water.

4. The tree of long life: This tree is very tall and strong, and its fruit bestows the accomplishment of longevity.

5. The bird of long life: This divine crane drinks from the stream and enjoys the fruit.
6. The deer of long life: The long-life male and female deer play happily together in meadows filled with wildflowers.

xii. Measurement for the hearth of the four activities

See figures 72–73 for the illustrations and measurement for the hearth of the four activities, which is used for fire pujas. This measurement is according to Karme Khenpo Rinchen Dargye. The upper part of the illustration shows the two-dimensional measurements and the lower part shows the measurement in three dimensions, as this measurement is for a hearth that is dug into the ground. (Some are built above the ground.)

c. An explanation of further important points

Generally Tibetan art is divided into physical, vocal, and mental art, and it is further divided into supreme and ordinary art. Physical art refers to art conveyed through material forms. Vocal art refers to art related to sound and words. Mental art refers to art that symbolizes the mind of the buddha, as well as the "mind's practice" of the teachings, such as meditation.

i. Physical arts

The supreme physical arts—the main subject of this book—are further divided into physical art of supreme body, physical art of supreme speech, and physical art of supreme mind.[132]

(1) Physical art of supreme body
(a) Elegant expressions

The elegant expressions of supreme body refers to the sambhogakaya and nirmanakaya buddhas, with their thirty-two major and eighty minor marks.

The peaceful buddhas and bodhisattvas smile with a peaceful expression. The female deities are seductive and youthful. The wrathful deities display a threatening show of strength—vast, mighty, majestic, and horrifying.

Wrathful deities are wrathful, smiling, and graceful. Although they are ferocious, they are also beautiful (see the nine expressions of the dance, page 106). Their eyes glare angrily, with a sideways look of wrath. From their mouth they utter "HA HA, HE HE, HŪM PHAT!" They hold weapons in their hands. The peaceful deities gaze peacefully, looking slightly downward toward the nose. Try to depict the deities' expressions in this way.

There are four different face shapes for the buddhas, bodhisattvas, female deities, and wrathful deities. The faces of saintly male figures and female deities have the shape of a hen's egg and a sesame seed, respectively, and the wrathful deity's face can be round or square shaped.

The long half-closed buddha eyes are called *bow-shaped eyes*. These are used for male and female buddhas, bodhisattvas, and semiwrathful deities. *Grain-shaped eyes* are the open eyes. These are generally used for nirmanakaya gurus and female buddhas and bodhisattvas. The male bodhisattvas and the semiwrathful deities can also have this eye shape. Buddhas usually are depicted only with bow-shaped eyes, and bodhisattvas with grainshaped eyes; the wrathful deities have *wrathful eyes*. To convey the activity of the deity, the shapes of the eyes are as follows: for pacifying activity, draw bow-shaped eyes; for increasing and power, draw grain-shaped eyes; and for magnetizing and subjugating, draw the wrathful eyes, round and square.

There are many yogic postures, and some of the basic ones are these: The *vajra posture* is the full vajra (or lotus) posture, with legs fully crossed and both feet resting on the thighs. When the ankles are crossed in front, it is called *lotus posture*. The half-lotus posture, with the right leg on the left, is the cross-legged bodhisattva posture. One leg folded in, not quite touching the thigh, with the other leg extended outward, is called *half-vajra posture*. The *standing posture of dancing on one leg* is with the left leg extended with the ball of the foot on the ground and the right leg folded with the foot resting on the left thigh. In the *standing posture of Vaisakha,* the body is standing upright with the legs apart, toes outward. The *posture of balance* is with an upright body and the ten toes aligned together, pointing to the front. The *auspicious seated posture [of Maitreya]* is with both legs extended down from the teaching throne and the toes pointed outward. Seated with one knee up and the other knee down with the feet pressed against each other or touching is the *posture of happiness*. The *crouching posture* is to be seated crouched with both knees up and apart, feet together on the ground in front. The *hero's posture* is to be seated with right knee up, the other down and slightly outward. The *heroine's posture* is similar, but the legs are reversed and the inner leg comes under the thigh a bit.

(b) Ornaments of the deities

Nirmanakaya buddhas wear the three dharma robes. Sambhogakaya buddhas wear the thirteen accoutrements (five cloths and eight ornaments).

For peaceful deities the earrings, necklace, and bracelets need to look a bit heavy, with the crown, armlets, anklets, and belt a bit lighter. The semi-wrathful deities have bone ornaments; the females generally have five bone ornaments but sometimes six, and the males have six. The wrathful deities' accoutrements are the three garments, two ornaments, and three smeared substances, known as the eight natural signs of wrathful deities. When they have wings and a garuda, they become the ten glorious ornaments of wrathful deities, as explained in more detail on pages 108–09.

(c) Hand implements

There are many different hand implements, and only a few are discussed here. The vajra is usually in five-pronged form, and the wrathful vajra has the prongs curling outward. The trident (*katvanga*) has an upper three-pronged fork with three heads on the shaft beneath, then a vase, and a crossed vajra. It has a long, slim shaft, the same length as the deity's body, from the fork to the bottom. There is a half-vajra at the bottom, and at the top there are silk ribbons, a small bell, and a small hand drum (*damaru*). Other important hand implements are the sword (*raldri*), small knife (*chudri*), curved knife (*driguk*), battle-ax (*drata*), pestle (*tunshing*), lance (*dungring*), lance banner (*dungdar*), short lance (*dungtung*), and shield (*pup*). See figures 92–94 for examples of some of these.

(d) Throne and ornate backrest

See figure 71 for the measurement of the throne. There are seven aspects to the throne: the throne seat, the throne front, the throne legs, the two throne supports, the pedestal, and the railings. These symbolize the seven branches of enlightenment.

The five supporting animals are the snow lion, elephant, horse, peacock, and shang-shang. The lotus, sun, and moon disk cushions rest on top of the throne.

The six ornaments on the backrest symbolize the six transcendent perfections. They are, from top to bottom: garuda, naga, sea monster, young boy, deer with a single horn, and elephant. Sometimes the elephant is replaced by a lion, and it is possible to have both; the meaning is the same. This is for the Buddha's throne. There can be twenty-one levels to a throne for a single deity. The medium-sized throne has a rounded back, like the leaves of a flower. The short throne is egg-shaped. The more beautifully it is depicted, the more merit there will be. Some people say that this custom of depicting

six ornaments is Tibetan, and that in India this was only used on the gate, but Situ Panchen stated that he found examples of this in Indian art.

(e) Color pigments

The color pigments are divided into root, branch, and leaf colors.[133] The root colors are white, yellow, red, blue, and green. Jamgön Kongtrul Rinpoche lists thirty-two branch colors.[134] He says the color pigment should be very clear, bright, pure, and slightly shiny.

(f) Stylistic features

There are many distinct traditions, forms, and styles from different countries, such as the eight distinctive patterns of basic design and three different types of flames. The Karma Gadri tradition has drawn elements of style mainly from India, China, and Tibet. The styles described in Jamgön Kongtrul's *Treasury of Knowledge* are as follows:[135]

In the Indian traditions there are beautifully depicted mansions, bodhi trees, flowers, offering clouds, auspicious designs, gemstone rosaries, and variegated motifs. The Chinese tradition has beautiful drawings, lustrous prints, auspicious forms, and cloth, cushions, and thrones. The distinctive features of the artistic traditions of Kashmir are in the depiction of sea creatures, lakes and ponds, forests, sacraments of the nagas, along with a variety of drawings of medicinal herbs, incense, and flowing scarves. The Newari style from Nepal expertly depicts the four elements, *pata* (decorative curlicues), rainbows and clouds, trees, glowing jewels, ornaments, birds, and divine adornments. The artistic traditions from Tibet beautifully depict rocks, cliffs, hills, antelope and other wild animals, canopies, ornaments with tassels and garlands, and snowy mountain ranges.

The Karma Gadri tradition of painting has incorporated some of these elements into its own distinctive and beautiful style. An early description of this tradition is given by the scholar Deumar Geshe in his *Brilliant Bouquet: A Clear Explanation of the Process of Preparing Pigments*:

> The charm of the color is similar to a Chinese [painting], but [here the colors are] a bit more splendid than [in] that one. Everything receives dilute washes of excellent and soft shading. The faces and eyes are lively. The bodies of lamas are rounded, their hats are small. The layout mostly conforms with Chinese paintings. This is the tradition of the Karma Encampment.[136]

(2) Physical art of supreme speech

This section of teachings comes from a variety of sources, but mainly from *Mipham's Art of Drawing Curlicues.*

(a) A general explanation of scripts

According to the *Sutra of Extensive Play,* there were sixty-four Indic and ancient scripts known to Buddha Shakyamuni.[137] The most important are the Ranjana (Lentsa) script, which derives from Brahmin script, and the Vartu script of the nagas. It is said that if one knows how to write these two scripts, one will have no difficulty with other scripts. In Tibet, Lentsa and Vartu are used for writing Sanskrit.

Tibetan script was adapted from Sanskrit, and the various writing systems can be included in six main scripts: (1) headed block-letter script (*zapchen* or *uchen*), (2) headless block-letter script (*zapchung*), (3) headless thick script (*druchen* or *ume*), (4) headless thin italic script (*druchung*), (5) formal handwriting script (*shurma*), and (6) cursive shorthand script (*kyuyik*). The first two are most commonly used to transcribe the Buddhist teachings. *Suktung* script is used when writing to a high lama. The *baho* script and *sukkor* are used for writing to a minister. For ordinary writing kyuyik is used.

There is the special dakini script, which can be understood only by the realized lamas and is not always the same.

When these scripts are written, the calligraphy mostly begins from the center of the letter and then moves to the upper part. The simple method described here for creating the graphic gridlines for Lentsa script (figure 75) is to draw three equally spaced lines lengthwise across the paper, using the width of your pen nib to define the spacing: First draw the upper line, and then along the left- and right-hand margins of your paper, use your inked pen nib to create five marks below the upper line. Draw the second horizontal line through the middle of the third marks, and the lowermost line through the bottom marks. This way the graphic gridlines are created for your letters. The upper section is for the pen strokes representing the head and neck of the letter, and the lower for the body of each letter. One needs to learn how to do Sanskrit and Tibetan calligraphy under the guidance of a teacher, so only a rough guideline is described here.

(b) Writing implements

When one is learning the calligraphy of the various scripts, it is necessary to begin with a piece of good paper, a pen, and some ink. There are teachings

on how to make paper, but these days this is not necessary, so these teachings are not included here.[138] A ruler is also useful. In Tibet the ruler is made from a long block of wood with perfectly square ends and smooth, sharp edges, so that it can be rolled on the calligraphy paper to make perfectly even lines for writing. The ruler can be rubbed with incense. Vermilion ink is used for the border lines.

The best material for the pen is bamboo. The bamboo pen is black and should not be too thick or too thin. There must be one knot in the length of the bamboo; that is, it should not be completely straight. It should be split in two and oiled, then placed near a stove for a few months and occasionally oiled and polished with a soft cloth. The bamboo will become incredibly hard so it is not softened by the ink when used for writing. A good, sharp iron knife is required for making the pen. Sharpen the blade on a whetstone, twenty times on one side and five times on the other. This is so the hollow shape required for the pen nib can be made easily. The blade should be sharp enough so that if you blow on a piece of hair held over the blade it is cut in half. There is a special whetstone for sharpening the knife that is not too hard but sharpens it very easily. The pen should not be shorter than your index finger or longer than one hand span. If the pen has been skillfully made, this really helps the quality of the calligraphy.

The Tibetan way to learn calligraphy is to copy from a sample script. It is necessary to learn how to roll the pen between the thumb and forefinger to form the letters beautifully. The letters need to be written with dexterity and speed and without spelling mistakes. A person with such confidence and elegance is a good calligrapher.

(c) How to make ink

Generally the artist needs to have black and vermilion red ink. There is a special tree called *drönma shing*[139] that contains a lot of gum. Wood from this tree is burned in a specially constructed stove, and a clay pot with holes in its base is placed on top. The pot accumulates soot inside from the burning wood. The soft top layer of this soot is what is used to make the ink. It is heated in an iron pot with skin glue and water. After this it is kneaded in a bag before being ground with a pestle for a long time, until it makes a *tsak, tsak* sound. It should not be ground too hard or too softly, just using a steady pressure and pace. This should be repeated many times, with more water slowly added each time it thickens and dries. If powder comes off on your finger when it is touched, it means there is not enough glue. If it is very

dry, there is too much glue. It should be like dough, so that the hand leaves an imprint without sticking to it.

Other colors can be added if you want to change the shade or color. The root of the salep orchid is used for its adhesive qualities, and if you add an infusion made from it, the ink becomes shiny. There is another medicinal plant called costus root, which is used as a flow medium. A kind of camphor called *gabur* gives it preservative properties. Ginger prevents it from freezing in the winter. These basic media are enough, although there are more.[140]

The best-quality vermilion red ink is made from cinnabar stone, which looks like crushed, shiny red crystal. The medium-quality stone is bright red, and the lowest quality is dark and opaque. It should be finely ground with a mortar and pestle, and then myrobalan is added. When the pigment sinks to the bottom, the yellow surface water is discarded. This is repeated three times. Add a little skin glue and gently grind it in the same way as before. Care must be taken not to grind too hard. There is a Tibetan saying that the best person to make vermilion red ink is an old person, as it is important to grind it gently and slowly for a long time, which is better than the quicker method of adding many media. It can be mixed in the sun for warmth, but not on a flame or element. This needs to be learned from experience.

(d) Mantra-wheel script

Mantra wheels are circular magic diagrams made of paper or cloth on which mantras or invocations are written or printed. They are widely used for a variety of purposes, activities, and rituals, usually for protection and liberation. The teachings here are from Mipham Rinpoche's *A Method for Drawing Chakra Wheels,* where he outlines some general principles. However, the mantra wheel can vary greatly according to the sadhana.

Begin the mantra wheel with the heart syllable in the center, for example, HŪṂ. The first letter of the circling mantra is usually placed directly below, to the "east," under the *zhapkyu* of the HŪṂ. Sometimes the sadhana may specify to begin the mantra above the head of the heart syllable. If there is a deity outside the wheel, then the mantra usually starts above the head of the mantra heart syllable. Wherever the mantra starts, all the subsequent mantras for the outer rings must start from that place.

If the sadhana specifies that the mantra circles clockwise, this means that the heads of the letters are to the outside. If the mantra turns counterclockwise, this means the heads are facing inward. If the mantra is too long to end at the same place it began, then it should keep spiraling inside but be

spaced evenly so that it ends inside the corresponding place where it began. If the head faces inside, then the opposite is the case: a long mantra should spiral from the inside to the outside, but again it needs to end at the same line where it began.

Mantra wheels to avert negativity are wrathful. Protection chakras are peaceful. The mantra wheels for wrathful deities and female deities usually circle counterclockwise with the head facing inside. For the peaceful protection chakras, it is the opposite. This is usual, but of course it can vary according to the sadhana.

Some mantra wheels are made for prayer wheels (also known as mani wheels) or other moving devices. Although most prayer wheels should be turned clockwise, some are turned counterclockwise, and the chakras to be placed inside need to be drawn accordingly. If the prayer wheel is to be turned counterclockwise, then the heads of the letters face outward, circling clockwise. If the prayer wheel is to be turned clockwise, in the usual way, then the heads of the mantra face inward and circle counterclockwise. This is for when the mantra wheel is placed inside the prayer wheel facing upward, but if the chakra is to be placed facing down, then the artist has to put everything the other way around. So, for a prayer wheel that is to be turned clockwise, with the chakra facing up, the heads of the letters face inward. However, for the same prayer wheel, if the chakra is to be facing down, the heads face outward. The artist must be mindful of these differences, as the prayer wheel will have no power if the mantras are placed or written incorrectly.

Sometimes a "male" mantra wheel is placed on top of a "female" mantra wheel so that they face each other. In this case the mantras must correspond correctly and begin at the same place. One syllable may face up and one down, but they need to be in the same location. It is important to take care that they are not reversed, otherwise the activity of the wheel will not work. Sometimes there is no syllable in the center because this part is placed on the axle of the wheel. When there is no central letter, we must choose the east and make sure the mantras correspond and begin and end properly. Also, when two are placed together such as the male and female, the direction mantras must correspond properly.

According to the *Yamaraja Secret Black Moon Tantra,* wheels that are turned by the wind also have mantra wheels that need to be placed together. Even though they are not male and female, they have to correspond in the same way. When an exact replica is needed, just trace from the back of the

original mantra wheel to make a mirror image, and then place them facing each other. If the chakra is not going to be moving, usually the male deity letter head faces out and the female faces in, but they still need to be placed correspondingly as before.

If a mantra is so short that to space it would leave too much space between each syllable, then it can be repeated to fill the space elegantly. Each mantra must be complete and must start and finish in the correct place. It is important not to break the mantra up.

If there is an eight-petaled lotus, try to fit the mantra in there even if it does not have the same number of syllables. Just try to space it as best you can. Some mantra wheels have special prayers, such as "May whoever holds this wheel have good fortune. . . ." If it does not fit easily, then sometimes the words of the prayer can be abbreviated or lengthened, but not always. Vowels and consonants are sometimes also written.

Most mantra wheels have an outer vajra fence and ring of fire, similar to the mandalas, but again you have to check, as this is not always the case. The fire should circle in the same direction that the mantra turns. If there is a knife wheel in the middle, the blades usually point outward and should not touch the rim, but sometimes they point inward. There are many mantra wheels for the four activities of pacifying, increasing, magnetizing, and subjugating. The artist must understand the meaning of the directions, the sides (left and right), upper and lower, and so on when they are referred to, to draw them correctly.

(3) Physical art of supreme mind
There are four parts: (1) stupas, (2) hand implements, (3) the symbolic meaning of mudras, and (4) monastic dance.

(a) Stupas
There are eight parts: (1) a general presentation on types of stupas, (2) techniques for stupa construction, (3) the eight great stupas, (4) stupa dimensions and materials, (5) the names of the stupa parts, (6) the symbolism of the stupa parts, (7) uncommon stupas, and (8) stupas from extraordinary traditions.

(i) General presentation on types of stupas
Stupas are representations of Buddha's mind. Jamgön Kongtrul says that a stupa is "a receptacle of the offerings of buddha mind or the buddha body of

actual reality."[141] There are five categories of stupa: the spontaneously arisen stupa, the unsurpassable stupa, the stupa consecrated by blessings, the stupa of genuine accomplishment, and stupas specific to different vehicles.

1) Spontaneously arisen stupas

Stupas that are spontaneously arisen are explained in the *Tantra of Inde-structible Array* as follows:

> The supreme bone relics [of the buddhas]
> Are always present
> In the [form of] mighty Mount [Sumeru]
> Within the world-system of desire,
> As an exalted tiered throne
> Within the world-system of form,
> And as a dome-shaped receptacle and plinth
> Within the world-system of the formless.[142]

The *Kalachakra Tantra* explains the various details of how this stupa represents the different parts of the buddha's cosmic body, in the form of the four elements and Mount Sumeru.

2) Unsurpassable stupas

Unsurpassable stupas are explained as extraordinary stupas in the supreme abode of Akanishta; they are not solid, but like a rainbow.

> In the east there is the [stupa named]
> Vajra Mountain of loving-kindness.
> In the south there is the [stupa named]
> Gemstone Mountain of compassion,
> In the west there is the [stupa named]
> Lotus Mountain of empathetic joy,
> And in the north there is the [stupa named]
> Crossed-Vajra Mountain of equanimity.[143]

3) Stupas consecrated by blessings

Stupas consecrated by blessings appear like a rainbow and have been explained in the *Chakrasamvara Tantra*:

The bone relics consecrated by blessing
Appeared in eight parts of the four continents.[144]

In the commentary this is further explained:

> In the eastern continent of Videha, there are two stupas known
> as the "treasure of resplendent equanimity" and the "svastika
> crest with its well-fashioned arms." In the southern continent of
> Jambudvipa, there are two stupas known as the "emanation of
> compassionate spirituality" and the "wish-fulfilling spontaneous
> presence." In the western continent of Aparagodaniya, there are
> two stupas known as "the peerless and inconceivable [reality]"
> and the "wondrous and renowned expanse of reality." Then in the
> northern continent of Uttarakuru, there are two stupas known
> as the "gemstone mountain of enlightened attributes" and the
> "lamp of extensive bliss."[145]

4) Stupas of genuine accomplishment

Stupas of genuine accomplishment are explained in the *Tantra of Supreme
Nectar*:

> The eight Matarah are established
> As the great protectresses of corpses,
> While the eight stupas are also established
> As their great power places.

The [commentary] on this text explains that "In ancient times,
when Rudra was disciplined by Heruka, eight stupas arose
through spiritual accomplishment as the receptacles of the eight
Matarah in the charnel grounds of eight [distinct] lands. These
included the Sankara Stupa in Magadha, the Mount Potala
[Stupa] in Singhala, the Bodhnath [Stupa] in Nepal, the Geu-
dosha [Stupa] in Singadvipa, the Gandha [Stupa] at Gomasa in
Khotan, the Kanaka [Stupa] in Kashmir, and the Sukhakumara
Stupa in Sahor.[146]

5) Stupas specific to different vehicles

There are stupas specific to the different vehicles: the Shravakayana, the Pratyekabuddhayana, the Mahayana, and the Tantrayana.

The shape of the Shravakayana stupa is supposed to be roughly the shape made by a monastic robe folded into four, with an upturned begging bowl and an upright monk's staff placed on top, like a square stack with a round top. The Pratyekabuddhayana stupa has a square-shaped base with a cube surmounted by a round top with twelve levels or tiers and an eight-spoked wheel.

Nagarjuna said that there are eight varieties of Mahayana stupa. For example, there is one that is round like an upturned begging bowl, and one that looks like a small house and another like a victory banner. The outer tantra stupa either has various tiers, some projecting outward and some inward, or it has two sides truncated and surmounted by twelve stacked wheels. The inner tantra stupas include the Vajra Mountain type and those described in the *Kalachakra Tantra*.

(ii) Techniques for stupa construction

There are four main types of stupa construction described in the Vinaya, which apply to stupas for ordinary people, shravakabuddhas, pratyekabuddhas, and fully enlightened buddhas. They are called the eight stupas of the conquerors.

The Stupa of the Sugatas was built by King Shuddhodana at Lumbini to celebrate the birth of Buddha Shakyamuni. This became known as the first Buddhist stupa. The first Buddhist reliquary stupa was made when Buddha's senior disciple Shariputra passed away and his body produced sacred pearl-like relics, which were carefully kept by his benefactor, Anathapindika. These relics became an object of veneration and attracted many devotees. Then one day Anathapindika had to go out, so he locked the door. The people complained that he had prevented them from making offerings to the relics, so he asked Buddha Shakyamuni if he could make a stupa for the relics. Buddha agreed and gave the following instructions: The stupa should have four square steps at the base, a vase seat, and a vase-shaped top. On top of this should be built a hollow square top, and a wooden central axis called the life-tree placed as the central channel or "heart." He said that it can have from one to thirteen parasols depending on the level of realization of the being it is commemorating. Stupas to hold the relics of ordinary people should be bare, without the parasol spire. Shravakabuddhas should have the parasol spires with the number of rings corresponding to their level of

attainment, which is four. For pratyekabuddhas, the parasol spire should have seven rings. For buddhas, the parasol spire has thirteen rings. All of them have a rain cloak and flaming jewel crest. Note that in this context, the parasol spire refers to the stacked rings or wheels corresponding to the teachings, and the upper part of the rain cloak is also sometimes called the parasol during measurement. It is important to study this carefully with a qualified teacher, as the terms differ when the measurements are made.

(iii) The eight great stupas of the conquerors

These teachings come from Jigme Lingpa and Jamgön Kongtrul. The descriptions of the shape and so on are quoted by Jamgön Kongtrul from Nagarjuna's *Eulogy to the Stupas of the Eight Supreme Places*.[147] The eight stupas of the conquerors refer to the eight principal deeds of the Buddha. Various esoteric instructions have stated that since all stupas contain relics of the sacred teachings, in the form of mantras, they can all be considered offering receptacles of the dharmakaya. Therefore, even if they do not contain bones or other sacred relics of Buddha Shakyamuni, the construction of any of these eight stupas is still valid today.

1) Stupa of the Sugatas

The Stupa of the Sugatas, also known as the Stupa of Heaped Lotuses or the Stupa of Auspicious Origin, was built by King Shuddhodana at Lumbini to celebrate the birth of Shakyamuni Buddha. It is round and adorned with lotus petals stacked in four or seven lotus tiers.

2) Stupa of Supreme Enlightenment

The Stupa of Supreme Enlightenment is also called the Conquest of Mara Stupa and was built by King Bimbisara to commemorate the time when Buddha overcame the hosts of maras and attained complete enlightenment at Vajrasana. It is square with four tiers.

3) Stupa of the Wheel of the Sacred Teachings

The Stupa of the Wheel of the Sacred Teachings is also known as the Stupa of Many Auspicious Doors or the Stupa of Pristine Cognition and was built by Buddha's first sangha of five monks, to commemorate his first turning of the wheel of dharma at Sarnath near Varanasi. It is square with four tiers and a boxlike decorative projection (lombur) at the center of each level on the four sides. The most elaborate of this type of stupa has sixteen doors spaced evenly along the tiers and projections of each side, symbolizing the sixteen

kinds of emptiness. The middling has twelve doors on each side, symbolizing the twelve links of dependent origination. The least elaborate has eight doors on each side, symbolizing the eight emancipations.

4) Stupa of Miracles

The Stupa of Miracles or Stupa Defeating Extremists was built by Licchavis, a noble famiy of Magadha, to commemorate the miracles that Buddha performed at the Jetavana Grove in Shravasti, which caused him to win a debate against another master. This is either square with four tiers and a projecting bay on each side or it can be round, with four tiers in the form of lotus petals.

5) Stupa of the Descent from Heaven

The Stupa of the Descent from Heaven, or the Stupa of the Thirty-Three Gods, was built by the people of Dyutimat to commemorate the time when Buddha, sojourning at Dyutimat in Vaishali, performed a rain retreat ceremony at Tushita heaven and established his deceased mother in the truth, before descending to Lanka in Jambudvipa in the afternoon. It has four or eight tiers with a projecting bay on each side, each with a ladder in the center.

6) Stupa of Reconciliation

The Stupa of Reconciliation, also known as the Stupa of Solar Rays or the Stupa of Manifest Loving-Kindness, was built by the people of Magadha to commemorate the time when Buddha reconciled quarreling factions of the sangha at the Bamboo Grove, after Devadatta had tried to provoke a split within the sangha. It is square with four tiers, all evenly truncated.

7) Stupa of Complete Victory

The Stupa of Complete Victory, or Stupa of Blessings, was built by the people of Vaishali to commemorate the time when the Buddha empowered his own life span to prolong his life for a further three months at Vaishali. This stupa is round with three tiers.

8) Stupa of Parinirvana

The Stupa of Parinirvana was built at Kushinagara to commemorate the Buddha's parinirvana. This stupa has no tiers and is positioned directly above the dome plinth, which rests upon the podium.

(iv) Stupa dimensions and materials

A stupa can be made from gold, silver, clay, stone, wood, sandalwood, medicinal substances, or plants. The sutras say that the size can vary greatly. A stupa could have an area of six miles or be as small as an arura grain, with the life-tree being as small as a needle. However, the proportional measurements must still be followed. The benefit of building or commissioning a stupa is so great it is incalculable.

Many great masters such as Butön, Taktsang Lotsawa, Trangkhawa Palden Zangpo, Miwang Sangye Gyatso, the eighth Karmapa, Mikyö Dorje, and others have all explained many different measurements for the eight stupas. The proportional measurements from Sangye Gyatso combine the best aspects from each of these systems, so they are widely used. The stupa measurements given here are from Rigdzin Jigme Lingpa's *Bodhi Tree: A Presentation of the Measurement for the Eight Stupas* (figures 78–86) with a supplemental example from Jamyang Khyentse Wangpo and Jamgön Kongtrul Rinpoche (figure 87).

(v) The names of the stupa parts

See appendix 3 for the names of the different parts of a stupa.

(vi) The symbolism of the stupa parts

The symbolism for the different parts of a stupa is as follows: The small capping slab represents the six subsequent testings. The large capping slab represents the ten limitless grounds of virtue. The virtuous foundation slab represents the four boundless attitudes. The four tiers represent the four foundations of mindfulness. The vase plinth symbolizes the five powers. The vase symbolizes the seven branches of enlightenment. The high pavilion symbolizes the eightfold noble path. All together they are the thirty-seven aspects of enlightenment of the causal vehicle.

The wooden life-tree placed inside the stupa symbolizes the relative transcendent contemplations. The lotus support symbolizes the union of skillful means and wisdom. The thirteen dharma wheels symbolize the ten powers and the three essential recollections. The rain cloak symbolizes compassion. The flaming jewel crest symbolizes the dharmakaya. Together they embody the essential nature of the stupa. The naturally pure fruitional attributes of the stupa include the decorative attributes, the sun and moon, the victory banner, and so forth.

(vii) Uncommon stupas

The *Kalachakra Tantra* describes the uncommon stupas such as the Stupa of Pristine Cognition, formed by the indestructible buddha body, seated in cross-legged posture. The area from his navel downward corresponds to the tiers of the podium. The vase plinth is his abdomen, and his chest up to the shoulders corresponds to the vase dome. His throat is the high pavilion, and his face corresponds to the face painted on the high pavilion. The area above corresponds to the area from his forehead to the ushnisha. There are differing methods of measurement, but the proportion is said to correspond to the proportions of the external world, the inner human form, and other subtle and divine forms.

(viii) Stupas from extraordinary traditions

There are also stupas of extraordinary measurement and shape, such as the Stupa of Intangible Glory (or Jnanabimbakaya Stupa) and the spontaneously arisen Swayambhu Stupa of Nepal.

1) Jnanabimbakaya Stupa

The sublime Jnanabimbakaya Stupa, "the form body of pristine cognition," is also known as the Stupa of Intangible Glory. This stupa is said to be present in the form of rainbow light, in the sky above the "town stupa" in the land of Konkana by the ocean in southwest India. It is said that this is where Vajravarahi abides and performed a miracle with the mead of the three levels of existence, after which the whole region was suffused with the scent of wine on certain auspicious occasions.

Beside the ocean there is a large stone statue of Manjushri, named Jnanakaya, the blessings of which were so powerful that many extraordinary phenomena occurred in its vicinity. Various strains of music and the scent of incense, along with fires glowing in the night sky, would be perceived by everybody. The stupa could be seen as a smoky apparition in the sky. There is great abundance in the area, and the beneficial attributes of this stupa are greater than those of stupas constructed by hand.

2) Swayambhu Stupa

In Nepal, in northwest Kathmandu, there is a similar stupa known as the Ultimate Self-Originated Great Stupa. It is also known as the Ox Hill Prophecy Stupa, as it is located on Ox Horn or Lotus Hill. There are many other such extraordinary stupas that existed in the past, not commonly spoken of today.

(b) Hand implements

The sacred hand implements are also included in the category of physical art of supreme mind. These teachings come from Jigme Lingpa's *Commentary on the Condensed Realization of the Gurus.*

(i) Vajra and bell

The vajra and bell (figures 88–89) are the most important of the symbolic hand implements. *Vajra* means "adamantine thunderbolt of indestructible reality." It is said that the first vajra was made from the bones of a powerful yogi dwelling at Mount Sumeru, called Drangsong Zhotung. When he died, the gods and demigods took his bones and made weapons from them. The vajra was made by Indra and had one hundred prongs.

The vajra has the following four qualities: (1) it always faces its target, (2) it always strikes its target precisely, (3) those it strikes will be destroyed, and (4) those it destroys will be liberated.

The vajra is a symbol of Buddha's mind, as well as the Buddha's body and speech. When the vajra is used in practice, it is referred to as the "secret vajra." It can have nine prongs, five, three, or one prong, or even one thousand prongs. The five- and nine-pronged forms are most common. The nine-pronged vajra and bell are called the wisdom vajra and bell. The five-pronged vajra is called the commitment vajra, which is skillful means. The wrathful form has open prongs.

Each part of the vajra symbolizes something: The five-pronged vajra represents the buddhas of the five families. The eight-petaled lotus on one side represents the eight bodhisattvas. The eight-petaled lotus on the other side symbolizes the eight dakinis. The other five prongs symbolize the five consorts of the buddhas of the five families. The nine-pronged vajra represents the nine buddhas. The prongs come out from a sea monster's mouth, which represents compassion. The mala around the lotus petals represents the light of buddha activity. The three bands on the central prong represent the body, speech, and mind of the buddhas. The moon disk symbolizes the bodhisattva's mind.

The bell can be made from gold, silver, copper, or bronze, which is the best metal to use to give a good sound. White, black, or red bronze can also be used. The bell is divided into six parts, with four parts for the bell and two for the handle, which has a half-vajra and face. The diameter of the base of the bell should be the same as the length of the handle. Three different types of bells are described:

Vajrasattva's bell can have either a five- or nine-pronged half-vajra handle.

The letters on the top of the bell are, to the east TAM, to the south PAM, to the west MAM, to the north LAM, to the southeast BAM, to the southwest TSŪM, to the northwest DRIM, and to the northeast MAM. These are the heart syllables of the dakinis. The face on the handle is a dakini's face, on the east, the side of the TAM syllable. There is a vase under the dakini's face, decorated with pendant ornaments.

The daka's, or hero's, bell is the same as above, but without the bone ornaments and dakini syllables. There is no ornamentation on the bell.

The buddha's, or tathagata's, bell is the same as Vajrasattva's bell, but along with the bone ornaments there are dharma wheels. This bell can have only a five-pronged half-vajra handle. Inside the bell there is an octagonal tongue or clapper that is smaller at the top and larger at the bottom.

The bell is empty, symbolizing the dharmadhatu, emptiness beyond extremes. The bell's clapper symbolizes the clitoris of the Queen of Space, Dhatvishvari. The eight sides of the tongue of the bell symbolize the eight subtle channels. The face symbolizes Vajrasattva's consort, Vajratopa.

Together, the vajra represents skillful means and the bell wisdom. They also represent bliss and emptiness. They must always be kept together and held together. It is also said that the tongue inside the bell is wisdom's "stick." When it moves, it symbolizes great bliss in union with wisdom, from which sound arises. This melodious sound is offered to the buddhas of the ten directions, who are pleased and send blessings so that all sentient beings will awaken from the sleep of ignorance and thus be freed from samsara. In this way the vajra and bell have profound meaning and should never be thought of as ordinary, like the bell that hangs from a cow's neck.

(ii) Damaru

The small hand drum known as a damaru is most often made from wood, in which case it is best if it is made from red sandalwood.[148] In the Vajrakilaya tantra it says it can be made from a human skull, preferably that of a sixteen-year-old boy or a twelve-year-old girl. The best skin for stretching on the drum is from a monkey. Inside the drum a lotus is drawn and some mantras written with menstrual blood. The mantra of the deity and consort needs to be written, and if it can be understood, then the drum is placed with the male up and female down. Otherwise place the drum on its side only.

The damaru needs to be played carefully and properly. Its shape is like a yoni, representing emptiness, and the mantra inside is the male, representing bliss. When the sound is created, consider it to be resounding with the

syllables HŪṂ and TRAṂ, which magnetize the dakinis. The bliss of the dakinis is offered to the gurus, devas, and dakinis, enabling us to receive the siddhis. When one plays the damaru, the samaya needs to be properly followed. Generate the vajra pride of oneself as the deity and great benefit will be reaped.

(iii) A ritual to bless the vajra, bell, and damaru

There are detailed instructions in the various tantras for blessing the vajra, bell, and damaru, but this is a concise method from Jigme Lingpa's *Commentary on the Condensed Realization of the Gurus*. These Vajrayana ritual implements need to be blessed before you use them for your sadhana practice.

First place the instruments on a high table and recite the mantra of emptiness "OṂ SVABHĀVA . . ." and so on. Then consider that a syllable HŪṂ[149] arises out of emptiness. Light radiates from the white HŪṂ to all sentient beings, who transform into the deity Vajrasattva. The light gathers back, enriching and empowering the HŪṂ, which immediately transforms the vajra into Vajrasattva, in single form. Pick up the vajra with your right hand and bring it (elegantly, with circular mudra) to your heart three times.

Next, recite the emptiness mantra again, this time recalling the empty nature of the bell. A syllable ĀḤ arises from emptiness and, through the emanation and absorption of light as before, transforms into the bell. The bell transforms into Vajrasattva's consort, Vajratopa, also white. With this in mind, pick up the bell and ring it three times while holding the vajra to your heart. The resounding of the bell represents all sentient beings continuously hearing the sound of the dharma.

Holding the vajra and bell, cross your arms in front of your heart. This represents the deity and consort in union, and from their union arises great bliss. Five-colored rainbow light radiates from their point of union, making offerings to all the deities, buddhas, and bodhisattvas. Then the light radiates to all sentient beings, who also transform into the deity with consort. Recite the following prayer:

> HŪṂ I hold the vajra and ring the bell;
> The weapons of dharmata, method and wisdom united.
> May this awaken and ripen all beings throughout time.[150]
> OṂ VAJRA GAṆḌE HŪṂ ĀḤ

Then ring the bell while holding the vajra to your heart. This is the blessing of the vajra and bell.

The samaya is to always leave these two together, which symbolizes the inseparability of skillful means and wisdom. When you place the vajra and bell in front of you, the bell needs to have the face on its handle toward you and the vajra lies to the bell's right (which means to your left, so you cross your arms when picking them up). These should now be respected as if they are the deity, always placed respectfully on the shrine or a high place. Also, you should never put a vajra and bell design on a cushion for this reason.

Then comes the blessing of the damaru, also from the *Condensed Realization of the Gurus*.

First recite the following words:

HŪṂ
The damaru and its beaters dissolve into emptiness.
From within emptiness an ĀḤ transforms into a damaru,
The bhaga of Samantabhadri, vast like the sky.
The beaters are the vajra of Samantabhadra;
Their play causes a continuous flow of bodhichitta to pervade the
 sky,
Filling the three-thousandfold world with the sound of the
 quintessential dharma.
DHARMĀ DHATU HŪṂ HŪṂ BAṂ KSHA SAMAYA HOḤ

Play the damaru while keeping this in mind.

(iv) Vase

The vase (*bumpa*) can be made from gold, silver, copper, or clay. The vase belly should be quite large and the neck thin, tapering open to the mouth at the top. The base is smaller. The vase should be undamaged, without holes or dents, and clean and attractive looking. A piece of cloth is tied to the neck of the vase, the same color as the deity that is being practiced. A small leafy branch is placed in the vase. It is auspicious to add flowers and fruit to ornament the mouth of the vase. This also depends on the sadhana—sometimes as many branches as there are deities are required. Usually there are two vases: one represents the yidam deity and is placed on the shrine, and the other one, the activity vase, is placed on the practice table for the practitioner's or vajra master's use. Traditionally twenty-five different substances

are placed inside the vase with water (five grains, incense, jewels, essences, medicines, and nectars) according to the outer Vajrayana, and according to inner Vajrayana there are thirty-five substances. They are all in multiples of five, to represent the buddhas of the five families, as follows:

1. Five grains are to ease our hunger: barley, rice, wheat, peas, and millet.
2. Five fragrances are to aid our discipline: saffron, musk, nutmeg, and red and white sandalwood.
3. Five precious jewels are to fulfill our needs and pacify war: gold, rubies, pearls, coral, and sapphire. Rubies can be replaced with silver or a conch shell.
4. Five potent essences are for accomplishment: Salt is the essence of water. Honey is the essence of flowers. Molasses is the essence of fruit. Sesame and *adre* are the essence of earth. Butter is the essence of grass.
5. Five medicines are to alleviate illness: camphor, saffron, gypsum, musk, and ghiwang. This system of five medicines is from the *Lotus Net Tantra*.

 The system from the *Tantra of Noble Apprehension* gives the following five substances: *kandakari, drihati, hasadewa, hasa,* and coconut.

The additional ten substances that make thirty-five are the five meats and five amritas.

The vase can also be ornamented with kusha grass. If the twenty-five medicines are placed inside, this aids the accumulation of merit of all sentient beings and also increases wealth. At the time of enlightenment it creates the cause to attain the sambhogakaya. The water represents the cooling of the afflicting emotions. The visualization differs according to the requirements of the particular sadhana. The same vase can be used for different sadhanas; just tie a cloth of the color of the deity of the main sadhana around the neck of the vase.

(v) Mala

The mala (*trengwa*) is used for counting mantras. *Treng* means a powerful feeling of yearning, which here applies to the yearning felt toward your guru, the yidam deity, and the dakinis. Mantras are constantly recited using the mala. The best malas are made from precious stones. The next best are

from wood, such as sandalwood. Lesser malas are made from clay, seed, stone, or medicinal wood.

More specifically, for peaceful practices the beads should be made from conch shell. Clay and wood or fruit seeds are also said to be good, as well as the wood from a bodhi tree. Gold is used for increasing practices. Coral is for magnetizing. Iron and turquoise are for subjugating practices. A very precious kind of onyx stone, *zi,* and agate are used for various kinds of practices. Bodhi seeds and ivory malas are the best for all activities.

White is good for peaceful-deity practice, yellow for increasing, red for empowering, and black for wrathful practice. Mixed colors can be used for any practice. The size and number of the beads can vary but are not discussed here.

White wool is used to string the mala for peaceful deities, yellow cotton for increasing, red silk for magnetizing, and leather for wrathful practice. For many different practices, five different colors can be placed together. The thickness of the string depends on the size of the hole in the beads. Do not make the string too long or too short; if it is too long, the accomplishment of the yidam will take a longer time, but if it is too short and tight, your life will be shortened. The gurus say that if the string is made by a dakini, it enables us to receive the siddhis. When threading the beads, recite HŪM continuously or the mantra of vowels and consonants.

The main bead of the mala symbolizes the main deity, and the other beads are the retinue. The main bead needs to be larger: for peaceful practice it is round and white, for increasing it is large and square, for power it is best if it is a red flower shape, and for wrath it is black and triangular. During all practices we utilize our body, speech, and mind, so the main bead should be divided into three parts, which can be in white, red, and blue. This is like the three vajras of body, speech, and mind. Sometimes it is in two parts, symbolizing skillful means and wisdom.

Before using a mala for the first time, wash and anoint it with something fragrant. Traditionally a substance called *bajung* is used, which is the manure from a red cow that has been led by a virtuous bhikshu to a fertile field of green, rich pasture. The manure collected from this cow is mixed with water and used to clean our mandala plate or mala, which is then cleaned with saffron water.

Carrying and using a mala for mantra recitation is part of the Vajrayana samaya. It is a symbol of your yidam deity and a reminder of the mantra. The full number of beads is generally 108, but it is also possible to have half that

many, that is, 54, or 21; the least is 11. Numbers other than these should not generally be counted.

There are different ways to use the mala, relating to the activities of the deity and mantra being recited. When reciting a peaceful mantra, move the beads toward your body over the forefinger. For increasing, move the beads over the middle finger. For magnetizing move the beads over the ring finger, and for wrathful mantras move the beads over the little finger. Always use the left hand when counting mantras with a mala. If the mala is very long, the excess can be picked up in the right hand, but the actual mantras cannot be counted with the right hand. For reciting the mantras of peaceful deities, the mala is held at the heart. For increase it is held at the navel, and for magnetizing it is held at the secret place. For wrathful mantras it is held in front or at the knee. The thumb that moves the beads toward you is like a hook, to hook the siddhis into you. When doing retreat you should always keep your mala with you. It should be kept secretly and not shown to others or hung around your neck like a necklace; especially do not let people with broken samaya near it. It is not appropriate to play with the mala. The mala needs to be blessed, and once it has been blessed it should not be lent or given to others or shown to others or put on the ground. The beads should be even in size and of the same color. If it is broken, it should be repaired immediately, not left for even one night. If it breaks and cannot be repaired, it should be burned in a fire or put in water. If you have a mala that is very precious and could be stolen, it should be kept secretly. When buying a mala, try to get the best one possible. If someone considers that this is not necessary, this means that they do not really understand the Vajrayana methods and meaning, as it is actually very important to follow this instruction. Doing so helps us achieve the accomplishment of the practice.

To bless the mala, consider yourself as the deity and place the mala in your left hand, coiled with the main bead facing up. Recite OM SVABHĀ-VA-SHUDDĀḤ SARVA-DHARMĀḤ SVABHĀVA-SHUDDHO HAM and consider all as emptiness, then sprinkle the mala with saffron water to cleanse and purify it. Consider that the main bead is the main deity and the other beads are the retinue. Invite the wisdom blessings to dissolve into the mala. When first considering this as the deity, think that the right hand is the sun, marked with the syllable HŪM, and the left hand is the moon, marked with the syllable ĀḤ, then consider yourself as the deity. When you recite JAḤ HŪM BAM HOḤ, the wisdom blessings dissolve into the mala in the form of the syllables OM ĀḤ HŪM. Now the mala is the Buddha and his

retinue—and this is really the case, not just our thinking. The thumb represents skillful means, the forefinger wisdom, and the two fingers together moving the beads are the deity's mantra. The beads are moved toward the body, for receiving the accomplishment. First say the mantra of vowels and consonants three times before reciting mantras, which increases the benefit by a hundred thousand.

(vi) Various wrathful hand implements
The *purba,* or ceremonial dagger, can be made from gold, silver, iron, or wood. If it is made from wood, the root end of the piece of wood is used for the handle, and the trunk or branch for the top. The size can vary: either 16, 12, 8, or 6 sor. It can be round, triangular, square, or semicircular, depending on the sadhana. There are also different purbas for the activities of pacifying, increasing, subjugating, and magetizing. If these different purbas are all made from one piece of wood, the top part should be used for the peaceful purba, then increasing, magnetizing, and finally the purba for subjugating is made from the root.

The driguk, a ceremonial curved knife, is the span of a hand in length, 5 sor wide, and has a half-vajra handle. The wrathful wheel is a circular knife; the proportion is calculated by dividing the circumference into three and drawing concentric circles inside. The inner circle is for the deity, and the middle circle is for the blades, which make a notch at each point there. The number of blades varies. There are many different weapons, sword and so on, but they are not all detailed in this book. Further examples are shown in figures 92–94.

(c) The symbolic meaning of the mudras
It is difficult to find teachings on the meaning of the mudras. Vairochana's mudra represents the subtle channels on the left side; therefore, his left finger points upward. The right finger is held in the palm of the left hand, meaning that the semen is not expressed.

(d) Monastic dance
The following teaching is from Kongtrul Rinpoche's *Treasury of Knowledge.* The traditions of monastic dance, along with stupas, hand implements, drums, cymbals, and so on, are included in the physical arts, in the subcategory of physical art of supreme mind. These are all part of the rare and precious ritual offerings of the Vajrayana.

The *Kalachakra Tantra,* the yoga tantra entitled *Tantra of the Indestructible Garland,* the *Tantra of the Ocean of Skyfarers,* and others all include descriptions on sacred monastic dance. The sacred masked dances of the herukas and the dance of expulsion are performed in accordance with the tantras of the Nyingma tradition, such as the *Wrathful Deities of the Magical Net,* the *Gathering of the Great Assembly,* the *Eight Transmitted Teachings: Means for Attainment,* and especially the cycles of Vajrakilaya.

The Indian master Chandrashri is quoted in Lochen Dharmashri's text on sacred dance, as describing the nine expressions of dance as follows:

> The upper part of one's body should have the demeanor of a lion.
> The waist should maintain the demeanor of elegance.
> The wrists and ankles should maintain a demeanor of dexterity.
> The thigh muscles should maintain a relaxed demeanor.
> The blood should maintain a fiery red demeanor.
> The countenance should maintain a handsome demeanor.
> The movements should maintain a slow demeanor.
> The knees should maintain a supple demeanor.
> The feet and head should maintain a demeanor of happiness.
> And overall [the dancer] should maintain a demeanor
> That is both heroic and magnificent.

And he also says:

> Dances evoking fear and awe are defective if they are too vigorous.
> Dances evoking grace and suppleness are defective if they are too
> carefree.
> Dances evoking speed and ease are defective if they are too hasty.
> Dances evoking slowness and relaxation are defective if they are
> too indolent.
> Dances evoking elegance and attractiveness are defective if they
> are too fickle.[151]

It is important for the practitioner to learn these dances according to the primary sources of their particular tradition. The costumes, masks, and headdresses are not simple articles of clothing: their function is to render inner qualities visible externally, bestowing "liberation through seeing." The magnificence of the music and the surroundings are not a sign of

ostentation or pride but a reminder of the splendor of meditation and of the primordial purity of all phenomena. The individual practitioners dance as a method to achieve meditative stability in the absolute truth. When monastic dance is performed, the choreography should be followed according to the tradition, as the blessing is contained within the movements.

The *Tantra of the Flash of the Splendor [of the Pristine Cognition]* says of the masked dances of the herukas according to the Nyingma tradition:

> It is said by the heroes [*viras*] that,
> Once the disposition in which all things are sameness has been understood,
> Everything that stirs or moves becomes the seal [of that reality].
> [Therefore], one who maintains these [sacred] dance steps
> With meditative stability in his or her own [meditational] deity,
> Would terrify even the buddhas themselves,
> Let alone the host of arrogant spirits![152]

The most important text for the Mindroling tradition of dance from the Nyingma tradition is Lochen Dharmashri's *Choreographic Treatise of the Sacred Dance Entitled "The Display of Samantabhadra."*

(4) The common physical arts

In brief, the *Treasury of Knowledge* says the common physical arts comprise the building of houses and ships, the design of clothing and jewelry, decorations, and the culinary arts. They also include the construction of weaponry and armories—cannons, catapults, and the like—along with war chariots, palanquins, and turbines. The aim of this kind of art is social enhancement or development and to adorn and beautify; it has no further sacred purpose.

ii. Vocal arts

The *Treasury of Knowledge* says the second category of fine arts is the vocal arts, which also have supreme and common forms. The supreme form refers to debate, destroying false conceptions, theoretical explanations of the sacred doctrine to attract students, and writings or compositions that clarify the explanations or teachings. To be considered an authentic art of supreme speech, these techniques need to be free from errors and complete with genuine qualities. Whether one is teaching, writing, or debating, it is

not about merely parroting the correct words; the most important thing is to have an experiential understanding of the meaning through engaging in the practice.

The art of melodic chanting is also included in vocal arts. At first Buddha Shakyamuni prohibited singing, dancing, and music, but when his disciples read aloud praises to the Buddha, they sounded garbled and unclear, so they were teased and ridiculed, and ordinary people lacked faith. Anathapindika, one of the Buddha's benefactors, requested Lord Buddha to change this rule, so he gave permission for melodic chants to be recited as an offering to the Three Jewels, saying that they should follow the same tradition as the Brahmana Vedas. There are many detailed teachings on melody and intonation, as well as explanations on what are known as the three essentials, the six defects, and the five negative causes, which will not be detailed here.[153]

The Tibetan schools each have their own traditions of chant, which need to be taught and followed according to their own unbroken lineages.

Common vocal arts relate to song, music, and formal speeches according to cultural forms and styles. These are for entertainment, creative expression, and the elucidation of worldly knowledge.

iii. Mental arts

The mental arts are also divided into supreme and common forms. The supreme mental arts comprise the study of the teachings and commentaries of the Buddha and his realized disciples, then reflection and contemplation on them, and finally the practice of the meditations related to them.

The common mental arts refer to the eighteen topics, which include music, lovemaking, food, arithmetic, grammar, and so on. The eight subjects of investigation include the study of land, gems, trees, chariots, horses, elephants, and the like. Another system enumerates sixty-four crafts, which includes thirty designated arts, eighteen requisites of musical performance, and so on.[154]

d. A general explanation of various additional subjects
i. The hand implements of the five wisdom buddhas

The *Secret Essence Tantra* describes the hand implements of the five wisdom buddhas as follows:

> 1. Vairochana is at the center of the mandala and holds a vajra[155] to symbolize the inseparability of emptiness and compassion.

2. Akshobhya, in the east, holds a dharma wheel to symbolize that, after having cut the afflicting emotions completely, he gave teachings.

3. Ratnasambhava, in the south, holds a jewel to symbolize that he fulfills the needs of all sentient beings.

4. Amitabha, in the west, holds a lotus flower to symbolize that he has purified all attachment.

5. Amoghasiddhi, in the north, holds a sword and bell to symbolize that he has cut the kleshas of all sentient beings through the four activities.

ii. The eight bodhisattvas

Mipham Rinpoche describes the eight bodhisattvas as follows:

1. Manjushri, who embodies enlightened wisdom, is white with a tinge of green and holds a blue utpala flower to symbolize that his afflicting emotions have been completely purified.

2. Vajrapani, embodiment of enlightened power, is green and holds a vajra to symbolize the annihilation of suffering.

3. Avalokiteshvara, embodiment of enlightened compassion, is red and holds a lotus flower to symbolize that he is faultless.

4. Kshitigarbha, embodiment of merit, is white and holds a seedling to symbolize that he plants the seed of wisdom.

5. Sarvanivaranavishkambhin, embodiment of enlightened qualities, is orange and holds a dharma wheel to symbolize that he bestows the sacred teachings on all sentient beings.

6. Akashagarbha, embodiment of blessings, is yellow and holds a sword to symbolize the cutting of the afflicting emotions.

7. Maitreya, embodiment of activities, is light yellow and holds a cactus to symbolize the cooling of the afflicting emotions.

8. Samantabhadra, embodiment of enlightened aspirations, is light red with green shading and holds a stalk with a head of wheat, which symbolizes the fruition of aspirations.

iii. The sixteen offering goddesses

This teaching comes from the *Secret Essence Tantra*. There are four outer, four inner, five secret, and three common offering goddesses, making a total of sixteen. There is also a description of these goddesses in the section on

mandalas which should be followed when drawing a mandala. This is a general description, and the eight offering goddesses are more common.

Four outer vajra goddesses

1. The white goddess of charm in the southeast is graceful, coquettish, and charming; she holds a mirror, with her hands held just below her hips and her body leaning slightly to the left. This is to show that all appearances are the essential nature of emptiness.
2. The green goddess of garlands in the southwest holds a jewel mala, symbolizing the inseparability of skillful means and wisdom.
3. The yellow goddess of song in the northwest plays a sitar to show that she continuously offers songs of the dharma.
4. The red goddess of dance in the northeast dances while holding a vajra and bell above her head to symbolize that she gives joy to others.

Four inner vajra goddesses

1. The light-yellow goddess of incense in the southeast offers incense to symbolize the fragrance of discipline.
2. The orange goddess of flowers in the southwest throws flower petals from a bowl of flowers that she is holding, to symbolize the elements of enlightenment.
3. The ocher-colored[156] goddess of lamps in the northwest holds a lamp to symbolize the illumination that dispels the darkness of afflicting emotions.
4. The light-green goddess of perfume in the northeast holds a conch filled with perfumed water to symbolize the purification of habitual tendencies.

Five secret vajra goddesses

1. Vajra Goddess of Form is white and holds a silver mirror in her left hand to show our buddha nature.
2. Vajra Round-Drum Goddess is red and beats a drum.
3. Vajra Lute Goddess is blue and sings while playing a lute.

4. Vajra Flute Goddess is yellow and plays a flute.
5. Vajra Clay-Drum Goddess is green and plays a drum held at her waist with both hands.

Three common vajra goddesses

1. Vajra Touch Goddess is white and offers a divine cloth.
2. Vajra Taste Goddess is yellow and offers a bowl of fruit.
3. Vajra Dharmadhatu Goddess is either blue or white and holds a *dharmodaya* (tetrahedron) that is white on the outside and red on the inside.

The sixteen goddesses are youthful, charming, and beautiful and offering the most delightful objects to all the senses. It is important to note that different teachings describe the goddesses in different ways, with different implements and colors, and this is an example from one tradition.

iv. The eight offering goddesses

These are the general, more common offering goddesses, which are similar to the eight outer and inner vajra goddesses but in different colors. The first four goddesses are in the direction colors.

1. In the east is the white goddess of charm; she is beautiful and charming, with her body tilted slightly to the left, holding a mirror.
2. In the south is the blue goddess of garlands; she holds a multicolored jewel mala.
3. In the west is the red goddess of song, who sings while playing a lute.
4. In the north is the green goddess of dance, holding a vajra and bell to her head and dancing.
5. In the southeast is the white goddess of flowers.
6. In the southwest is the orange goddess of incense.
7. In the northwest is the red goddess of lamps.
8. In the northeast is the green goddess of perfume.

v. The six sages of the six realms

There are six sages, munis or buddhas, who abide in the six realms of samsara. They are all standing and holding symbolic implements, each a different color:

1. Sage of the Gods abides in the god realm to subdue the pride of the gods and relieve their suffering. He is white and holds a sitar.
2. Splendid Fabric is blue and abides in the realm of the demigods to subdue their jealousy and relieve the suffering of constant fighting and warfare. He holds a sword or coat of armor.
3. Shakyamuni, Sage of the Shakyas, abides in the human realm to subdue desire and relieve the suffering of birth, old age, sickness, and death. He is yellow and holds a monk's staff and bowl.
4. Splendid Lion abides in the animal realm to subdue the defilement of ignorance and relieve the suffering of being hunted, eaten, and tortured. He is green and holds a dharma text.
5. Flaming Mouth abides in the hungry-ghost realm to subdue the defilement of miserliness and relieve the suffering of hunger and thirst. He is red and holds a small casket.
6. Sovereign of Dharma, or Avalango, abides in the hell realm to subdue the hell beings' defilement of hatred and relieve the suffering of extreme heat and cold and other intense sufferings. He is brown and holds a conch shell filled with fire and water.

vi. The eight auspicious symbols
These teachings come from Jigme Lingpa's *Commentary on the Condensed Realization of the Gurus,* unless otherwise indicated.

Formerly, the eight auspicious symbols were offered by Brahma to all buddhas. In the same way, for the sake of accumulating merit for oneself and all sentient beings, this extraordinary representational mandala of the eight auspicious symbols should be understood as an object of support for visualization, whereby all phenomenal appearance is seen as the sphere of wisdom.

The eight auspicious symbols are as follows: (1) The *parasol* is the expression of wisdom, miraculously manifested as a white parasol with a golden handle. Its cloth flutters in the breeze and a precious sapphire ornament adorns its top. It is offered above the Buddha's head.

(2) The two *golden fish* have fine and supple turquoise-colored fins and are offered to Buddha's divine eyes. (3) The thousand-petaled *lotus* arises above the water. It has fragrant red petals that waver gently in the breeze and is offered to his lotus tongue. (4) The *auspicious right-turning white dharma conch* takes birth in this world for the purpose of aiding all bodhisattvas' activity to enlighten all sentient beings. It is offered to Buddha's teeth. (5) The *treasure vase* holds the nectar of immortality. Its mouth is

ornamented with a wish-fulfilling tree, and it is offered to his throat. (6) The precious blue *glorious knot of eternity,* source of wish-fulfilling treasuries, is offered to his heart. (7) The unceasing doctrine's *victory banner* of the dharma is offered to his invaluable body. (8) The *dharma wheel* eradicates the afflictions of the web of samsaric existence and is offered to his venerable feet.

When offering these, dedicate it with the wish that, by means of the auspicious connection created through this action, I and all other transmigrating beings may enjoy an ocean of blessings and favorable circumstances.

vii. The seven precious royal emblems

The seven precious royal emblems are the accessories of the chakravartin (universal monarch). In the context of the Buddhist teachings, the chakravartin refers to a bodhisattva. The emblems represent different abilities or supports that he must possess in order to maintain his dominion and are symbolically offered to the Buddha for the same purpose. The *Sutra of Extensive Play* explains the origin of these seven treasures or attributes as follows:

One day of the full moon, the chakravartin and his entourage of queens performed cleansing vows and purifications and made offerings toward the east, when in the sky before them the sublime thousand-spoked precious golden wheel miraculously appeared. Other sutras say that the precious wheel was offered as a gift by Indra or that it arose spontaneously from the Precious Mountain due to his previous great merit, so there are a few versions of this story. Whichever is the case, at this point the chakravartin brought to mind his previous great accumulation of merit and held up both hands. The wheel descended directly into his hands, and he said:

Listen! Precious wheel;
May the former traditional path of the Noble Ones
Become all-victorious!

The wheel rose up and flew toward the east to establish the doctrine of the past there. The chakravartin rallied his four kinds of troops—cavalry, elephants, chariots, and infantry—and thus established the countries in this direction under his domain. In the same way he established his dominion in each direction, through the power of the precious golden wheel. This is how he first established his dominion as the universal king. He never has

the thought of subjugating or destroying others at the expense of his rule, his activity being that of a bodhisattva. His dominion always arises spontaneously, without harming anyone.

There are four grades of precious wheel: one is gold, the next is silver, then copper, and then iron. The golden wheel has the power to establish rule over all four directions; the others can establish power, respectively, over three directions, then two, and finally one domain. The quality of wheel and its subsequent power to establish dominion over increasing areas corresponds to the level of attainment of the bodhisattva ruler or king: the first three levels of ruler, supported by the iron, copper, and silver wheels, have reached differing levels of attainment within the first bodhisattva bhumi. The ruler who has reached the second bodhisattva bhumi is supported by the golden wheel, which establishes his dominion over all four directions up to the top of the precious mountain.

The qualities of each of these precious emblems are as follows: The *precious wheel* establishes dominion over a third-order three-thousandfold universe or a single-order thousandfold universe, depending on the level of attainment of the chakravartin. It has five qualities: (1) The precious wheel is made from pure gold. (2) It is five hundred leagues in size. (3) It is beautiful to behold and as brilliant as the sun. (4) It can circle an area of 100,000 leagues in one day. (5) It enables the chakravartin to immediately arrive where he wants to go, traversing the skies with his army and establishing his rule. Its power also gives him supernatural hearing, and his subjects all obey him without the need for verbal commands.

The *precious elephant* symbolizes strength of mind and has eight qualities: (1) He is intelligent; (2) he is obedient; (3) he has seven points of beauty; (4) he has the strength of one thousand elephants and is thus impossible to conquer; (5) his scent stuns and confounds other elephants; (6) he always vanquishes the enemy; (7) he travels by sky, ground, and water into battle; and (8) he can travel around the world in one day. The elephant is white in color and can be easily held by a fine thread. He spontaneously travels wherever the chakravartin wishes to go. His head and body are naturally ornamented with gem-encrusted gold jewelry.

The *precious horse* symbolizes the mobility and speed of the universal ruler and is also his personal mount. The horse has eight qualities: (1) He has variegated colors like the feathers of a peacock's throat that shimmer and change with the light; (2) his conformation is perfect; (3) he can circle the continent of Jambudvipa three times in a single day; (4) his body is free

from sickness or flaws; (5) a crown jewel naturally adorns his head; (6) he can fly through the sky; (7) he is obedient when ridden; and (8) he can move in many different ways.

The *precious queen* has countless virtues, which here are condensed into five: (1) She is agreeable; (2) she is willing and able to give birth to many children or few; (3) she is congenial, treating all women like her sister, and is never jealous; (4) her speech is refined and wise; and (5) she does not have wrong views or lack faith.

The *precious jewel* is octagonal, the circumference of a great man's thigh, clear, and brilliant. Although its qualities are inexpressible, they can be summarized into eight: (1) The circumference of its radiance completely illuminates the night sky, and its appearance is a source of bliss like a crown ornament. (2) When the chakravartin travels through a drought-stricken land where people are tormented by thirst, pure water with eight qualities will arise, quenching everyone's thirst. (3) The chakravartin's counsel and advice are always bestowed by the jewel. (4) From each of its eight points variegated beams of light shine forth to a distance of eight hundred leagues, blessing the beings of the area to be free of disease and to abide continuously in meditation. (5) It immediately fulfills all wishes. (6) The surrounding area will be free from hurricanes and torrential rain. (7) The surrounding land will be free from frightening precipices and gorges and instead have pleasant ponds, green meadows, forests, and gardens. (8) It causes the inhabitants of the surrounding area to have no untimely death or injury from animals, and the chakravartin will have many strong and courageous sons. These are the eight qualities bestowed by the precious jewel.

The *precious minister* has four main qualities: (1) He causes precious substances such as vajras, sapphires, emeralds, cat's eyes, gold, silver, jewelry, and any precious stones or valuables to arise spontaneously and remain inexhaustible. (2) He obeys and carries out all the chakravartin's orders. (3) He understands the chakravartin's deepest resolves and without command carries them out in a dharmic way. (4) Being free from afflicting emotions, he is not jealous of others and does no harm. He exerts his authority only if ordered by the chakravartin. These are the ideal attributes of the precious minister (or householder) according to many scriptures.

The *precious general* is endowed with eight qualities: (1) He fulfills the general and specific wishes of the chakravartin when going to battle, without requiring a verbal command. (2) He has the perfect, complete qualities of strength and heroism. (3) For himself, he has completely discarded any

nondharmic activity. (4) He does not accept bribes, gifts, property, and the like and conducts his royal duties impeccably without interruption. (5) He entirely destroys aggressive foes. (6) He is powerful, splendid, and majestic, performing his glorious work properly. (7) He has entirely overcome the defiling three poisons. (8) He goes into battle only at the order of the chakravartin.

The *Ornament of Mahayana Sutras* says that these seven precious emblems all magically arose due to the chakravartin's previous great merit. The sutras say that the benefits of offering these to any supreme body representation are immense. Offering them through visualization and in actuality will result in a great accumulation of merit and wisdom. The specific benefits are as follows:

These seven precious royal emblems have such extraordinary qualities as cannot be found in the ordinary world. They are properly offered as infinite all-encompassing purity to the peaceful and wrathful deities of the mandala, by arranging their representations and through visualization, along with the combination of mantra and mudra. The result of this action is similar to the cause, meaning that one attains rebirth in the mandala of the chakravartin (bodhisattva).

In particular, offering the precious wheel creates the cause to completely sever the chain of samsara, which is caused by the confused habitual clinging to self and other as real. For oneself, the twofold purity of the dharmakaya and rupakaya will be attained. For others, one will be able to appear as a master and turn the wheel of the doctrine in vast ways for the supreme benefit of sentient beings.

The benefits of offering the precious jewel are that on the relative level, one will have an abundance of the finest-quality material riches. On the absolute level, one will have the wisdom that gives the capacity to discriminate between what is genuine and what is merely apparent. The experience of poverty will be completely purified. One will also attain the seven jewels of the aryas and the five certainties, thereby enabling sublime benefit for the dharma and all sentient beings.

Offering the precious queen creates an auspicious link to rid oneself of the confusion held by the lower vehicles concerning method. Through the perfect realization of profound wisdom, method—in other words, all that appears—need not be abandoned or transformed. Through mastery over suchness (perfect wisdom/awareness), purity (the realization of the inseparability of appearance and emptiness) will be won. Externally, the

conventional union of method and wisdom, mastery of the four joys of both descent and ascent, and the simultaneous release of the twenty-one knots of the central channel will result in the attainment of the awakened kaya adorned with the seven features of union.

The benefit of offering the precious minister is that one will actualize without delusion the three vehicles of the external body tantra of development-stage mahayoga, the inner speech tantra of anuyoga (Vehicle of Scriptures), and the secret exalted mind tantra of the Great Perfection atiyoga, thus apprehending the nature of suchness beyond ordinary consciousness and free from concept. In addition, through one's learning and virtue, one will teach and uphold this precious doctrine.

Offering the precious elephant subdues the wrong views of eternalism and nihilism upheld by non-Buddhists along with the lower yanas' subtle belief in substantiality and so forth, which is like riding an ordinary hooved beast. Instead, having mounted the supreme elephant of the Vajrayana, one will reach the city of complete omniscience.

By offering the precious horse, one will traverse the five great paths and attain the four legs of miracles. Thus, through this great means, one will swiftly attain the great nonconceptual awareness and gallop to the buddha fields.

Offering the precious general creates the cause to cut ordinary conceptuality, the enemy of wisdom, completely from the root, thereby becoming victorious in the battle with ego-clinging and the obscuring emotions. Unafraid and victorious in all directions like a tigress aimlessly roaming the wilderness, one will perform actions impartially for the benefit of beings.

In this way, by offering these symbols, the practitioner attains the means to work for the benefit of all sentient beings. Thus it is stated in Jigme Lingpa's *Commentary on the Condensed Realization of the Gurus.*

viii. The seven secondary treasures

There is a further group of seven secondary treasures associated with the chakravartin which can be enumerated in various ways. According to Rigdzin Jigme Lingpa's *Commentary on the Condensed Realization of the Gurus,* they are the precious sword, sea-naga hide, bedding, gardens, house, garment, and boots.

The qualities of the chakravartin's *precious sword* are that it is efficacious and assiduous in bringing about his wishes. It vanquishes foes without harming anyone; the mere sight of the sword causes them to surrender.

The *hide of the sea naga* provides protection from destruction by wind, fire, and water. Through its power the chakravartin can control the weather, bringing warmth in cold conditions and coolness in the heat, and bringing or preventing rain as required. Its breadth is five leagues and its length ten leagues.

The *precious bedding* has the following qualities: The blanket is large and smooth and the mattress is springy and neither too high nor too low. Sitting on it, one is freed from the power of attachment and the defilements.

When entering the *precious gardens,* the chakravartin abides in blissful meditative absorption. They are filled with attractive varieties of colorful flowers, fruit trees, ponds, and waterfalls. Beautiful maidens delight his eyes, and he enjoys the five sense pleasures.

The *precious house* is so attractive that even the moon and stars will visit. Those who are suffering will be freed from their torment as soon as they enter. They will sleep blissfully and experience positive signs in their dreams. During the winter it is warm and in the heat of the day it is cool, always pleasant and comfortable.

The *precious garment* possesses the magical qualities of durability, lightness, and comfort in heat or cold. It is of the finest quality, of excellent softness, and unstained. It cannot be burned by fire or cut by a knife or weapon. Wearing this cloth frees the person from cold, heat, hunger, thirst, weakness, and fatigue.

The *precious boots* of a chakravartin are comfortable, soft, light, strong, and energizing. The chakravartin can traverse vast distances with ease and speed over land and water without the shoes getting wet or damaged.

A sutra says:

> A sparkling blue sword, a soft [naga] skin, delightful groves, fine garments,
> Powerful shoes, and immeasurable mansions with soft beds and warm blankets.[157]

These precious items of a chakravartin existed when the life of humans was eighty thousand years.

ix. The seven precious gems

The seven precious gems are also auspicious objects traditionally offered to the Three Jewels: (1) The *three-eyed gem* represents the Three Jewels. Offer-

ing it to the Three Jewels gives rise to the first of the seven noble jewels of the aryas: unshakable faith. (2) The *unicorn* is white in color, symbolizing its purity. When it is offered along with jewels, one attains the noble jewel of morality and the determination to personally achieve the benefit of sentient beings. (3) The *pair of king's earrings* are square shaped, gold, and encrusted with jewels; they give rise to the spontaneous accomplishment of the four activities and the noble jewel of generosity. (4) The *coral* is red and tree-shaped with a gold base. Offering the coral symbolizes that just as it is immersed in the ocean, we too will be soaked by the noble jewel of the Dharma. (5) The two *elephant's tusks* are offered because the conduct of an elephant is noble. This offering thus creates the cause for the noble jewel of modesty and decorum. (6) The round *pair of queen's earrings* with their exquisitely intricate design symbolize feminine beauty and shyness. Similarly, whether in ordinary life or on the path of the dharma, by offering these one will be "shy" of faults, thus aquiring the noble jewel of a constant sense of modesty and ethics. (7) The *crossed gem* is made from a crossed book (*pecha*) cover. It is white and beautifully designed. Offering this creates the cause for a mind of complete purity and freedom from defilements; thus the dharma eye of clairvoyance, the noble jewel of wisdom, is attained.

All together, offering these seven gems creates the cause for attaining the seven jewels of the noble ones.

There are three classes of jewels: those from the god realm, the human realm, and the naga realm. The jewel of the god realm is rimmed by flames. The jewel of the human realm has three eyes, and the jewel of the naga realm is the perfect swirling jewel.[158]

These articles can be described differently according to the teaching; for example, the crossed gem is sometimes described not as a book cover but as a golden digging tool.

x. The four spontaneous enjoyments

The four spontaneous enjoyments are included in the mandala offering. (1) The *wish-fulfilling precious mountain* is made from a vast mountain of jewels. (2) The *wish-fulfilling tree* is made from the seven jewels, and its branches are adorned with leaves, jewels, and flowers. It has the power to fulfill all wishes. (3) The *wish-fulfilling cow* is a caramel-colored cow, with an attractive appearance and rounded body. (4) The *wish-fulfilling harvest* consists of a variety of nourishing grains reaped from a miraculous field.

xi. The eight bringers of good fortune

This teaching on the eight bringers of good fortune is from Jigme Lingpa's *Commentary on the Condensed Realization of the Gurus.*

(1) The *mirror* was offered to Buddha Shakyamuni by the Goddess of Form; the Buddha blessed the mirror to have the miraculous power for all beings everywhere to achieve the unobscured wisdom of the victorious ones when offering this pure auspicious object. (2) *Ghiwang medicine*[159] was offered to Buddha by the two elephants Norkyong and Sasung. Buddha blessed this supreme medicine with the power to purify the afflicting emotions, the discomfort and pain of illness, and all torment and sorrow and to transform one's awareness to the supreme natural state. (3) When either the bodhisattva Bhadrapala or Sujata offered special *yogurt* to Buddha, he blessed it with the special power that whoever offers this will pacify the three poisons and achieve the supreme wisdom of buddhahood. (4) *Durva grass* was offered by Svasti to Buddha as a cushion just prior to his final enlightenment. Offering it creates the cause for purifying our afflicting emotions and the cessation of the suffering of birth and death, and thus for achieving immortal vajra life. (5) The *bilva fruit* was offered to Buddha by a tree goddess, or some say by Brahma. This creates the cause for attaining the fruit of complete buddhahood. (6) The *right-turning conch shell* was offered to Buddha by the lord of the gods, Indra. Offering this will bring the blessing of being fully tamed by the wheel of the doctrine of the three vehicles. (7) Vermilion pigment was offered by the brahmin Kargyal to Buddha (or some say it was offered by the earth goddess) who empowered this substance with the blessing to bestow the wealth and good fortune of a dharma king upon everyone in samsara and nirvana. (8) *White mustard seeds* were offered by the Lord of Secrets Vajrapani to Buddha, who empowered them with the blessing so that the one offering will achieve the power and mastery to eradicate all obstacles to enlightenment.

In this way, these eight bringers of good fortune are widely renowned to possess such powerful blessings.

xii. The deer and dharma wheel

This teaching comes from the sutras. The depiction of the two deer and dharma wheel represents the first teaching of Buddha Shakyamuni, given at Sarnath. At that time, Buddha said to his five disciples, "Monks, the time has come for you to listen to my teachings! Come, be seated comfortably

and listen with one-pointed concentration and a firm resolve to put them into practice."

As they came to be seated, their head hair miraculously fell out and monastic robes adorned their bodies, giving them the appearance of monks who had been practicing for a hundred years, with smooth heads and faces as if freshly shaved.

Brahma offered Buddha a lavishly ornamented thousand-spoked wheel, shining brilliantly as the sun, just as he had offered it to the three former buddhas. Indra offered a right-turning conch, and they requested Buddha to teach. At that time, two golden deer called Ruru came from the forest and seated themselves in front of the golden wheel, transfixed by its splendorous appearance. Buddha taught the four noble truths to his five disciples, as well as gods, goddesses, and a multitude of worldly and otherworldly beings. Kundinaya attained the level of arhat. This was the auspicious occasion of the Three Jewels of Buddha, Dharma, and Sangha coming to the world for the first time (in this era) for the liberation of all sentient beings. Therefore, the image of the two deer and wheel is a reminder and symbol of that supremely fortunate moment.

The wheel symbolizes the continuous teachings of the three vehicles bestowed by Buddha Shakyamuni for the benefit of all sentient beings. The two deer are symbols of skillful means and wisdom and of the union of emptiness and compassion. They concentrate one-pointedly as they gaze at the wheel, which symbolizes the strength of concentration of Buddha's diligent disciples of various levels in maintaining their vows and engaging in their practice.

xiii. The buddhas of the ten directions

The buddhas of the ten directions are: (1) Rinchen Jungne (Mine of Jewels) to the east; (2) Nyangen Mepa (Without Lament) to the south; (3) Rinchen Ötro (Radiant Jewel) to the west; (4) Gyalwai Wangpo (Supreme Conqueror) to the north; (5) Tingedzingyi Langpo Dampai Pal (Excellent Elephant of Samadhi) to the northeast; (6) Pemo Dampai Pal (Excellent Glorious Lotus) to the southeast; (7) Nyimai Kyilkhor Nangwa Dampai Pal (Luminous Supreme Orb of the Sun) to the southwest; (8) Duk Dampa (Excellent Parasol) to the northwest; (9) Pemö Pal (Majestic Lotus) below; and (10) Gawai Palchen (Supremely Joyous One) above.

The ten directions refer to the four cardinal directions, the four intermediate directions, and the central point directly above and below. This way of naming the ten direction buddhas comes from Jamyang Khyentse Wangpo.

xiv. The victorious ones of the six families

The victorious ones of the six families are the buddhas of the five families (Vairochana, Akshobhya, Ratnasambhava, Amitabha, and Amoghasiddhi) plus Vajradhara, which is according to the advice of Guru Padmasambhava. Scholars of the New Translation tradition sometimes add Vajrasattva instead of Vajradhara.

xv. The mudras of the buddhas of the five families

In Vajrayana Buddhism, the buddhas of the five families—also known as the five dhyani buddhas, five wisdom buddhas, five direction buddhas, five great buddhas, or five jinas (victors)—are representations of the five qualities of the Buddha. The five wisdom buddhas are a later development, based on the Yogachara school's teachings on the wisdom of the buddhas. The five buddha families are the buddha family, vajra family, ratna family, padma family, and karma family.[160] The mudras of the five wisdom buddhas are enumerated. Mudras are usually made with the right hand, the left hand remaining in the lap.

(1) Vairochana is the lord of the buddha family. He is in the center and holds his hands in the *enlightenment mudra*, or the *turning the wheel of dharma* mudra. (2) Akshobhya in the east is the lord of the vajra family. His hands are in the *earth-touching mudra*. (3) Ratnasambhava in the south is the lord of the ratna family. His hands are in the *mudra of giving*. (4) Amitabha in the west is the lord of the padma family. His hands are in the *meditation mudra*. (5) Amoghasiddhi in the north is the lord of the karma family. His hands are in the *mudra of protection*, also known as the *mudra of granting refuge*.

xvi. The four ornaments

Generally speaking, the deities' ornaments symbolize the purification of the five poisons. These four ornaments can be depicted at the back of a buddha's throne: the garuda ornament purifies ignorance; the sea monster purifies desire; the eight-legged lion purifies hatred; the elephant purifies jealousy; and all four ornaments together purify pride.

xvii. The six ornaments

The six ornaments are lion, elephant, supreme horse, peacock, shang-shang bird, and strong man. These are the ornaments that can be depicted surrounding a buddha.

xviii. Additional accoutrements

Although the thirteen requisites of a monk have already been listed along with the measurements for monastic robes, further details and additional teachings are included here.

The three robes are the two upper robes and the lower robe.

The six necessities of livelihood for a fully ordained monk are the two upper robes, lower robe, sitting mat, begging bowl, and water filter.

The five dry-skull ornaments refers to a five-pointed crown made from the skulls of five different beings, as follows: the middle skull is from a demon; to its right is a raksha skull; to its left, a *tsen* spirit skull; to the far right, a king demon skull, and to the far left, the skull of a heretic.

There are many others enumerated that are not included here.

xix. Points on clay sculpture making

This section contains some essential points from my own experience about preparing clay for sculpture making. The artist first needs to understand the difference between good- and poor-quality clay. Good-quality clay is smooth, pliable, and free from grit or sand. The clay is kneaded very well, and cotton wool is mixed into it during the process.

There are two kinds of clay: one is ordinary and one is known as medicinal clay, which is used for Buddhist statue making. For that purpose, powdered *mendrup* (herbal medicinal substances) and other blessed substances, sacred water, medicine, silk cloth, gold, silver, and powder from ground gemstones are added. Only small amounts of these are needed. The cotton is necessary to hold the sculpture together well. This is now special medicinal clay, and the statue is known as a medicinal statue. This tradition of sacred medicinal clay statue making came to Tibet from India and China.

Clay is an easily workable material that is relatively inexpensive. Kyapje Dilgo Khyentse Rinpoche preferred medicinal clay sculpture to that made even from gold, silver, copper, or other precious materials, because if the statue is destroyed, then it will not be plundered afterward as precious materials are. Sometimes metal icons have even been melted down to make guns and weapons, which is harmful for the doctrine and for the karma of those who have misused it. Even if the clay sculpture is gilded, the gold cannot be removed and used, so this is why he said it is the best material. If a benefactor really wanted to commission a statue from gold, silver, or copper, he would not insist, but for himself he always commissioned statues in clay. This is why I want to share my guru's advice with you.

The teachings on measurement, posture, proportions, and so on, encompassed by the three noble principles are also relevant for statue makers or any artist of the sacred Buddhist art traditions.

xx. Tangka brocade

Here the traditional colors and measurements used for tangka brocade are explained. The main tangka brocade is usually blue, with the lower section half the height of the tangka. The upper section is half the height of the lower section. The width of the sides is half the length of the upper section. Red and yellow inner brocade borders are placed directly around the tangka, and their width is half the width of the blue sides. These proportions are used regardless of the size or proportion of the tangka. The red and yellow inner brocade borders symbolize a rainbow, with the red on the inside. A decorative white cord is stitched inside the border next to the tangka. There is decorative red stitching on the outside of the main tangka brocade. This is the same for green tangka brocade. If the main brocade is red, then only use a single yellow brocade border, which makes the colors harmonious. In that case the decorative inner cord can be red and the decorative stitching on the outside can be blue. If the main color of the brocade is yellow, then the inner brocade border is red, the inner decorative cord is white, and the outer decorative stitching can be blue.

For more elaborate brocade, the outer stitching can be in five different colors, but the inner cord is always only one color. It is possible to choose one or two "rainbow" colors for the inner brocade borders. If the main colored brocade in the lower section looks too big, then a colored rectangle can be sewn below the center and decorative motifs can be embroidered on this section, depending on the wishes of the sponsor. If many colors are being used, it is good to use the four colors for increasing, pacifying, magnetizing, and subjugating.

The front curtain can be yellow with red sides or just one color, usually red or yellow. The two long ribbons at the front are red; they can be straight or in the shape of a narrow necktie, with the lower end wider and pointed. This is all according to tradition, but it depends on the individual benefactor's choice.

Each part of the tangka brocade has symbolic meaning: The blue brocade symbolizes enlightened mind. Red symbolizes enlightened speech. Yellow symbolizes the Buddha's body. The decorative cords and stitching symbolize the left and right subtle channels. The tangka painting itself symbolizes the

central channel. The colors of the brocade are an offering; therefore, it is important for them to be attractive and of good quality. The meaning of the colors in terms of the ground is the enlightened body, speech, and mind. The meaning in terms of the path is the practice of the three channels. In terms of fruition, the meaning is the three kayas.

e. Various practical guidelines
i. Painting preparations
(1) Materials

The best-quality surface to paint on is gold or silver, whether one is painting onto it directly or after it has been applied to a tangka cloth. The medium-quality surface is good cotton or silk. The lowest-quality surfaces are clay, stone, wood, or paper. There are some special surfaces, such as the bone, skull, or shroud of a highly realized or enlightened being. However, it is not necessary to use only the skull of a lama; any human skull can be used as long as it has the right auspicious signs.

There is no limit to the size of the painting surface; it can be as big as a mountain if necessary. Any large cloth or wall painting is considered a medium-sized artwork. The smallest is on a small piece of paper or other material. The only limitation is the area available. If it is as big as a mountain, then the artwork would usually be made from cloth. The medium-sized artwork, on the wall and so on, is usually embroidered or painted. The smallest size is painted or drawn. "Smallest" usually refers to works such as *tsakli* (small images used in rituals and empowerments), which consist of a drawing with simplified color.

(2) How to prepare the painting surface
(a) Preparing the tangka cloth

Ordinary-quality white cotton or wool cloth, never synthetic, is used for a tangka. The weft should be neither too tight nor too loose. A rectangular piece of cotton, just a little larger than the size you need for your tangka, is sewn onto a light frame of thin bamboo sticks bound at the corners with string, which is then sewn with cord onto the wooden tangka frame and stretched as tightly as possible. For large tangkas, quite thick cloth is required, which can be made smooth with a knee bone, as otherwise it will be too rough; this softens the weave of the cloth. Then combine a small amount of skin glue with white clay or chalk and cold water and stir well

until it is smooth. Then slowly add more water and heat the mixture in a pot while stirring. When it is ready, while it is still very hot, quickly apply it to both sides of the tangka with a soaked piece of cloth, making sure to cover the entire cloth with the gesso, right up to the stitching at the edges. Then smooth the gesso evenly all over the surface with your hand. Once this is done, leave it in the sun until it is completely dry. After it is dry, check the gesso by touching it with a folded damp cloth—if the water from the cloth immediately goes through to the backside of the tangka cloth, then there is not enough glue in the gesso. In this case you can add a little more glue to the remaining gesso mixture and apply it to the tangka once more. If the water does not go through to the backside after this, there is no need to repeat it; once is enough. On the other hand, if the water does not go through to the back and in addition, the gesso surface is very rough, then the glue is too strong. You can then repeat the process with a more diluted gesso.

To make the tangka surface smooth, you will need a flat, very smooth piece of wood, ideally just smaller than the size of the cloth, and a smooth river stone with a flat edge that is not too blunt. Put the wood on the floor and place the tangka frame on it, with the cloth section over the wood. Moisten a piece of cotton cloth and rub it quickly over the tangka canvas in small patches, rubbing in one direction only (e.g., horizontally). Quickly rub the smooth stone firmly over that moist patch, then quickly move on and moisten the area next to that patch, working in rows until the entire surface has been moistened and rubbed smooth in small patches. This needs to be done very quickly before it dries. Once the entire cloth surface has been smoothed on one side, put it out to dry and then do the other side of the cloth. The next time around, work in the opposite direction (e.g., vertically). Each time you repeat this, moisten the cloth with a little more water. This needs to be done on both sides, usually three times, but it can be more; increase the level of water a little each time. If the water comes through to the backside of the cloth, either the glue is too weak or you are using too much water. This entire process should be studied with a teacher, as it can be properly understood only through demonstration.

It is unacceptable to color the gesso to make the tangka look old or antique in order to suit a market. Anyone who does that does not understand that their artwork is an offering to the Three Jewels and therefore it should look clean and fresh.

(b) Mural painting

The following should not be considered a complete teaching. It is meant to give just a rough idea of what is required, which, as with all art traditions, can be learned properly only through experience and under the guidance of a qualified teacher.

One of the general principles in mural painting is to make the surface as smooth as possible. It is not possible to explain exactly how to do this, as that will depend on the nature of the surface and the materials at hand. In any case, the surface of the wall needs to have a sealant applied. In Tibet, strong skin glue was applied to the clay walls of a building. The sealant should not be too strong or too weak, and this can be gauged only through practice. If the glue or sealant is too strong, the painting surface will be easily scratched, and if it is too weak, the paint and other media will not adhere well. Especially with materials like stone or iron, the glue should not be too strong. This instruction for applying a sealant is for when it is necessary or preferable to paint directly onto a raw surface, without making a gesso ground.

When a gesso ground is being used, some kind of cloth is needed. The cloth first is washed thoroughly, then applied to the wall, and glue is applied on top. When the cloth is glued to the wall, it must be tightly stretched. Then white gesso mixed with the correct amount of skin glue is painted on and left to dry. When it is dry, it should be rubbed with a smooth stone and some water, in the same way as for a tangka ground, to make it smooth. This should be done about three times. A colored base is then applied; it is usually white but it can be red. If the painting is in "three shadings" style, then the ground color should be dark, as the line for three shadings is white.

(c) Modern materials

Once the appropriate primer has been applied—whatever the surface—various nontraditional paints can be used, such as oil paint, acrylic, and so on. It is not possible to say anything specific here, as each country has different materials to be investigated. However, the same basic principles apply when one is painting the sacred icons, and the effect should be clean, attractive, and correctly proportioned. Of course, the visualization from the sadhana or narrative icon should be correctly depicted. In general, there are media that can be used to help the paint flow easily, such as watercolor. For example, acrylic does not naturally flow well, especially for fine line work. On the other hand, acrylic is much easier to use for shading.

ii. Drawing and painting tools and techniques
(1) Charcoal
Charcoal is traditionally made from willow. Himalayan juniper or cypress and daphne (Indian) paper tree are also used. Only soft wood is used for making charcoal. The sticks chosen should be thinner than a finger, but not too thin, as they become thinner when they are heated. The longest should be the span of your outstretched thumb and forefinger. Put the sticks into a thin iron pipe, seal both ends with clay, and then pack the outside of the pipe with clay and place it in a fire. The pipe must be longer than the pieces of wood, about two sor at each end. If a metal pipe cannot be found, the sticks can be rolled in a cotton or wool cloth or in a bamboo tube. Again, pack the outside with clay, but not too thickly, and place it in the fire. The length of time it should be left in the fire depends on how hot it is. This can be understood through experience—if it is left for too long, it turns into dust. When you take it out of the fire, bury it in the earth to cool down slowly for about half an hour to an hour, then remove the charcoal when it has cooled.

(2) Paintbrushes
The tangka painter traditionally has three paintbrushes. Two are for applying color (one large and one small), and one is for line. The large brush is used for wall painting and other large areas and is made from the bristle of a fat, strong pig. The bristle should be very straight. The small brush can be made from the soft hair inside the ear of a healthy cow or goat, or a cat or rabbit. The best hair for a line brush is sable, either water or mountain sable. Tiger or deer hair can also be used. It must have a very sharp point.

When checking the quality of the hair, first carefully check each of the strands, making sure that they are all straight with good shape and consistency. Separate them into two different thicknesses: the thick ones are used for thicker lines and the thin ones for thinner lines.

When everything is ready, the hair needs to be bound at the same level, and for this a small tool is used that looks like a thimble but is narrower. It is neither perfectly flat at the bottom nor completely round, but just slightly round (to make the tapered tip), and it must be very smooth. Three or four different sizes of this instrument are required. Make all the brushes in the same way, whether they are for solid color or for line work. The hair is brought to the same level using this tool, which tapers the end. The size

of this tool is determined by the size of the brush you are making. When placing the hairs in the hole, put the hair tip end inside and tap the bottom of it on a hard surface, not too hard or too gently, while simultaneously turning it. The hair needs to be completely dry, so it helps to put fine ash inside first. When it looks as though the hairs are all the same level, take the hair out very carefully, by grasping the end firmly and holding it very tightly, without letting it move. Then place the brush tip in some (weak) glue solution and leave it to dry.

When it is dry, cut the end that is to be bound to the brush handle, so that it is straight and the right length. The handle of the brush should be as long as the span of your hand; for the shape and design you need to have experience or to see a photograph or sample. Glue the end of the brush to the handle and leave it to dry. After it is dry, bind it to the handle with fine string. It is not necessary to glue the string; just paint a little varnish over it, which allows the brush to be washed and dipped without being damaged. Finally, dissolve the weak glue by holding the tips in water, and your brush is ready. To learn more than this, you need to be shown by a teacher.

(3) Other implements and methods
(a) Implements for making straight lines

Two implements are used for making straight lines: chalk string and a ruler. Whether the artwork is big or small, from the eight lines up to the detailed iconometry, the drawing is all based on straight lines. Chalk string is first used to make the lines. This is especially important for large surfaces. The material should be cotton or wool, not synthetic. It is pulled through a "mouse-sized" cloth bag containing colored chalk powder or pigment. Traditionally, a medium pink ocher is used, as it is good for both light and dark surfaces. For a tangka, making straight lines with the chalk string is commonly done at least for its eight lines, and then a ruler may be used with a pencil to make it more permanent. For a mural, most of the lines are made with a chalk string. Chalk string with a plumb is also necessary for making accurate vertical lines. It is best to use thin string, but for very long measurements it should be a bit thicker for strength. The ruler is traditionally square shaped. It is best to have one small and one large ruler.

(b) Compasses

A compass is used to accurately calculate the placement of the straight lines and to draw circles. There are many different names for this in Tibetan; one

is *tangkor*. The compass is traditionally made from iron or wood, but the best compass is made from bamboo because it is light, strong, and easy to use and make. The shape and design are understood from seeing a sample. The artist should have one small and one big compass.

(c) Measuring devices

Traditionally a piece of bamboo or paper is used to mark out units of measurement. There is no fixed size in Tibetan art measurement: the size of one sor or one chachen, for example, depends on the size of the surface that is being used, and everything within that is proportional. In old Tibet an artist always carried a couple of pieces of flat bamboo for this purpose, one the length of a hand span and a longer one the length of a forearm. The bamboo was marked with notches or ink to signify the units of measurement for the particular piece of work. When the measurements were finished, the marks were washed off or smoothly taken out with a knife so that it could be reused for the next artwork. Alternatively, paper is used, as the marks can be very fine and precise, which is good for accuracy.

(d) How to copy an image

The first method for copying an image is called *tsakpar,* which means "many holes." It is a used when copying a particular drawing, or part of it, many times. First, draw the image you wish to copy onto a piece of paper. Then, on this drawing, pierce holes along the lines with the point of a needle, spacing them neither too far apart nor too close. If the holes are too far apart, the drawing cannot be seen accurately, and if they are placed too close together, the paper will split between the holes. To copy from this stencil, a bag of powder pigment is used. The best material to use for the bag is cotton or wool, but synthetic is also fine. The most important factor is that the weave of the cloth for the bag is not too tight or too loose—a medium weft is best. A mixture of powdered ash and charcoal is traditionally used to fill the bag, with a small amount of clay added for weight. Then, wherever you wish to copy this image, firmly hold the paper to that surface, without moving it at all, while tapping or wiping the bag over the holes to copy the picture there.

The second method is called *kapshok,* or "tracing paper." This method is often used when copying a drawing from a tangka, such as an old tangka. Thin paper (e.g., tracing paper) is placed over the image you wish to copy, and then the tangka is held to the light so that you can trace the image onto

the paper. If the paper surface is too thick for the light to come through, then you can rub butter on the paper and leave it to dry in the sun. Once it has dried, rub off any excess grease with a cloth, then trace the image using ink mixed with strong glue, or a pencil. This method is often used by people who do not have good drawing skills. It is not very useful for accomplished artists, but the first method is very useful.

(4) Color teachings
The color palette outlined here comes to a total of 105 colors (see appendix 4). There are six root colors, six branch colors, seventy-nine leaf colors, and fourteen special colors. The six root colors are white, blue, yellow, green, red, and black. These six root colors are always required. Without them the other colors cannot be made. Blue, yellow, green, and red are the basic root colors. White and black are for modifying the root colors, and are thus known as the companions of the four true root colors.

Painting methods in the Karma Gadri tradition
Each tradition of painting has its own methods of application. Previously only mineral and vegetable pigments were used, so the color had to be applied very thin. The pigment was carefully sifted and ground with water and glue to the consistency of milk, then applied to the canvas in about twenty-five very thin layers, so that it would not crack. When it was held up to the light, the drawing could be seen from behind. This was a special technique of the Karma Gadri tradition, but it would be very rare for someone to follow this nowadays. However, artists training in Karma Gadri should understand the tradition and try to follow the methods of this lineage as much as possible.

(a) Shading
There are three main shading techniques: wet shading, dry shading, and three shadings.

Wet shading is used on hard surfaces—wood, walls, and so on—and usually on large surfaces. This technique is never used on a tangka, whatever the size. In wet shading, a dark and light color are painted next to each other fairly thickly and then quickly blended together with a flat brush while they are still wet. Three flat brushes are used: one for the dark color, one for the light color, and one to blend the two colors. This technique creates a very smooth and soft shading effect.

The authentic Karma Gadri tradition of dry shading does not use a pointillist technique as do some of the other Tibetan painting traditions. Instead, color diluted to a thin consistency is applied in washes, leaving the canvas to dry completely between each wash. It is traditionally stated that the shading color should be two times thinner than the base color, but this statement was made when the base color was applied in twenty-five layers. These days, because the base color is not built up in such thin washes, the shading color should be much more diluted than the base color.

The technique of shading is used directly on the bare canvas for the sky and the ground (grassy hills and so on). It is also used on top of base colors. When painting the sky and grass areas, start from the darkest area, which is at the top, and work down with increasing dilution, leaving the lower section unpainted. This should be repeated three to seven times, each time diluting the color by half and using a smaller brush. Finally, dilute the color so that it is nearly as clear as water. The main point is that the color is made more transparent and the brush used is smaller each time. Grassy hills are shaded more evenly than the sky, but there are specific techniques and styles of shading for the sky and grass or ground that the artist needs to understand. The size of the brushes also depends on the size of the tangka, with larger brushes used for larger work.

When shading on the base colors, such as for the skin, cloth, clouds, trees, and so on, the artist should again learn and follow the particular style of shading for each element in the painting according to the tradition. The artist needs to be particularly careful when shading on top of a base color, ensuring that it has completely dried before applying the next layer, as otherwise the base color can start to come off and develop a pitted appearance, which is very hard to remedy once it has started. Shading gives subtlety to the work and softens the bright primary colors used in the Karma Gadri tradition. It takes time but is well worth it, creating a very beautiful, soft effect where no brushstrokes can be seen at all.

The three-shadings technique is generally used only for decorative painting on walls and buildings or for craft items, and acrylic paint is the most common medium for these kinds of surfaces nowadays. It is not used on tangkas, except sometimes to depict brocade cloth and robes. In this technique there is no blending of the colors, and the palette is limited to the base color, a light tone of the same color, and black and white. These colors are next to each other to indicate tone. The effect is bright and cheerful and easily seen from a distance.

(b) Line

There are five colors used for line: blue line, red line, white line, black line, and gold line. Blue line is used on blue and green of any shade, as well as on brown and purple, whether for skin or cloth. The line colors are made lighter or darker depending on the tone of the base color. Red line is used on reds, yellows, and oranges of any shade, again whether for skin or cloth. In the Karma Gadri tradition, white line work is only used for the bindu on the tip of jewels or when using the three-shadings technique. White line work is not used on water, as it is in some other Tibetan painting traditions. The color of the line on a white base color varies: A light-red line is used on white human or deities' bodies (including bone and nails) and on white flowers. Light-blue or black line is used for white animals, buildings, cloth, and ornaments.

The tone of the line depends on the tone of the base color: if it is light, then the line is correspondingly light, and if the base color is dark, then the line color is also dark. The body lines should be drawn very thin and straight, without much *khamshe* (the elegant brushwork that begins and ends at a fine, tapered point, thickening in the middle). For flowing cloth, trees, leaves, and rocks, the line should be thicker with quite pronounced khamshe.

(5) Research before drawing

The attributes of a deity depend on the type of deity it is, and the artist must research all the details of a particular deity's attributes before starting the drawing. If it is a guru, the artist must check whether he should be depicted as a monk or in another form. If it is a sambhogakaya deity, then it is depicted with the sambhogakaya attributes. If it is semiwrathful or wrathful, its attributes need to be drawn accordingly. If it is a yidam, then the artist must determine from which type of tantra and whether it is peaceful, wrathful, or semiwrathful. If it is a peaceful deity, is it in dharmakaya, sambhogakaya, or nirmanakaya aspect? If it is wrathful, is it in the form of yama or rakshasa? Yaksha and yama are quite similar; the difference is whether they have the eight wrathful ornaments or the eight natural signs of wrathful deities—this kind of detail needs to be thoroughly researched. If it is a female deity, then the artist has to determine whether she is peaceful, wrathful, or semiwrathful. If peaceful, is she wearing a deity's ornaments or Tibetan dress? Is she a nun or laywoman? If she is in the form of a deity, is she naked or adorned? If she has ornaments, which kind are they? For dharma

protectors, the artist needs to determine whether they are peaceful, wrathful, or semiwrathful. If peaceful, do they have a deity's attributes or Tibetan clothing? If they are wrathful, then what attributes do they have? There are so many local deities, they cannot all be mentioned, but, regardless of their clothing and ornaments—such as the natural signs of the wrathful deities' bodies and the charnel-ground ornaments—for all of them it is important to check whether there is anything unusual or different about their ornaments. This basic inquiry must be done before the start of any tangka.

(6) Composition and design

The artist uses basic principles of composition and design according to tradition, but within those guidelines there is leeway for personal creativity and expression. Sometimes, having consulted with a lama, the patron is able to provide a photograph or a rough diagram of the image. If the patron does not have this information, the artist has to refer to his own sources or may need to consult a lama to learn the proper iconography and composition. Of course it is much easier if the artist has a diagram or plan to begin with. With this basic information, the composition can be established. There are a few basic principles of composition: (1) dividing the tangka in half, (2) dividing the tangka into three parts, and (3) dividing the tangka into four parts.

When dividing the tangka in half, place the gurus, devas, dakinis, buddhas, and bodhisattvas in the upper section. If it is a tangka with a guru as the main figure, place his disciples and/or dharmapalas, local deities, and wealth deities in the lower half.

When the tangka is divided into three parts, the upper third is for the buddhas, bodhisattvas, and gurus. The middle section is for the peaceful devas and dakinis to the right of the main deity[161] and the wrathful devas and dakinis to the left. The guru's disciples are placed underneath, with the dharmapalas, local deities, and wealth deities.

When dividing the tangka into four parts, place the lineage gurus in the uppermost section directly above the main deity. Place the buddhas and bodhisattvas to the right and left of them. Place the peaceful devas and dakinis in the next section down. Place the wrathful dakinis in the lower middle section. Position the guru's disciples in the lowest section, in the center below the main deity. Place the male dharmapalas on the upper right, with the female dharmapalas to the left or below. The local deities and wealth deities are placed around the lower area of the ground in front of the deity.

To summarize, the buddhas and dharmakaya buddhas must be placed in the highest section or in the upper center. The lineage gurus must also be placed above the central figure or in the upper center to the left and right. If they are placed in the uppermost middle section, then the sambhogakaya buddhas should be placed on the right. If the gurus are in the middle top section, with the dharmakaya buddha above them, then the nirmanakaya buddhas are placed to the right and sambhogakaya buddhas to the left. If there are wrathful devas, they should be on the left, with the peaceful devas on the right. Alternatively, they can be placed on both sides, with the peaceful devas above and the wrathful devas in the central part. If there are wrathful and peaceful devas in the upper sections, then the peaceful dakinis can be placed below to the right and the wrathful ones below to the left. When there are four dakinis, the peaceful ones are higher. The guru's disciples can be in the lower center section or on the lower sides. The disciples can be placed in the upper section, but they can also be placed below. Generally, the dharmapalas are in the lower center or the right side, but they can also be placed in the upper section if there are no other deities there. The female dharmapalas can be placed to the lower left side.

This is general advice, and the positioning can be changed; for example, in the Nyingtik Mangun, Ekajati *must* be placed in the center, with Gönpo Maning on the right and Dorje Lekpa on the left; this is particular to Nyingtik, so in cases like this the instructions should be followed accordingly. Sometimes the deities must be placed as in the visualization of the sadhana, according to the directions of east, south, north, and west. Generally, as in a mandala, the east is in the lower part of the tangka, on the Brahma line. If it is not possible to place the deity there, then east can become the lower right corner and south the top right, and so on. Thus, these rules can be adapted when necessary. When gurus are depicted, the first one in the lineage is positioned highest. That is, as the buddha of the past is placed above the buddha of the present and so on, the same is done for gurus.

The term "higher" in the context of tangka composition means above the central deity's head, but it can also mean to its right or in front of it, as these are also considered high positions. A "low" place means to the lower left side or at the very bottom of the tangka. The dharmakaya is uppermost, sambhogakaya is in the middle, and nirmanakaya is beneath. This is counted from top to bottom or from right to left. The middle, above the center, and on the right side are all considered the highest level, the places of greatest importance.

(7) Rules of perspective

Rules of perspective are used to make things appear three dimensional. Although Western rules of perspective were not followed in Tibet, it is fine to try to utilize these in some way. Here is a brief description of the methods of perspective drawing.

First, draw a central vertical line, which is the point of reference for the rest of the lines. To the right and left, draw two or more parallel lines and then a horizon line for the eye level. Determine how high you want this line based on the distance you want to depict. Then draw one or many lines above and below this to make a grid. Draw two diagonal lines through the center, crossing at the level of the horizon. These eight lines are used for creating the illusion of distance. Perspective lines are used for the sides of a house, for example. This teaching uses rules of perspective drawing from Western traditions. Tibetan traditions do have some rules of perspective, but they do not create the same degree of realism.

(8) How to make paints[162]
(a) Pure and imitation gold and silver

To make gold paint, first beat the pure gold into thin leaves, then cut them into very small pieces with scissors. For one gram of gold, add three grams of white sea salt and pound it with a wooden pestle. It is very important to pound it as if with a hammer rather than grinding it. Then remove the salt with hot water by allowing the gold dust to sink to the bottom and then pouring off the liquid, repeating until it is completely clean. After this, add skin glue, not too much or little, the same as for the paints, and a little *chang*.[163] Then with a stone pestle, pound it again very slowly and gently until the gold becomes very fine. Any gold that floats to the surface is taken out and collected in a clean vessel. The rest continues to be ground until it is processed into a very fine powder, while ensuring that it is kept clean and free from dust. At the end, again clean it by taking out the liquid as explained before, without losing any of the gold. Repeat this many times until it is completely clean.

The basic ingredients required for making gold are salt, alcohol, skin glue, and a medicinal plant used for washing called *sukpa*. If you want to adjust the color of the gold after preparing it, various organic dyes can be used. The first one is made by combining and heating *tarbu* (the berries of the common sea buckthorn or hippophae rhamnoides shrub), *sedru* (the juice of a pomegranate), and *sertsur*. After these three have been heated with water,

use the dye formed to tint the gold by again heating them together. For a more orange-colored gold, add a dye called *tsö* (Indian madder or rubia cordifolia) and heat them together. For a more yellow-colored gold, heat a small amount of a dye made from the medicinal plant *nyangtsi* and saffron and add it to the gold. For a reddish tint, heat the gold together with *bong nga marpo* (red aconite).

Processing silver to use in painting or calligraphy is similar to processing gold. However, the following method is a bit easier: Put a generous amount of charcoal from *la ma*[164] in a stone pot, then pour in heated silver and pound them together quickly before they become cool. It is best to pulverize them very well at this stage so that there is no need to process it much more; the mixture will become a coarse powder like tsampa, which is then easy to process further into a fine powder. Separate the charcoal from the silver with hot water in the same way as for gold, then put the remaining clean silver powder in a stone mortar. Add water again, and further refine and pulverize it until it is very fine. Then take out the water and add pomegranate juice, chang, and more water and boil. This is the proper method, the quintessential instruction on how to cleanse and remove impurities from silver, which gives it a beautiful, fine radiance.

Alternatively, combine the following three substances: tarbu, bultok (soda), and salt. Add this solution to the silver and stir while hot; this removes the oxide. If you combine and stir this mixture again and again before it becomes cool, the silver will become white, bright, and pure. Moreover, if processed further with a mixture of pomegranate juice and chang, it will have a fine and pleasing luster.

To make imitation gold paint from copper, first choose the correct copper. The best copper to use is the "female," which is light red, not the dark maroon "male" copper. With a metal tool, grind it into powder, then add alum and water and heat it repeatedly. Having been cleaned in this way, it will become similar to gold. Mix it with whey, a blue or green herb called *ngo,* and *drung,* and boil together to separate the oxide.

To make imitation gold from brass, shred the brass with a strong metal tool like a rasp, and then pulverize until it becomes a fine powder. Add a liquid made from *tsurnak* (black earth pigment), then heat and stir together until it is refined and purified. Then take off the water, and it will look just like gold. Next, add a small amount of a dye made from polygonum divaricatum, *sertsur* (gold color) and bultok. Boiling them together will cleanse it until it looks just like gold. Finally, add gum resin and the medicinal herb *nyangtsi tre,* which will enhance the glittering golden quality.

Another method for making imitation gold combines musk, aconite, fat from a female yak, red aconite, yellow clay pigment, a herb called *shudak nakpo,* and human blood together with chang until it is as thick as yogurt. Get some very thin copper-leaf sheets and cut them into tiny pieces. Add this to the mixture, then pack it with cow manure and leave it for five or six days. Burn the wood of a barberry plant, and bury the mixture packed with cow manure in the embers. Keep the coals alive with bellows, which at first need to be pumped strongly, then the intensity is slowly reduced until it is barely enough to keep the fire going. If it has a white residue, this is a sign that it has been inhabited by a spirit, which should be exorcised. The product from this really looks like gold.

Imitation silver is used for calligraphy or for painting, as is real silver. The three things to use are, as before, tarbu, bultok, and salt. These are combined, ground, and stirred. When the mixture is ready, it can be used for writing or drawing just like real silver. It will become shiny if polished with a zi stone (a form of agate).

(b) Mineral pigments

The following is a rough guide to making the traditional mineral pigments for tangkas, as it is not really possible to explain this fully in writing.

(i) Mineral blue and green[165]

Blue and green are presented first, as the first two colors applied to the tangka are the blue sky and the green grass; the minerals used also occur together in nature, being made from basic copper carbonates commonly known as azurite and malachite. In Tibet they were mainly sourced from Nyemotang in the Tsang region. They came in a sandy form that had three distinct colors: azurite blue, malachite green, and turquoise. These have to be first cleaned, ground, and separated into different values for each color. The cleaning is accomplished by repeatedly stirring and rinsing off the sand with warm water. After it has settled, the impurities are poured off. A little glue is added; it is then kneaded and rubbed between the hands, and then warm water is added to clean it as before. When this has been repeated until the water is clear, the pigment is placed in a mortar for grinding, with a little water added. The colors emerge very clearly through this process of cleaning and grinding. This pigment should not be ground too hard or the color will disappear. Different shades are obtained when the different grades of the powdered mineral are separated through the usual cleansing process; the lighter particles are poured off and become a distinctly separate color.

In this way, three colors—blue, green, and turquoise, or four colors if you include light blue—are derived from the same stone.

(ii) Mineral vermilion red

The mineral used in Tibet for red is cinnabar stone. Cinnabar looks like crushed, shiny red crystal and was mainly sourced from southeast Tibet. The medium-quality stone is bright red, and the lowest-quality is dark and opaque. It should be washed and ground in the same way as the azurite and malachite. Although it is metallic, it is a soft mineral that is easily ground, even in a ceramic cup. If it is quite clean, it can first be ground without water. Otherwise it should be ground and cleaned with water as for blue and green. A liquid made from *arura* (myrobalan or amla) is added in the same quantity as the powder and left for one night in a clean place. When this liquid turns yellow, it is poured off and the pigment is pounded until smooth, which will be very easily done and yield a good result. This is repeated three times. In general, vermilion red should be ground continuously for a long time, using a little water, until it is smooth. Care must be taken not to grind it too hard and to use equal amounts of a circular and an up-and-down motion, otherwise it can turn white. At the end, mix in a little skin glue and gently grind it a little more in the same way. Then it is ready to use.

The tone of the red can be adjusted in the following ways: For a more orange-colored red, after adding the arura liquid, do not pour off the yellow water or adjust the amount of yellow water removed. If a stronger red is required, add *kasi,* and to make it even stronger, add *kaping.* For a clear red color, add the arura juice and pour off the yellow water a few times, as explained previously. To make it even redder, you can mix salt water into it. Another method of adjusting the color involves the way the paint is taken up from the pot with the brush when you are painting: If you want a yellower red, then take it from the upper part of the paint, which will be more diluted. If you would like it to be more orange, then take the middle part, and if you want a stronger red, then take the color from the bottom. Sometimes the paint is too sticky and can leave a mark when the tangka is rolled or pressed against something. To prevent this, use a medium called *pökar*[166] made from the resin of the shorea robusta plant or from *gyatsa* (sal ammoniac, an Indian table salt). If you want it to be shinier, then add kaping and salt with a bit more glue. As a flow medium you can add a mixture of *sengden* (acacia) and salt.

(iii) Other pigments

The minerals or compounds used for white, yellow, and black can be ground quite hard. Other than blue, green, and red, most pigments need to be ground when dry. Care must always be taken to keep them clean and free of dust.

The traditional Tibetan pigment for orange is sindura or minium orange, which is lead oxide. This was imported from China, India, and Nepal. It can be cleansed if necessary using the usual method, but should not need much further processing, as it is already very soft. It is better not to mix orange and red together, as it will spoil, especially if the proportion of orange is greater.

The mineral pigment used for yellow is orpiment yellow, which is arsenic trisulfide. It was mostly sourced from eastern Tibet near Chamdo. It is heavy and soft; the poorest grades are greenish, the best a pure yellow. Never mix green and orpiment yellow, as they become putrid. For the same reason they also should not be painted on top of each other. Another compound used for orange-yellow was arsenic disulfide. Yellow ocher was made from mineral limonite. This was used mostly as the undercoat for gold.

White is made from the earth pigment calcium white, which probably consists mostly of calcium carbonate, the main component in limestone, marble, and chalk.

(c) Organic dyes

Organic dyes (*tö*) are used for the shading and line work done when the main painting areas have been filled in with the mineral paints.

(i) Red shading and line color

Red line and shading are done with lac dye. This is produced from the resins secreted by the tiny lac insect (laccifer lacca). Tibetans either received the dye in a processed form from India or China or extracted it in crude forms. When cleaned and crushed, it is melted in hot water in the sun. A single leaf of the *zhumkhen* plant (probably cassia) is added to facilitate the extraction of the dye, and it is left in the sun. A little bit of salt can be added so that the color emerges more quickly. The process can be quickened by heating the substances gently on the stove in a small pot placed inside a larger pot with water and tea leaves. The color will then emerge without going black, as it does if you try to heat it directly on the stove. This is used mostly for red shading but can be used for red line if it is further heated and condensed so that it darkens.

(ii) Indigo

Indigo is a dye that traditionally was derived entirely from plants, mostly the genus Indigofera. It is very rarely found nowadays. Only the best-quality indigo was used for tangka painting. It should be moistened and ground repeatedly for a long time. A little glue is added at the end. The process can take a couple of days. Indigo blue is used for blue line and shading.

This concludes part two, the main teachings.

PART THREE
Concluding Teachings

There are four main subjects that make up the concluding teachings: (1) mantras to bless the artwork, (2) consecrating the artwork, (3) the general benefits of the supreme arts, and (4) dedicating the merit.

I. Mantras to Bless the Artwork

THERE ARE ELABORATE methods and rituals for blessing large statues, stupas, and other art, but here are some simple methods that are easily carried out. During the time of Buddha Shakyamuni, stupas and statues were not filled with blessed substances because they were blessed by the gaze of the Buddha himself. After he passed into nirvana, his relics were placed inside these objects to consecrate them. Nowadays it is difficult to find relics of Buddha Shakyamuni, so mantras and relics from enlightened masters are used. During the time of the Buddha, when he commissioned a tangka with his image on it, he would write some verses underneath it, which is the same principle as being blessed with mantras. Statues, stupas, and tangkas are consecrated to prevent demons and negative spirits from inhabiting them.

A. Mantras for Filling Statues

A new statue should always be filled with mantras and consecrated. Begin by thoroughly cleaning the statue, then burn some frankincense and hold the statue over the smoke while reciting prayers to eliminate the obstacle makers, offering the gektor. Then purify the statue by putting saffron and fragrant substances inside it. In his *Ocean of Merit and Wisdom: Instructions for Filling Sacred Objects with the Five Types of Relics,* Drigung Chödrak says that the following five sacred relics are necessary for filling a statue or stupa:

1. Relics of the body of reality, which refers to mantra script
2. Relics the size of mustard seeds, which refers to pearl-like relics left after a realized master dies
3. Relics of clothing
4. Dharma relics, which refers to mendrup, statues, religious texts, tsa-tsa, and statues

5. Relics of bone remains, which refers to bones of a deceased real-
ized master and includes hair and nails

The mantra is the most important of the relics. The others should be added
when possible but are not absolutely necessary. Each mantra should be
written in one continuous line from start to finish without using the *tsek*
marker.[1] It should be written so that it fits easily on a strip of paper, without
leaving much blank space on the sides and ends. If it is a long mantra and
the paper runs out before the mantra is completed, then stick another piece
of paper at the end of the first one so it can be continued on the same line,
without leaving any space between them. Do not overlap the letters or leave
empty spaces between them; they should be written evenly and attractively.
Mistakes or corrections cannot be included (such as inserting a missing let-
ter above the others). When the mantra is complete, purify it by painting
saffron water lightly over the top. Then the mantra is to be rolled, and there
are many different instructions for this. The method taught here is from
Jamgön Kongtrul and Jamyang Khyentse Wangpo:

Roll the paper so that the writing is facing inside, with the first letter
innermost. If it is for a prayer wheel, roll it in the same way but with the
writing facing out. Mark the top of the paper roll in some way, such as dip-
ping it in red paint, so you cannot accidentally place the mantra in the statue
upside down. Stick yellow cloth around the side of the rolled mantras. The
guru and deva mantras are put in the upper part of the statue, and the main
deity's mantra is placed in the heart center along with any relics. Dakini
mantras are placed under the heart area of the statue. Dharmapala mantras
can be placed in the area of the lotus seat and feet. Karmapa Mikyö Dorje
said that for very small statues, the mantras can be placed all together in one
place. When a statue is too small for the mantra to be placed upright, you
can put the roll on its side with the heads of the letters to the deity's right
side. If you want to place sacred texts in the statue, the text needs to be facing
in the correct direction, as if the statue will read it. The five types of dharani
should be placed inside some stupas; these are tantric protection formulas
that can also be placed inside statues. The shortest or most essential mantra
that can be used to fill a statue is OM ĀH HŪM.

ॐ ཨཱཿ ཧཱུྃ

These three syllables are the king of all mantras, the essence of the body,
speech, and mind of all the buddhas. If there is not enough space for that,
then simply put HŪM, which is the heart syllable for all the peaceful and

wrathful deities. A statue should not be left without any syllables inside it, as they protect it from ghosts or demons entering it. If you do not know the mantra of a particular statue, then you can do as follows, using Dudjom Rinpoche as an example: his name is Jikdral Yeshe Dorje, so the mantra would be written as OM ĀḤ GURU JIKDRAL YESHE DORJE HŪM SVĀHĀ:

ཨོཾ་ཨཱཿགུ་རུ་འཇིགས་བྲལ་ཡེ་ཤེས་རྡོ་རྗེ་ཧཱུྃ་སྭཱ་ཧཱ།

Mantras for the life-tree

The life-tree (*sokshing*) is the central axis or backbone of the statue, representing the central channel (*avadhuti*). It is a long, four-sided obelisk made from wood, tapering from the base to the top and ending in a pyramid-like shape, or pyramidion, at the very top. It should be placed inside any statue large enough to contain it, sized according to the dimensions of the statue or stupa. Ideally, the life-tree is made from red or white sandalwood or another precious type of wood. It is important not to use cracked or damaged wood. Where possible, it is preferable to know the direction that the tree faced and then place it in the statue so it faces in the corresponding directions with the front of the statue considered east. Divide the vertical faces of the front and back of the life-tree into five and put a large syllable in the middle of each division: OM ĀḤ HŪM SVĀHĀ.

ཨོཾ་ཨཱཿཧཱུྃ་སྭཱ་ཧཱ།

If there is not enough space to write other mantras, then these five letters fulfill what is required. Otherwise write an upside-down HAM on the top or just under the stupa drawing/carving if there is one.

ཿ

At the top you can carve or draw a stupa. On the stupa vase, write the letter BHRŪM.

 བྷྲཱུཾ

If there is not enough space to write this on the stupa vase, then write it under the HAM. If you wish to do a more elaborate version, then under the BHRŪM put the letters HŪM and then OM.

ྃབྷྲཱུཾ

Then on the other sides, at the same level as the OM, to the right, put TRĀM, then at the back HRĪḤ, and on the other side ĀḤ:

ཧྲཱིཿ ཏྲཱཾཿ ཨཱཿ

Then directly under the *main* large OM in the top fifth division, write OM SARVA VIDYA SVĀHĀ:

ཨོཾསརྦབིདྱསྭཱཧཱ།

Under the ĀḤ of the five main syllables, write the mantra of vowels and consonants:

ཨ་ཨཱ། ཨི་ཨཱི། ཨུ་ཨཱུ། རྀ་རཱྀ། ལྀ་ལཱྀ། ཨེ་ཨཻ། ཨོ་ཨཽ། ཨཾ་ཨཿ ཀ་ཁ་ག་གྷ་ང་།

ཙ་ཚ་ཛ་ཛྷ་ཉ། ཊ་ཋ་ཌ་ཌྷ་ཎ། ཏ་ཐ་ད་དྷ་ན། པ་ཕ་བ་བྷ་མ། ཡ་ར་ལ་ཝ། ཤ་ཥ་ས་ཧ་ཀྵ།

Under the main HŪṂ, write the following mantra OM VAJRA ĀYUSHE SVĀHĀ:

ཨོཾབཛྲཨཱཡུཥེསྭཱཧཱ།

Under this mantra, put the mantra of the deity of the statue. Then under the main SVĀ, if there is space and time, write the five dharani mantras and under them put the dharani mantra of dependent origination (YE DHARMĀ HETU):

ཡེ་དྷརྨཱ་ཧེ་ཏུ་པྲ་བྷ་ཝཱཿ ཧེ་ཏུནྟེ་ཥཱནྟ་ཐཱ་ག་ཏོ་ཧྱ་བ་དཏ༔ ཏེ་ཥཱཉྩ་ཡོ་ནི་རོ་དྷ། ཨེ་ཝཾ་བཱ་དཱི་མ་ཧཱ་ཤྲ་མ་ཎཿསྭཱཧཱ།

Under the main letter HĀ put:

སུཔྲ་ཏིཥྛ་བཛྲ་ཡེ་སྭཱཧཱ།

A half-vajra can then be drawn or carved at the bottom of the life-tree.

The last thing for filling the statue is a mantra wheel on an eight-petaled lotus wheel, with the syllable JAṂ written in the center and within each petal, with the head toward the center:

ཛཾ

Then in exactly the same way, draw a mantra wheel on an eight-petaled lotus with the syllable BAṂ in the center and at each petal, but this time with the head facing out:

བཾ

The wheel with the syllable JAṂ is placed face down on top of the wheel with the syllable BAṂ , which faces up, and they are placed together inside the statue base. The heads of the central syllables must face the back of the statue when placed inside. Then the filling of the statue is complete and the plate can be fixed under the statue to seal it. A drawing or an embossed image of a crossed vajra must be placed on the outside of the base plate of the statue.

B. Mantras for Tangkas

Traditionally, before an artist would begin a tangka, the deity was roughly sketched out on the tangka cotton before the gesso was applied, so that the syllables could be written at the deity's five centers. Nowadays, this is not done, and though it is good to do, it is not absolutely necessary. When the tangka is completely finished and the red border has been painted, the syllables OṂ ĀḤ HŪṂ SVĀHĀ must be written on the back of the tangka, in the areas corresponding to the five centers of the main deity:

ཨོཾ་ ཨཱཿ་ ཧཱུྃ་ སྭཱ་ ཧཱ།

Mantras are written under each of the syllables. Under OṂ write:

ཨོཾ་སཪ་བི་ད་སྭཱ་ཧཱ།

Under ĀḤ write the mantra of vowels and consonants:

ཨ་ཨཱ། ཨི་ཨཱི། ཨུ་ཨཱུ། རྀ་རཱྀ། ལྀ་ལཱྀ། ཨེ་ཨཻ། ཨོ་ཨཽ། ཨཾ་ཨཿ ཀ་ཁ་ག་གྷ་ང་།

ཙ་ཚ་ཛ་ཛྷ་ཉ། ཊ་ཋ་ཌ་ཌྷ་ཎ། ཏ་ཐ་ད་དྷ་ན། པ་ཕ་བ་བྷ་མ། ཡ་ར་ལ་ཝ། ཤ་ཥ་ས་ཧ་ཀྵ།

Under HŪṂ write:

ཨོཾ་བཛྲ་ཛྙཱ་ན་སྭཱ་ཧཱ།

Then under this mantra write the mantra of the main deity. For example, if it is Buddha Shakyamuni, you can write the *hundred syllables of the tathagatas* or the shorter *essential mantra of the tathagatas*. After the SVĀ put the mantra of interdependent causation:

ཨྱེ་དྷརྨྨཱ་ཧེ་ཏུ་པྲ་བྷ་ཝཱཿ ཧེ་ཏུནྟེ་ཥཱནྟ་ཐཱ་ག་ཏོ་ཧྱ་ཝ་དཏ། ཏེ་ཥཱཉྩ་ཡོ་ནི་རོ་དྷ། ཨེ་ཝཾ་བཱ་དཱི་མ་ཧཱ་ཤྲ་མ་ཎཿ་སྭཱ་ཧཱ།

After the HĀ write:

སུ་པྲ་ཏིཥྛ་བཛྲ་ཡེ་སྭཱ་ཧཱ།

As with the mantras for statues, the tsek is not generally used, but Kyapje Trulshik Rinpoche said that for a tangka you can write the tsek. It is not necessary to include mantras for the retinue deities, as this would make the back of the tangka untidy, so OM ĀḤ HŪM SVĀHĀ is usually written for them. For a more elaborate representation of the retinue, the large letter script from the *Sangye Rapdun Sojong* can be written beneath the other mantras (see appendix 6 for the Tibetan script). These letters should be in gold, silver, or red pigment mixed with mendrup or the blood of a high lama, such as from their nosebleed.

II. Consecrating the Artwork

THE CONSECRATION (*rapne; pratishta*) is the ceremony and dedication performed when an artwork is complete, giving it a final blessing and seal.

The Sanskrit word *pratistha* means "well established" or "to thoroughly abide." It is through the consecration ceremony that the support (the sacred image or art) and the supported (the invoked wisdom being) are made indivisible and, as such, "thoroughly abide" together, transforming the nature of the image into a fully blessed sacred art object or nirmanakaya emanation.

The dharmakaya is free from all fabrication; there is no wisdom buddha apart from this. Although there is no truly existent wisdom being that is invited from another place to come and dwell in the image, with the understanding that everything is illusory and empty, one performs the consecration to sanctify the artwork, rendering it an appropriate recipient of offerings and increasing the merit and welfare of the faithful and the world at large. This is how the practice of consecration is to be understood.

The *Condensed Consecration Tantra* says:

> Regardless of consecration, Buddha abides everywhere and is ever enduring, like the sky; nevertheless, the practice of consecration was taught as a convention.[2]

If a supreme artwork is completed and then left for a long time without being blessed, it is impossible for auspiciousness and virtue to arise. Offerings should not be made to such an object.

The consecration ceremonies should be conducted only by following the appropriate sadhanas. Performing the consecration ceremony is a practice that fulfills the two accumulations. Although the Vinaya teachings do not specifically mention the consecration ceremony, the same principle is

followed in that the sacred objects such as the wooden gong, the monk's robes, and so on are blessed, which is like a consecration. Before the consecration is performed, to protect the tangka or statue from being inhabited by spirits, the artwork should always be left with the art tools, which are visualized as weapons. A consecration ceremony should be conducted by, first, a fully ordained monk or, second, a novice monk or, third, a lay practitioner who has taken one-day vows. Ideally, the consecration ceremony is conducted by an authentic guru. However, if none of these is possible, then doing at least the brief consecration is better than leaving the object without any ceremony having been performed. However, if it is done by someone whose mind is not pure, the work is not properly blessed.

Blessing the artwork with the consecration sadhana, whether long or short, will imbue it with the power to benefit those who come within its sphere. Although the art object does not have a mind as such, through the consecration it is imbued with the enlightened nature, and so it has the ability to bestow blessings on sentient beings, in the same way that the statues at Lhasa Samye temple do. The supreme art objects representing the body, speech, and mind of the buddhas all have this extraordinary ability to benefit. The form and wisdom are completely unified through this ceremony. Therefore, wherever the objects are placed, the surrounding environment will receive the blessings of the buddhas and bodhisattvas and will also be protected from obstacles and negativity.

III. The General Benefits of the Supreme Arts

THE BENEFITS GAINED from studying, practicing, and patronizing the supreme arts are related here. To engage in art practice while applying the three noble principles of generating bodhichitta at the beginning, engaging in the main practice of visualization in the middle, and dedicating the merit at the end, together with the consecration of the art object, is said to create immeasurable benefit for the artist and the surrounding environment. This is discussed in great detail in the Buddhist teachings and commentaries.

The *Chakrasamvara Tantra* says that Vajrayana practitioners who meditate on an image they have painted themselves will achieve much greater accomplishment. The *Root Tantra of Manjushri* says that there are three levels of benefit: great, middling, and lesser. The great benefit was spoken of by Buddha Shakyamuni when he said that an intelligent person who makes an image of Buddha's body will accrue such great benefit that it will purify the negativity he has accumulated for innumerable aeons. The power of the image is such that whoever views this image with faith and devotion will easily purify his negativity. Conversely, someone who views this image without faith may increase his negative karma, so it must be kept where skeptics will not see it. If, with a mind of devotion, someone prostrates to an image of the Buddha with her body and recites mantras with her speech, it has immeasurable benefit, and if she does so with one-pointed concentration, she will easily achieve her aims. The benefit of executing one drawing of Buddha's body is greater than making offerings to the Buddha for many immeasurable aeons. This is the great benefit.

The teachings on the middling benefit say that whoever makes a supreme image will be free from sickness, the poor will become wealthy, a barren woman will conceive, and whoever merely sees this image will accumulate

immense merit. This person will be reborn in the higher realms of gods and humans and is guaranteed to quickly achieve enlightenment in future lives. Whoever reads Buddhist scriptures, writes commentaries, uses dharma texts as an object of veneration while making prostrations to them, or even merely sees or touches a tangka or dharma text will purify his obscurations by doing so. The representations of enlightenment—supreme art objects— have the power to bestow blessings on the patron, the artist, and anyone who simply rejoices in this artwork. It has the same benefit as actually seeing the Buddha for one hundred million aeons; whoever sees a supreme image will also achieve enlightenment. The lesser benefit related to the supreme artwork is that the artist or patron will accumulate the same merit as by making offerings to the Buddha.

The benefit of creating an image of the Buddha, whether using paint, clay, sand, wood, stone, brass, iron, gold, silver, sapphire, glass, or pearl, or even just repairing an image of the Buddha, is that the person doing so will not be reborn into an unfortunate lineage, engage in negative deeds, hold wrong views, or have a crippled body, and so on. Even the negative karma accrued from having committed the five crimes with immediate retribution[3] can be purified through the act of creating a supreme representation with great devotion. Even someone with extremely negative karma can purify her karma without having to experience much suffering and will be able to traverse the three vehicles and easily attain enlightenment.

Just as anyone who accidentally touches excrement will wash it off immediately, the artist also purifies the five crimes with immediate retribution by creating supreme representations. Someone who has committed one of the ten negative actions of body, speech, and mind but subsequently makes supreme representations with sincere devotion—whether statues, paintings or other forms—can easily purify her negative karma in the same way that butter is easily melted by flames.

The *Sutra Expressing the Realization of All* recounts one of the previous lives of Buddha Shakyamuni, when he was King Murdhabhisikta, who had great devotion to the buddha of the time, called Purna (Gangpo). Out of his sincere devotion, the king made many offerings to the buddha. When the buddha passed into parinirvana, the king commissioned a great number of buddha statues made from precious jewels and invited many beings to celebrate when they were completed. Through his act of devotion, countless sentient beings were also inspired to faith when seeing these statues and were thus able to progress to enlightenment.

In the *Sutra Requested by the Girl Rinchen,* Buddha explained to the girl Rinchen how he achieved the thirty-two major and eighty minor marks, saying: "A buddha has these signs because he made and repaired statues and stupas in his previous lives along with giving refuge to people who were afraid and reconciling people who were in dispute. Girl, because the Buddha did these things in his previous lives, he has the thirty-two major and eighty minor marks."

In the *Sutra Analyzing Action,* Buddha told Dramse Kyiu Netso that whoever builds a stupa will receive the eighteen benefits: (1) They will be born into a noble family. (2) They will have an attractive form. (3) Their body will be unblemished. (4) They will be intelligent. (5) They will have many disciples and retinues. (6) They will become the refuge of all beings. (7) They will be famous. (8) Their speech will be powerful. (9) They will be great. (10) They will attract offerings. (11) They will be wealthy. (12) They will abide in the palace of a chakravartin. (13) They will enjoy a long life. (14) They will attain the vajra body. (15) The gods will make offerings to them. (16) They will attain the thirty-two and eighty marks of a buddha. (17) They will always be born in the higher realms. (18) They will easily achieve enlightenment.

The *White Lotus Sutra* says that whoever builds a stupa to contain the Buddha's relics, whether of rock, precious stone, wood, or clay, with great concentration and diligence, or even merely makes a stupa from clay or dirt while playing, will easily attain enlightenment through this merit. Whoever cleans a temple, stupa, or statue and makes offerings with great respect will always have an attractive, fragrant body in future lives and always enjoy good influence. Whoever paints, builds, or repairs a temple, a stupa, and so on, will be born in the realms of gods or humans and enjoy a life of beauty and goodness. Whoever paints a statue or stupa with care can easily attain buddhahood. Whoever offers ornaments to statues and stupas will attain the seven precious substances and the seven branches of enlightenment.

When speaking about the benefit, the texts usually refer to either statues or stupas, but this also applies to paintings or any other sacred art form. The *Sutra That Teaches Miraculous Manipulation* says that whoever has made or offered a stupa, painting, or drawing of the Buddha's body will attain buddhahood easily. The *White Lotus of the Holy Doctrine* by King Songtsen Gampo says that if someone merely offers one beat of a drum or one flower to the Buddha's sacred relics, a statue, or stupa, or even if he repairs a broken statue when he is angry, he will meet with many buddhas in the future. Also,

whoever makes one prostration with pure devotion, or touches her head to a statue or stupa, or makes one circumambulation of a statue or temple can easily attain enlightenment. The *Sutra of the Ten Wheels Requested by Kshitigarbha* says that in samsara whatever pleasures and comforts people enjoy all come as a result of their making offerings to the Three Jewels, so if people want these things, they should make offerings to the Buddha, Dharma, and Sangha. Buddha said that suitable offerings are flowers, garments, melodious music, incense, a parasol, and so on, as outlined previously.

In a sutra Buddha told a great rishi, "It makes no difference if an offering is made to a buddha of the past, present, or future; to an image of Buddha; or to a stupa, scripture, or relic. If you wonder why, it is because the forms of awakening originate from the dharmakaya, and not the other way around. Therefore, offerings made to Buddha, or to his relics or image, are considered equal."

If one respectfully makes offerings to the buddhas and bodhisattvas, whether past or present, the merit of this act is exactly the same. Also, writing or listening to teachings, composing prayers, and engaging in meditation all accumulate great merit.

Anyone who makes, repairs, or cleans a statue, sacred text, stupa, or temple, or cleans the kitchen of a temple, or merely has the wish to do so and begins to walk seven steps toward that task, will always be reborn in the higher realms. Even one who is merely touched by the smoke of a fire used to cook food for buddhas will be reborn in the celestial realms. If someone walks in the direction of a virtuous task and accidentally kills an animal underfoot, the animal will also be reborn in the higher realms. Therefore, the best way to engage in something meritorious is to make a representation of the Buddha's supreme body.

The *Sutra of Entry into the Great Array* says that when we make a supreme image in material form, this will purify our negative karma and become a cause for enlightenment. Depicting our guru's image will surpass the merit of fashioning many images of the Buddha in gold, silver, or other precious material. In the same way, because of the importance of the guru, to make a single offering to our guru or to recite one verse of praise to our guru, is the same as or superior to making ten million offerings and praises to Vajradhara and Buddha Shakyamuni. To make continuous offerings, praises, and supplications to our guru's body is better than reading sutras.

The *Supreme Blazing Vajra Mind* says that those who wish to practice properly should take a small piece of their guru's cloth, hair, or nails and

keep it as an object of veneration, whereby they will easily realize buddha-hood and attain the two siddhis.

We need to consider our guru as the main deity because, having come in person to benefit us, the guru is the kindest of all teachers. There are many other sayings like this. Those who consider their guru as a fully enlightened buddha can receive benefits in the ways that have been related here. Having a strong feeling of devotion for the guru and remembering the guru during all activities is the indispensable, supreme practice.

IV. Dedicating the Merit

DEDICATING WHATEVER virtuous actions we have engaged in toward complete enlightenment is a crucial aspect of the Buddhist path. Whether the act is drawing, or making a statue of, a buddha or bodhisattva, or whether it is writing a book on the dharma teachings, building a stupa, or teaching the dharma, it is crucial to dedicate to enlightenment the merit accumulated through your body, speech, and mind. Through dedication the merit will never be exhausted, which is why this practice is so important.

A. General Advice

It is the dedication prayer that determines whether or not virtuous activity will propel you to enlightenment. If you have gold and make an ornament for the buddhas and bodhisattvas out of it, then it is being used for a good purpose. Otherwise the gold is nothing special. In the same way, dedication prayers transform all our good actions. Dedicating activity to enlightenment is particular to the Buddhist tradition; other religions do not place such importance on it. The *Praise of the Buddha* says that the practice of dedicating our virtue for the enlightenment of all sentient beings is found only in the Buddhist tradition.

It is important to dedicate all merit, whether great or small, from the past, present, and future, at the end of any virtuous activity. In the beginning, generate bodhichitta for the sake of all sentient beings. During the main practice, meditate on emptiness. At the end, dedicate the merit. These three noble principles are vital to our practice. If you apply them to your actions, then whatever virtue you have dedicated will never be exhausted and you will be able to reap the benefits of this positive karma many times, until enlightenment is achieved. Therefore the dedication is indispensable. The *Sutra Requested by Sagaramati* says:

> Just as a drop of water that falls into the ocean
> Will never disappear until the ocean runs dry,
> Merit totally dedicated to enlightenment
> Will never disappear until enlightenment is reached.[4]

Any source of merit not dedicated in this way will bear fruit only once and will then slowly be exhausted. In the *Way of the Bodhisattva*, Shantideva says:

> Good works gathered in a thousand ages,
> Such as deeds of generosity,
> Or offerings to the Blissful Ones—
> A single flash of anger shatters them.[5]

In this way, any merit can be lost through a single flash of anger if it has not been dedicated. The *Sutra Requested by Litsavi* says that even a great act of virtue will be made small if it is not dedicated to enlightenment. Therefore, you always need to imbue your practice with these three noble principles: beginning by generating bodhichitta, meditating on emptiness in the middle, and dedicating the virtue at the end. Without these three, your virtue will not bring liberation.

B. Specific Advice
1. The merit to be dedicated

Any act of virtue that has not been stained by the three poisons must be dedicated toward enlightenment. Virtue, or merit, has three main categories: (1) the merit of generosity, (2) the merit of discipline, and (3) the merit of meditation. The making of Buddhist art includes all three in the following ways: First, the merit of generosity is practiced through the diligent effort and concentration employed in the creation of supreme images, whether they are made from gold and precious substances or from low-quality materials. The merit of discipline is practiced by following the proper rules of deity measurement, along with the general guidelines and precepts of supreme art, while observing vows such as the novice or bhikshu vows, the bodhisattva vow, and the Vajrayana vows. The merit of meditation is practiced by engaging in the outer practice of generating bodhichitta and the inner practices of sadhana and meditation on a daily basis. When the artist draws an image of the Buddha, a detailed understanding of his shape and attributes is developed—this is the same as training in the development

stage. When joined with the understanding that the deity's supreme form is not solid but is the union of emptiness and compassion, this is the same as the completion stage. Therefore, when you practice art properly in this way, you combine the development and completion stages of meditation, just as in your sadhana practice. When you consider all this, how could you not dedicate your art activity toward supreme enlightenment?

The merit of generosity includes the giving of material offerings, the giving of teachings and explanations on the dharma, and the giving of love and compassion. To be properly called generosity, something should be given in the following four ways: (1) at the time it is requested, (2) without regret, (3) politely and respectfully, and (4) without hope of reward. Conclude by dedicating the virtue. Whatever act of virtue you have carried out, whether great or small, should always be dedicated for the purpose of enlightenment. Any act of generosity performed in accord with these four points will include all generosities. Even if you wish only for rebirth in the higher realms, as either a god or a human, it is important to dedicate your virtue to this end.

Drigung Kyopa Rinpoche said:

> Unless, by making wishing prayers,
> You rub the wish-granting gem of the two accumulations,
> The result you wish for will never appear,
> So do the concluding dedication wholeheartedly.[6]

The power of dedication is what determines whether or not positive actions lead to complete enlightenment. The conditioned positive actions you accumulate, immense though they may be, cannot lead to liberation unless you direct them by dedicating them to that purpose. Geshe Khampa Lungpa says:

> No conditioned good actions have a direction of their own,
> So make vast prayers of aspiration for the benefit of beings.[7]

It is said that any positive activity you might undertake on behalf of your father, mother, or loved ones, or for the dead, must be dedicated in their name, otherwise it will not achieve its aim. If you dedicate it to them and all sentient beings, they will benefit accordingly.

The following story, as told by Patrul Rinpoche in *The Words of My Perfect Teacher,* also shows the importance of dedicating the merit:

Once the inhabitants of Vaishali came to invite the Buddha to a meal on the following day. After they had left, five hundred pretas arrived and requested him, "Please dedicate to us the merit of the alms that the people of Vaishali are going to offer to you and your followers tomorrow."

"Who are you?" the Buddha asked, although he already knew the answer. "Why should the sources of merit of the people of Vaishali be dedicated to you?"

"We are their parents," the pretas replied. "We were reborn as pretas as the effect of our miserly behaviour."

"In that case," said the Buddha, "come along at the time of the dedication and I shall do as you ask."

"That is impossible," they replied, "we are too ashamed of our ugly bodies."

"You should have been ashamed when you were doing all those wrong deeds," the Lord replied. "What sense does it make to have felt no shame then but to feel ashamed now, when you have already taken rebirth in this miserable form? If you do not come I shall not be able to dedicate the merit to you."

"In that case we shall come," they said, and departed.

The following day, when the moment arrived, the pretas came to receive the dedication. The inhabitants of Vaishali were horrified and started to run away.

"There is no reason to be afraid," the Buddha reassured them. "These are your parents who have been reborn as pretas, they told me so themselves. Should I dedicate your sources of merit to them or not?"

"You certainly should!" they cried.

The Buddha said:

May all the merit of this offering
Go to these pretas.
May they be rid of their ugly bodies
And obtain the happiness of the higher worlds!

No sooner had he spoken than all the pretas died. The Buddha explained that they had been reborn in the Heaven of the Thirty-Three.[8]

When we dedicate in this way, it will also have the corresponding effect. The *Great Compendium Sutra* says that in the ten directions of the three-thousandfold universe, all the buddhas of the past, present, and future, as well as the bodhisattvas, shravakas, pratyekabuddhas, gods, and humans, all need to dedicate both their pure and impure virtue for the enlightenment of all sentient beings in the same way.

The merit you accumulate should not be dedicated toward worldly aims such as achieving rebirth in the realms of the gods or for other temporary gain, as this will not take you out of the cycle of samsara. Also, the Prajnaparamita states that you should not dedicate your merit toward achieving the lesser enlightenment of an arhat or that of the shravakas and pratyekabuddhas, but only to complete enlightenment.

2. How to dedicate
There are two parts: what to abandon and what to adopt.

a. What to abandon
For any dedication of merit to lead to perfect enlightenment, it must be free from concepts of the three spheres of activity. The *Transcendent Wisdom Sutra in 8,000 Verses* says:

> The Conqueror has said that to do good with concepts
> Is like eating wholesome food mixed with poison.[9]

What does it mean to have concepts of the three spheres? In this context, it means to have a concept of a source of merit to dedicate, someone for whom it is dedicated, and a goal toward which the dedication is directed. Maitreya Buddha said that when we dedicate the merit with these concepts, it is part of our cognitive obscurations.

b. What to adopt
We need to adopt activity that utilizes both skillful means, which is bodhichitta, and wisdom, which is the understanding of emptiness. The proper attitude to have when dedicating the merit is to look on all sentient beings with compassion, while realizing that everything is empty. In this context, the practice of skillful means is to dedicate by saying, "I dedicate all my virtue for the sake of all sentient beings, as many as fill the sky, not just for their worldly benefit but for the purpose of complete enlightenment."

Shantideva said:

> Whatever virtue I have done,
> Or have requested others to do,
> For the sake of sentient beings—not for other aims,
> All this we dedicate toward enlightenment.

If you dedicate your merit toward the enlightenment of all sentient beings in this way, the benefit is supreme. Whoever wishes to follow the bodhisattva's training needs to dedicate all their virtue, otherwise it is wasted, like a fruit tree that bears fruit only once. As it is said in the *Way of the Bodhisattva*:

> All other virtues, like the plantain tree,
> Produce their fruit, but then their force is spent.
> Alone the marvelous tree of bodhichitta
> Will bear its fruit and grow unceasingly.[10]

In his *Jewel Garland,* Nagarjuna says that just as sentient beings are too numerous to count, our dedication likewise must be immeasurably vast.

To summarize, one's dedication of virtue is aimed toward the enlightenment of all sentient beings, viewed as having the nature of emptiness.

C. The Author's Dedication

I have been speaking on many subjects from beginning to end, so as the author of this book I also need to dedicate this merit. Therefore, in recognition of cause and effect, I will write a few words of dedication. It is important to always follow the laws of cause and effect and dedicate in this way, so that whatever virtue we have accumulated is witnessed by the buddhas and bodhisattvas of the ten directions, who can clearly perceive the three times. Therefore, with the buddhas and bodhisattvas as my witness, all the virtue that I have accumulated through preparing this book I now dedicate toward the enlightenment of all sentient beings.

All those on the Buddhist path must dedicate in the same way. There are two points, which are to dedicate (1) for the benefit of all sentient beings and (2) to attain complete enlightenment. The *Subsequent Tantra: The Continuous Cycle of the Four Activities* says that in this decadent age, Marichi[11] is the supreme female deity and Manjushri is supreme among the male bodhisattvas. In this age they are unequaled in terms of power and activ-

ity. Bodhisattva Manjushri presented the Mahayana view with unequaled clarity. From among all the great teachers, the supreme teacher is Buddha Shakyamuni and bodhisattva Samantabhadra. We need to try to practice virtue for sentient beings and then dedicate this to enlightenment just like them, so I am also going to dedicate in this way.

Patrul Rinpoche said that dedicating one's merit from within the state of wisdom, fully realizing how false the concepts of the three spheres are, is indeed an uncontaminated dedication prayer. This may not be within the reach of ordinary people at our level. Nevertheless, if we simply think that we are dedicating the merit in the very same way as the buddhas and bodhisattvas of the three times, this will serve as a dedication totally free from the concepts of the three spheres. The *King of Aspiration Prayers: The Prayer for Noble Excellent Conduct* says:

> Emulating the hero Manjushri,
> Samantabhadra, and all those with knowledge,
> I too will fully dedicate
> All these virtuous deeds.[12]

In this way, always be sure to seal your positive actions with a proper dedication, for that is the only infallible method for ensuring that the merit will lead to perfect enlightenment. Some say that a dedication prayer is simply the dedication of the merit of a virtuous deed, and that an aspiration prayer is when there has been no particular act of virtue being dedicated. Actually the difference is that the dedication of merit must be imbued with the wisdom of understanding the emptiness of the three spheres (subject, object, and action). Anything else is simply a prayer of aspiration.

Jamgön Kongtrul Rinpoche said that in this world, the writings of Buddha Shakyamuni are supreme. Even if you do not understand the meaning, merely reading them bestows immeasurable blessings; therefore, you should hold the Buddha's words as dear as your own heart. In the same way, the best dedication prayer is Samantabhadra's *King of Aspirations for Noble Excellent Conduct*. Even though other aspiration prayers are wonderful, if you recite just this prayer it is enough.

In India, the holy land of the Buddha, the greatest Mahayana teachers were known as the Six Ornaments and the Two Wonderful Teachers. In Tibet, the most renowned were Khenchen Bodhisattva (Shantarakshita), Guru Padmasambhava, and King Trisong Deutsen. It is because of the

great kindness of these teachers that we can drink the nectar of the buddha dharma through the three lineages of teachings. I have not listened to many teachings, so I do not have much knowledge, but I have great devotion to the Buddha, because I have received teachings from the mouth of a fully realized guru. I do not have much worldly wealth, but I have compassion for other sentient beings. How such a beggar as I can feel for others in this way is due solely to the fact that I have received teachings on the doctrine of the Buddha. It is very difficult to meet the radiant teachings of the Buddhist doctrine and to receive the four empowerments. It is also difficult to understand the meaning. All of this I have received only through the kindness of my guru, who remains always on the crown of my head, the only embodiment of all the buddhas. As a supplication to my guru, I have written these words.

My only father, my guru, said to me: "You are making supreme art, which is for the accumulation of merit. To achieve wisdom you need to learn the development stage and imbue your practice with the three noble principles. In this way, skillful means and wisdom are unified, and the fruit of the dharmakaya will be attained easily, without hardship."

Guided by his words of precious advice, I have written this book to show this unmistaken path. My wish is that whoever combines the advice in this book with their supreme art practice will be benefited and attain the four kayas. Whatever virtue I have accumulated, I now dedicate before the buddhas and bodhisattvas, without any concept of the three spheres, so that all those who have a connection with me, along with all sentient beings, may reach the buddha realm of my guru. In the same way, I have written this book to be of some benefit to ordinary people who, like me, are not able to listen to, practice, or understand many dharma teachings. In this day and age, there are many people who claim to be tangka painters. Merely because they do a few deity drawings, they say, "I am a lhadripa." Although they do not know the difference between a deity and a demon, they continuously produce images of peaceful buddhas and wrathful deities; seeing this, I thought that it would be good to write this kind of artist's manual, which includes a brief explanation of basic Buddhist teachings along with deity measurements so that perhaps some people may understand the necessity of learning this.

Even the words of this book have not been eloquently expressed, so there is no need even to mention the rendering of the correct meaning, but even though the writing is poor, I have not written this book for the purpose

of inflating my own name or ego. The one who wrote this is very poor at listening, reflecting, and meditating, so there must be many mistakes in the words and meaning, and learned scholars will not be pleased by this writing. In view of this, I sincerely convey my apologies to the three roots and all the learned ones. I dedicate any virtue that has been accrued through the writing of this book, along with the virtue accumulated by others, to the enlightenment of my parents, who have given me this body, and to those with whom I have a connection, along with all sentient beings.

Although many marvelous new things of this world are constantly appearing in our field of knowledge, I have never seen any of them as being altogether meaningful. This knowledge of supreme art is studied only to aid the practice of the Buddha's doctrine; therefore, to apply the three noble principles to this art is indispensable. In writing this book I have mainly extracted the meaning by referring to the original teachings of the Buddha along with teachings from the realized masters, with my guru as an ornament. These teachings are like gold that I am now sharing with others as fortunate as I. May these teachings illuminate the minds of those who come into contact with them in the same way a blind person is given sight, and may they see the buddha dharma as an open door, enabling them to understand how to begin the path and continue along it until reaching complete liberation.

Although my words are not eloquent, my motivation is pure, as I am only thinking of the benefit of others, so the main meaning contained herein cannot be mistaken. Whoever studies these teachings can certainly achieve liberation. Mentangpa wrote the main point of the measurement; Deumar Geshe wrote about general art; and I, the lowly one, have written about the three noble principles. May the gathering of these three subjects together increase the Buddha's doctrine!

Jamgön Lama Gyurme Tekchok Tenpe Gyaltsen Pal Zangpo, also known as Dilgo Khyentse Rinpoche, whose name is famous throughout the world, is Guru Rinpoche in person and manifested out of kindness to benefit all sentient beings. Out of his kindness he accepted me, the least of all his disciples, the one who was born in Puma Changdang in Tsang, called Konchog Lhadri. I later came to teach at Shechen Monastery's Tsering Art School in Nepal at the order of Kyapje Shechen Tenpe Takpo Rabjam Rinpoche, the main abbot of Shechen Tennyi Dargyeling—an order that could not be refused—and while teaching there I wrote this book.

May the lives of the three, His Holiness Tenzin Gyatso, the fourteenth

Dalai Lama of Tibet; Shechen Tenpe Dakpo Rabjam Rinpoche; and the reincarnation of my guru, Ugyen Tenzin Jigme Lhundrup, along with all who are taking responsibility for the Buddha's doctrine, be long, and may their activity increase. May the countries that hold the Buddha's doctrine, along with all the countries of the world, not be plagued by sickness or war. May peace prevail on earth, and may all that beings need of power, riches, and happiness be found. May Tibet swiftly gain its freedom, and may the merit of others and my own increase. Especially, may the Buddhist doctrine of peace expand in all directions. May all this be so!

Sarva Mangalam!

ILLUSTRATIONS

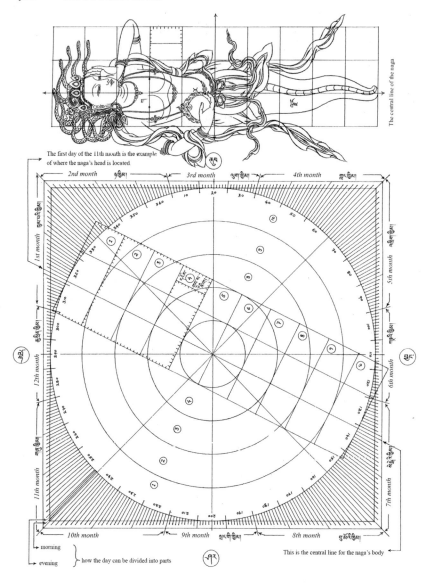

1. Naga king Sadak Toche: measurement

These calculations are done according to the Tibetan calendar. The outermost circle within the square is divided into quadrants of three months each, a total of twelve months, and further divided into 360 days (which is one year in the Tibetan system, each month consisting of 30 days). Each quadrant, also indicating the cardinal directions, is divided into nine chachen, which are further divided into ten chatren each. In this way 90 days are calculated within each quadrant. The measurement for the naga's body is calculated using a different system: it is ten chachen, with each chachen divided into nine chatren.

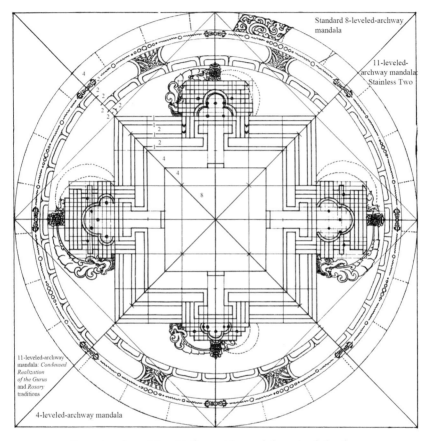

Standard 8-leveled-archway mandala

11-leveled-archway mandala: *Stainless Two*

11-leveled-archway mandala: *Condensed Realization of the Gurus* and *Rosary* traditions

4-leveled-archway mandala

2. Examples of mandalas with four-, eight-, and eleven-leveled archways

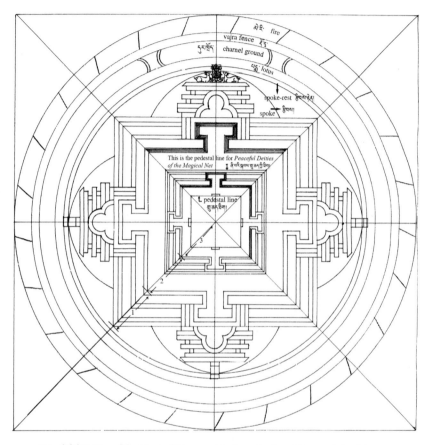

3. *Wrathful Deities of the Magical Net* mandala from Lochen Dharmashri, with some modifications indicated for *Peaceful Deities of the Magical Net*

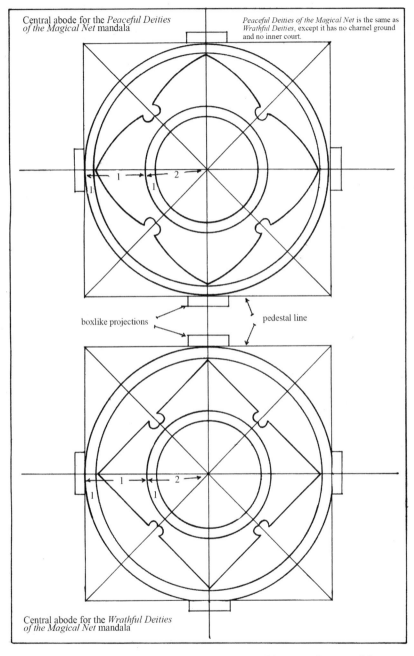

Central abode for the *Peaceful Deities of the Magical Net* mandala

Peaceful Deities of the Magical Net is the same as *Wrathful Deities*, except it has no charnel ground and no inner court.

boxlike projections

pedestal line

Central abode for the *Wrathful Deities of the Magical Net* mandala

4. Central court for *Peaceful and Wrathful Deities of the Magical Net* mandalas

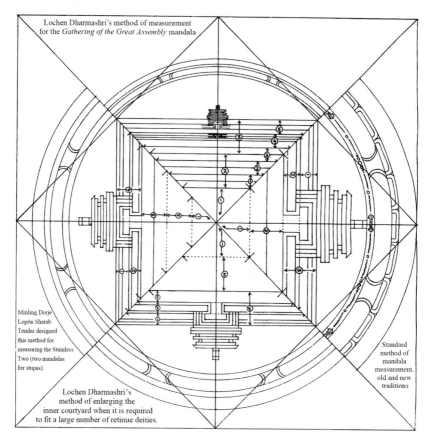

Lochen Dharmashri's method of measurement
for the *Gathering of the Great Assembly* mandala

Minling Dorje
Lopön Sherab
Tendar designed
this method for
measuring the Stainless
Two (two mandalas
for stupas).

Lochen Dharmashri's
method of enlarging the
inner courtyard when it is required
to fit a large number of retinue deities.

Standard
method of
mandala
measurement,
old and new
traditions

5. Examples of four different methods of mandala measurement
The four quarters of this example show various traditions of measuring the main mandala,
from the parapet line to the walls. The pediment levels of the doorways are not significant
here and are interchangeable depending on the mandala being drawn.

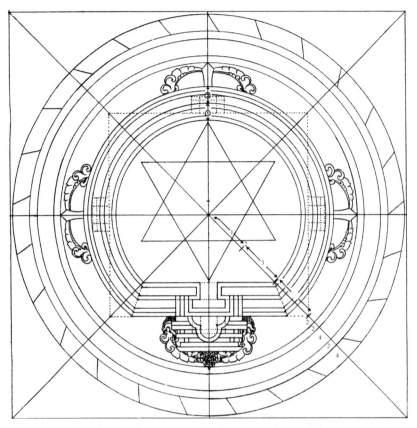

6. The standard measurement for semicircular mandalas

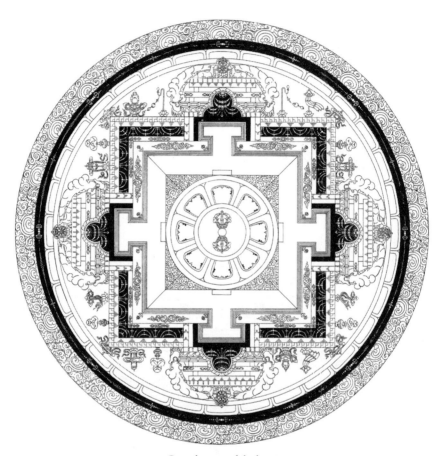

7. Complete mandala drawing

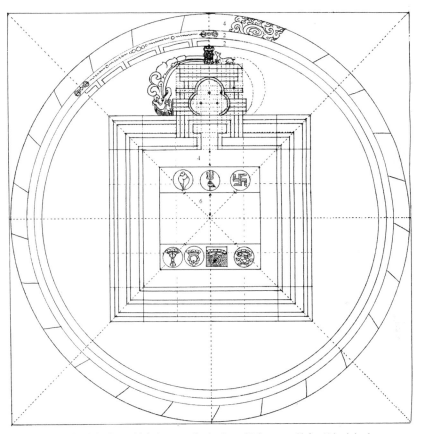

The *Immaculate Ushnisha* mandala is the same as *Spotless Rays of Light,* except with four 11-leveled archways and a different inner court: refer to specifications in text.

8. *Spotless Rays of Light* mandala measurements, with modifications noted for *Immaculate Ushnisha*

These are the two standard mandalas that are inserted into newly constructed stupas, known together as the the Stainless Two. (See part 2, chapter 3, "Mandalas from the Nyingma Kama.")

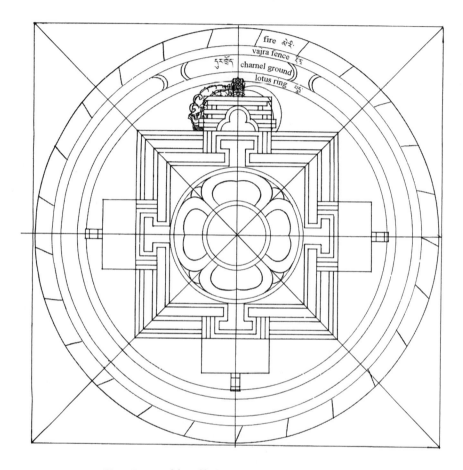

fire ꜱꜱ.
vajra fence ꜱꜱ
ꜱꜱꜱꜱꜱ charnel ground)
lotus ring ꜱꜱ

9. *Heart Essence of the Self-Born Lotus* mandala, a Hayagriva terma
discovered by Kyapje Dilgo Khyentse Rinpoche

Note that *Padmasambhava's Heart Essence of Longevity* mandala is the same as this one,
except the inner sadhana's mandala has a twelve-petaled lotus and no charnel ground. The
mandalas for the outer and secret sadhanas of *Padmasambhava's Heart Essence of Longevity*
have eight-petaled lotuses. (See part 2, chapter 3, "New terma mandalas discovered by Dilgo
Khyentse Rinpoche.")

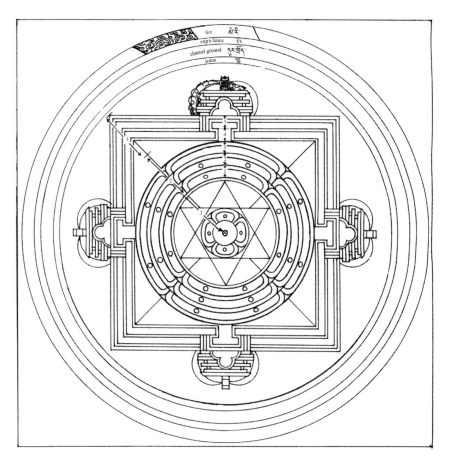

10. *Heart Essence of the Self-Born Lotus: Mother Queen of the Ocean* mandala,
a Yeshe Tsogyal terma discovered by Dilgo Khyentse Rinpoche

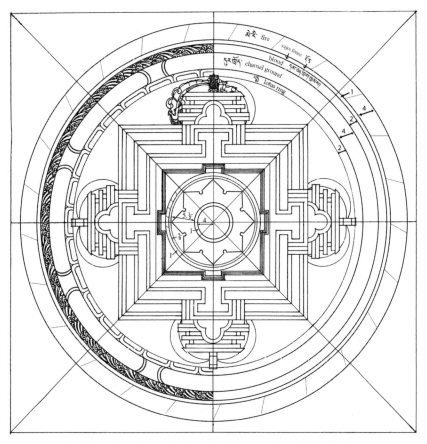

11. *Vajrakilaya According to the Nyak Tradition* mandala, a Vajrakilaya terma rediscovered by Dilgo Khyentse Rinpoche

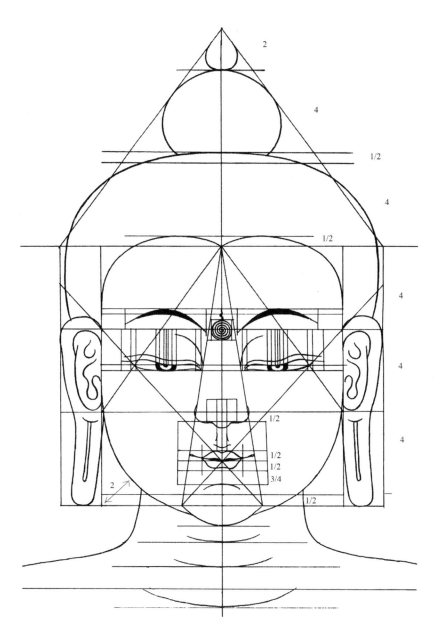

12. Buddha head: measurement

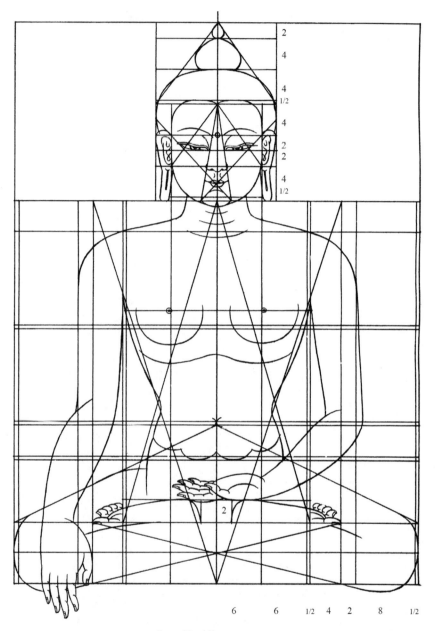

13. Seated buddha: measurement
Most measurement units are given in sor, unless zhal are indicated.

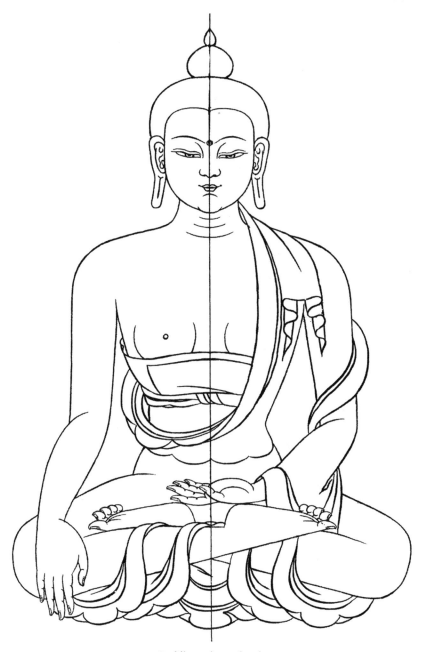

14. Buddha with simple robes

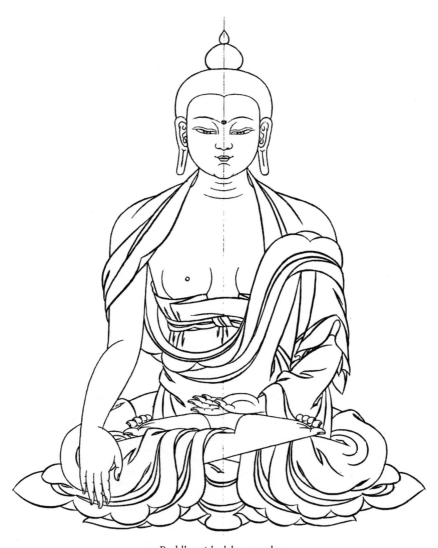

15. Buddha with elaborate robes

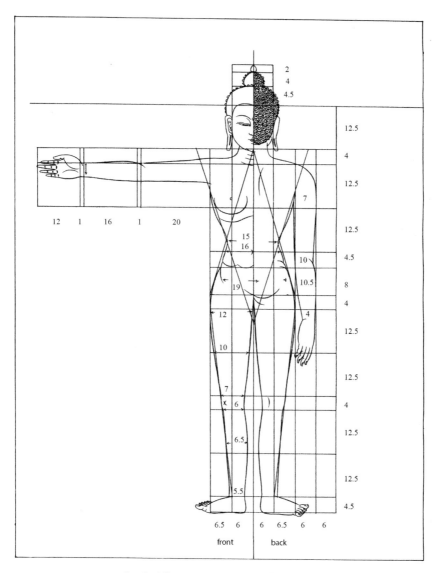

16. Standing buddha: measurement with front and back view

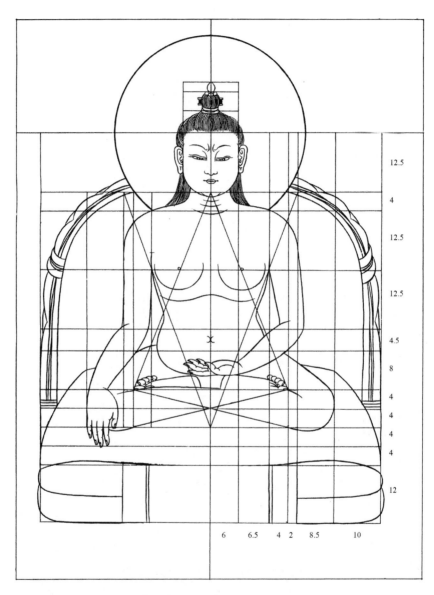

12.5

4

12.5

12.5

4.5

8

4

4

4

4

12

6 6.5 4 2 8.5 10

17. Seated guru on throne: measurement

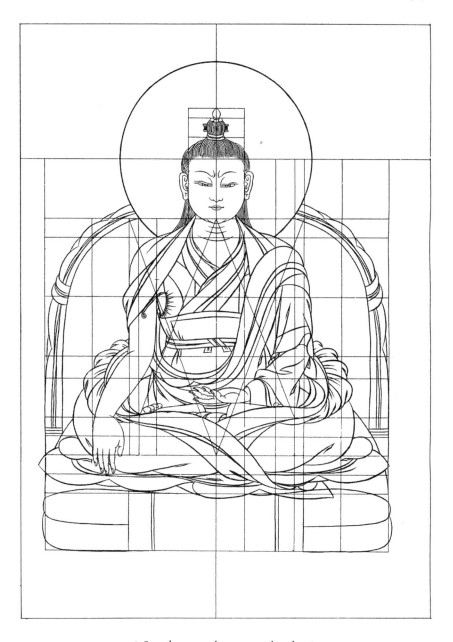

18. Seated guru on throne: complete drawing

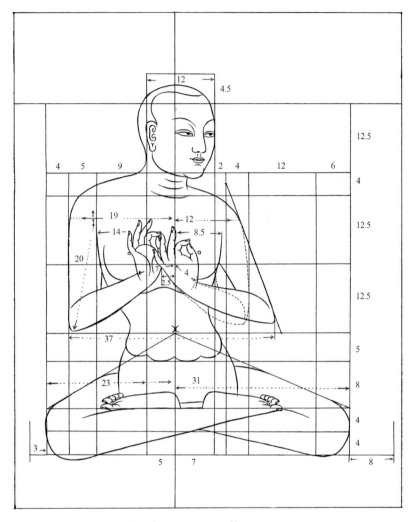

19. Seated guru in semiprofile: measurement

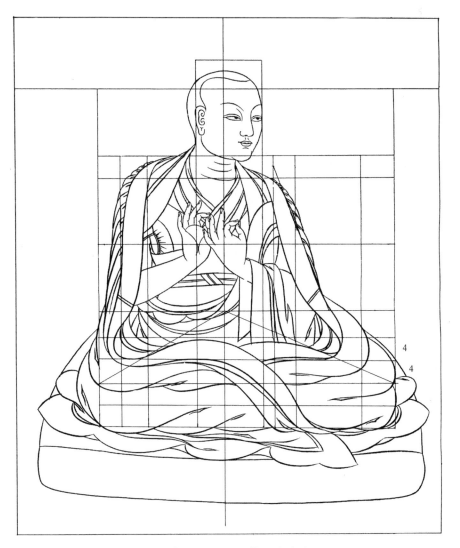

20. Seated guru in semiprofile with cloth

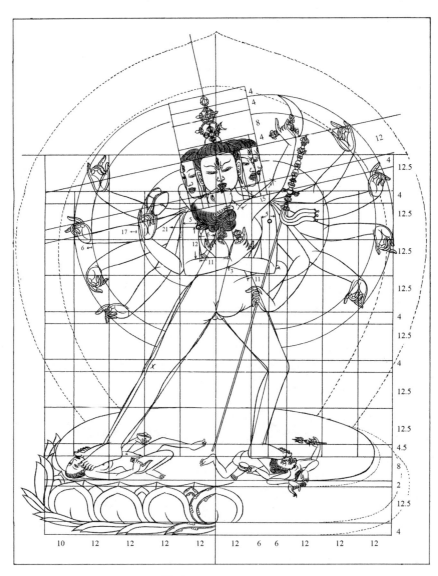

21. Chakrasamvara: measurement

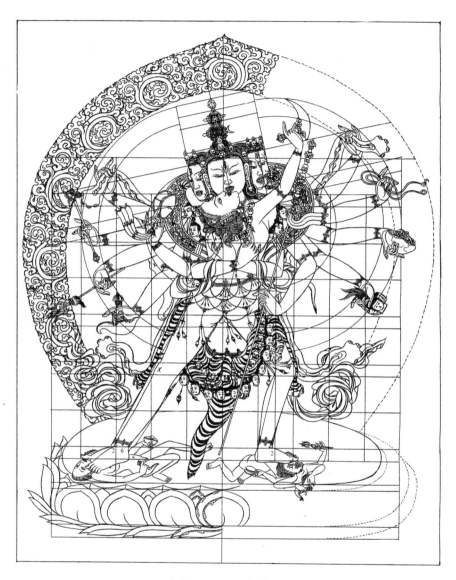

22. Chakrasamvara with adornments

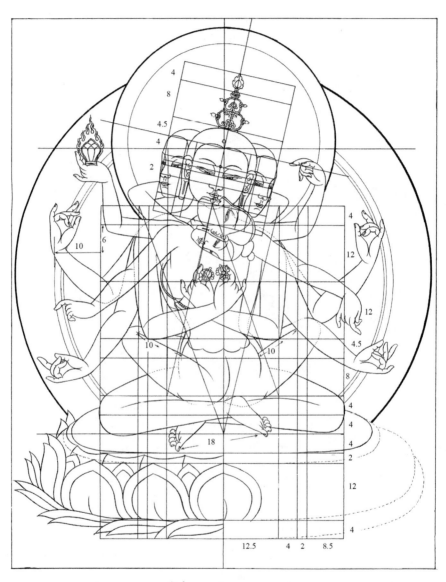

23. Guhyasamaja: measurement

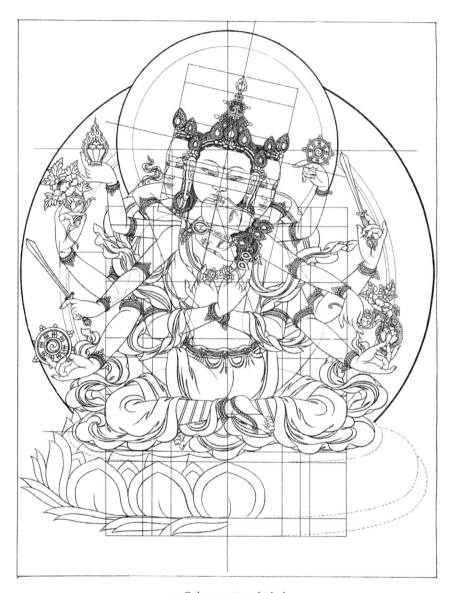

24. Guhyasamaja with cloth

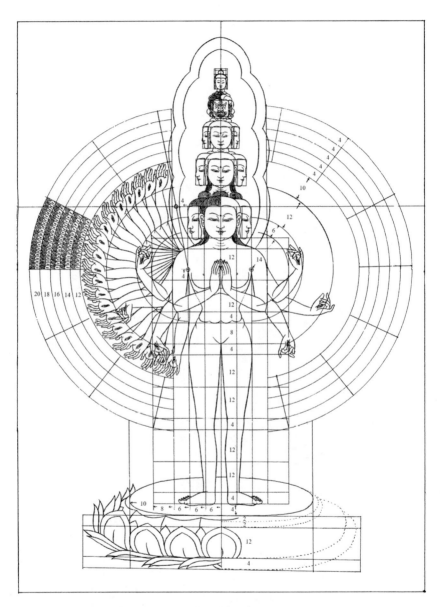

25. Thousand-Armed Avalokiteshvara: measurement

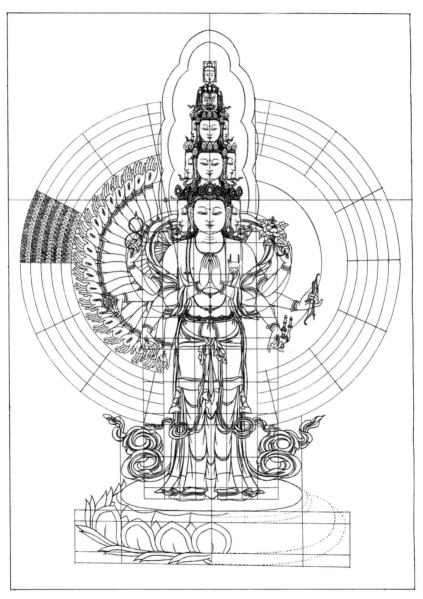

26. Thousand-Armed Avalokiteshvara with cloth and adornments

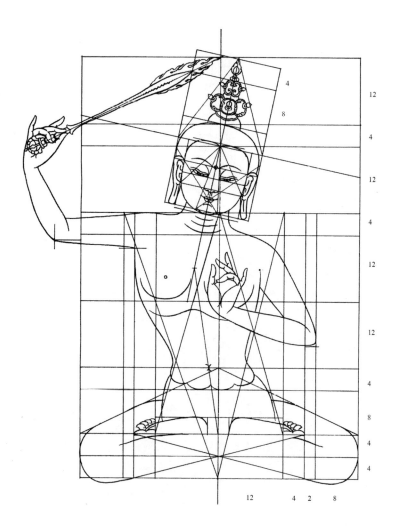

27. Manjushri: measurement

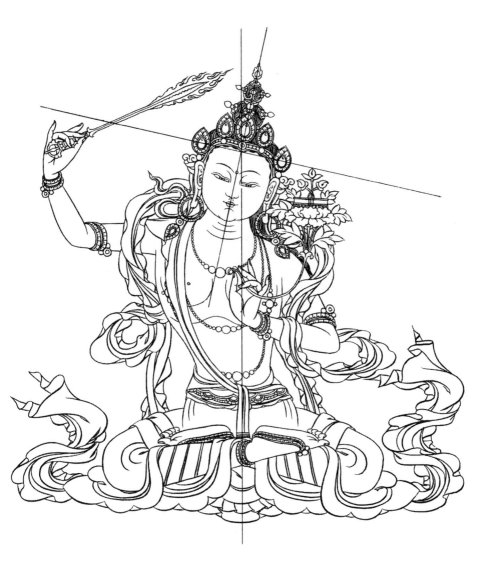

28. Manjushri with adornments

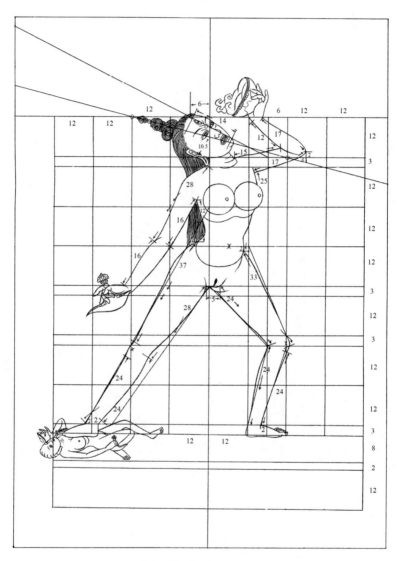

29. Naro Khachö: measurement

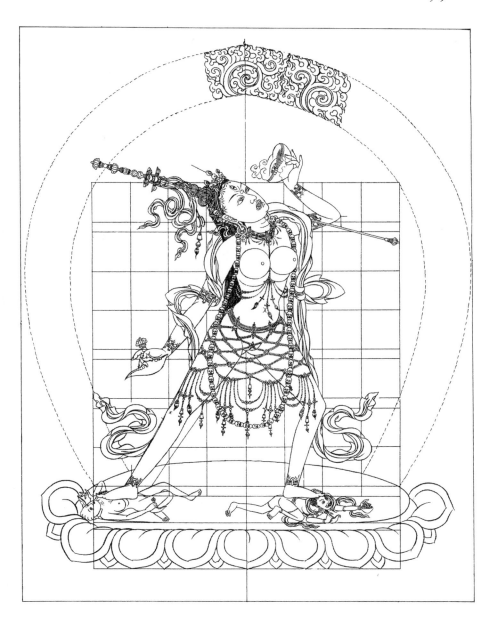

30. Naro Kachö with adornments

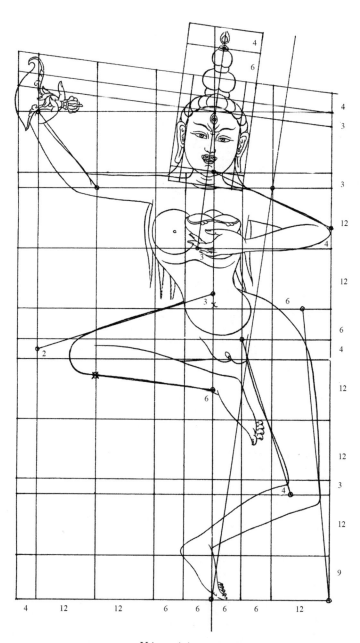

31. Vajrayogini: measurement

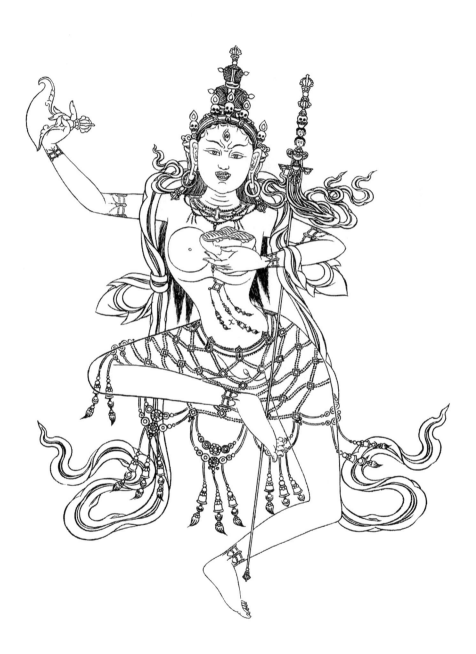

32. Vajrayogini with adornments

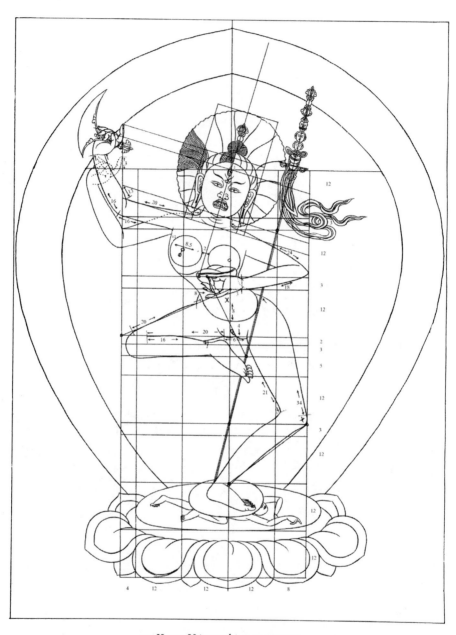

33. Kagyu Vajravarahi: measurement

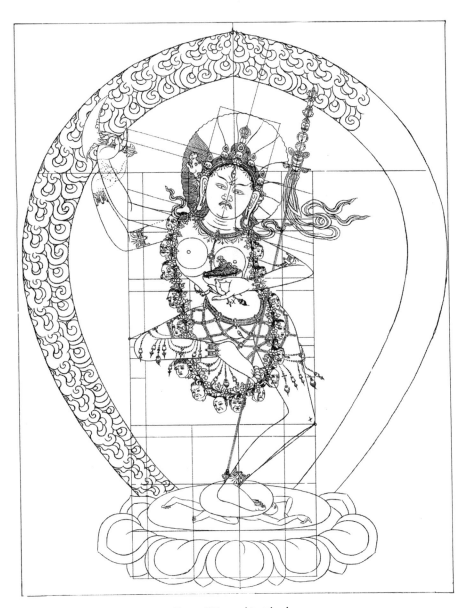

34. Kagyu Vajravarahi with adornments

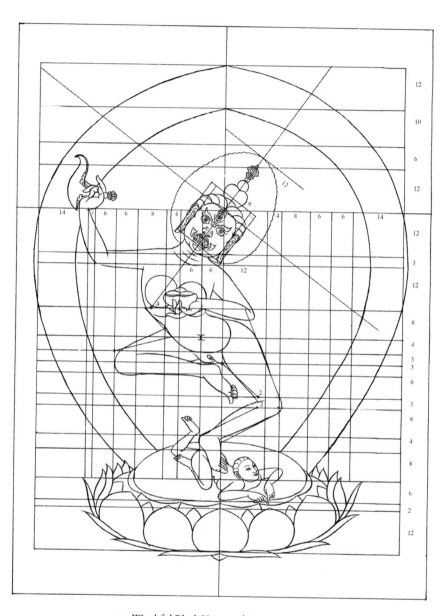

35. Wrathful Black Vajravarahi: measurement

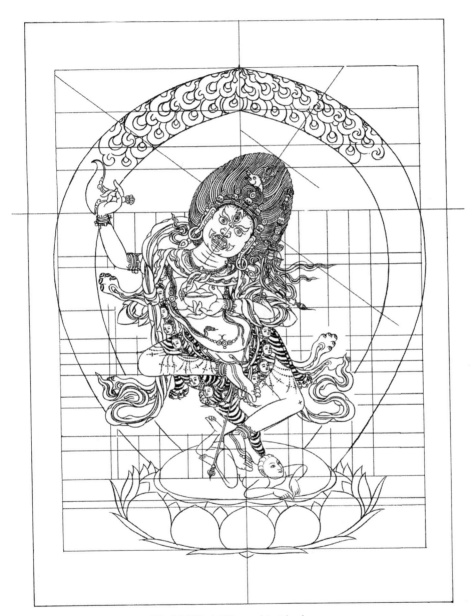

36. Wrathful Black Vajravarahi with adornments

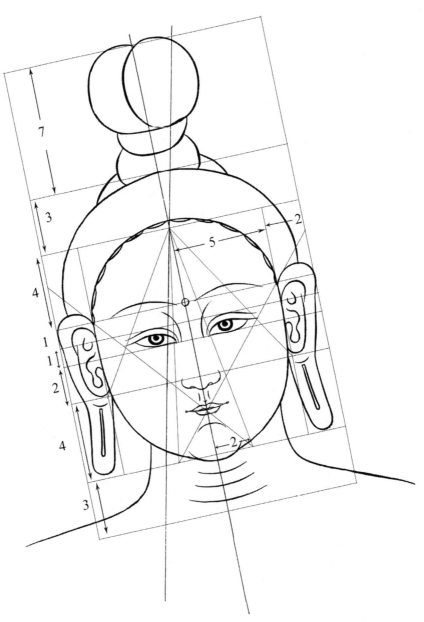

37. Female deity head: measurement

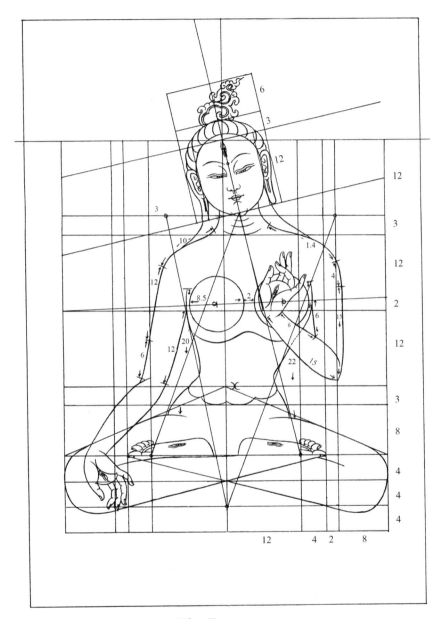

38. White Tara: measurement

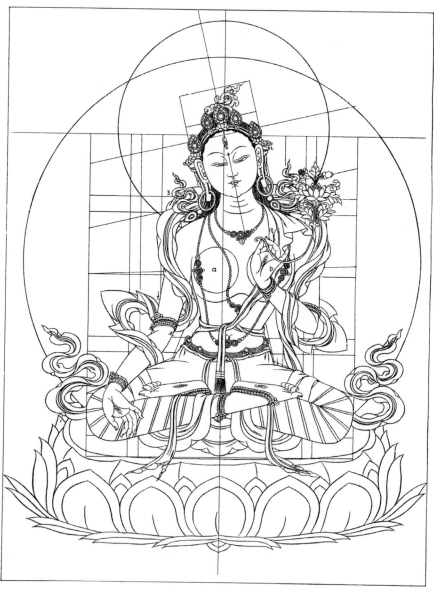

39. White Tara: complete drawing

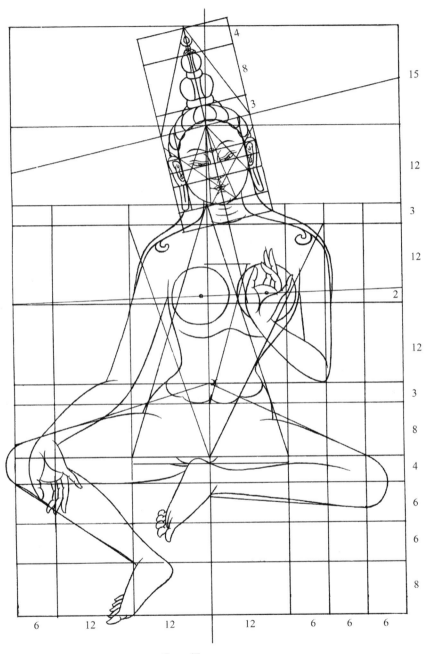

40. Green Tara: measurement

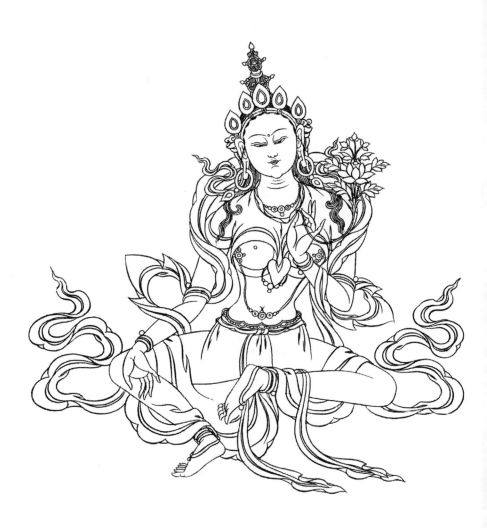

41. Green Tara with adornments

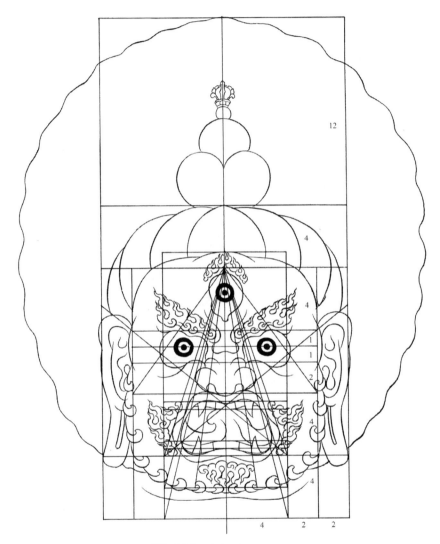

42. Wrathful male head: measurement

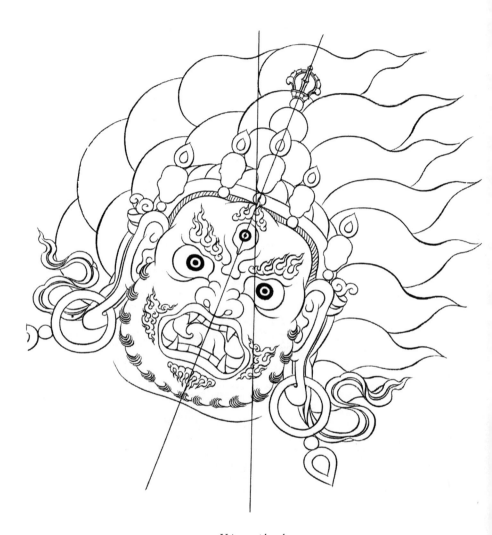

43. Vajrapani head

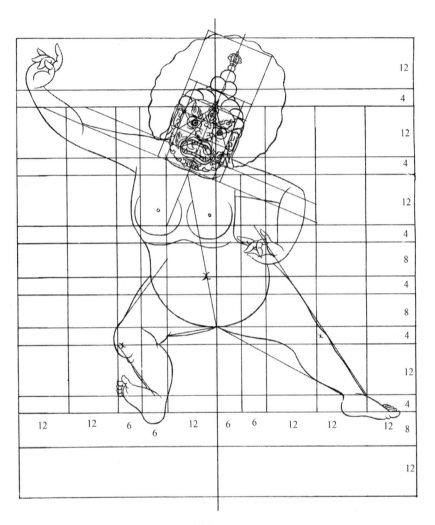

44. Great Wrathful Vajrapani: measurement

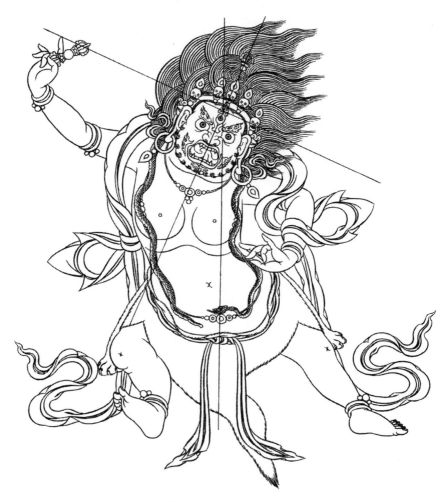

45. Vajrapani with adornments

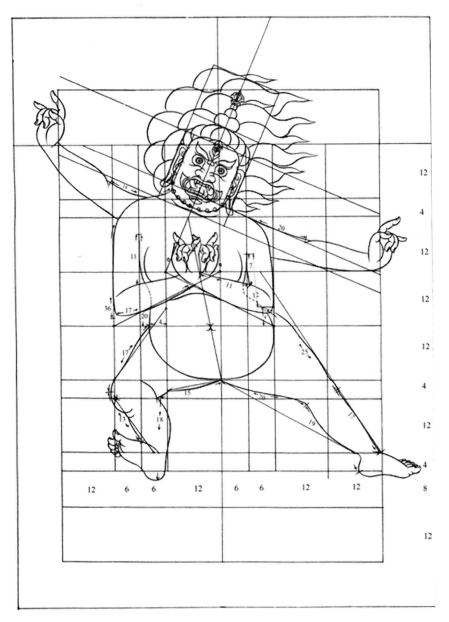

46. Vajrapani the Conqueror: measurement

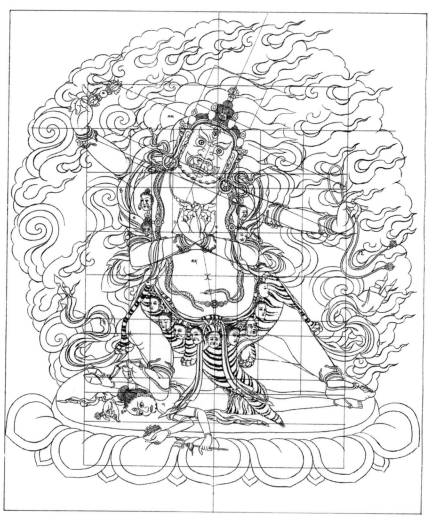

47. Vajrapani the Conqueror with adornments
From the *Hevajra Explanatory Tantra,* sadhana written by Konchog Lhundrup

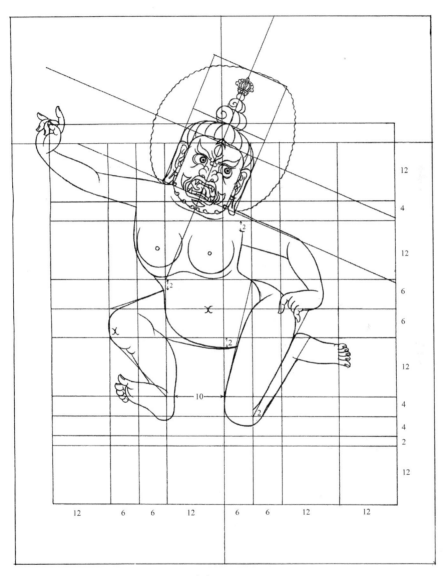

48. Achala: measurement

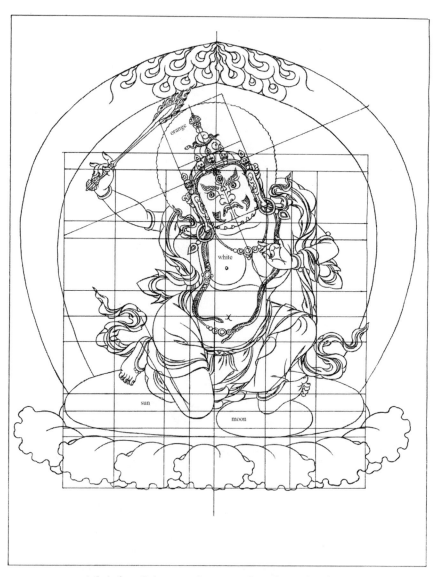

49. Achala from *Relaxing in the Nature of Mind:* complete drawing

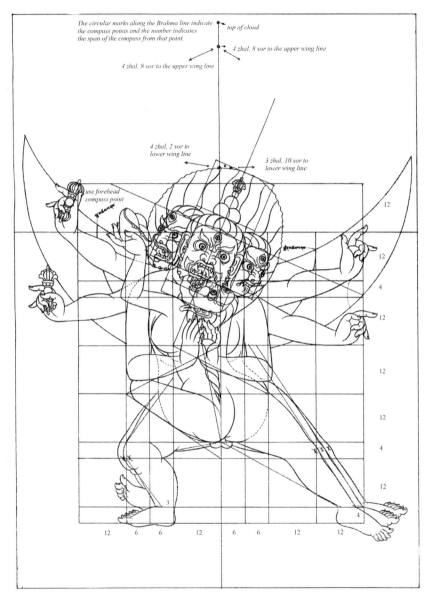

The circular marks along the Brahma line indicate the compass points and the number indicates the span of the compass from that point.

top of cloud

4 zhal, 8 sor to the upper wing line

4 zhal, 8 sor to the upper wing line

4 zhal, 2 sor to lower wing line

3 zhal, 10 sor to lower wing line

use forehead compass point

12

12

4

12

12

12

4

12

3

12 6 6 12 6 6 12 12

4

50. Vajrakilaya: measurement

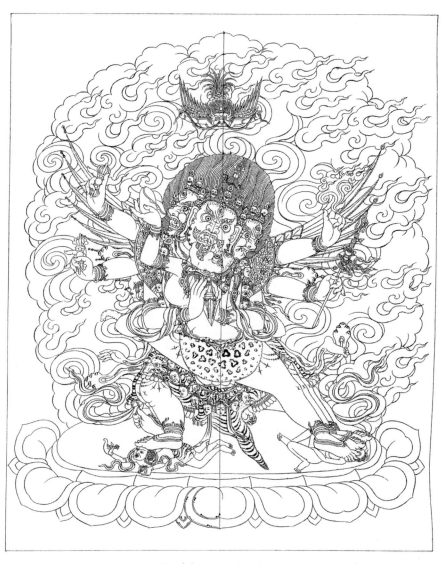

51. Vajrakilaya: complete drawing

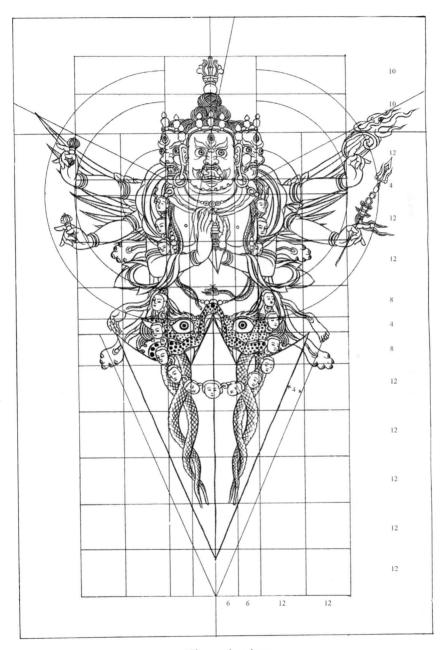

52. Kilaya with end part

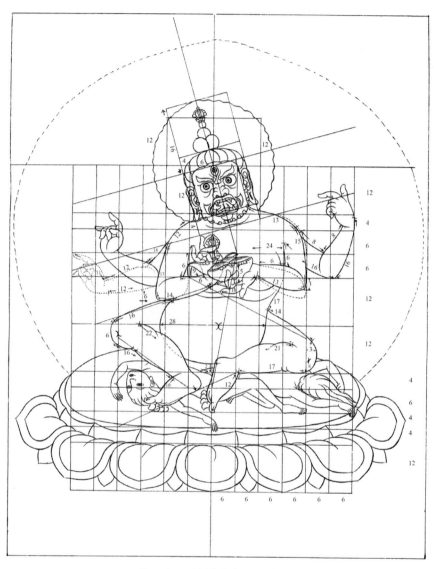

53. Four-Armed Mahakala: measurement

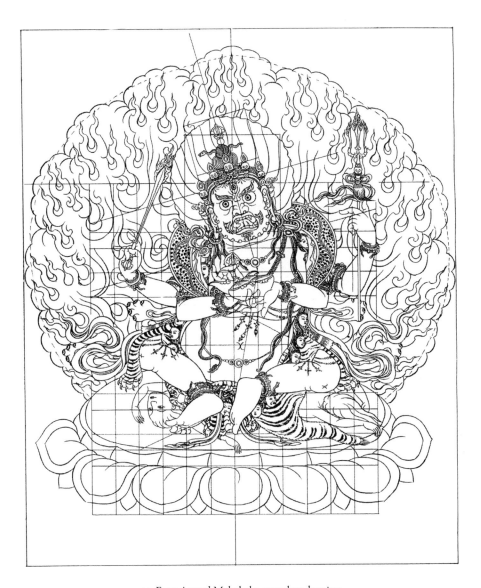

54. Four-Armed Mahakala: complete drawing

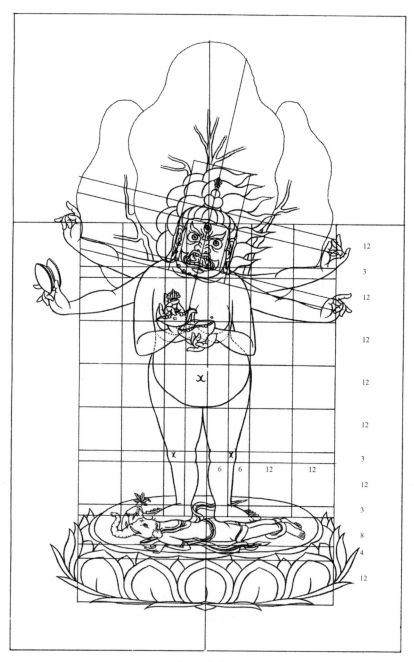

55. Six-Armed Mahakala: measurement

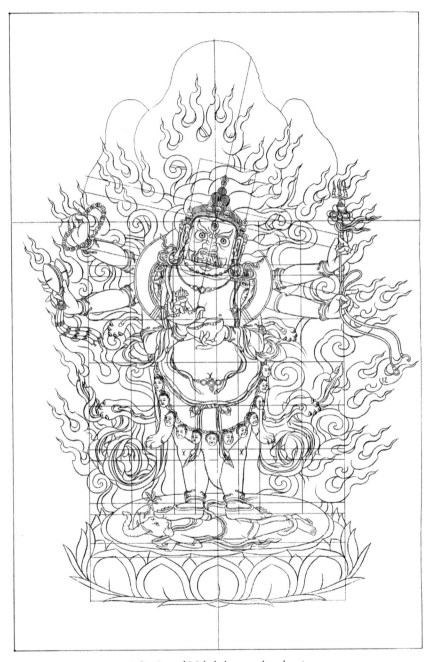

56. Six-Armed Mahakala: complete drawing

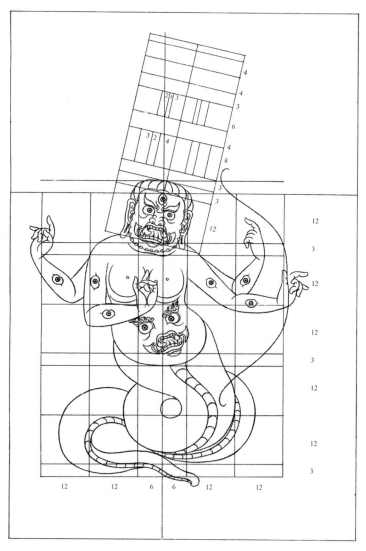

57. Rahula: measurement

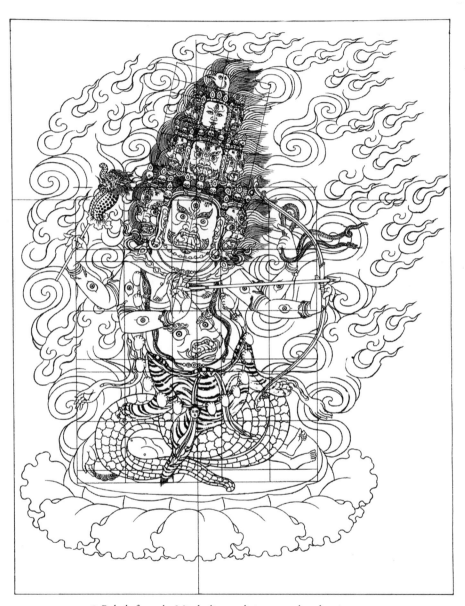

58. Rahula from the Mindroling tradition: complete drawing

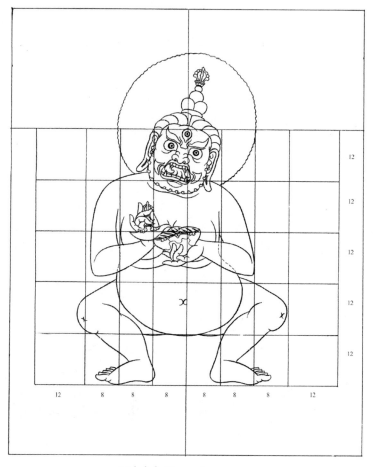

59. Mahakala Ganapati: measurement

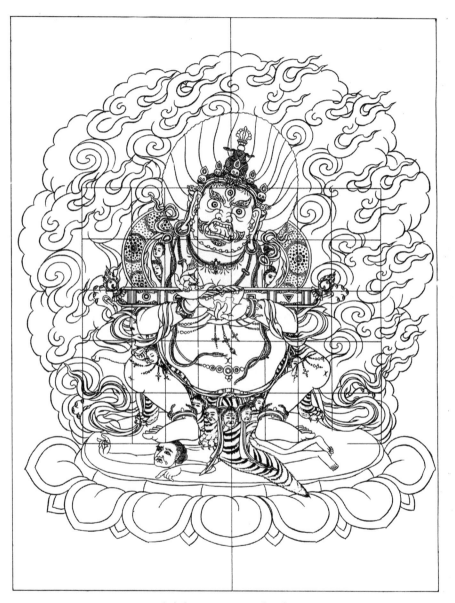

60. Mahakala Ganapati: complete drawing

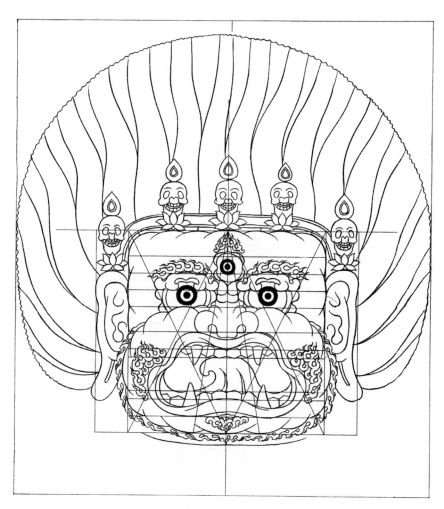

61. Mahakala Bernakchen head

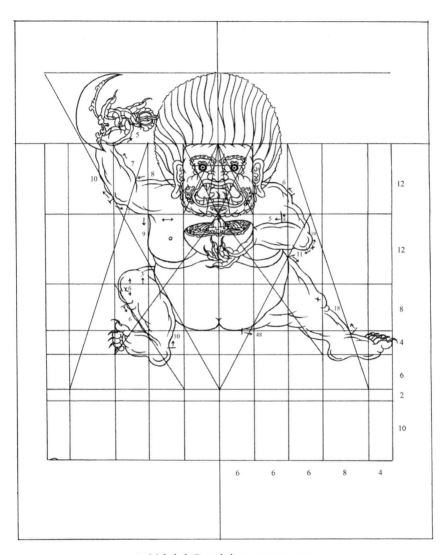

62. Mahakala Bernakchen: measurement

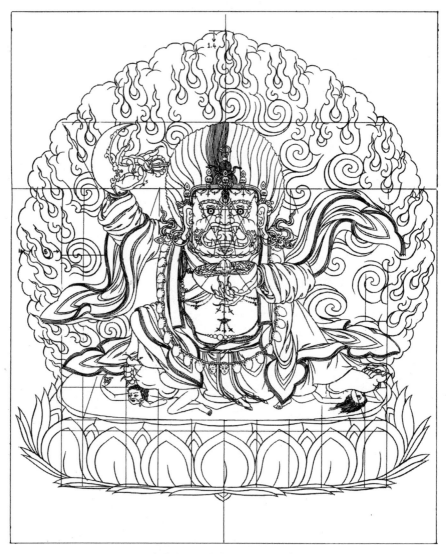

63. Mahakala Bernakchen: complete drawing

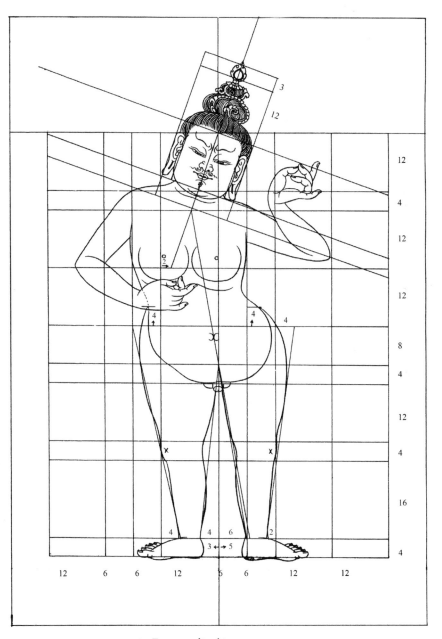

64. Four guardian kings: measurement

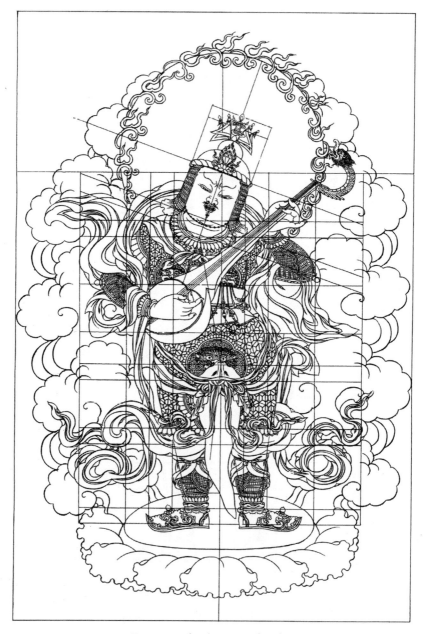

65. Eastern guardian king: complete drawing

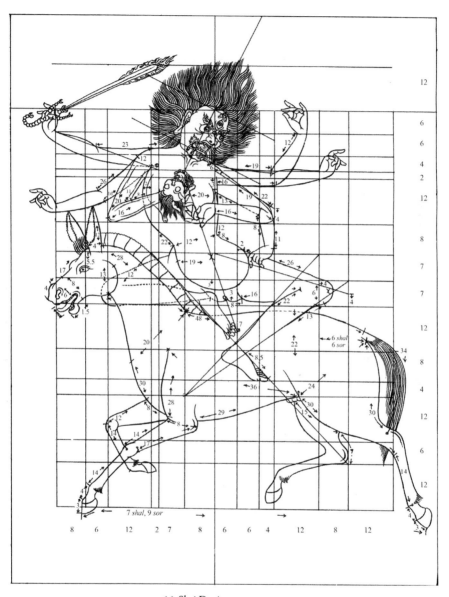

66. Shri Devi: measurement

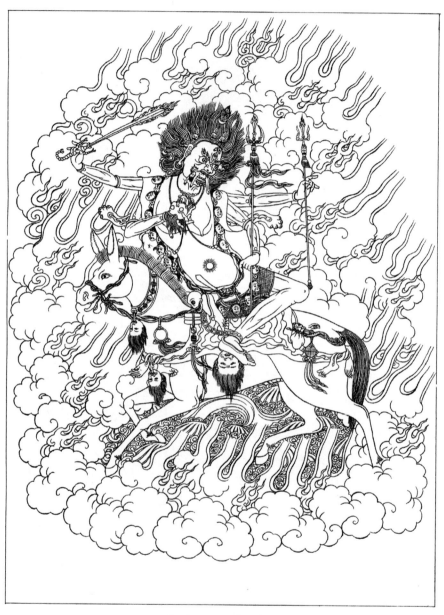

67. Shri Devi: complete drawing

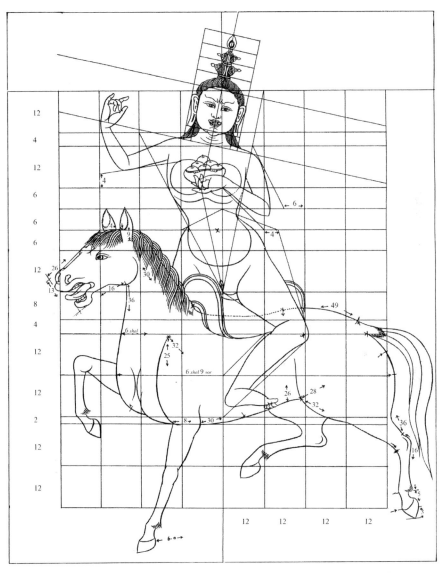

68. Achi: measurement

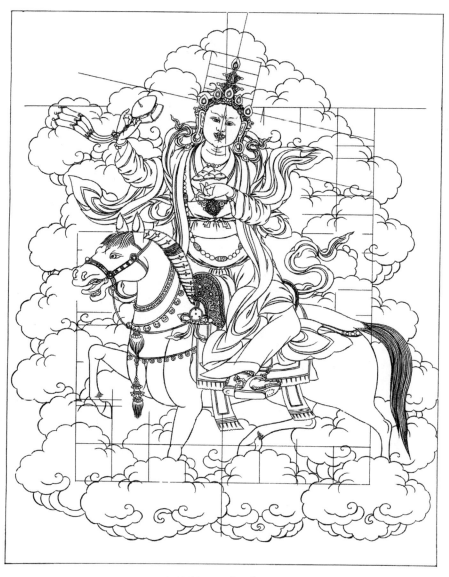

69. Achi: complete drawing

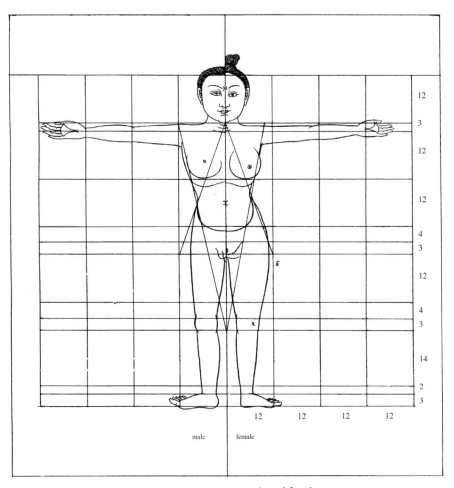

70. Human measurement, male and female

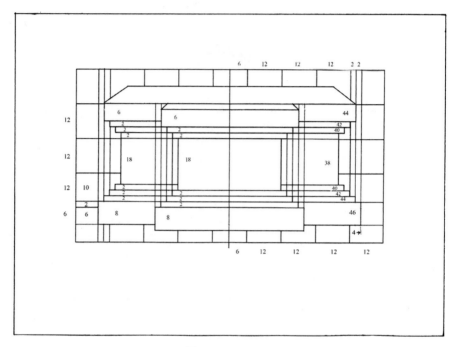

71. Throne measurement

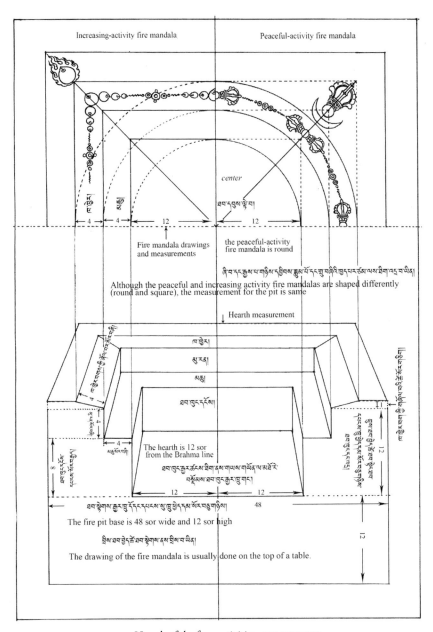

Increasing-activity fire mandala

Peaceful-activity fire mandala

center

Fire mandala drawings
and measurements

the peaceful-activity
fire mandala is round

Although the peaceful and increasing activity fire mandalas are shaped differently
(round and square), the measurement for the pit is same

Hearth measurement

The hearth is 12 sor
from the Brahma line

The fire pit base is 48 sor wide and 12 sor high

The drawing of the fire mandala is usually done on the top of a table.

72. Hearth of the four activities: measurement
Including drawing for fire puja mandalas (pacifying and increasing)

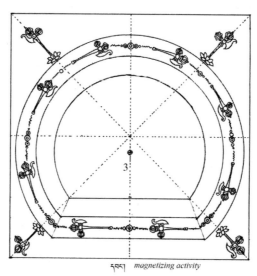

5ผรุ *magnetizing activity*

The compass point for the circular lines is 3 sor to the east along the Brahma line

5ๆ้ั *subjugating activity*

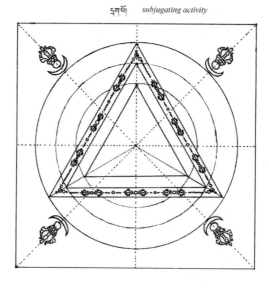

73. Fire puja mandalas (subjugating and magnetizing)

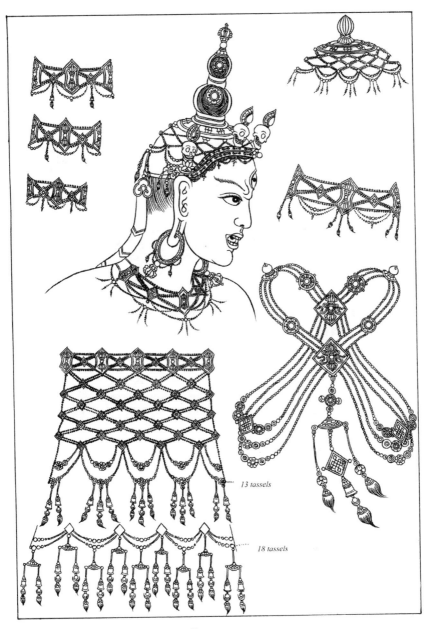

13 tassels

18 tassels

74. Bone ornaments

75. Lentsa Sanskrit script

76. Vartu Sanskrit script

77. Uchen Tibetan script

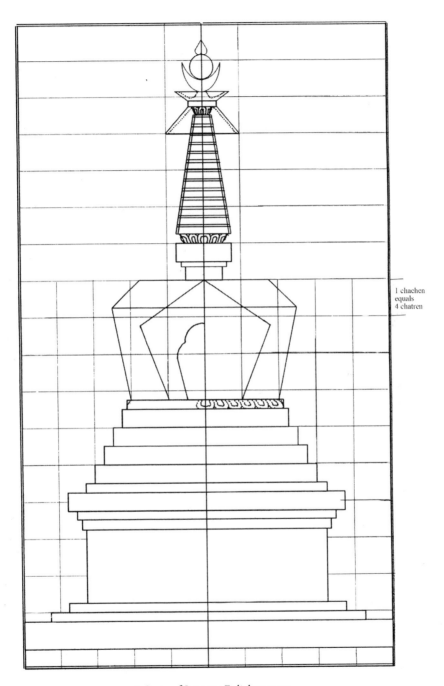

1 chachen
equals
4 chatren

78. Stupa of Supreme Enlightenment

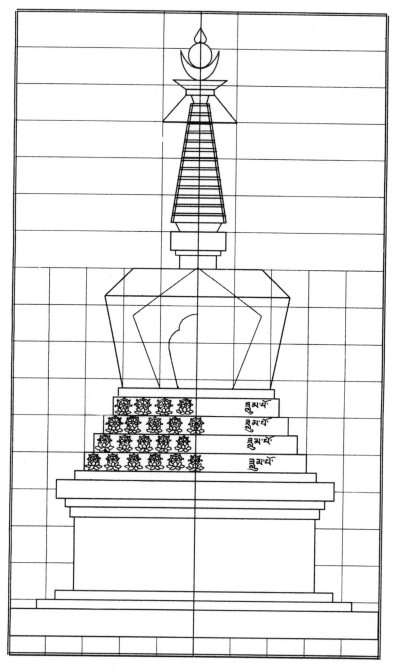

79. Stupa of the Sugatas (or Stupa of Heaped Lotuses)

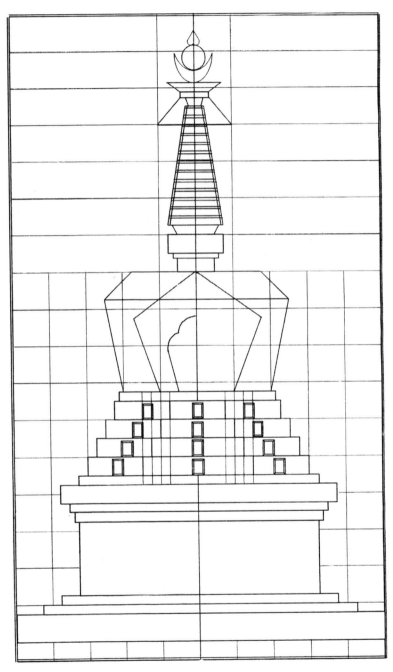

80. Stupa of the Wheel of the Sacred Teachings (or Stupa of Many Auspicious Doors)

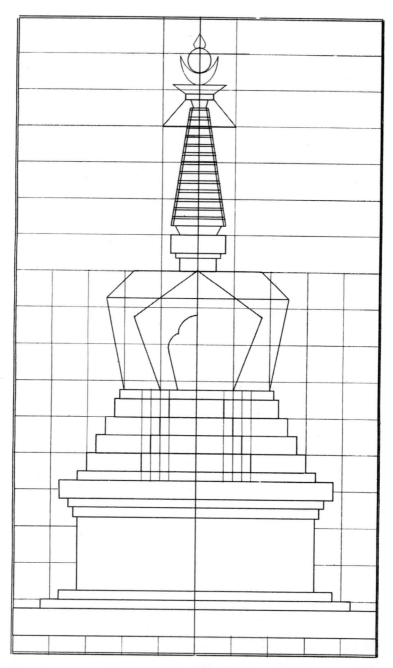

81. Stupa of Miracles

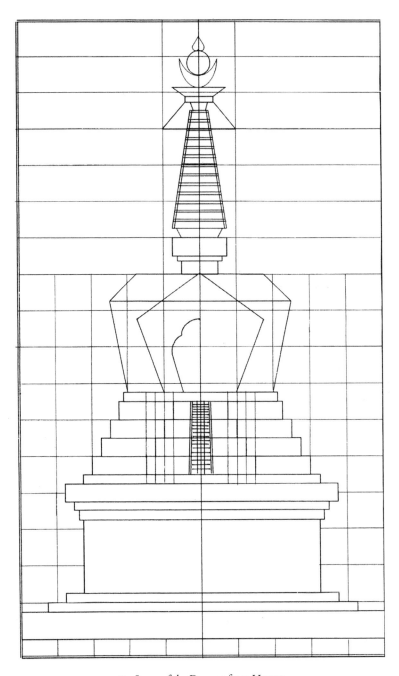

82. Stupa of the Descent from Heaven

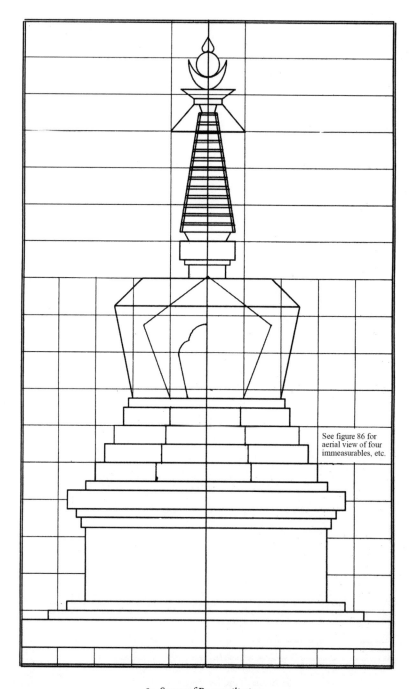

See figure 86 for
aerial view of four
immeasurables, etc.

83. Stupa of Reconciliation

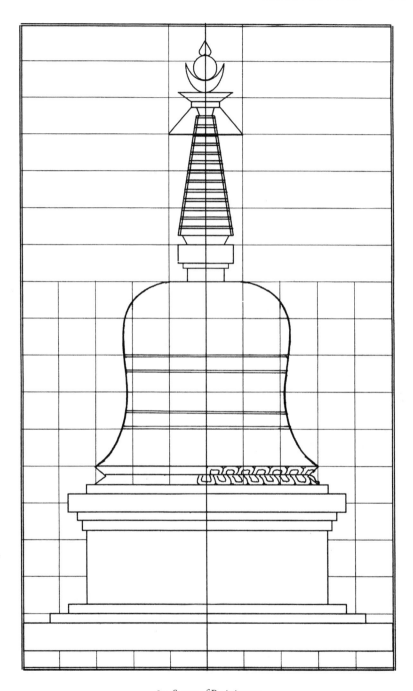

84. Stupa of Parinirvana

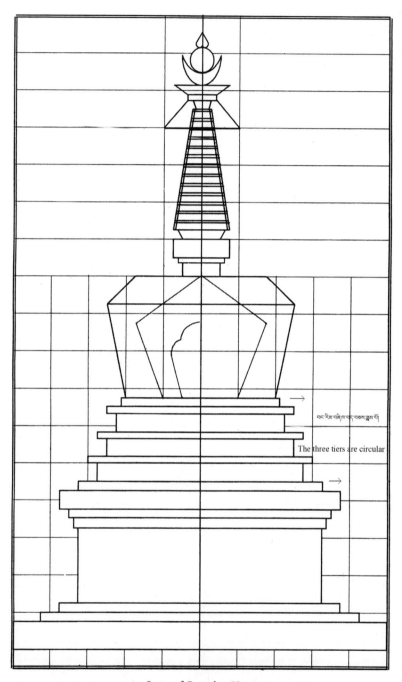

ཝང་རིན་བཞི་ཁ་འདུ་འཆམ་རྒྱས་གོ།

The three tiers are circular

85. Stupa of Complete Victory

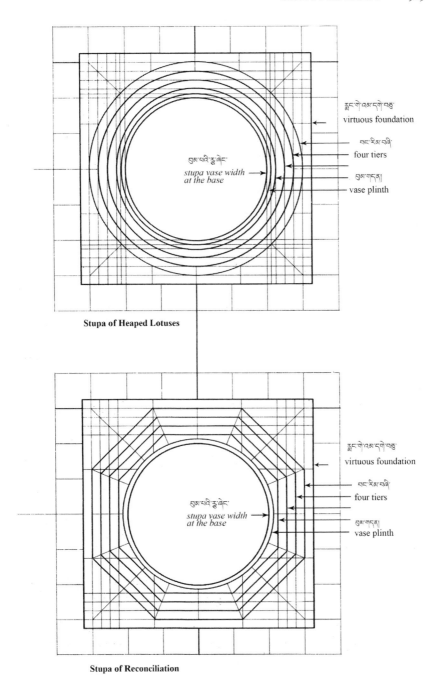

རྩང་གི་འཆ་དགེ་བཙུ་
virtuous foundation

བང་རིམ་བཞི་
four tiers

བུམ་པའི་རྩ་ཞེང་
stupa vase width at the base

བུམ་གདན།
vase plinth

Stupa of Heaped Lotuses

རྩང་གི་འཆ་དགེ་བཙུ་
virtuous foundation

བང་རིམ་བཞི་
four tiers

བུམ་པའི་རྩ་ཞེང་
stupa vase width at the base

བུམ་གདན།
vase plinth

Stupa of Reconciliation

86. Aerial view of two stupas

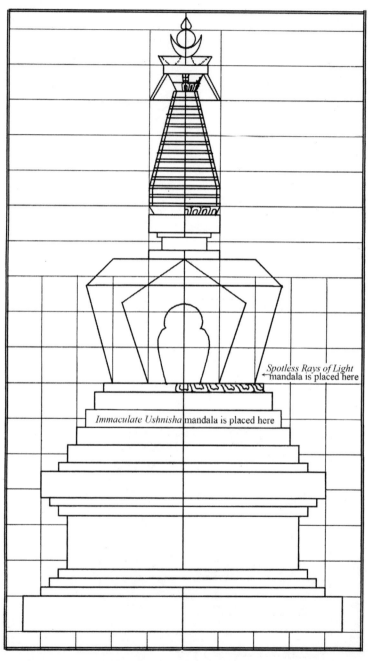

Spotless Rays of Light
←mandala is placed here

Immaculate Ushnisha mandala is placed here

87. New tradition of measurement by Jamyang Khyentse Wangpo and Jamgön Kongtrul
for the Stupa of Supreme Enlightenment

The central spoke has four sides

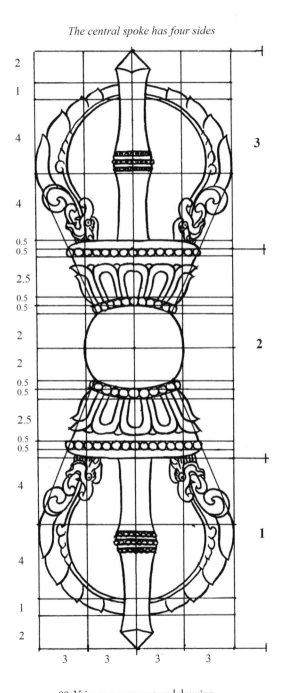

88. Vajra measurement and drawing

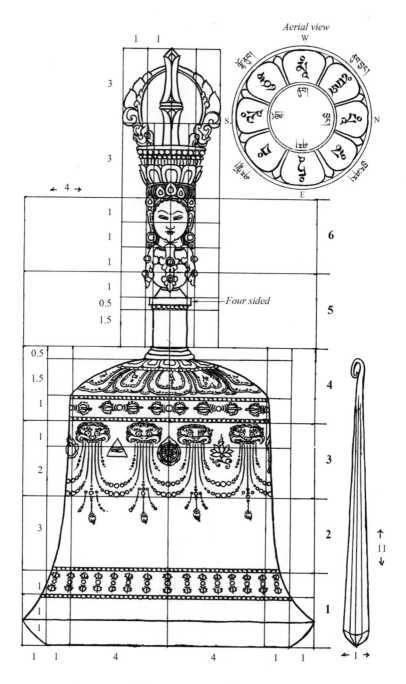

89. Bell measurement and drawing

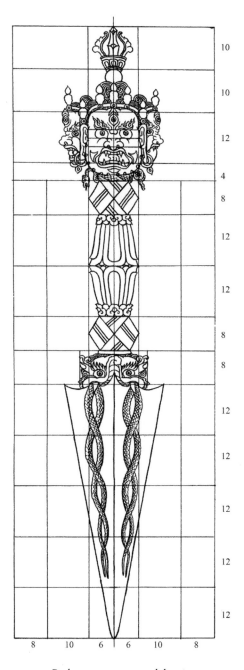

10

10

12

4

8

12

12

8

8

12

12

12

12

12

8　　10　　6　6　　10　　8

90. Purba measurement and drawing

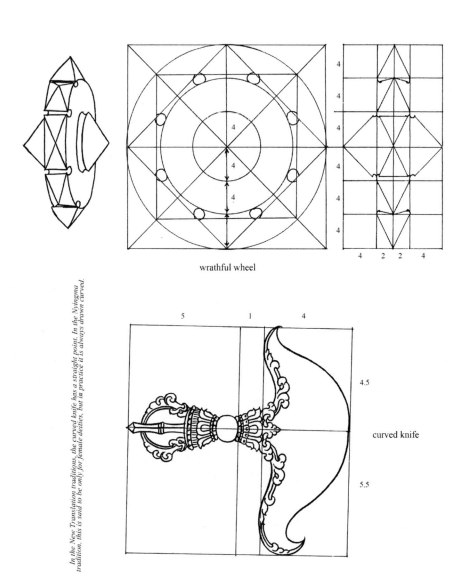

wrathful wheel

In the New Translation traditions, the curved knife has a straight point. In the Nyingma tradition, this is said to be only for female deities, but in practice it is always drawn curved.

curved knife

91. Wrathful wheel and curved knife measurement and drawing

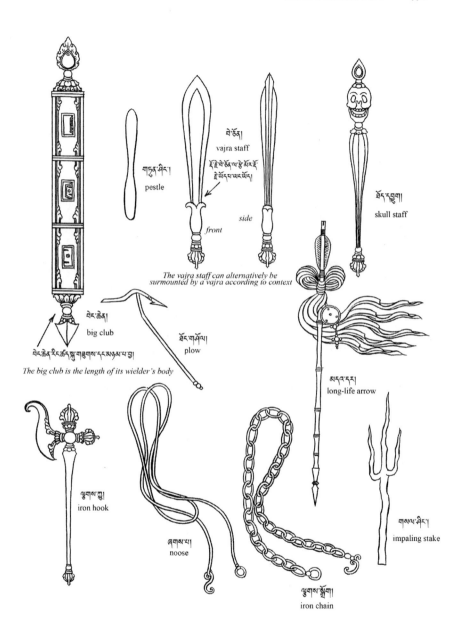

པེ་ཚོན།
vajra staff

གཏུན་ཤིང་།
pestle

རྡོ་རྗེ་པེ་ཚོན་ལ་རྗེ་པོར་རོ།
རྗེ་ཡོངར་པ་ཡང་ཡོང་།

front

side

The vajra staff can alternatively be surmounted by a vajra according to context

ཐོད་དབྱུག
skull staff

བེང་ཆེན།
big club

ཞིང་གཤོལ།
plow

བེང་ཆེན་རིང་ཚོད་གུ་གཟུགས་དང་མཉམ་པ་རྒྱུ།
The big club is the length of its wielder's body

མདའ་དར།
long-life arrow

ལྕགས་ཀྱུ།
iron hook

ཞགས་པ།
noose

ལྕགས་སྒྲོག
iron chain

གསལ་ཤིང་།
impaling stake

92. Various hand implements

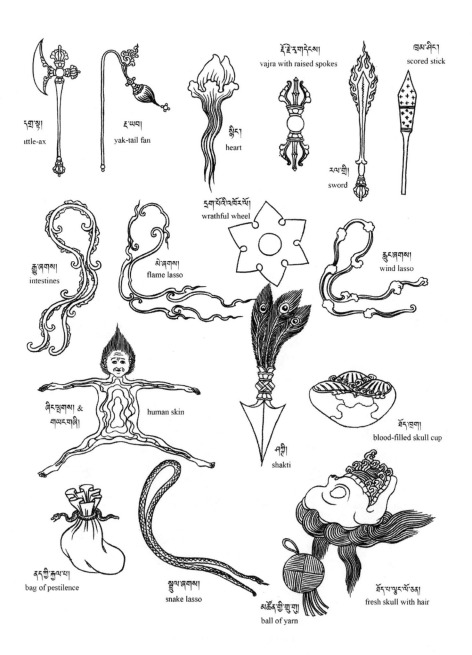

དགྲ་སྟ།
little-ax

རྔ་ཡབ།
yak-tail fan

སྙིང་།
heart

རྡོ་རྗེ་རྩ་གདེངས།
vajra with raised spokes

ཁྲམ་ཤིང་།
scored stick

རལ་གྲི།
sword

དུག་པོའི་འཁོར་ལོ།
wrathful wheel

རྒྱུ་ཞགས།
intestines

མེ་ཞགས།
flame lasso

རླུང་ཞགས།
wind lasso

ཞིང་སྤགས་ & གཡང་གཞི།
human skin

ཤཀྟི།
shakti

ཁྲག་ཞལ།
blood-filled skull cup

ནད་ཀྱི་རྐྱལ་པ།
bag of pestilence

སྦྲུལ་ཞགས།
snake lasso

མཚོན་གྱི་གྲུ་གུ།
ball of yarn

ཐོད་པ་ལྗང་ལོ་ཅན།
fresh skull with hair

93. Various hand implements and accoutrements

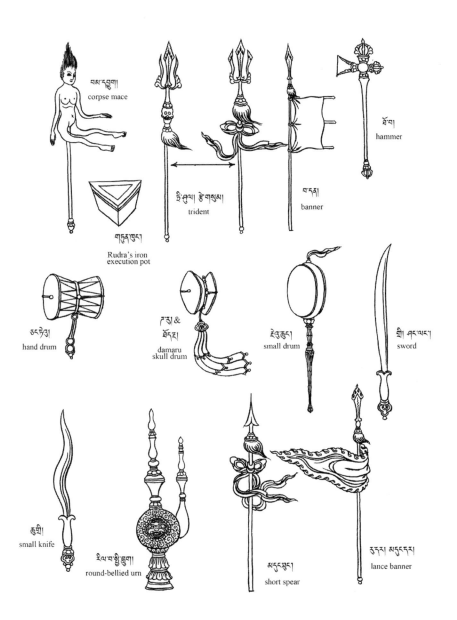

94. Various hand implements

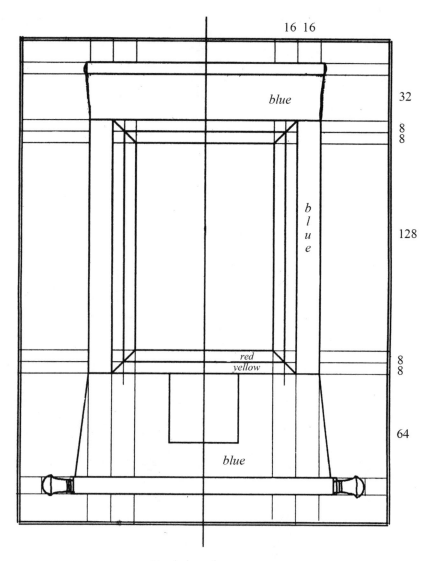

95. Tangka brocade measurements

Appendix 1: Direction Terms

Tibetan Terms for the Directions

Direction (chog)	Conventional term	Mandala term
East	shar (*shar*)	driza (*dri za*); gyajin (*brgya byin*); wangpo (*dbang po*); nyewang (*nye dbang*)
South	lho (*lho*)	shinje (*gshin rje*)
West	nup (*nub*)	chulha (*chu lha*)
North	jang (*byang*)	nöjin (*gnod sbyin*)
Southeast	sharlho (*shar lho*)	me (*me*)
Southwest	lhonup (*lho nub*)	sinpo (*srin po*); dendral (*bden bral*)
Northwest	nupjang (*nub byang*)	lunglha (*rlung lha*)
Northeast	jangshar (*byang shar*)	wangden (*dbang ldan*); jungpo (*'byung po*)

APPENDIX 2: ICONOMETRIC TERMS

DEITY MEASUREMENT UNITS

The terms in this table pertain only to deity iconometry, with one chachen equal to twelve chatren. (In mandala measurement, which uses only the units called *chachen* and *chatren* [or *chachung*], one chachen is equal to four chatren.)

UNIT OF MEASUREMENT	WYLIE	ENGLISH	SYNONYMS
chachen	*cha chen*	face size	zhaltse (*zhal tshad*); zhal (*zhal*); dong (*gdong*); to (*mtho*); talmo (*thal mo*); til (*mthil*)
sor (¹⁄₁₂ of 1 chachen)	*sor*	finger size	chatren (*cha phran*); chachung (*cha chung*)
kangpa (¼ of 1 sor)	*rkang pa*	leg size	
ne (½ of 1 kangpa or ⅛ of 1 sor)	*nas*	grain size	

Chart continues on next page

Deity Measurement Lines

Note that all these terms pertain to deity drawing. Of the eight lines in mandala drawing, the diagonal lines are known as *zurtik* (zur thig).

Name of line	Wylie	Description	Synonyms
tsangtik	*tshangs thig*	Brahma line, the central vertical line	namtik (*gnam thig*); tsatik (*rtsa thig*); utik (*dbus thig*); kyiltik (*dkyil thig*)
zhungtik	*gzhung thig*	Lines parallel to the central vertical line	chutik (*chu thig*); gyentik (*gyen thig*)
tretik	*'phred thig*	Horizontal axis, cross-line	Second tsangtik
gyingtik	*'gying thig*	Lines that cross the central line at an angle	
kyutik	*dkyus thig*	Any other lines at angles	

Appendix 3: The Parts
of a Stupa (from lower to upper)

Stupa part name	Phonetics	Wylie	Sanskrit
Podium base	den gyi sadzin	*gdan gyi sa 'dzin*	gandhara
Three stages of refuge (steps)	kyam dro rim sum/temke sum	*skyabs 'gro rim gsum them skad gsum*	
Lion throne podium	sengtri	*seng khri*	nemi
Small capping slab (two)	bechung (nyi)	*bad chung (gnyis)*	
Large capping slab	bechen	*bad chen*	
Virtuous foundation (slab)	mang gewa	*rmang dge ba*	
Four immeasurables (four tiers)	tseme zhi bang rim zhi	*tshad med bzhi bang rim bzhi*	caturvedi
Vase (dome) plinth	bumten/bumden	*bum rten/ bum gdan*	kantika
Vase (actual dome)	bumpa	*bum pa*	kumbha
High pavilion plinth	dreten	*'bre rten*	
High pavilion	dre	*'bre*	harmika
Lotus support of parasol	dukdek	*gdugs 'degs*	padmamula
[Thirteen] dharma wheels	chökhor chusum	*chos 'khor bcu gsum*	

Chart continues on next page

Stupa part name	Phonetics	Wylie	Sanskrit
Male and female wheels	phokhor mokhor	*pho 'khor mo 'khor*	
Conjunction of mercy crossbeam	tukje dozung	*thugs rje mdo bzung*	
Crossed bow-shape	zhu gyadram	*gzhu rgya gram*	
Parasol	duk	*gdug*	catravali
Rain cloak	charkheb	*char khebs*	varsathali
Five families	rik nga	*rigs lnga*	
Crescent moon	dawa	*zla ba*	
Sun disk	nyima	*nyi ma*	
Flaming jewel crest	tok	*tog*	ketu; ushnisha

Appendix 4: Colors

The 105 Colors

	English	Phonetics	Wylie
Root Colors (6)			
1	White	karpo	*dkar po*
2	Blue	ting	*mthing*
3	Yellow	serpo	*ser po*
4	Green	janggu or pang	*ljang gu; spang*
5	Red	marpo	*dmar po*
6	Black	nakpo	*nag po*
Branch Colors (6)			
1	Bluish-green	janggu	*ljang gu*
2	Turquoise	yukha	*g.yu kha*
3	Purple	mönkha	*mon kha*
4	Yellowish-green	jangser	*ljang ser*
5	Orange	marser or litri	*dmar ser; li khri*
6	Reddish-brown	jakha	*ja kha*
Leaf Colors (79)			
Blue (6)			
1	Medium blue	barting	*bar mthing*
2	Dark pale blue	tingkya tso	*mthing skya tsho*
3	Pale blue	tingkya	*mthing skya*

Chart continues on next page

	ENGLISH	PHONETICS	WYLIE
4	Light pale blue	tingkya kyawo	*mthing skya skya bo*
5	Extremely pale blue	tingdrek	*mthing dreg*
6	Dark blue	tingnak	*mthing nag*
	Yellow (3)		
1	Pale yellow	serkya	*ser skya*
2	Light pale yellow	serkya kyawo	*ser skya skya bo*
3	Dark yellow	sernak	*ser nag*
	Gold base colors (5)		
1	Gold base	serden	*gser gdan*
2	Dark gold base	serden nak	*gser gdan nag*
3	Reddish-gold base	serden marwa	*gser gdan dmar ba*
4	Yellowish-gold base	serden serwa	*gser gdan ser ba*
5	Pale gold base	serden kyawo	*gser gdan skya bo*
	Green (5)		
1	Dark pale green	pangkya tso	*spang skya tsho*
2	Pale green	pangkya	*spang skya*
3	Very pale green	pangkya kyawo	*spang skya skya bo*
4	Extremely pale green	pangdrek	*spang dreg*
5	Dark green	pangnak	*spang nag*
	Red (4)		
1	Medium red (deep pink)	marpo bartso	*dmar po bar tsho*
2	Dark light red	markya tso	*dmar skya tsho*
3	Pale red (pink)	markya	*dmar skya*
4	Very pale red (pale pink)	markya kyawo	*dmar skya skya bo*
	Dark red (4)		
1	Dark red	marnak	*dmar nag*
2	Medium maroon/red	chinkha bartso	*mchin kha bar tsho*
3	Pale maroon	chinkha kyawo tso	*mchin kha skya bo tsho*
4	Very pale maroon	chinkha kyawo	*mchin kha skya bo*

	ENGLISH	PHONETICS	WYLIE
	Gray (4)		
1	Medium gray	nakpo bartso	*nag po bar tsho*
2	Gray	nakya tso	*nag skya tsho*
3	Pale gray	nakya	*nag skya*
4	Very pale gray	nakya kyawo	*nag skya skya bo*
	Turquoise (3)		
1	Medium turquoise	yukha bartso	*g.yu kha bar tsho*
2	Pale turquoise	yukha kyawo	*g.yu kha skya bo*
3	Light pale turquoise	yudrek	*g.yu dreg*
	Purple (12)		
1	Blue-purple	mönting	*mon mthing*
2	Red-purple	mönmar	*mon dmar*
3	Dark purple	mönak	*mon nag*
4-12	If more white is added to each of these, *mönkya tso* is appended to the name of the color; with even more white, *mönkya kyawo;* with still more, *mönkya kyadrek,* making 9 more purple colors.		
	Orange (3)		
1	Medium pale orange	likya bartso	*li skya bar tsho*
2	Pale orange	likya	*li skya*
3	Very pale orange	likya kyawo	*li skya skya bo*
	Brown (12)		
1	Yellow-brown	jaser	*ja ser*
2	Red-brown	jamar	*ja dmar*
3	Dark brown	janak	*ja nag*
4-12	If more white is added to each of these, *jakha bartso* is appended to the name of the color; with even more white, *ja kya;* with still more, *jakha kyawo,* making 9 more brown colors.		
	Skin color (18):		
1	Skin color	shakha	*sha kha*

Chart continues on next page

	ENGLISH	PHONETICS	WYLIE
2	Bluish skin	sha ngön	*sha sngon*
3	Greenish skin	shajang	*sha ljang*
4	Yellowish skin	shaser	*sha ser*
5	Reddish skin	shamar	*sha dmar*
6	Blackish skin	shanak	*sha nag*
7-18	If more white is added to each of these, *kyawo tso* is appended to the name of the color; with even more white, *kyawo* is appended to the second set of 6, making 12 more skin colors.		

SPECIAL COLORS (14)

Five special colors (5)

1	Indigo blue	ram	*rams*
2	Red-violet	kak	*skag*
3	Green shading	zhumken	*zhu mkhan*
4	Gold	ser	*gser*
5	Silver	ngul	*dngul*

Indigo blue for line and shading (3)

1	Dark blue (for line)	ramnak	*rams nag*
2	Blue shading	dangram	*mdangs rams*
3	Light blue shading	dangram dangma	*mdangs rams dvangs ma*

Red-violet for line and shading (3)

1	Dark red line	chekak	*bcad skag*
2	Red shading	dangkak	*mdangs skag*
3	Light red shading	dangkak dangma	*mdangs skag dvangs ma*

Green shading (1)

1	Green shading	zhumkhen dangma	*zhu mkhan dvangs ma*

Gold (1)

1	Gold shading	dangser	*mdangs gser*

Silver (1)

1	Silver shading	nguldang	*dngul mdangs*

Appendix 5: Archway Terms

Phonetic Tibetan	Wylie	Description
Resultant eight-leveled archway (*'bras bu'i rta babs brgyad*)		
1) takang	*rta rkang*	blue ground with gold vajra uprights
2) chukye	*chu skyed*	lotus motif (red colored)
3) drombu	*sgrom bu*	beam with box-motif beveling (blue/orange alternating with red/green)
4) zartsak	*zar tshag*	white pearl pendant ornaments (*drawa drache*)
5) nachang	*sna 'phyang*	jeweled beam (yellow with studded jewels in alternating colors)
6) chunchang	*chun 'phyang* or drilchang (*sgril 'phyang*)	tassels and garlands
7) sharbu	*shar bu*	cornice and beams with rainspout motifs (light blue with white drawing)
8) khyungo	*khyung mgo*	small flat roof with garuda or eagle-head motif (blue). Also known as gyapup (*rgya phub*), roofed canopy
Four-leveled archway (*rta babs bzhi ma*)		
1) sernam	*gser snam*	red (or yellow)
2) sharbu	*shar bu*	rainspout motif, blue
3) rinchen	*rin chen*	green (or red)
4) dayap	*mda' yab*	yellow (or green)

Chart continues on next page

Phonetic Tibetan	Wylie	Description
ELEVEN-LEVELED ARCHWAY (*RTA BABS BCU GCIG MA*)		
The Stainless Two (Immaculate Ushnisha and Spotless Rays of Light) Tradition		
1) sernam	*gser snam*	blue
2) sharbu	*shar bu*	red
3) rinchen	*rin chen*	green
4) mikpa	*rmig pa*	yellow
5) munpa	*mun pa*	red on outside, blue on inside
6) varanada	*va randa*	red
7) munam	*mun snam*	red on outside, blue on inside
8) sharbu	*shar bu*	yellow
9) rinchen	*rin chen*	light blue
10) mikpa	*rmigs pa*	red
11) dayap	*mda' yab*	white
The Condensed Realization of the Gurus and Rosary Traditions		
1) sernam	*gser rnam*	yellow
2) sharbu	*shar bu*	blue
3) rinchen	*rin chen*	red
4) mikpa	*rmig pa*	green
5) munpa	*mun pa*	blue
6) varen	*va ran*	yellow
7) munam	*mun snam*	blue
8) sharbu	*shar bu*	blue
9) rinchen	*rin chen*	red
10) tamik	*rta mig*	green
11) dayap	*mda' yab*	white

APPENDIX 6: SANGYE RAPDUN SOJONG

Refer to the mantras for tangkas on page 279 for instructions on writing this prayer on the back of a tangka as a more elaborate way to bless it.

དང་པོ་སངས་རྒྱས་རྣམ་གཞིགས་ནི། བཟོད་པ་དཀའ་ཐུབ་དམ་པ་བཟོད་པ་ནི། །མྱ་ངན་འདས་པ་མཆོག་ཅེས་སངས་རྒྱས་གསུངས། །རབ་ཏུ་བྱུང་བ་གཞན་ལ་གནོད་པ་དང་། །གཞན་ལ་འཚེ་བ་དགེ་སློང་མིན་ནོ། །གཉིས་པ་གཙུག་གཏོར་ཅན་ནི། མིག་ལྟར་འགྲོ་བ་ཡོད་པ་ཡིས། །རྣམས་དང་དག་ཏེ་བཞིན་དུ། །མཁས་པས་འཚོ་བའི་འཇིག་རྟེན་འདིར། །སྡིག་པ་དག་ནི་ཡོངས་སུ་སྤང་། །གསུམ་པ་ཐམས་ཅད་སྐྱོབ་ནི། སྐུར་པ་མི་གདབ་གནོད་མི་བྱ། །སོ་སོར་ཐར་པའང་བསྡམ་པར་བྱ། །ཟས་ཀྱི་ཚོད་ཀྱང་རིག་པར་བྱ། །བས་མཐའི་གནས་སུ་གནས་པར་བྱ། །ལྷག་པའི་སེམས་ལ་ཡང་དག་སྦྱོར། །འདི་ནི་སངས་རྒྱས་བསྟན་པ་ཡིན། །བཞི་པ་འཁོར་བ་འཇིག་གས་ནི། ཇི་ལྟར་བུང་བས་མེ་ཏོག་གི །ཁ་དོག་དྲི་ལ་མི་གནོད་པར། །ཁུ་བ་གཞིབས་ནས་འཕུར་བ་ལྟར། །དེ་བཞིན་ཐུབ་པ་གྲོང་དུ་རྒྱུ། །ལྤ་བ་གསེར་སྦུབ་ནི། བདག་གིས་རིགས་དང་མི་རིགས་ལ། །བཏང་དག་པར་བྱ་སྟེ་གཞན་རྣམས་ཀྱི། །མི་མཐུན་པ་དང་གཞན་དག་གི །བྱས་དང་མ་བྱས་རྣམས་ལ། མིན། །ཕྱག་འཚལ་འོད་སྲུང་ནི། སྤྱག་པའི་སེམས་ལ་བག་བྱ་ཞིང་། །ཕྱུག་པའི་བསྒྲུབ་གཞི་རྣམས་ལ་སྤོང་། །ཅེར་ཞི་དུག་ཏུ། དན་ལྷན་པའི། །སྤྱོད་པ་སྙ་ངན་མེ་དཔ་ཡིན། །སྟིན་པས་བསོད་ནམས་རབ་ཏུ་འཕེལ། །ལེགས་པ་བསྲུབས་དགོ་སོགས་མི་འགྱུར་རོ། །དགེ་དང་ལྡན་པས་སྟིག་པ་སྟོང་། །ཉིད་ཁོངས་ཟད་པས་སྒྱུ་ཟན་འདའ། །དཀུན་པ་ཤྲུག་རྒུན་ནི། སྟིག་པ་ཅི་ཡང་མི་བྱ་ཞིང་། །དགེ་བ་ཕུན་སུམ་ཚོགས་པར་སྤྱད། །རང་གི་སེམས་ནི་ཡོངས་སུ་གདུལ། །འདི་ནི་སངས་རྒྱས་བསྟན་པ་ཡིན། །ལུས་ཀྱི་སྡོམ་པ་ལེགས་པ་སྟེ། ན། །དག་གི་སྡོམ་པ་ལེགས་པ་ཡིན། ཡིད་ཀྱི་སྡོམ་པ་ལེགས་པ་ན། །ཐམས་ཅད་དུ། །ཉི་སྡོམ་པ་ལེགས་པས། ཐམས་ཅད་བསྡུང་བའི་དགེ་སློང་དག །སྡུག་བསྔལ་ཀུན་ལས་རབ་པར་གྲོལ། །དག་རྣམས་སྲུང་ཞིང་། ཡིད་ཀྱང་རབ་བསྲུངས་ཏེ། །ལུས་ཀྱི་མི་དགེ་བ་དག་བྱེད་ཅིང་། །ལས་ལམ་གསུམ་པོ་འདི་ལ་རབ་སྦྱངས་ན། །དྲང་སྲོང་གསུངས་པའི་ལམ་ནི་ཐོབ་པར་འགྱུར། །

NOTES

PREFACE

1. Konchog Lhadrepa, *The Path to Liberation: The Tsering Art School Manual for the Basic Gradual Stages of Study of Deity Drawing (tshe ring bzo rigs slob grva'i lha sku bzheng thabs kyi sngon 'gro nag 'gros su bkod pa thar pa'i lam ston chen mo zhes bya ba bzhugs so)* (Delhi: Shechen Publications, 2005).
2. Khyentse Yangsi Rinpoche (Urgyen Tenzin Jigme Lhundrup) is the reincarnation of Dilgo Khyentse Rinpoche (1910–1991), who built Shechen Monastery in Nepal and was Konchog's own root guru.

INTRODUCTION

1. The first-person speaker in this book is the primary author of the source text, Konchog Lhadrepa.
2. Translated by Ven. Sean Price.

PART ONE: PRELIMINARY TEACHINGS

1. Patrul Rinpoche, *The Words of My Perfect Teacher*, rev. ed., trans. Padmakara Translation Group (New Delhi: Vistaar Publications, 1999).
2. Four noble truths (*pakpai denpa zhi*): suffering, the origin of suffering, the cessation of suffering, and the path that brings the cessation of suffering.
3. See Patrul Rinpoche, *Words of My Perfect Teacher*, 19–31.
4. Translated by Konchog Lhadrepa (KL) and Charlotte Davis (CD).
5. Quotations in this section were translated by Ven. Sean Price 2015.
6. Translated by CD and KL.
7. Unless otherwise indicated, quotations are translated by Ven. Sean Price 2015.
8. Translated by KL and CD.
9. Kangyur Rinpoche, *Treasury of Precious Qualities*, trans. Padmakara Translation Group (Boston: Shambhala Publications, 2001), 155.
10. Unless otherwise indicated, quotations are translated by Ven. Sean Price 2015.
11. Shantideva, *The Way of the Bodhisattva*, trans. Padmakara Translation Group (Boston: Shambhala South Asia Editions, 1999), 35.
12. Translated by KL and CD.

13. Kangyur Rinpoche, *Treasury of Precious Qualities*, 188.
14. Ibid., 189–90.
15. Unless otherwise indicated, quotations are translated by Ven. Sean Price 2015.
16. *The King of Aspirations for Noble Excellent Conduct*, trans. Padmakara Translation Group (Plazac, France: Editions Padmakara, 2007).
17. Kangyur Rinpoche, *Treasury of Precious Qualities*, 174.
18. Chandragomin, *Twenty Verses on the Bodhisattva Vows*, trans. Joan Nicell. An FPMT Masters Program Translation (n.p.: FPMT, 2005), 5, 22.
19. Quotations translated by KL and CD.
20. Circling in nonaffliction (*nyon mongs med par 'khor*) refers to cutting the afflictions completely at the root; i.e., the accumulation of wisdom takes one out of samsaric existence completely.
21. A nonreturner is a disciple at the third level of attainment according to the Foundation Vehicle.
22. Unless otherwise indicated, quotations are translated by Ven. Sean Price 2015.
23. Quoted in Dilgo Khyentse Rinpoche, *Zurchungpa's Testament*, trans. Padmakara Translation Group (Boston: Snow Lion Publications, 2007), 153.
24. Grateful acknowledgment to Khenpo Sönam Puntsok, who helped clarify this section. [CD]
25. Unless otherwise indicated, quotations are translated by Ven. Sean Price 2015.
26. See "General Guidelines for the Artist and Patron," page 67, for a description of the three categories of nirmanakaya emanations.
27. Quotations translated by KL and CD.
28. Vishvakarman, "Maker of All," is the presiding deity of all craftspeople and architects. See page 224 for the teachings on the seven precious royal emblems.
29. This story has been adapted from Gega Lama, *Principles of Tibetan Art*, vol. 1 (Darjeeling, India: Jamyang Singe, 1983), 41.
30. See pages 213–39 for a more detailed explanation of these three categories.
31. See "The eight great stupas of the conquerors," page 225.
32. Adapted from Gega Lama, *Principles of Tibetan Art*, 41–44.
33. Adapted from Kangyur Rinpoche, *Treasury of Precious Qualities*, 20.
34. Gega Lama, *Principles of Tibetan Art*, 43–44.
35. See Jamgön Kongtrul, *The Treasury of Knowledge, Book 6, Parts One and Two: Indo-Tibetan Classical Learning and Buddhist Phenomonology*, trans. Gyurme Dorje (Boston: Snow Lion Publications, 2012), 177–316.

PART TWO: THE MAIN TEACHINGS

1. See pages 213–39 for a more detailed explanation of this subject.
2. The third Khamtrul Rinpoche (1680–1729), a great master of the Drukpa Kagyu lineage and also a highly accomplished artist.
3. Unless otherwise indicated, quotations are translated by Ven. Sean Price 2015.
4. Parts of this section have been gratefully adapted and quoted from *The Treasury of Knowledge, Book 6*, 177–316.
5. Unless otherwise indicated, quotations are translated by Ven. Sean Price.
6. Jamgön Kongtrul, *Treasury of Knowledge*, 177–316.

7. See "A Supreme Liturgy for Artists," pages 127–47.
8. These two texts have been published together in *Vajra Wisdom: Deity Practice in Tibetan Buddhism*, trans. Dharmachakra Translation Committee (Boston: Snow Lion Publications, 2012).
9. Quotations translated by CD and KL.
10. A colloquial term referring to Tibetan people.
11. *Vajra Wisdom*, 23–24.
12. Ibid., 24–25.
13. Ibid., 25–26.
14. Ibid., 27.
15. Ibid., 28.
16. Ibid., 29–30.
17. Ibid., 30.
18. Ibid., 31–33.
19. Ibid., 33–34.
20. Ibid., 34–35.
21. Translated by KL and CD.
22. *Vajra Wisdom*, 40.
23. Ibid., 149.
24. Ibid., 40–41.
25. Ibid., 151.
26. Ibid., 41.
27. Ibid., 152–53.
28. Ibid., 74.
29. The syllable E is explained further by KL as transforming into a three-dimensional upside-down pyramid, which sometimes is white. The syllable E symbolizes space, Samantabhadri's *bhaga* (vagina) of great bliss, within which all mandalas are contained. He further notes that all the elements are placed horizontally except the pyramid.
30. A lattice.
31. This is a flattish circle, not a sphere, also horizonally placed, inside the pyramid. [KL]
32. *Vajra Wisdom*, 42.
33. dönam.
34. dharmodaya (chöjung).
35. pagu.
36. trebung.
37. drawa drache.
38. sharbu.
39. dayap.
40. tabap. The translation of this term used in this text is *archway*.
41. takang.
42. chukye.
43. drombu.
44. zartsak.
45. nachang.
46. chunchang.
47. khyung-go.

48. lang gyap.
49. *Vajra Wisdom*, 155–57.
50. Ibid., 157.
51. Ibid., 43.
52. Ibid., 43–44.
53. Depicted with a white disk on top like the moon disk. [KL]
54. Samantabhadra and Samantabhadri. [KL]
55. *Vajra Wisdom*, 162. The thrones of wrathful deities may also consist of male and female human corpses. [KL]
56. The shang-shang is a supernatural creature, half-eagle and half-human, similar to a garuda.
57. This refers to the twelve vajra spokes (*rwa bcu gnyis*).
58. *Vajra Wisdom*, 158–61.
59. Ibid., 44–45.
60. Ibid., 53–55.
61. Ibid., 55–56.
62. Sometimes stockings are counted, with alternating stripes of five colors or plain red. The red stockings are called *pati* (*'pa' ti*) [KL]
63. *Vajra Wisdom*, 56.
64. Ibid., 180.
65. Ibid., 56.
66. Ibid., 181.
67. The hair is standing on end, not bound. [KL]
68. This should be silken ribbons. [KL]
69. *Vajra Wisdom*, 181–82.
70. Ibid., 182.
71. Ibid., 58 (with numbering added).
72. Ibid., 182. Sometimes the black and green colors are interchanged.
73. Ibid., 183.
74. The oral transmission lineage of the Ancient tradition (Nyingma Kama; *rnying ma bka' ma*), together with the terma lineage, are the two modes of transmission of the Sutrayana and Vajrayana teachings of the Nyingma school.
75. *Vajra Wisdom*, 58.
76. The protrusion on the top of the head, one of the signs of a buddha.
77. *Vajra Wisdom*, 183.
78. Ibid., 58–59.
79. Ibid., 59.
80. Ibid., 60.
81. Ibid., 61.
82. Ibid.
83. Ibid., 196.
84. This pertains also to the body color of the deities, not just the consorts. [KL]
85. *Vajra Wisdom*, 61–62.
86. Ibid., 196.
87. Ibid., 62–63.
88. Ibid., 63.
89. Ibid., 67.

90. Ibid., 65.
91. Ibid., 53.
92. Ibid., 45.
93. Ibid., 46.
94. Ibid., 47.
95. Ibid., 48–49.
96. Ibid., 49.
97. Ibid., 50.
98. Ibid.
99. Ibid., 50–51.
100. Ibid., 51.
101. Ibid., 52–53.
102. Ibid., 233–34.
103. *A Supreme Liturgy for Artists and A Ritual to Repair Artworks* were partially translated in preliminary form by Ani Lodro Palmo, and then revised with further sections translated by Ven. Sean Price, in collaboration with Konchog Lhadrepa and Charlotte Davis.
104. The eight working lines are made on the canvas with a chalk string, which is held tautly across the precise location for the line to be drawn (e.g., from corner to corner), then picked up in the center with the thumb and forefinger, about an inch or so from the canvas, then released so that it rebounds or snaps onto the canvas, leaving a precise line.
105. The artist needs to become familiar with the Tibetan names for the different parts of the mandala. See the glossary for translations of these terms.
106. See appendix 2.
107. If we followed this instruction exactly, the string would be too thick, so just note this and make it a practical thickness. [KL]
108. See figure 1 in the illustration section at the back of the book.
109. See appendix 1 for the names used for directions in drawing a mandala.
110. The various kinds of mandalas are grouped according to the levels of archway, as this is the major factor in the differences in dimensions when making the measurements for drawing mandalas; therefore, they are referred to as four-leveled archway, eight-leveled archway, etc.
111. Note that for mandala measurement, one chachen is always divided into four chatren. For deity measurement, however, although the same names are used, a different system applies, whereby one chachen (or *zhal*) is divided into twelve chatren (or *sor*). See appendix 2 for the various names of the units of measurement used in deity iconometry.
112. See appendix 5 for more details about the various archways and their components.
113. The standard direction colors are white (east), yellow (south), red (west), and green (north).
114. An area drawn in the outer circular areas for the gurus to dwell, but it is actually in the sky, similar to the vajra canopy. [KL]
115. The ratna wheel looks like the usual knife wheel, but the spokes or points have rounded edges.
116. In this case, the measurement outlined by Lochen Dharmashri, which is a more complex method, has been modified by the author, Konchog Lhadrepa, as an easier way of delineating the inner pedestal area into the nine small mandalas.
117. If the mandala has a four-leveled archway, then measure the surrounding areas from the

diagonal line, one chatren for the first circle which is for the spoke-rest, and then the rest of the circles are the same from there. Otherwise it will not fit properly if measuring from the Brahma line. [KL]

118. This refers to both the peaceful and wrathful versions of this mandala. [KL]

119. If the space is too small, it is possible to make the walls white with skull drawing. [KL]

120. In the terma it says the lotus ring is one chachen, so here we will include two chatren for the lotus pistil rim, otherwise it is very big.

121. "Nyak" refers to Jnana Kumara of Nyak, one of Guru Rinpoche's twenty-five main disciples.

122. The first section was discovered by Dilgo Khyentse Rinpoche in 1935 at Ladro Samdrup Lhaden Chökhorling (*gla gro bsam 'grub lha ldan chos 'khor ling*). He found the rest of the work in the following year at Pema Shelpuk (*pad ma shel phug*), a site near Dzongsar in eastern Tibet that had previously been opened by Chokgyur Lingpa and Khyentse Wangpo. See John Powers and David Templeman, *Historical Dictionary of Tibet* (Lanham, MD: Scarecrow Press, 2012), 208.

123. A red gemstone.

124. These stupas have different colors, but it is better to make them all white, according to Karmapa Tekchok Dorje. [KL]

125. Jamgön Kongtrul, *Treasury of Knowledge*, 188.

126. See ibid., 187–93, for a detailed explanation of these traditions. Jamyang Khyentse Wangpo's disciple Kato Nezang Gendun here argues that both Kalachakra and Chakrasamvara tantras give 12½ sor for 1 zhal, so both support the buddhas' measurement as 125 sor.

127. See appendix 2 for a table detailing these measurement terms.

128. The eight close sons are the foremost male bodhisattvas Kshitigarbha, Maitreya, Samantabhadra, Akashagarbha, Avalokiteshvara, Manjughosha, Nivaranavishkambin, and Vajrapani. Some have many diverse aspects, especially Avalokiteshvara and Manjughosha.

129. See page 208.

130. The wrathful victory banner (*gyaltsen*) has a top ornament of a skull and trident. The sides have white horizontal and vertical strips ornamented with skulls and white strings hanging in the black spaces between.

131. Unless otherwise indicated, quotations are translated by Ven. Sean Price.

132. For an extensive explanation of this subject, see Jamgön Kongtrul, *Treasury of Knowledge*, 180ff.

133. See appendix 4 and further teachings on color on pages 262–64 and 267–72.

134. Jamgön Kongtrul, *Treasury of Knowledge*, 230.

135. Ibid., 232.

136. David Jackson, *A History of Tibetan Painting*, 50 (Wien: Verlag Der Osterreichischen Akademie Der Wissenschaften, 1996).

137. See Jamgön Kongtrul, *Treasury of Knowledge*, 246, for further details on the various scripts and the complete list of sixty-four scripts.

138. Ibid., 260–64.

139. Probably pinewood.

140. Jamgön Kongtrul, *Treasury of Knowledge*, 269.

141. Ibid., 272.

142. Ibid., 273.
143. Ibid., 275.
144. Ibid.
145. Ibid.
146. Ibid., 276.
147. Ibid., 277–82.
148. In the Nyingma tradition, the damaru is referred to as *chang teu* (hand drum). In the New Translation traditions, the damaru is referred to as *tö-nga* (skull drum), while chang teu is used for a slightly more elongated drum, with heads fastened by cord latticework. Either type of drum can be called *daru*, or damaru. Here *damaru* refers to the skull drum. See examples of both in figure 94. [KL]
149. Generally the syllable HŪṂ is blue, but here the main deity is Vajrasattva, so it is white. [KL]
150. Unless otherwise indicated, quotations are translated by Ven. Sean Price 2015.
151. Jamgön Kongtrul, *Treasury of Knowledge*, 297–98.
152. Ibid., 298–99.
153. For a detailed explanation on chanting, see ibid., 303–9.
154. Ibid., 313–14.
155. Sometimes Vairochana is said to hold the dharma wheel and Akshobhya the vajra.
156. Red mixed with green.
157. Unless otherwise indicated, quotations are translated by Ven. Sean Price 2015.
158. Similar to the yin-yang symbol, in three colors, with three swirls.
159. Anthelminthic medicine, extracted from elephant bile.
160. Although not explained in detail in this book, the five wisdom buddhas are important for the artist to understand, especially in reference to the placement and color of buddhas within the mandalas. Further teachings can be found in Thrangu Rinpoche's *The Five Buddha Families and the Eight Consciousnesses* (Boulder, CO: Namo Buddha Publications, 2013).
161. With respect to a shrine or supreme artwork in the Buddhist tradition, "right" and "left" always refer to the deity's right and left rather than the viewer's.
162. For a detailed explanation of this subject, see the excellent article by David Jackson and Janice Jackson, "A Survey of Tibetan Pigments," *Kailash: A Journal of Himalayan Studies* 4, no. 3 (1976): 273–94.
163. A traditional Tibetan alcoholic beverage made from fermented barley.
164. A mud-grass root that is burned as fuel when dried.
165. Partly adapted from Jackson and Jackson, "A Survey of Tibetan Pigments."
166. Transliterations for the Tibetan terms can be found in Jackson and Jackson, "A Survey of Tibetan Pigments," or from the Tsering Art School.

PART THREE: CONCLUDING TEACHINGS

1. The dot between syllables in Tibetan writing.
2. Translated by Ven. Sean Price.
3. The five crimes with immediate retribution are killing one's father, one's mother, or an arhat; creating a split in the sangha; and malevolently causing a buddha to bleed.
4. Patrul Rinpoche, *Words of My Perfect Teacher*, 326.

5. Shantideva, *The Way of the Bodhisattva*, 78.
6. Patrul Rinpoche, *Words of My Perfect Teacher*, 326.
7. Ibid.
8. Ibid., 326–27.
9. Ibid., 327.
10. Shantideva, *Way of the Bodhisattva*, 35
11. Özer Chenma, the consort of Hayagriva.
12. *The King of Aspirations for Noble Excellent Conduct*, trans. Padmakara Translation Group (Plazac, France: Editions Padmakara, 2007).

GLOSSARY

Achala. Miyowa (*mi g.yo ba*), one of the ten wrathful kings and one of the main meditational deities of the Kadampa school.

Achi. (*a phyi ma*) "Grandmother," a wealth deity and dharma protector of the Drigung Kagyu school.

Akanishta. (*'og min*) Unsurpassed pure realm, the highest realm of existence.

Akashagarbha. Namkhai Nyingpo (*nam mkha'i snying po*), "Essence of Space," one of the eight bodhisattvas.

Akshobya. Mikyöpa, lord of the vajra family.

Amitabha. Nangwa Taye (*snang ba mtha' yas*), "Limitless Illumination," or Öpakme (*'od dpag med*), "Buddha of Boundless Light," one of the five dhyani buddhas; the lord of the padma family.

Amitayus. Tsepakme (*tshe dpag med*), "Buddha of Boundless Life," the sambhogakaya aspect of Amitabha Buddha.

Amoghasiddhi. Döndrup (*don grub*), "Accomplishing What Is Meaningful," one of the five dhyani buddhas; the lord of the karma family.

amrita. (*bdud rtsi*) The "nectar of immortality," a samaya substance that is composed of eight primary and one thousand subsidiary substances; one of the three inner offerings in tantric Buddhist practice (along with rakta and torma).

Amrita Kundali. Dutsi Khyilwa (*bdud rtsi 'khyil ba*), a wrathful deity practiced particularly to eliminate negative influence.

Anathapindika. Gönme Zejin (*mgon med zas sbyin*), also known as Anathapindada; a generous benefactor who accommodated Buddha in Jetavana Grove at Shravasti.

archway. See tabap (*rta babs*).

art incarnation. (*bzo sprul sku*) Created nirmanakaya forms such as statues, tangkas, and sacred books.

Avalokiteshvara. Chenrezig (*spyan ras gzigs*), "All-Seeing One," the bodhisattva of compassion.

Bernakchen, Vajra Mahakala. (*mgon po ber nag can*), "The Great Black-Cloaked Vajra Mahakala," the personal protector of the Karmapas and the special protector of the Karma Kagyu school.

boxlike projections. See lombur (*glo 'bur*).

Brahma line. See tsangtik (*tshangs thig*).

buddha field. (*zhing khams*) Heavenly paradise, enlightened realm.

Butön. (*bu ston rin chen grub*, 1290–1364) A Tibetan scholar and historian who was an early compiler of the Kangyur, the Buddhist canon.

chachen. (*cha chen*) A unit of measurement used in deity iconometry and mandala drawing. It is not a fixed size but is calculated proportional to the space required for drawing the mandala or deity.

Chakrasamvara. (*'khor lo bde mchog*), "Wheel of Supreme Bliss," a yidam deity from the tantra of Anuttara yoga.

chatren. (*cha phran*) A unit of iconometric measurement equal to one-quarter of one chachen in the context of mandala measurement, and one-twelfth of one chachen in the context of deity measurement.

daruga. See sharbu (*shar bu*).

datik. (*mda' thig*) The parapet line, an important term of measurement in mandala drawing.

dayap. (*mda' yab*) In mandala drawing, the sixth and upper square frieze of white lotus petals, which represents the lotus parapet that runs around the edge of the mandala's flat roof.

Deumar Geshe Tenzin Puntsok. (*de'u smar dge shes bstan 'dzin phun tshogs*) Born in eastern Tibet in 1725, a famed Tibetan doctor who wrote the authoritative *Crystal Rosary* (*shel phreng*), a text devoted to Tibetan *materia medica*.

deva. (*yi dam*) Personal deity visualized in Vajrayana practice and depicted in tangkas and other supreme artworks.

dharmadhatu. (*chos kyi dbyings*) Sphere of reality; nature of phenomena.

dharmakaya. (*chos sku*) See kaya.

dharmata. (*chos nyid*) Suchness; the true or ultimate nature of phenomena.

dharmodaya. (*chos 'byung*) A triangle or tetrahedron representing the source of phenomena.

Dhatvishvari. (*dbyings phyug ma*) Queen of Space, a dakini.

Dilgo Khyentse Rinpoche. (*dil mgo mkhyen brtse rin po che*, 1910–1991) Born in the Derge region of Kham, eastern Tibet, he was recognized as the mind emanation of Jamyang Khyentse Wangpo (1820–1892). In Tibet, he trained at the great Nyingma monastery Shechen, which he later rebuilt in exile at Boudhanath in Nepal. Regarded by many as one of the greatest Dzogchen masters of the twentieth century and the very embodiment of Padmasambhava, as well as being a holder of all schools of Tibet and proponent of the nonsectarian (Rimey) movement, Dilgo Khyentse Rinpoche was the teacher of many important contemporary lamas.

dönam. (*'dod snam*; *'dod yon gyi snam bu*) "Platform of delights," the protruding ledge of the mandala palace for offering goddesses.

Dorje Drolö. (*rdo rje gro lod*) One of the eight aspects of Guru Rinpoche.

drawa drache. (*drva ba drva phyed*) Pendant garland ornaments. In a mandala, these are white hanging pearl pendant garlands decorating the dark hollow spaces of a divine palace. This is also the name for the fourth level of the palace. In other contexts the pendants are made from different jewels.

Drigung Chödrak. (*'bri gung chos grags*, 1597–1659) One of the main lineage holders of the Drigung Kagyu school.

druche. (*gru chad*) Literally, "corner": the square outer tier of the layered pedestal where the main mandala deity abides.

elephant's-back hollows. See lang gyap (*glang rgyab*).

face of glory. (*dzi pa tra;* kirtimukha) A swallowing fierce monster face with huge fangs and

gaping mouth, spewing hanging pendant garland ornaments. Used as a decorative motif in temples and mandalas.

fire ring. (*me ri*) Part of the surrounding canopy protecting the mandala.

five poisons. (*dug lnga*) Ignorance (*gti mug*), attachment (*'dod chags*), aversion (*zhe ldang*), pride (*nga rgyal*), and jealousy (*phrag dog*).

four beams. (*gdung bzhi*) Part of a mandala palace.

gandabhadra. (*gan dha bha dra*) One of the eight outer principal medicines.

Ganesha. (*tshogs bdag*) Also called Ganapati, an elephant-headed deity of wealth and prosperity.

garuda. (*khyung*) A mythical bird of great size; deity and enemy of the nagas.

gentsira. (*ga.nydzi ra*) A temple rooftop ornament.

gold courtyard. (*ser khyam*) An area of a mandala.

gong-re. (*gong ras*) The ground area inside a mandala's central circle, between the spokes (tsip) or petals and spoke-rest. Also known as the tsipchen.

Gönpo Gur. (*gur gyi mgon po*) Panjaranatha, "Lord of the Tent or Pavillion," a protective deity of the Sakya school.

Gönpo Lekden. (*mgon po legs ldan*) Bhagavan Mahakala, a protective deity.

Gönpo Maning. (*mgon po ma ning*) Eunuch Lord, the body emanation of Mahakala and lord of all enlightened and worldly protectors of the Nyingma school.

Guhyasamaja. Sangwa Dupa (*gsang ba 'dus pa*), "Assemblage of Secrets," a deity of the father tantras.

Guru Chöwang (Guru Chökyi Wangchuk) (*gu ru chos kyi dbang phyug*, 1212–1270), one of the five tertön kings. His name means "Master Lord of the Dharma."

Hayagriva. Tandrin (*rta mgrin*), "Horse-Headed One," one of the eight herukas.

heruka. (*he ru ka*) A wrathful meditational deity; also used as a synonym for Chakrasamvara.

Immaculate Ushnisha. Tsugtor Drime (*gtsug tor dri med*), a kriyayoga tantra deity, whose mandala is placed inside newly built stupas along with the *Spotless Rays of Light* mandala.

inner courtyard. (*nang khyam*) The courtyard of the mandala, outside the pedestal, sometimes referred to simply as *khyam;* also known as *lhanam* ("seat of the deity"), as this is where the retinue abides.

iron mountains. (*lcags ri*) The ring of mountains surrounding Mount Sumeru and the four continents.

jeweled architrave. See pagu (*pha gu*).

kagyen. (*ka rgyan*) Pillar ornaments.

Kama. (*bka' ma*) Oral lineage; scripture; the canonical teachings of the Buddha.

Karma Chakme Raga Asya. (*karma chags med rā ga a sya*, 1613–1678) The lama who established the Nedo Kagyu (*gnas mdo bka' brgyud*) subschool of the Karma Kagyu.

Karmey Khenpo Rinchen Dargye (b.1823?) A reincarnation of the great pandita Shantarakshita. He had his own seat at the great monastery Karmey Gön in Kham. Although he was a disciple of Chokgyur Lingpa, his background was Karma Kagyu.

kaya. (*sku*) Literally, "body," in the sense of an embodiment of numerous qualities. The three kayas are (1) the dharmakaya, "body of truth," the absolute or emptiness aspect of buddhahood; (2) the sambhogakaya, "body of perfect enjoyment," which is the aspect of spontaneous clarity, perceptible only to beings of extremely high realization; and (3) the nirmanakaya, "body of manifestation," the compassionate aspect, perceptible to ordinary beings and appearing most often in human form. When four kayas are enumerated, the

fourth is the svabhavikakaya, "body of suchness," which is the union of the other three kayas. The three kayas are sometimes condensed into two: (1) the dharmakaya and (2) the rupakaya, "form body," which includes the sambhogakaya and nirmanakaya.

khoryuk. (*'khor yug*) "Environment"; the outer surrounding area of the mandala palace (up to the fire ring); ramparts.

khyam. (*khyam*) An empty space or area; specifically, the courtyard area of the mandala court between the square pedestal and the walls or other empty areas of the mandala.

Kshitigarbha. Sayi Nyingpo (*sa yi snying po*), "Essence of Earth," one of the eight bodhisattvas.

ladre. (*bla bre*) The rectangular brocade canopy suspended from the ceiling above the guru's throne.

lang gyap. (*glang rgyab*) "Elephant's back"; the extension of dark hollow space beneath the mandala archway.

lhadripa. (*lha bris pa*) Icon painter; artist of deities.

lhanam. (*lha snam*) See inner courtyard.

local guardians. (*zhing skyong*; kshetrapala, lokapala) Multiheaded beings who dwell in charnel grounds; protectors of sacred places.

Lochen Dharmashri. (*lo chen dha rma shri*, 1654–1717) Also named Ngawang Chöpal Gyatso (*ngag dbang chos dpal rgya mtsho*), one of the greatest scholars and masters of the Nyingma school, whose collected writings fill twenty volumes. He was an emanation of Yudra Nyingpo and the younger brother of Minling Terdak Lingpa Gyurme Dorje, the founder of Mindroling Monastery.

lombur. (*glo 'bur*) The four boxlike decorative projections at the central edge of the deity's square pedestal (druche).

Lord of Secrets. Sangdak Tumchen (*gsang bdag gtum chen*), a yama-style wrathful deity.

Mahakala Ganapati. (*mgon po tshogs bdag*) Ganesha (Ganapati), a deity of wealth and prosperity.

Mahayana. (*theg pa chen po*) "Great Vehicle," one of the three main vehicles of Buddhism. Mahayana also refers to the path of the bodhisattva seeking complete enlightenment for the benefit of all sentient beings and is thus also called the Bodhisattvayana or Bodhisattva Vehicle.

Maitreya. Jampa (*byams pa*), "The Loving One," the bodhisattva regent of Buddha Shakyamuni, presently residing in the Tushita heaven until becoming the fifth buddha of this aeon.

mala. (*phreng ba*) A rosary or string of beads used for counting mantras.

Manjushri. Jampalyang (*'jam dpal dbyangs*), buddha of wisdom; also one of the eight bodhisattvas.

medicinal clay. (*sman rdza*) Clay mixed with sacred substances.

medicinal statue. (*sman sku*) An image made from medicinal clay.

mendrup. (*sman sgrub*) Blessed medicinal substances.

midway courtyard. (*bar khyam*) A courtyard in a mandala with more than one court, such as *Wrathful Magical Net*.

Minling Terdak Lingpa Gyurme Dorje. (*smin gling gter chen o rgyan gter bdag gling pa 'gyur med rdo rje*, 1646–1714) Terdak Lingpa was a great master and tertön of the Nyingma lineage. Together with his brother Lochen Dharmashri, he played an important role in the transmission of the Nyingma Kama, bringing together the Rong lineage of central Tibet and the Kham lineage of eastern Tibet. The two brothers also compiled the terma collec-

tion known as the Döjo Bumzang, which was a precursor of the Rinchen Terdzö. Terdak Lingpa established the great Mindroling Monastery of the Nyingma tradition in 1676.

Miwang Sangye Gyatso. (*mi dbang sangs rgyas rgya mtsho*, 1653–1705) A great scholar of Tibet.

Mount Sumeru. (*ri'i rgyal po*) King of mountains, at the center of the universe.

mukyu. (*mu khyud*) A rim, or anything circular. In the context of mandala drawing, this refers particularly to the double circular rims around the central circle, representing the vajra beam, spoke-rest, and the like.

munpa. (*mun pa*) "Region of darkness," the vertical innermost section at the mandala doorway, extending down from the *lang gyap miksum* between the walls and the pillar. Depicted as black with white hanging pendant garlands. See also lang gyap.

naga. (*klu*) A class of powerful serpent spirits, owners of the land or earth lords.

Naro Khachö. (*na' ro mkha spyod*), "Magic Stick," the name of a dakini.

Ngawang Kunga Tenzin. The third Kamtrul Rinpoche (1680–1729) of the Drugpa Kagyu lineage, a great master of painting, sculpture, astrology, and medicine.

nirmanakaya. (*sprul sku*) See kaya.

Nyang Ral Nyima Özer (*nyang ral nyi ma 'od zer*, 1124–1192) The first of the five tertön kings and a reincarnation of King Trisong Deutsen. Several of his revealed treasures are included in the Rinchen Terdzö, of which the most well known is the *Kagye Deshek Dupa*, a cycle of teachings focusing on the *Eight Sadhana Teachings*. Nyang Ral means "Braided One from Nyang," and Nyima Özer means "Ray of Sunlight."

oath-bound protectors. (*dam can*) Dharma protectors who have vowed to guard the teachings. In wrathful mandalas, the surrounding area for the oath-bound protectors is depicted as blood red or black.

outer courtyard. (*phyi khyam*) The outer empty area in the mandala, between the datik and khoryuk surrounding area.

pagu. (*pha gu*) Jeweled architrave border at the top of the mandala palace walls; the third square linear section of the mandala, a frieze of colored geometrical forms.

palace. (*pho brang*) The celestial mansion of the mandala deity.

parapet. See dayap (*mda' yab*).

pedestal. See druche (*gru chad*).

Pema Dongak Lingpa. (*pad ma mdo ngag ling pa*) The tertön name of Dilgo Khyentse Rinpoche.

pendant garland ornaments. See drawa drache (*drva ba drva phyed*).

phen. (*phan*) A hanging multicolored cloth ornament in downturned triangular layers.

physical art of supreme speech. (*gsung rten*) A technical term for sacred scriptures and other sacred writing.

pillar ornament. (*ka rgyan*) Multicolored pillar ornaments at the sides of the mandala doors.

platform of delights. See dönam.

preta. (*yi dvags*) A tormented spirit or hungry ghost, one of the six classes of beings of the desire realm.

puja. (*mchod*) Offering, worship.

Purna. (*gang po*) An important monk follower of the Buddha, an arhat of the Abhidharma tradition.

queen's courtyard. (*dbang mo'i khyam*) A name for the outer celestial courtyard area of a mandala that has two inner mandalas.

rainspout cornice. See sharbu (*shar bu*).

rakshasa. Sinpo (*srin po*), a cannibal demon or ogre.

rakta. (*khrag*) Blood. A tantric substance: one of the three smeared substances, and one of the three inner offerings, along with amrita and torma.

Ratnasambhava. Rinchen Jungne (*rin chen 'byung gnas*), one of the five dhyani buddhas; the lord of the ratna family.

rear area with three elephant's back hollows. (*glang rgyab mig gsum*) Part of the mandala doorways, depicted as black with white hanging pendant garlands.

Red Bhairava. Shinje Shemar (*gshin rje gshed dmar*), a wrathful deity.

resultant archways. (*'bras bu'i rta babs*) Mandala palace door archways.

rinpoche. (*rin po che*) Literally, "precious jewel"; a title given to reincarnate lamas.

rudra. (*ru dra*) A type of unruly half-god half-demon; the demon of ego-clinging.

rupakaya. (*gzugs sku*) See kaya.

sadak. (*sa bdag*) Earth-owner spirits; demons of the naga class.

Sadak Toche. (*sa bdag lto 'phye*) The naga king.

sadhana. (*sgrub thabs*) Literally, "means of accomplishment"; tantric liturgy and procedure for practice, usually emphasizing the development stage. The typical sadhana structure involves a preliminary part including taking refuge and arousing bodhichitta, a main part involving visualization of a deity and recitation of the mantra, and a concluding part with dedication of merit to all sentient beings.

Samantabhadra. Kuntuzangpo (*kun tu bzang po*), "Thoroughly Good," the first of the eight bodhisattvas, used as the example for the perfection of increasing an offering infinitely. In the Nyingma tradition, Samantabhadra is the name of the primordial buddha.

sambhogakaya (*longs sku*) See kaya.

Sangye Lingpa. (*sangs rgyas gling pa*, 1340–1396) A reincarnation of the second son of King Trisong Deutsen; a major tertön and revealer of the *Lama Gongdu* cycle in thirteen volumes. His name means "Sanctuary of Awakening."

Sarvanivaranavishkambhin. Drippa Namsel (*sgrib pa nam sel*), one of the eight bodhisattvas.

sea monster. (*chu srin*; makara) A mythological dragon-like or crocodile-like water creature.

sharbu. (*shar bu*) The cornice along the beams of the roof with decorative rainspout motifs. The fifth layer of the mandala palace. Daruga (*da ru ga*) is a synonym.

sharbu zaratsak. (*shar bu za ra tshags*) The watercourse motif of the sharbu.

Shri Devi. Palden Lhamo Makzor Gyalmo (*dpal ldan lha mo dmag zor rgyal mo*), a wrathful protectress.

six transcendent perfections. (*pha rol tu phyin pa drug;* paramita) Six qualities developed on the bodhisattva path: generosity (*sbyin pa*), ethics (*tshul khrims*), patience (*bzod pa*), diligence (*rtson 'grus*), meditative concentration (*bsam gtan*), and discriminating wisdom-awareness (*shes rab*).

sixteen offering goddesses. (*mchod pa' lha mo bcu drug*) Sixteen vajra goddesses (*rdo rje lhamo bcu drug*) who make offerings to the main deity of the mandala. They are situated as follows: to the east, (1) the lute goddess (Piwangma), (2) the flute goddess (Lingbuma), (3) the clay-drum goddess (Dzangama), (4) the round-drum goddess (Ngadumma). To the south, (5) the goddess of charm (Gekmoma), (6) the goddess of laughter (Shyema) or goddess of garlands (Trengwama), (7) the goddess of song (Luma), (8) the goddess of dance (Garma). To the west, (9) the goddess of flowers (Metokma), (10) the goddess of incense (Dukpöma), (11) the goddess of light (Marmema) or lamp goddess (Nangselma), (12) the goddess of perfume (Drichapma). To the north, (13) the goddess of form

(Zukma) or mirror goddess (Melongma), (14) the goddess of taste (Roma), (15) the goddess of touch (Rekchama), (16) the goddess of dharmadhatu (Chökyiyingma).

sky line. (*gnam thig*) The lines symbolically "drawn" in the sky above a mandala; also called a wisdom line (*ye thig*). A line made with a plumb can also be called a sky line.

spoke. See tsip (*rtsibs*).

spoke-rest. See tsipden (*rtsibs gdan*).

Stainless Two. (*dri med rnam gnyis*) The two mandalas placed inside a stupa: *Tsuktor Drime* (*Immaculate Ushnisha*) and *Özer Drime* (*Spotless Rays of Light*).

sugatagarbha. (*bde gshegs snying po*) Buddha nature, the essence of enlightenment present in all sentient beings. A synonym for tathagatagarbha.

supreme body representation. (*sku rten*) Representations of the Buddha's body in the form of images and sacred objects.

svabhavikakaya. (*ngo bo nyid sku*) See kaya.

tabap (*rta babs*) The pediments above the mandala palace doors consisting of four, eight, or eleven levels.

tail fan. (*nga yab*) A decorative tassel, yak-tail fan, or whisk ornamenting the mandala.

tangka. (*thang ka*) A Tibetan scroll painting.

Tara. (*sgrol ma*) A female bodhisattva.

tathagatagarbha. (*de bzhin gshegs pa'i snying po*) Buddha nature, the primordial, enlightened nature of all sentient beings, obscured by adventitious defilements from the deluded apprehension of a truly existent self and other.

terma. (*gter ma*) Concealed and rediscovered treasure teachings or sacred blessed objects.

tertön. (*gter ston*) One who discovers or reveals terma, due to his or her purified perception.

three kayas. (*sku gsum*) See kaya.

three noble principles. (*sbyor dngos rjes gsum*) (1) The preliminary, which is to begin one's practice by generating bodhichitta (*sems bskyed*); (2) the main practice (*dngos gzhi*), which is any act of virtue undertaken without fixation on the three spheres of subject, object, and action; and (3) the conclusion, which is to seal one's practice by dedicating the merit (*bsngo ba*) toward the enlightenment of all sentient beings.

three roots. (*rtsa gsum*) Producers of dharma: the root of blessing is the guru, the root of accomplishment is the deva, and the root of activity is the dharma protector.

three samadhis. (*ting 'dzin rnam gsum*) The samadhi of suchness, the samadhi of total illumination, and the causal samadhi.

three spheres of activity. (*'khor gsum*; trimandala) The agent, the action, and the object of the action.

torma. (*gtor ma*; baling) A sculpted "cake" made from edible substances and used as an offering.

Trengkhawa Palden Zangpo. (*'phreng kha ba dpal ldan bzang po, 1447–1507*) Also known as Tulku Tanak (*sprul sku rta nag*), a scholar of the Geluk tradition.

tru. (*khru*) A forearm's length in measure; a cubit.

Trulshik Rinpoche Ngawang Chökyi Lodrö. (*'khrul zhig ngag dbang chos kyi blo gros, 1924–2011*) One of the seniormost lamas of Tibetan Buddhism. He was considered the spiritual heir of Kyapje Dilgo Khyentse Rinpoche and became a teacher to His Holiness the Fourteenth Dalai Lama, and in 2010 the head of the Nyingma school.

Tsamo Rongpa Sönam Özer. (*tsha mo rong pa bsod nams 'od zer*) A thirteenth-century master who was a disciple of the fifth patriarch of the Sakya lineage, Pakpa Lodrö Gyaltsen (1235–1288), and wrote a treatise on iconometry of mandalas and images.

tsangtik. (*tshangs thig*) "Brahma line," the central vertical line of a deity drawing or mandala, one of the eight preliminary lines.

tsatik (*rtsa thig*) The innermost line for the five walls of the main celestial palace of the mandala; it is also one of the primary points of mandala drawing measurement.

tsen. (*btsan*) One of the eight kinds of gods and spirits.

tsikpa. (*rtsig pa*) Walls of a mandala palace; they can also be one or three layers.

tsip. (*rtsibs*) Spokes, usually of a wheel, but can also refer to the pointed end of the straight-edged knife-wheel blades or round-edged jewel-wheel blades, which are types of chakra wheels in the center of a mandala. The knife wheel is only used in wrathful deity mandalas, and the jewel wheel can be used for peaceful deity mandalas.

tsipchen. (*rtsibs chen*) Also known as gong-re (*gong ras*), the space between the tsip and the tsibden.

tsipden. (*rtsibs gdan*) Spoke-rest; in a mandala, the circular rim where the point of the knife- or jewel-wheel spoke (*tsip*) rests.

urnakesha. (*mdzod spu*) The coiled hair treasure at the forehead of a buddha.

ushnisha. (*gtsug tor*) The crown protuberance on the head of a buddha.

utpala. A kind of blue flower.

Vairochana. Nampar Nangdze (*rnam par snang mdzad*), one of the five dhyani buddhas; the lord of the buddha family.

vajra. (*rdo rje*) Diamond/adamantine scepter, a samaya ritual implement of Vajrayana practice, never separate from its partner, the ritual bell with a half-vajra handle, symbolizing skillful means and wisdom, respectively.

vajra beams. (*rdo rje gdung*) Part of the mandala. These can consist of circular (*gdung zlum*) or straight beams made of vajras, forming part of the palace, placed at the center of the mandala diagram.

vajra fence (*rdo ra; rdo rje'i ra ba*) The protective circular fence or canopy of vajras surrounding a mandala.

Vajrayana. (*rdo rje theg pa*) "Diamond Vehicle"; the tantric tradition of Buddhism, a branch of the Mahayana.

vase. (*bum pa*) A ritual tantric vessel containing sacred purifying water.

victory banner. (*rgyal mtshan*) A tube-shaped multicolored ornamental hanging brocade, or its equivalent in sculptural or architectural form.

Vinaya. (*'dul ba*) A set of teachings on Buddhist monastic discipline.

wall line. See tsatik.

wheel spokes (*'khor lo'i rtsibs*) The spokes or points (tsip) of the blades of a jewel- or knife-wheel in a mandala.

wisdom line. (*ye thig*) See sky line.

yaksha. (*gnod sbyin*) A wrathful deity and a type of wealth deity.

Yama. Shinje (*gshin rje*), "Lord of the Dead." A wrathful deity and a class or type of wrathful divinity. A personification of impermanence and the unfailing law of cause and effect.

Yamantaka. Shinje She (*gshin rje gshed*), Vajrabhairava, a wrathful form of Manjushri.

yidam. See deva.

zi stone (*gzi*) A divine agate or onyx with eye-shaped markings, held to have protective properties.

Translation Equivalents

English	Tibetan	Sanskrit
action tantra	*bya rgyud*	kriya
aeon	*bskal pa*	kalpa
afflicting emotions	*nyon mongs pa*	klesha
anklets	*zhabs gdub*	
armlets made of human skull fragments	*tshal bu'i dpung rgyan*	
art emanation	*bzo yi sprul sku*	
artist	*bzo bo*	
arts	*bzo rig pa*	
aspiration prayer	*smon lam*	
attendant deities	*bka' sdod*	
auspicious seated posture [of Maitreya]	*bzang po'i stabs*	
bag of pestilence	*nad kyi rkyal ba*	
ball of yarn	*mtshon gyi gru gu*	
banner	*ba dan*	
battle-ax	*dgra sta*	
big club	*beng chen*	
blood-filled skull cup	*thod khrag*	
bodhisattva's posture	*sems dpa'i skyil krung*	
bone earrings	*ska rags bya grub*	
bone latticed skirt with sixty-four crosshatches over a tiger-skin skirt	*sku smad stag sham kyi sten du rus pa'i drva mig re bzhi*	
bone necklace with sixteen cross-meshed arrangements	*rus pa'i drva mig bcu drug mgul rgyan*	

ENGLISH	TIBETAN	SANSKRIT
bone ornaments	*rus rgyan*	
bone pendants	*'phyang 'phrul*	
bone skirt with sixty-four crosshatches	*sna cha sor rtog*	
bow-shaped eyes	*gzhu spyan*	
bracelets	*phyag gdub*	
buddha	*sangs rgyas*	
buddha nature	*bde gshegs snying po*	sugatagarbha
buddhas of the ten directions	*phyogs bcu'i sangs rgyas*	
calligrapher	*yig mkhan*	
causal samadhi	*rgyu'i ting nge 'dzin*	
central prong [of a vajra]	*dbus rwa*	
ceremonial dagger	*phur bu / phur ba*	
charnel ground	*dur khrod*	
circular vajra beam	*gdung zlum*	
color pigment	*tshon rtsi*	
commitment being	*dam tshig sems dpa'*	samayasattva
common physical arts	*lus bzo phal pa*	
common vocal arts	*ngag bzo phal pa*	
completion stage	*rdzogs rim*	sampanakrama
Conquest of Mara Stupa	*bdud 'dul mcho rten*	
consecration	*rab gnas, rab tu gnas pa*	pratishta, supratishta
corpse mace	*bam dbyug*	
cross-legged bodhisattva posture	*sems dpa'i skyil krung*	
cross-legged posture	*skyil krung*	
crossed vajra	*rdo rje rgya gram*	vishvavajra
crouching posture	*tsog pu'i stabs*	
crown of five dry skulls	*thod pa skam po lnga'i dbu gyan*	
curlicues	*pa tra*	
cursive shorthand script	*dkyus yig*	
curved knife	*gri gug*	
dakini	*mkha' 'gro ma*	
damaru	*thod rnga*	

ENGLISH	TIBETAN	SANSKRIT
dark-blue diadem	*mthing nag cod pan*	
dedication of merit	*bsngo ba*	
demigod	*lha ma yin*	asura
demon/obstacle	*bgegs*	vighna
demon/devil	*bdud*	mara
development stage	*bskyed rim*	utpattikrama
dharma protectors	*chos skyong*	dharmapalas
dharma relics	*chos kyi ring bsrel*	
dharma wheel	*chos kyi 'khor lo*	dharmachakra
Dharmaraja	*chos rgyal*	
double-stringed bone girdle	*se ral kha rus phreng*	
earth-touching mudra	*sa gnon phyag rgya*	bhumi-akramana mudra
eight auspicious symbols	*bkra shis rtags brgyad*	
eight bringers of good fortune	*bkra shis rdzas brgyad*	
eight charnel-ground ornaments	*dur khrod chas brgyad*	
eight charnel grounds	*dur khrod brgyad*	
eight great stupas	*mchod rten che'i brgyad*	
eight jewel ornaments	*rin po che'i rgyan brgyad*	
eight natural signs of wrathful deities	*dpal gyi chas brgyad*	
eight-spoked (knife or wheel)	*rtsibs brgyad*	
elephant-skin cloak	*glang chen gyi ko rlon*	
empowerment	*dbang bskur*	abhisheka
emptiness	*stong pa nyid*	shunyata
enlightenment	*byang chub*	bodhi
enlightenment mudra	*byang chub mchog gi phyag rgya*	dharmachakra mudra; bodhyangi mudra
essential mantra of the tathagatas	*de bzhin gshegs pa spyi'i snying po*	
female appearance	*yum*	
fire puja	*sbyin sreg*	
five aggregates	*phung po lnga*	skandhas, panchaskandha

ENGLISH	TIBETAN	SANSKRIT
five bone ornaments of the female deities	*yum la rus pa'i phyag rgya lnga*	
five silken garments	*dar gyi chas gos lnga*	
five types of dharani	*gzungs chen sde lnga*	
flame lasso	*me zhags*	
flayed human skin	*zhing chen gyi pags pa*	
form	*gzugs*	rupa
formal handwriting script	*bshur ma*	
Four-Armed Mahakala	*mgon po phyag bzhi pa*	
four boundless attitudes	*tshad med bzhi*	
four doors of the secret teaching	*gsang sngags lung sgo bzhi*	
four harmonious friends	*mthun pa spun bzhi*	
four kayas	*sku bzhi*	
four kinds of birth	*skye gnas bzhi*	
four noble truths	*'phags pa'i bden pa bzhi*	
four spontaneous enjoyments	*lhun grub gyi 'dod yon bzhi*	
four stakes that bind the life force	*srog sdom gzer bzhi*	
four thoughts that change the mind	*blo ldog rnam bzhi*	
frankincense	*gu gul*	
fresh skull with hair	*thod pa lcang lo can*	
front curtain (of a tangka)	*mdun kheb*	
garland of light	*'od 'phreng*	
grain-shaped eyes	*'bru spyan*	
Green Tara	*sgrol ljang*	
guardians of the directions	*phyogs skyong*	
guru	*bla ma*	
hair tied in a knot	*dbu skra gyen brdzes*	
half-vajra posture	*skyil krung phyed pa*	ardha-paryanka
halo	*dbu yol*	
hammer	*tho ba*	
hand drum	*cang te'u*	
hand implements	*phyag mtshan*	
headed block-letter script	*gzab chen* or *dbu can*	

ENGLISH	TIBETAN	SANSKRIT
headless block-letter script	*gzab chung*	
headless thick script	*'bru chen* or *dbu med*	
headless thin italic script	*'bru chung*	
heart	*snying*	
hearth	*me thab*	
hero's posture	*dpa' bo'i 'dug stang*	
heroine's posture	*dpa' mo'i 'dug stang*	
Heruka of Supreme Power	*dbang mchog he ru ka*	
human skin	*zhing lpags* or *gyang gzhi*	
hundred syllables of the tathagatas	*de bzhin gshegs pa'i ye ge brgya pa*	
impaling stake	*gsal shing*	
interdependent connection	*rten 'brel*	
intestines	*rgyu zhags*	
iron chain	*lcags sgrog*	
iron hook	*lcags kyu*	
Jnanabimbakaya Stupa	*ye shes gzugs kyi sku*	
kilaya with end part	*phur mjug can*	
lance	*mdung ring*	
lance banner	*mdung dar*	
league	*dpag tshad*	yojana
life-tree	*srog shing*	yupa
long-life arrow	*mda' dar*	
long musical horn	*dung chen*	
long necklace of fifty fresh dripping heads	*rlon pa lnga bchu'i do shal*	
lotus	*pad ma*	
lotus posture	*pad ma skyil krung*	
Mahamudra	*phyag rgya chen po*	
Mahottara Heruka	*che mchog he ru ka*	
malicious demon	*rgyal 'gong*	
mantra wheel	*'khor lo*	chakra

English	Tibetan	Sanskrit
meditation mudra	*mnyam bzhag phyag rgya*	dhyana mudra
merit	*bsod nams*	
mighty coat of armor	*dbang gi bse khrab gzi 'bar*	
monastic dance	*'cham*	
monk's staff	*mkhar gsil*	
mudra	*phyag rgya*	
mudra of giving	*mchog sbyin phyag rgya*	varada mudra
mudra of granting refuge	*skyabs sbyin*	
mudra of protection	*mi 'jigs pa'i phyag rgya*	abhaya mudra
nine expressions of the dance	*gar gyi nyams dgu*	
nine traits of the peaceful deities	*zhi ba'i tshul dgu*	
nine vehicles	*theg pa dgu*	
noose	*zhags pa*	
obstructors	*bgegs*	vighna
Ox Hill Prophecy Stupa	*glang ru lung bstan*	
parasol	*gdugs*	chattra
patron	*yon bdag*	
pendant garlands	*drva ba drva phyed*	
perfect swirling jewel	*nor bu dga' 'khyil*	
pestle	*gtun shing*	
pistils	*ze 'bru*	
plow	*thong gshol*	
posture of balance	*mnyam pa'i stabs*	
posture of happiness	*bde legs skyil krung*	
preliminary	*sngon 'gro*	
queen's courtyard	*dbang mo'i khyam*	
Ranjana script	*lanydza*	Lentsa
relics of bone remains	*sku gdung ring bsrel*	
relics of clothing	*sku bal ring bsrel*	
relics of the body of reality	*chos sku'i ring bsrel*	
relics the size of mustard seeds	*yungs 'bru lta bu'i ring bsrel*	

English	Tibetan	Sanskrit
restore and repair ritual	*a.rga'i spo chog*	
ritual bladed weapons	*mtshon cha rnams*	
round-bellied urn	*ril ba spyi blug*	
Rudra's iron execution pot	*gtun khung*	
sacred pearl-like relics	*ring bsrel*	
samadhi of suchness	*de bzhin nyid kyi ting nge 'dzin*	
samadhi of total illumination	*kun tu snang ba'i ting nge dzin*	
scored stick	*khram shing*	
secret vajra	*gsang ba'i rdo rje*	
semicircle	*zla gam*	
semiwrathful deities	*zhi ma khro*	
seven jewels of the aryas	*'phags pa'i nor bdun*	
seven precious gems	*nor bu rin po che rnam bdun*	
seven precious royal emblems	*rgyal srid rin chen rnam bdun*	
seven secondary treasures of the chakravartin	*nye ba'i rin chen rnam bdun*	
sexual union	*yab yum*	
Shiva	*drag po*	
short lance	*mdung thung*	
silk streamers/ribbons	*dar 'phyangs*	
Six-Armed Mahakala	*mgon po phyag drug*	Saḍbhuja mahakala
six bone ornaments	*rus pa'i rgyan drug*	
six ornaments	*rgyan drug*	
six ornaments on the backrest	*khri rgyab rgyan drug*	
six symbols of longevity	*tshe ring skor drug*	
skull cup	*ka pa la*	
skull drum	*thod rnga*	
skull garland	*thod phreng*	
skull rim	*thod rwa*	
skull staff	*thod dbyug*	
small knife	*chu gri*	
snake lasso	*sbrul zhags*	

English	Tibetan	Sanskrit
stable pride	nga rgyal rten pa	
standing posture	bzhengs stabs	
standing posture of dancing on one leg	bzhengs pa'i phyed skyil	
standing posture of Vaisakha	sa ga'i stabs	
stupa	mchod rten	
Stupa Defeating Extremists	mu stegs pham byed kyi mchod rten	
Stupa of Auspicious Origin	bkra shis 'byung ba'i mchod rten	
Stupa of Blessings	byin rlabs mchod rten	
Stupa of Complete Victory	rnam rgyal mchod rten	
Stupa of Heaped Lotuses	pad ma spungs mchod rten	
Stupa of Intangible Glory	dpal reg pa med pa'i mchod rten	
Stupa of Manifest Loving-Kindness	byams dngos mchod rten	
Stupa of Many Auspicious Doors	chos 'khor bkra shis sgo mang mchod rten	
Stupa of Miracles	cho 'phrul mchod rten	
Stupa of Parinirvana	mya ngan 'das pa'i mchod rten	
Stupa of Pristine Cognition	ye shes kyi mchod rten	
Stupa of Reconciliation	dbyen bzlums mchod rten	
Stupa of Solar Rays	'od zer can gyi mchod rten	
Stupa of Supreme Enlightenment	byang chub chen po'i mchod rten	
Stupa of the Descent from Heaven	lha bab mchod rten	
Stupa of the Sugatas	bde gshegs mchod rten	
Stupa of the Thirty-Three Gods	sum cu rtsa gsum lha'i mchod rten	
Stupa of the Wheel of the Sacred Teachings	chos 'khor mchod rten	
Stupas Consecrated by Blessings	byin gyis brlabs pa mchod rten	
Stupas of Genuine Accomplishment	dngos grub 'byung ba	
Stupas Specific to the Different Vehicles	theg pa so so'i mchod rten	
styles	rnam 'gyur	

ENGLISH	TIBETAN	SANSKRIT
sun and moon seat	*nyi da*	
sun seat	*nyi gdan*	
supreme art	*mchog gi bzo rigs*	
sword	*ral gri*	
tangka brocade	*sku thang gi gong sham*	
tangka painter	*lha bri pa*	
Tara	*sgrol ma*	Arya Tara
ten glorious ornaments of wrathful deities	*dpal gyi chas bcu*	
ten powers	*stobs bcu*	
thigh-bone trumpet	*rkang gling*	
thirteen requisites of a monk	*dge slong gi 'tsho ba'i yo byad bcu gsum*	
thirty-two cross-meshes	*drva mig so gnyis*	
throne	*khri*	
throne front	*khri gdong*	
throne legs	*khri rkang*	
throne seat	*khri gdan*	
tiger-skin skirt	*stag lpags kyi sham thabs*	
town stupa	*mchod rten grong*	
treatise	*bstan bcos*	shastra
trident	*tri shu la* or *rtse gsum*	
turning the wheel of dharma mudra	*chos kyi 'khor lo'i phyag rgya*	dharmachakra mudra
twelve links of dependent origination	*rten 'brel bcu gnyis*	
Ultimate Self-Originated Great Stupa	*rang byung mchod rten chen po rje bo dam pa*	
uncommon stupa	*thun mong ma yin pa'i mchod rten*	
underground vajra	*'og gzhi'i rdo rje*	
unsurpassable stupa	*bla na med pa mchod rten*	
vajra at the crown	*spyi gtsug rdo rje*	
vajra garuda wings	*rdo rje'i khyung gshog*	
Vajra Hungchen Kara	*rdo rje hung mdzad*	

ENGLISH	TIBETAN	SANSKRIT
vajra master	*rdo rje slob pon*	vajra acharya
vajra posture	*rdo rje skyil krung*	vajrasana
vajra staff	*rdo rje be con*	
Vajra Ushnisha	*rdo rje gtsug tor*	
vajra with raised spokes	*rdo rje rva dengs*	
Vajradhara	*rdo rje 'chang*	
Vajrakilaya	*rdo rje phur pa*	
Vajrakilaya from the Razor Scriptures	*phur pa spu gri*	
Vajrapani	*phyag na rdo rje*	
Vajrapani the Conqueror	*phyag rdor 'byung 'dul*	
Vajrasattva	*rdo rje sems dpa'*	
Vajratopa	*rdo rje snyem ma*	
Vajravarahi	*rdo rje phag mo*	
Vajrayogini	*rdo rje rnal 'byor ma*	
victorious ones of the six families	*rgyal ba rigs drug*	
Vishnu	*khyab 'jug*	
wall	*rtsig pa*	
wall line	*rtsa thig*	
watercourse motif	*za ra tshags*	
wheel	*'khor lo*	chakra
wheel on the crown of the head	*'khor lo chos dbyings mtshon byed*	
White Tara	*sgrol dkar*	
wind lasso	*rlung shags*	
wisdom being	*ye shes sems dpa'*	jnanasattva
wisdom line	*ye thig*	
working line	*las thig*	
Wrathful Black Vajravarahi	*phag mo khros ma nag mo*	
wrathful eyes	*khro spyan*	
wrathful wheel	*drag po'i 'khor lo*	
Wrathful Yama	*gshin rje khros pa*	
yogic postures	*yang stangs stabs kyi khyad par*	

Bibliography

The original Tibetan text for *The Art of Awakening*

Lhadrepa, Konchog. *The Path to Liberation: The Tsering Art School Manual for the Basic Gradual Stages of Study of Deity Drawing* (tshe ring bzo rigs slob grva'i lha sku bzheng thabs kyi sngon 'gro nag 'gros su bkod pa thar pa'i lam ston chen mo zhes bya ba bzhugs so). Delhi: Shechen Publications, 2005.

Primary Texts

Catalog of Treatises on the Buddha's Words (bstan 'gyur dkar chag)

Chetsun Senge Wangchuk (lce btsun seng ge dbang phyug, 12th c.)
 Song of Spiritual Realization (lce btsun chen po'i mgur)

Chobgye Trichen Rinpoche, Ngawang Khyenrap Lekshe Gyatso
 The Collected Writings of Chobgye Trichen Rinpoche (bco brgyad khri chen ngag dbang mkhyen rab legs bshad rgya mtsho'i gsung 'bum)

Chöying Dorje, 10th Karmapa (karma pa chos dbyings rdo rje, 1604–1674)
 Radiant Victorious Sun Art Manual (thig yig rnam rgyal nyi ma'i 'od zer)
 Detailed Explanation on Deity Painting, Which by Merely Seeing Brings Success (bris sku'i rnam bshad mthong ba don ldan)

Deumar Geshe Tenzin Puntsok (de'u smar dge shes bstan 'dzin phun tshogs, b. 1725)
 A Brilliant Bouquet: A Clear Explanation for the Process of Preparing Pigments (kun gsal tshon gyi las rim me tog mdangs ster 'ja' 'od 'bum byin)

Drigung Chödrak ('bri gung chos grags, 1597–1659)
 An Ocean of Merit and Wisdom: Instructions for Filling Sacred Objects with the Five Types of Relic (ring bsrel lnga'i bzhugs tshul lag len tshogs gnyis rgya mtsho)

Dungkar Lobsang Trinley (dung dkar blo bzang 'phrin las, 1927–1997)
 Great Dictionary (dung dkar tshig mdzod chen mo)

Jamgön Kongtrul Lodrö Taye ('jam mgon kong sprul blo gros mtha' yas, 1813–1900)
 Treasury of Knowledge (shes bya mdzod)

Jamgön Mipham Gyatso ('jam mgon mi pham rgya mtsho, 1846–1912)
 Collected Works (mi pham gsung 'bum)

The Brilliant Sun: Iconographic Proportions (sku gzugs kyi thig rtsa rab gsal nyi ma)
A Method for Drawing Chakra Wheels ('khor lo'i bris thabs)
Mipham's Art of Drawing Curlicues (mi pham bzo rigs pa tra)

Jamyang Khyentse Wangpo ('jam dbyangs mkhyen brtse'i dbang po, 1820–1892)
 An Instruction Manual for the Painting of Tangkas, Tsakli, Calligraphy, and So On,
 Covering the Entire Teaching of the Snowy Land (gangs can bstan pa yongs rdzogs bris
 thang dang rtsakli sogs bris yig)
 Writings on Various Aspects of Science and Culture (rig gnas sna tshogs)

Jigme Lingpa ('jigs med gling pa rang byung rdo rje, 1729/30–1798)
 The All-Pervasive Ornament of the World: The Precious History of the Collected Nying-
 mapa Tantras (snga 'gyur rgyud 'bum rin po che'i rtogs brjod 'dzam gling tha gru khyab
 pa'i rgyan)
 Bodhi Tree: A Presentation of the Measurement for the Eight Stupas (mchod rten brgyad
 kyi thig gi gtam byang chub ljon shing)
 A Collection of Anecdotes and Discourses (kun mkhyen gsung gtam tshogs)
 Commentaries to the Treasury of Precious Qualities: The Chariot of the Two Truths and the
 Chariot to Omniscience (yon tan mdzod 'grel pa bden gnyis shing rta dang rnam mkhyen
 shing rta)
 Commentary to the Condensed Realization of the Gurus (dgongs 'dus rnam bshad)
 The Mirror Reflecting the Brilliance of Wisdom and Compassion: A Commentary on the
 Condensed Realization of the Gurus (bla ma dgongs 'dus cho ga'i rnam bshad mkhyen
 brtse'i me long 'od zer brgya pa)
 A Ritual to Repair Artworks (ar ga'i spo chog)
 The Tantra System of Vajrakilaya (phur pa rgyud lugs)
 Treasury of Precious Qualities (yon tan mdzod)

Kunkhyen Tenpai Nyima (kun mkhyen bstan pa'i nyi ma, b. c.1818)
 The Compendium of Oral Instructions: General Notes on the Rituals of Development Stage
 (bskyed rim gyi zin bris cho ga spyi 'gros ltar bkod pa man ngag kun btus zhes bya ba) [in
 translation as *Vajra Wisdom*]

Lochen Dharmashri, Ngawang Chöpal Gyatso (lo chen dharma shri, ngag dbang chos dpal
rgya mtsho, 1654–1717)
 A Brief Explanation on the Filling of Sacred Objects (rtan la gzung 'brul lag len mdor
 bsdus)
 Choreographic Treatise of the Sacred Dance Entitled the Display of Samantabhadra ('chams
 yig kun bzang rol pa)
 A Delightful Illumination: A Handbook of Mandala Measurement and Color (dkyil 'khor
 spyi thig tshon gyi cha ba rab gsal kun dga')
 An Explanation on the Celestial Mansion from Manjushri's Magical Net Emanation Tan-
 tra [known as] the Clear Lamp of the Source and Commentaries (sgyu 'phrul drva ba'i gzhal
 med gang gi rnam bzhag gsal ba'i sgron me rtsa ba dang 'grel pa gnyis)
 Important Points on the Building of Stupas and Insertion of the Two Stainless Mandalas
 (dri med rnam gnyis kyi mchod rten bzhengs pa la nye bar mkho ba'i cho ga bklag pas
 grub pa)
 Lord of Secret's Oral Advice (gsang bdag zhal lung)

Ornaments of the Peaceful and Wrathful Deities (lo chen gsung zhi khro'i rgyan chas)
Vajrapani's Ornamented Wisdom: A Commentary on the Guhyagarbha [Secret Essence] Tantra (gsang snying gsang bdag dgongs rgyan)

Longchen Rabjam (klong chen rab 'byams, 1308–1364)
Precious Wish-Fulfilling Treasury (yid bzhin rin po che mdzod)
Relaxing in the Nature of Mind (sems nyid ngal gso)
Trilogy of Finding Comfort and Ease (ngal gso skor gsum)

Menlha Döndrup (sman lha don 'grub, b. 1440)
Wish-Fulfilling Jewel of Proportions/The Wish-Fulfilling Jewel: An Explanation on the Measurements of the Sugata's Bodily Form (bde bar gshegs pa'i sku gzugs kyi tshad pa yid bzhin nor bu; cha tshad yid bzhin nor bu)

Mikyö Dorje, 8th Karmapa (karma pa mi bskyod rdo rje, 1507–1554)
Great Sun Art Manual (thig yig nyi ma chen mo)

Ngari Panchen, Pema Wangyal (mnga' ris pan chen pad ma dbang rgyal, 1487–1542)
Practice of the Three Vows (sdom gsum rnam nges)

Palden Lodrö Zangpo (dpal ldan blo gros bzang po, b. 16th c.)
Clear Mirror of Sutra and Tantra: Art Treatise on Proportions of the Assembly of Peaceful and Wrathful Deities (mdo rgyud gsal ba'i me long; zhi khro rab 'byams kyi cha tshad bzo rig bstan bcos mdo rgyud gsal ba'i me long)

Patrul Rinpoche (rdza dpal sprul rin po che, 1808–1887)
Instructions on Refuge and Bodhichitta (skyabs sems kyi khrid bsdus pa sangs rgyas chos tshogs ma'i 'grel pa)

Pema Karpo, Druk Kunkhyen (kun mkhyen pad ma dkar po, 1527–1592)
An Analysis of Metals (li ma brtag pa)
Meaningful to Behold: An Explanation of Deity Painting (bris sku'i rnam bshad mthong ba don ldan)

Rigdzin Gödem Ngödrup Gyaltsen (rig 'dzin rgod ldem dngos grub rgyal mtshan, 1337–1408)
Heart Accomplishment of the Northern Treasures (byang gter thugs grub)
Iconographic Measurements from the Heart Accomplishment Practice of the Northern Treasures (byang gter thugs sgrub kyi thig rtsa)

Sangye Lingpa (sangs rgyas gling pa, 1340–1396)
Condensed Realization of the Gurus (bla ma dgongs 'dus)

Shechen Gyaltsap Gyurme Pema Namgyal (zhe chen rgyal tshab 'gyur med pad ma rnam rgyal, 1871–1926)
The Chariot of Complete Freedom: A General Presentation of the Preliminaries for the Diamond Vehicle (rdo rje thegs pa'i thun mong gi sngon 'gro spyi sbyor chog pa'i khrid kyi rgyab yig kun mkhyen zhal lung rnam grol shing rta)
The Illuminating Jewel Mirror: A Brief, Clear, and Comprehensible Overview of the Development Stage (bskyed rim spyi'i rnam par bzhag pa nyung gsal go bder brjod pa rab gsal nor bu'i me long) [in translation as *Vajra Wisdom*]

Tekchok Dorje, 14th Karmapa (karma pa theg mchog rdo rje, 1798/89–1868/69)
An Easy Way to Understand the Drawing and Measurement of Myriad Mandalas from the Oceanic Tantras (rgyud sde rgya mtsho'i dkyil 'khor gyi thig rtsa dang bris tshom gyi dbye ba go bder bkod pa)

Terdak Lingpa, Gyurme Dorje (smin gling gter bdag gling pa 'gyur med rdo rje, 1646–1714)
Embodiment of All the Sugatas (bde gshegs kun 'dus; thugs rje chen po bde gshegs kun 'dus)
Appendix to the Recitation Manual of the Embodiment of All the Sugatas

Tsamo Rongpa Sönam Özer (tsha mo rong pa bsod nams 'od zer, 13th c.)
Source of All Qualities: A Manual for the Depiction of Various Buddhist Representations (rten gsum bzhugs gnas dang bcas pa'i bzhengs tshul yon tan 'byung gnas)

Tsongkhapa (rje tsong kha pa, 1357–1419)
Great Exposition of the Stages of the Path (lam rim chen mo)

WORKS CITED

Sutras

Bodhisattva Pitaka (byang chub sems dpa'i sde snod)
Cloud of Jewels Sutra (dkon mchog sprin; Ratnamegha Sutra)
An Explanation of Realization's Powerful Merit (bsod nams kyi stobs kyi rtogs pa brjod pa'i skabs te/brgyad pa)
Great Compendium Sutra (phal po che'i mdo; Avatamsaka Sutra)
Great Nirvana Sutra (mya ngan las 'das pa chen po'i mdo)
King of Concentrations Sutra (ting 'dzin rgyal po'i mdo; Samadhiraja Sutra)
Queen Shrimala Sutra (dpal phreng gi mdo; Shrimaladevisimhanada Sutra)
Sutra Analyzing Action (las rnam par 'byed pa'i mdo)
Sutra Expressing the Realization of All (gang po'i rtogs pa rjod pa'i mdo)
Sutra of a Hundred Invocations and Prostrations (dpang skong phyag brgya pa'i mdo)
Sutra of Entry into the Great Array (bkod pa chen po las la 'jug pa)
Sutra of Extensive Play (rgya cher rol pa; Lalitavistara Sutra)
Sutra of Manjushri's Perfect Emanation ('jam dpal rnam par rol pa'i mdo; Manjushrivikridita Sutra)
Sutra of the Immaculate Goddess (lha mo dri ma med pa'i mdo)
Sutra of the Multistoried House (khang bu brtseg pa'i mdo; Kutagara Sutra)
Sutra of the Pacifying Stream's Play (zhe byed chu klung rol pa'i mdo)
Sutra of the Precious Lamp (dkon mchog ta la'i mdo; Ratnaloka Sutra)
Sutra of the Ten Wheels Requested by Kshitigarbha (gsang snying 'khor lo bcu pa'i mdo)
Sutra on Cause and Effect (rgyu 'bras bstan pa'i mdo)
Sutra on the Application of Mindfulness (mdo dran pa nyer bzhag)
Sutra Requested by Druma (ljon pas zhus pa'i mdo, Drumakinnararajaparipriccha Sutra)
Sutra Requested by Litsavi (li tsa bis zhus pa'i mdo)
Sutra Requested by Sagaramati (blo gros rgya mtshos shus pa'i mdo; Sagaramatiparipriccha Sutra)
Sutra Requested by the Girl Rinchen (bu mo rin chen gyis zhus pa'i mdo)
Sutra Requested by Upali (nye bar 'khor gyis zhus pa'i mdo; Upaliparipriccha Sutra)

Sutra Revealing the Compassion of the Sugata (nying po bstan pa'i mdo; Tathagata Maha-karuna Nirdesha Sutra)

Sutra That Gathers All Intentions ('dus pa mdo; mdo dgongs pa 'dus pa)

Sutra That Teaches Miraculous Manipulation (cho 'phrul rnam par bstan pa'i mdo)

Transcendent Wisdom Sutra (Medium) in 25,000 Lines ("Medium-Length Mother"; yum bar ma; sher phyin stong phrag nyi shu lnga pa; Pancavimshatisahasrika Prajnaparamita Sutra: the mid-sized collection in four volumes).

Transcendent Wisdom Sutra in 8,000 Verses (brgyad stong pa; Astasahasrika Prajnaparamita Sutra is the "Short-length Mother"; yum bsdus pa: the short collection in one volume.

Transcendent Wisdom Sutra in 20,000 Verses (nyi khri)

Translated Word (bka' 'gyur)

White Lotus Sutra (mdo sde pad dkar; Saddharapundarika Sutra)

Treatises (Shastras)

Asanga
Bodhisattva Grounds (byang sa; Bodhisattva-bhumi)
Five Treatises on the Levels (sa sde; Yogachara-bhumi-shastra)

Atisha
Lamp for the Path to Enlightenment (byang chub lam gyi sgron ma; Bodhipatha-pradipa)
Chandragomin
Twenty Verses on the Bodhisattva Vows (byang chub sems dpa'i sdom pa nyi shu pa; Sam-varavimsaha)

Indrabhuti
Accomplishment of Wisdom (ye shes grub pa; ye shes grub pa zhes bya ba'i sgrub pa'i thabs; Jñānasiddhi or Jñānasiddhirnāmasādhanam)

Mahamaudgalyayana
Discourse on Designations (gdags pa'i bstan bcos; Prajnaptipada or Prajnaptisastra, one of the seven Abhidharma-pitaka)

Maitreya (Asanga)
Ornament of Clear Realization (mngon rtogs rgyan; Abhisamayalankara)
Sublime Continuum (rgyud bla ma; theg pa chen po rgyud bla ma'i bstan bcos; Uttaratan-tra-shastra)

Nagarjuna
Disclosure of the Awakening Mind (byang chub sems 'grel; Bodhicittavivarana)
Jewel Garland (rin chen phreng ba; Ratnavali)
Praise of the Vajra Mind (sems kyi rdo rje la bstod pa)

Ratnakarashanti
Supreme Essence (*snying po mchog;* Saaratamaa)

Shantideva
Way of the Bodhisattva (spyod 'jug; Bodhicharyavatara)

Totsun Drupje (mtho btsun grub rje)
Praise of the Buddha (khyad par 'phags bstod)
Translated Treatises on the Buddha's Words (bstan 'gyur; shastra)

Tantras

Assemblage of Secrets (gsang ba 'dus pa; Guhyasamaja-tantra)

Awesome Flash of Lightning (rgyud ye shes rngam glog; jnanascaryadyutitantra)

Gyutrul Ngamlok (sgyu 'phrul rngam glog) most likely another name for *Awesome Flash of Lightning*

Chakrasamvara "Binder of Chakras" ('khor lo sdom pa)

Chakrasamvara Tantra ('khor lo bde mchog rgyud)

Condensed Consecration Tantra (rab gnas kyi rgyud mdor bsdus)

Condensed Realization of the Gurus (bla ma dgongs 'dus)

Eight Transmitted Teachings: Means for Attainment (sgrub pa bka' brgyad)

Exposition Tantra of the Two Segments (brtag gnyis bshad rgyud; Sambhuti)

Galpo Tantra (gal po bsdus pa) Also named: Tantra of the General Accomplishment of Knowledge Mantras (rig sngags spyi'i sgrub lugs kyi rgyud)

Gathering of the Great Assembly (tshogs chen 'dus pa)

Great Ati Array Tantra (a ti bkod pa chen po rgyud)

Great Vastness of Space Tantra (nam mkha' klong yangs kyi rgyud)

Heruka Galpo Tantra (he ru ka gal po che'i rgyud)

Kalachakra Tantra (dus 'khor)

Lotus Net Tantra (pad ma drva ba)

Lotus Stages of Activity (pad ma'i las rim)

Magical Web (rgyud kyi rgyal po chen po sgyu 'phrul 'drva ba; Mayajala-mahatantra-raja)

Mighty Black Yama Tantra (gshed nag; gshin rje shed nag po'i rgyud rim par phye bab cu bzhi pa)

Precious Assemblage Tantra (kun 'dus rin po che'i rgyud)

Root Tantra of Manjushri ('jam dpal rtsa rgyud; Manjushrimula-tantra)

Secret Essence Tantra (gsang ba snying po; Guhyagarbha-tantra)

Subsequent Tantra: The Continuous Cycle of the Four Activities (las bzhi'i 'khor lo'i rgyud phyi ma)

Supreme Blazing Vajra Mind (rdo rje thugs mchog 'bar ba)

Tantra of Indestructible Array (rdo rje bkod pa'i rgyud; Vyuhavajratantra)

Tantra of Noble Apprehension (bzang po yongs bzung)

Tantra of Realization in Three Words (dgong pa tshig gsum pa'i rgyud)

Tantra of Secrets (gsang rgyud)

Tantra of Supreme Nectar (bdud rtsi mchog gi rgyud)

Tantra of Supreme Placement (rab gnas rgyud)

Tantra of Supreme Samaya (dam tshig mchog gi rgyud)

Tantra of the Emergence of Chakrasamvara (sdom 'byung gi rgyud; Samvarodaya-tantra)

Tantra of the Glorious Dark-Red Bhairava (dpal gshin rje gshed dmar nag gi rgyud)

Tantra of the Ocean of Skyfarers (mkha' 'gro rgya mtsho; Dakarnavamaha-yogini-tantra-raja)

Tantra Which Draws Out the Heart of Awareness (bkra shis rig pa khu byug gi rgyud)

Union of the Buddhas Tantra (sangs rgyas mnyam sbyor; Sarvabuddhasamayayoga-tantra)

Unshakable Tantra (mi g.yo ba'i rgyud)

Yamaraja Secret Black Moon Tantra (gshin rje zla gsang nag po'i rgyud)

Sadhanas

Guru Chöwang

Most Secret Razor Kilaya (phur pa yang gsang spu gri)

Nyang Ral Nyima Özer

Eight Sadhana Teachings: Assemblage of the Sugatas (bka' brgyad bde gshegs 'dus pa), divided into *Peaceful Assemblage* (bde 'dus zhi ba) and *Wrathful Assemblage* (bde 'dus khro ba) mandalas

Pema Dongak Lingpa

Heart Essence of the Self-Born Lotus (rang byung pad ma snying thig)

Heart Essence of the Self-Born Lotus: Mother Queen of the Ocean (rang byung pad ma snying thig gi yum ka mtsho rgyal ma)

Padmasambhava's Heart Essence of Longevity (pad ma tshe yi snying thig)

Vajrakilaya According to the Nyak Tradition (gnyags lugs phur ba)

Minling Terchen Terdak Lingpa

Heart Essence Amitayus That Embodies All (tshe dpag med yang snying kun 'dus)

Heart Essence of the Vidyadharas (rig 'dzin thugs thig)

Minling Vajrasattva (smin gling rdo sems), also found in the Nyingma Ka'ma

Minling Wrathful Guru (smin gling gur drag)

Peaceful Guru (bla ma zhi ba), from the *Heart Essence of the Vidyadharas* (rig 'dzin thugs thig)

Vajrakilaya from the Razor Scriptures (phur pa spu gri), from the *Most Secret Razor Kilaya* sadhana (see Guru Chöwang)

Yamaraja the Destroyer (gshin rje 'joms byed), from the *Lord of the Dead Who Destroys Arrogant Spirits,* revealed by Terdak Lingpa

Nyingma Kama Liturgies

Gathering of the Great Assembly (tshogs chen 'dus pa), from the *Sutra That Gathers All Intentions* (mdo dgongs pa 'dus pa).

One That Stirs from the Depths (dong sprugs brgya ldan)

Spotless Rays of Light ('od zer dri med)

Peaceful Deities of the Magical Net (sgyu 'phrul zhi ba)

Wrathful Deities of the Magical Net (sgyu 'phrul khro bo)

Other Tibetan Texts

Accomplishment of the Three Kayas (sku gsum 'grub pa)

Aspiration for Rebirth in Sukhavati (bde chen smon lam) (Karma Chagme Rinpoche)

Commentary on the Secret Essence (gsang 'grel)

Crown Ornament of the Victory Banner (rgyal mtshan rtse ma'i dpung rgyan)

Crystallization of Practical Procedures (lag len zhun thig) (Pandit Mriti)

Dharma Activities (chos spyod)

Oral Advice (zhal lung)

Oral Instructions of the Heruka (he ru ka'i zhal lung)

Stages of Meditation of the Assemblage of Sugatas (bde gshegs 'dus pa sgom rim)

Works in English

Apte, V. S. *The Practical Sanskrit-English dictionary.* Revised and enlarged edition. 3 vols. Poona, India: Prasad Prakashan, 1957–1959.

Beer, Robert. *The Encyclopaedia of Tibetan Symbols and Motifs.* Chicago: Serindia Publications, 2004.

Brauen, Martin. *The Mandala: Sacred Circle in Tibetan Buddhism.* Boston: Shambhala Publications, 1997.

Chandragomin. *Twenty Verses on the Bodhisattva Vows.* Translated by Joan Nicell. An FPMT Masters Program Translation. *N.p.: FPMT, 2005.*

Dilgo Khyentse Rinpoche. *Zurchungpa's Testament: A Commentary on Zurchung Sherab Trakpa's Eighty Chapters.* Translated by Padmakara Translation Group. Boston: Snow Lion Publications, 2007.

Dudjom Rinpoche, Jikdrel Yeshe Dorje. *The Nyingma School of Tibetan Buddhism: Its Fundamentals and History.* Translated and edited by Gyurme Dorje and Matthew Kapstein. Second ed. Boston: Wisdom Publications, 2002.

Gega Lama. *Principles of Tibetan Art.* 2 vols. Darjeeling, India: Jamyang Singe, 1983.

Jackson, David. *A History of Tibetan Painting.* Wien: Verlag Der Osterreichischen Akademie Der Wissenschaften, 1996.

_____, and Janice Jackson. "A Survey of Tibetan Pigments." *Kailash: A Journal of Himalayan Studies* 4, no. 3 (1976): 273–94.

Jamgön Kongtrul. *Myriad Worlds: Buddhist Cosmology in Abhidharma, Kalacakra and Dzogchen.* Translated by Kalu Rinpoche Translation Group. Ithaca, NY: Snow Lion Publications, 1995.

_____. *The Treasury of Knowledge, Book 6, Parts 1 and 2: Indo-Tibetan Classical Learning and Buddhist Phenomenology.* Translated by Gyurme Dorje. Boston: Snow Lion Publications, 2012.

Jamgön Mipham Gyatso. "The Treasure of Blessings: A Sādhana of the Buddha." In *Collection of Practices.* Translated by Padmakara Translation Group. Plazac, France: Editions Padmakara, 2007.

Je Jikten Sumgon Rinchen Pel. *The Twelve Deeds of the Buddha.* Compiled by Matthew Akester. Kathmandu: Shechen Publications, 2003.

Kangyur Rinpoche, Longchen Yeshe Dorje. *Treasury of Precious Qualities: A Commentary on the Root Text by Jigme Lingpa.* Translated by the Padmakara Translation Group. Boston: Shambhala Publications, 2001.

The King of Aspirations for Noble Excellent Conduct. Translated by Padmakara Translation Group. Plazac, France: Editions Padmakara, 2007.

Kunkhyen Tenpe Nyima and Shechen Gyaltsap IV. *Vajra Wisdom: Deity Practice in Tibetan Buddhism.* Translated by the Dharmachakra Translation Group. Boston: Snow Lion Publications, 2012.

Lowenstein, Tom. *The Vision of the Buddha.* Boston: Little, Brown, 1996.

Ngawang Kunga Tenzin, Khamtrul III. *A Supreme Liturgy for Artists.* Translated by Ven. Sean Price and Konchog Lhadrepa. Delhi: Shechen Publications, 2015.

Patrul Rinpoche. *The Words of My Perfect Teacher.* Translated by the Padmakara Translation Group. Revised ed. New Delhi: Vistaar Publications, 1999.

Powers, John, and David Templeman. *Historical Dictionary of Tibet.* Lanham, MD: Scarecrow Press, 2012.

Rangjung Yeshe Wiki, Dharma Dictionary http://rywiki.tsadra.org/index.php/Main_Page

Shantideva. *The Way of the Bodhisattva*. Translated by the Padmakara Translation Group. Boston: Shambhala Publications, 1999.

Thinley Norbu. *The Small Golden Key*. Translated by Lisa Anderson. Boston: Shambhala Publications, 1993.

Tsepak Rigdzin. *Tibetan-English Dictionary of Buddhist Terminology*. New Delhi: Library of Tibetan Works and Archives, 1997.

Warder, A. K. *Indian Kavya Literature: The Art of Storytelling, Vol. 6*. Delhi: Motilal Banarsidass Publications, 1992.

INDEX

About the Authors

Konchog Lhadrepa has been the Principal of the Tsering Art School since its foundation in 1996. He is an authentic holder of the Karma Gadri lineage of painting, which originated in Eastern Tibet, and is famous for the beauty of its spacious landscapes. He became a disciple of Dilgo Khyentse Rinpoche at the age of ten and served as his personal attendant from the age of sixteen to twenty-two. Over the years, Konchog painted many works for Rinpoche and his associated centers throughout the Indian subcontinent and Europe. His remarkable abilities, training, and knowledge of the sacred arts alone make him an exceptional artist.

Charlotte Davis completed a Bachelor of Fine Arts from the Australian National University before traveling to Nepal in 1998 to study traditional Tibetan art at the Tsering Art School under Konchog's guidance. She was among the first group of graduates to complete their studies at Tsering Art School in 2003. She worked in the school administration alongside Konchog from 1998 to 2004 and today continues to work for the art school and monastery, while maintaining her practice as a thangka painter.